The Death of the Artist as Hero

ESSAYS·IN·HISTORY·AND·CULTURE

BERNARD·SMITH

Melbourne
OXFORD UNIVERSITY PRESS
Auckland Oxford New York

OXFORD UNIVERSITY PRESS AUSTRALIA
Oxford New York Toronto
Delhi Bombay Calcutta Madras Karachi
Petaling Jaya Singapore Hong Kong Tokyo
Nairobi Dar es Salaam Cape Town
Melbourne Auckland
and associated companies
in Beirut Berlin Ibadan Nicosia

National Library of Australia
Cataloguing-in-Publication data:

Smith, Bernard, 1916–

 The death of the artist as hero.

 Includes index.
 ISBN 0 19 554844 2.
 ISBN 0 19 554845 0 (pbk.).

 1. Art – Philosophy – Collected works. 2. Aesthetics
 – Collected works. 3. Art and society – Collected works.
 4. Art and history – Collected works. 5. Art,
 Australian – Collected works. I. Title.

701

Edited by Lee White
Designed by Pauline McClenaban
Typeset by Setrite Typesetters Ltd, Hong Kong
Printed by Ko's Arts Printing Co., Ltd., Hong Kong
Published by Oxford University Press, 253 Normanby Road,
South Melbourne, Australia
OXFORD is a trademark of Oxford University Press

Contents

Abstract Art and the Antipodean Intervention

Reflections on Australian Art

Preface

The essays brought together here explore issues that have con-
cerned me for most of my life. The need to develop and describe
an aesthetic suited to a modern democratic society has been at
the centre of that concern. In these essays I explore problems
involved in developing such an aesthetic from several points of
view in both Australian and more general contexts. Most have
been developed from lectures given during the past ten years and
all have been written in the hope of opening out issues rather
than closing them off. The three essays concerned with the work
of Jack Lindsay give me an opportunity to pay a small tribute to a
writer whose *Short History of Culture* (1939) played an important
part in the development of my own cultural and intellectual
interests.

I wish to express my gratitude to all those who invited me to
write the lectures or articles from which these essays have been
developed. I also wish to express my thanks to those editors and
publishers who first published many of the texts and have agreed
to their being published in this collection. A full list of these
earlier publications is provided in the Acknowledgements sec-
tion. I also wish to thank Lee White for her help in editing the
manuscript. Five essays (numbers 6, 13, 15, 20 and 26) are here
published for the first time.

Acknowledgements

'Notes on Élitism and the Arts' was first published in *Meanjin Quarterly*, 2 (1975). 'The Death of the Artist as Hero' was first published in *Meanjin*, 1 (1977); in its original form it was first given as the John Power Lecture in Contemporary Art, University of Sydney, in July 1976 and later in Brisbane, Canberra, Melbourne, Devonport, Launceston, Hobart, Adelaide, Perth, Alice Springs, Darwin and Wagga Wagga. 'Art and Industry: a Systematic Approach' was first published in *Studio International* (April 1974). An earlier version of the paper formed the subject of a discussion in Professor Sir Ernst Gombrich's 'Work in Progress' seminar at the Warburg Institute, University of London, 7 November 1973. 'Art, Craft and Community' was first given as a lecture at the Community Arts Conference held in the Darwin Community Art College in October 1975. 'The Writer and the Bomb' was given as a short paper at a symposium entitled 'Imagining the Real' held in the Academy of Science, Canberra, on 11 November 1986, in which writers from throughout Australia voiced their concern about the growth of nuclear technology for both civil and military purposes. 'History as Criticism' was read in the 'Historians on History' forum arranged by the History Institute of Victoria and held at the University of Melbourne on 28 April 1985. 'Art Objects and Historical Usage' was given as a paper in the Fourteenth Annual Symposium of the Australian Academy of the Humanities entitled 'Who Owns the Past?' held at the Academy of Science, Canberra, in May 1983. It was later published in *Who Owns the Past*, ed. Isabel McBryde, Oxford University Press (Melbourne, 1985). 'History and the Architect' was first read to the Halftime Club, Victoria, on 24 July 1982 at the University of Melbourne. It was later published in *Transition*, nos 18 & 19 (September 1986). 'History and the Collector' was originally given as an address on the occasion of the official opening of the Rex Nan Kivell Room,

National Library of Australia, Canberra, on 4 April 1974. 'Jack Lindsay' was first given as a lecture at the University of Queensland on 27 May 1982 and later published in *Australian Literary Studies* (October 1983). 'Jack Lindsay's Marxism' was first read at the Marxist Summer School, held at Sydney University in January 1985 and was later published in *Arena, 71* (1985). 'Jack Lindsay's Biographies of Artists' was first published in *Culture and History, Essays presented to Jack Lindsay*, Hale and Iremonger, ed. B. Smith (Sydney, 1984). 'Marx and Aesthetic Value' was developed from a paper originally given to the Conference on Culture, the Arts, Media and Radical Politics, held at the New South Wales Institute of Technology, Sydney, in July 1985. 'The Social Role of the Art Museum' was first published in *Meanjin*, v (1946). 'The Art Museum and Public Accountability' was first given as a paper entitled 'Documentation in Australian Art' to the second Margaret Carnegie Seminar held in the Riverina–Murray Institute of Higher Education, Wagga Wagga, in November 1985. 'Notes on Abstract Art' was first published in *Abstract Art in Australia*, ed. Jenny Zimmer, RMIT Gallery (August 1983). 'The Antipodean Manifesto' was first published as a preface to the Antipodean exhibition held at the Victorian Society of Artists Gallery, Eastern Hill, Melbourne, in August 1959. 'The Truth about the Antipodeans' was first given as a lecture at Ormond College, University of Melbourne, in July 1984 and later at the Australian National Gallery, Canberra and the University of Western Australia. It was published first in *Praxis M 8 (The West Australian Journal of Contemporary Art* (Autumn 1985). 'The Myth of Isolation' was the first of two lectures given as the John Murtagh Macrossan Lectures for 1961, University of Queensland. It was first published in *Australian Painting Today, The John Murtagh Macrossan Lectures, 1961*, University of Queensland Press (St Lucia, 1962). 'Is there a Radical Tradition in Australian Art?' was given as a lecture in the series 'Radicalism and Conservatism in the Arts' held at the Canberra Art School during March–April 1984. 'An Australian Impressionism?' first appeared in *The Age Monthly Review*, December–January 1985–86 under the title 'New Light on Old Light: Impressionism and the Golden Summers Exhibition'. 'Apollo's Vanguard' was read in the New England Regional Art Museum, at the annual conference of the Association for the Study of Australian Literature, held at Armidale, August 1985. 'Two Art Systems' was originally written for the one-day seminar, 'St Petersburg or Tinsel Town? Melbourne and Sydney: their Differing Styles and Changing Relation',

held at the State Film Centre, East Melbourne, on 29 November 1980. It was later published, first in *Meanjin 40*, 1 (Autumn) (April 1981), and again in *The Sydney–Melbourne Book*, ed. Jim Davidson, Allen and Unwin (Sydney, 1986). 'Some Northern Critics of Southern Art' was first published as a Foreword to Peter Fuller, *The Australian Scapegoat: Towards an Antipodean Aesthetic*, University of Western Australian Press (Nedlands, 1986). 'Five Options for Australian Culture' was read at the seminar 'Australia: a Dependant Culture', sponsored by the Australian Studies Centre, University of Queensland, which was staged in conjunction with the Commonwealth Games, held in Brisbane in September 1982. It was later published in *The Age Monthly Review* in November 1982. 'On Cultural Convergence' was read in the lecture series held at the Glasshouse Theatre, Royal Melbourne Institute of Technology, during April–May 1985 in connection with the 'Dot and Circle' exhibition of Papunya art then on show in the RMIT Gallery.

List of Illustrations

To the memory of
Norman and Lionel Lindsay
in appeasement
and to Jack Lindsay
in gratitude

Art and Élitism

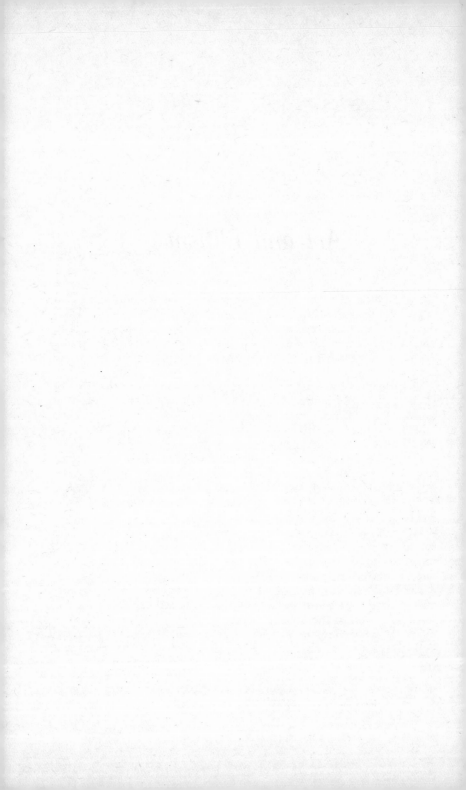

1
Notes on Élitism and the Arts
—1975—

The idea of an élite comes to us, like so much else, from the Greeks. In its primal form the notion is theological. The god chooses some rather than others, the chosen are his elect. Christian theology took over the Jewish conception of a national élite and applied it to individuals—to that small number who on the last day would be gathered from the uttermost parts of the earth unto Abraham's bosom. Chosen of god, Hebrew ancestor and Christian ancestor, Abraham had it on all counts: he is the prototype of the elect.

The idea has possessed aesthetic implications from the time of Homer. 'So will I be thy witness among all men,' says Ulysses to the minstrel Demodocus, 'how the god of his grace hath given thee the gift of wondrous song.' For the Greeks, poets were an elect of the gods: they did not create by *techne*, by skill and rules, but by inspiration. Plato, of course, gave it classical expression: 'the authors of those great poems which we admire, do not attain to excellence through the rules of any art, but they utter their beautiful melodies of verse in a state of inspiration, and, as it were, possessed by a spirit not their own.'

The notion of an artistic élite remains pretty much confined to the word-men and (since poetry was accompanied by music) the music-men among artists until the time of Ficino and Alberti, who included painters and architects among those who were capable of creating not by skill but by inspiration. Somewhat later Michelangelo put in a word for the sculptors and they too were admitted to the Divine Lodge. Élitism was then applied to manners and behaviour by Castiglione, who held that aristocratic behaviour is to be cultivated as an endowment rather than as a skill; a grace rather than a craft; a cult of the amateur.

The romantics adopted élitism and secularized it. With Nietzsche the artist is no longer a man inspired by the gods. He is a god to

himself and, hopefully, to others; a man beyond morality who listens to his inner voice, which is no longer the voice of conscience but a primitive creative daemon.

This is the way élitist theory came to dominate the arts in Australia; in Nietzsche's form. But it was not the first aesthetic theory to find roots in Australia. The first was of a different kind; we might call it, in the modern aesthetic jargon, an instrumentalist theory. Art was championed as an aid to civilization, to morality, to good behaviour in general; it was an aspect of utilitarianism. It activated those who created the art schools, colleges and galleries of this country from the 1860s to the 1880s. It is to be found particularly in the essays on art given in the Mechanics Institutes by Benjamin Duterrau, John Woolley, John Prout Hill, John West; in the newspaper articles of James Smith and James Green. All mostly forgotten.

Joseph Sheridan Moore, for example, the first man so far as I know to put forward a considered case for art education in Australia, could quote Ruskin to his purpose:

We want one man to be always thinking and another to be always working, and we call one a gentleman, and the other an operative; whereas the workman ought often to be thinking, and the thinker often to be working, and both should be gentlemen, in the best sense. As it is we make both ungentle, the one envying, the other despising, his brother; and the mass of society is made up of morbid thinkers and miserable workers.[1]

The democratic meliorism of the well-meaning colonials who pioneered our art institutions did not survive. It is remarkable how little the views of Ruskin, Morris and the Arts and Crafts Movement have influenced either Australian artists or critics during the twentieth century. Such views were based upon the dignity of craft rather than the inspirations of art. Julian Ashton in Sydney and Tom Roberts and his circle in Melbourne, after a flutter with populism, opted for Whistler, for art for art's sake, rather than for Ruskin. Perhaps in a raw, provincial, mainly pastoral society there was no alternative. If there was, it seems clear that the artists around Ashton and Roberts decided not to take it. 'You don't as a rule sell your pictures,' Roberts once remarked, 'to people who rent cottages at seventeen-and-six a week.'[2] Roberts may well have helped to create an Australian egalitarian mythos, but it seems clear that neither he nor his generation wanted artists themselves to get too involved in the mythos. It was bad for business. (It may be noted that in theology too, doctrines of election became dominant both in the Pro-

testant and Catholic Churches of Australia; and in politics racialist assumptions, the ethnic counterpart of élitism, became acceptable to all parties.)

Aestheticism, which the artists of the 'nineties (men embattled by philistinism and a depression) espoused, promoted two kinds of élitism. First was professional élitism: you had to be a practising artist before you could be a judge, to be a cook before you knew you were poisoned. The democratic institutions, the art galleries and the art schools were created largely by public-spirited Victorians in which laymen, not artists, were leaders, though professional artists joined the committees. Artists did not lead the battle for the public art institutions. But when they were created they became actively interested in the importance of a dominant voice on their councils. That was the production side of aesthetic élitism. But there was also a consumer's side. To be a judge of art you had to possess 'a good eye' or a 'natural taste'. This you were born with, that is to say chosen by God or the luck of the gene. It was impossible to learn or to teach art. That is still the conventional wisdom wherever art is taught in Australia.

Élitism, as I said, was greatly reinforced around the turn of the century in Australia by contact with the writings of Nietzsche. Norman Lindsay envisaged himself as a genius fighting a nation of wowsers and sedulously cultivated his personal legend (as did Percy Grainger). Later artists may have rejected Norman's pictorial style, but they adopted the life-style of the artist which he cultivated.

What Norman Lindsay did for art, his brother Lionel did for criticism. And the critics who have come after him, though they may have rejected his aesthetic preferences, have remained élitists almost to a man; that is to say they subscribe to the belief in creative genius being visited only upon an elect minority, in natural taste, and the good eye—or have written and acted as if they did; all aristocratic, exclusivist notions which cut off the artist and those few capable of enjoying his art from the great uncreative majority. Élitism in art and philistinism are the Siamese twins of taste in the industrial society; they depend upon each other like Tweedledum and Tweedledee. The first generation of Lindsays was suspicious of the educational activities of museums. Although Daryl Lindsay's views mellowed over the years, he always put his faith in taste—you had it or you didn't—a sort of aesthetic fundamentalism. The next generation of critics (the Bell and Fry men) put their trust in form. Élitism, however, remained fundamental to their practice.

This, substantially, is the way things have remained. True, since the Second World War the prejudice against an active educational programme for art has broken down. Art is taught, but it is still taught by those who believe that art cannot be taught. A demeaning, paradoxical activity; better not to be caught at it if you can escape it.

The major change has been revealed in the increasing readiness with which the cultivated minority of artists and the taste-makers have accepted avant-garde styles. Art dealers and the educational programmes of art galleries have addressed themselves to the creation of a more open-minded and cultivated minority—a static élitism has been exchanged for a dynamic élitism; but the old assumptions hold. Art is created by an élitist minority and is addressed to an élitist minority.

As a result of the transference of inspiration theory from poetry to the visual arts, skill (once the hallmark of creation in the visual arts when combined with invention) has gradually been eroded by intuition and accident. For avant-garde art, skill has come to be held in less and less regard. In the more recent moves towards conceptual art and its varieties, the wheel turns full cycle, and the skill men, the manual craftsmen, turn themselves into word-men and produce a mode analogous to poetry—which is where the élitist myth began. We are back with Homer by arrangement with Kosuth.

Élitism's main defence in these troubled times is the claim that it is the only sure guardian of excellence. This is where the Labor Party's programme for the visual arts went wrong. Its notions concerning the promotion of excellence, as revealed in Whitlam's and other official pronouncements, are naïve. If one proceeds to make grants to artists who have already achieved what is regarded as a measure of excellence without funding, how can it be argued that funding is required to produce excellence? If the decision about excellence is in the hands of a Statutory Authority, what is the Authority doing but using government funds to promote the standards (as expressed in the works of its chosen) which it itself approves? The Authority becomes taste-maker to the public at large.

There is something circular about the élitist theory of excellence. Samuel Alexander called taste a conspiracy among the informed: so it is, so long as taste is in the hands of an élite. In order to sustain excellence, so the élitist argument runs, we must encourage those who have already been endowed with excellence. How do the endowed reveal themselves to their official choosers?

In practical terms statutory authorities who subscribe to élitist theories perpetuate their own values. Excellence achieved in this way is a kind of conspiracy of the few against the many. In the long run, however, and it may be a very long run (from the eighteenth century rule of taste to the twentieth century rule of form) élites decay and become irrelevant.

In opposition to the élitist theory of excellence, we should seek a democratic theory of excellence. It is true, perhaps, that there has never been a democratic theory of excellence which has been shown to work in practice. That may be because those who have sought for one during the past century or so have paid too much attention to Marx, who tended to see art through the image of literature as an aspect of the theory of ideas and communication. Although he thought much about commodities, he did not give enough attention to the production of art as a material commodity. A democratic theory of excellence is more likely to emerge from a reconsideration of the French utopian socialists, and of Pugin, Ruskin and Morris, men who took the arts and crafts seriously. Man at work was the unit of their study, upon which they sought to build a just society, not Rousseau's natural man, who remains the unit upon which most of our medical, psychological, social and political sciences are based today.

As to excellence itself, we might begin by considering it increasingly as a grading procedure in a continuing debate, an unstable consensus established momentarily not by those chosen to judge, but by those who choose to judge. More people are judging these days.

We might gain a hint from outside art. Australia did not gain its achievements in cricket, tennis and swimming by the cultivation of sporting élites. True, the best were encouraged and carefully trained. But it was the ubiquity of these sports throughout the community that has told. We began with a broad democratic base, not a few score chosen ones, chosen by wealth or by their personal friends, but culled from the populace at large. If your object is excellence, you begin with a broad base: élitism fails because it insists upon a narrow base; its apex fails to reach the limits of the possible.

2
The Death of the Artist as Hero
—1976—

This year (1976) we celebrate the bicentenary of the Declaration of American Independence, the publication of Adam Smith's *Inquiry into the Nature and Causes of the Wealth of Nations*, and of James Watt perfecting the second patent of his steam engine. Those momentous events may serve to remind us that our industrial society is now two hundred years old and showing signs of wear and tear. During those two hundred years the artist has been called upon to play a traditional role, the role of hero. A chosen few have played the role with great brilliance to the profound enrichment of our civilization; but it seems to me, the role is now being played with an increasing lack of conviction. It is one which the artist may not be called upon to play much longer.

Hero. The word is Greek, but heroic cults are common to all communities, and the myths which accompany the cults also have much in common. The typical hero or heroine is separated in early life, or separates himself or herself, from family, tribe or nation, to embark upon, or be compelled towards, a series of adventures, physical, mental or spiritual. Daunting challenges are confronted and overcome with the aid of some super-human power or divine tutelary companion who makes it possible for the hero or heroine to return to the forsaken community with some great boon or blessing for the receipt of which an admiring people establishes a cult. The cult is usually centred upon the grave or tomb of the hero or heroine, but the birthplace, places of residence, or of the heroic action, may also become venues for veneration.

Scholars have long concerned themselves with the hidden symbolic meanings and structures of heroic myths. For Lévi-Strauss, myths embody not only the social and environmental situations of a community, but also the unresolved human con-

traditions of that community. Myth admits such contradictions, if not in manifest then in symbolic form. The hero's role embodies a paradox: his exploits act out contradictions which his society is unable to resolve in real life. It may be his role to adumbrate imaginatively social change of a crucial kind, or conversely to sustain some life-enhancing virtue at risk in his community. The processes which he sets in motion may bring about his own destruction and exacerbate in real life the contradictions which his actions have made symbolically visible. Heroic action is thus paradoxical both for hero and community. At a personal level the ego of the hero challenges its super-ego; the heroic achievement being attained by pride at the price of guilt. At a social level, the hero is destroyed continuously in real life in order that he or she may be venerated in myth.

Heroes arrive in different kinds of packages: as warriors, revolutionaries, legislators, priests, doctors, poets, philosophers, athletes. None of these need directly concern us here. Our concern is with a variety of the culture-hero, the hero whose life-enhancing action is embodied in some form of production, either material or mental. It is within the *genus* of culture-hero that our object, the artist as hero, is located, and from which it may be said to have evolved. Communities are prone to produce culture-heroes at moments of major change, at times when significant shifts are occurring in the techniques and social relationships of that community's mode of production. At such times wilful, highly individualistic personages appear who have it in them to defy custom, and those of their community who help maintain the conventions. They differ from other kinds of hero in being venerated not only for their actions but also for their inventions: those material or mental innovations by which they convey benefits to their community.

It is possible, I would suggest, to distinguish three distinct but widely-separated occasions in the history of western society during which the culture-hero and his legitimate heir, the artist as hero, has flourished. Each occasion is associated with a major shift in the mode of production and in each the hero's situation embodies contradictions developed by the shift.

The First Occasion
The first occasion is associated with the birth of technology. The use and containment of fire for cooking and comfort, for making tools, the invention of pottery, together with the domestication of

plants and animals were, as is well known, crucial stages in those early developments of technology by means of which *Homo sapiens* emerged from his original animality. For the Greeks these significant shifts in production were embodied in the myth of Prometheus, the Titan who at first sided with the new (usurping) Olympian gods in their battle against his kinsmen. Prometheus then proceeded to betray his new friends by stealing their fire from them, bringing it as a gift to mankind. It was Prometheus who taught mankind the arts of architecture, pottery, astronomy, mathematics and metallurgy, having learnt them from his divine helpmate Athena, at whose birth from the head of Zeus, with the aid of an axe, he had assisted. For this great benefit to man Zeus made him suffer cruelly, chaining him upon a rock on the Caucasus where Zeus's eagle devoured his (daily-growing) liver daily until at last, after a thousand years, the hero who brought the arts and skills to man was released from his torment by Herakles, the hero of labour.

Prometheus was a culture-hero for art at a time when it had not yet been separated from the crafts and trades; art that is to say as *techne*, or *ars*; art as skill. Yet long before the crucial break which occurred during the fifteenth century, between the arts and crafts, Greek mythology prefigured the possibility of such a division in the legend of Daedalus—a later, more specialist form of the artist as hero. Said to have been of noble birth, Daedalus was a legendary artist, craftsman and inventor of archaic times. He may have been an historic personage or, on the other hand, merely the eponymous hero of his calling, for his name denotes cunning workmanship. Cunning he is, like Prometheus, and like him a clever smith taught by the tutelary goddess Athena. Growing jealous of his talented apprentice Talos (who invented the saw, the potter's wheel and the compass) he took him to the top of Athena's temple and pushed him off, killing him. Daedalus then fled to Crete where he made puppets for King Minos and an artificial cow for Minos's wife Parsiphae. This enabled her to copulate in comfort with the beautiful white bull that Poseidon had sent to her husband as a sacrifice and which Minos, betrayed by his greed, had decided to save for his herd.

Parsiphae's night in Daedalus's artificial cow made it possible for her to conceive a novel biological horror, the Minotaur. Minos, understandably angry at the turn of events, imprisoned Daedalus in his own labyrinth, created to hold the Minotaur; but Athena, the ever-helpful girl friend, released him. Daedalus thereupon constructed artificial wings for himself and his son Icarus by

means of which they escaped from Crete. But Icarus, disobeying his father's instructions, flew too close to the Sun, and the wax holding the feathers to his back melting, he drowned in the Aegean. Having landed in Sicily, Daedalus befriended King Cocalus and his daughters for whom he made toys. When Minos at last discovered him, Daedalus succeeded, with the assistance of the girls, in destroying him by pouring boiling water or boiling pitch from a pipe artfully constructed in the ceiling of the royal bathroom.

Clearly there is a sharp difference between these two early culture-heroes, Prometheus and Daedalus; and their respective myths symbolize two distinct phases in the history of early technology. The art of Prometheus, crafty and disloyal though he be, is not for himself but a gift to all mankind. He is the primal culture-hero, symbolizing a time when the craft skills were for the first time beginning to produce a surplus. He is the hero of the first surplus; the ambiguity of his character, the deceit built into his altruism, may symbolize the ambiguity of the new situation. Who should benefit from the surplus, gods or men, heroes or the commonality?

It is not without significance that it is Herakles, the hero of labour, the one major Greek hero whose ancestry appears to have been indubitably human, who rescues Prometheus from his age-long agony.

With Daedalus we are in no doubt for whom the surplus is intended. Himself nobly born, he hangs about courts, amusing the women and outwitting his rivals, a conceptual artist, a happenings man, keen on novelties and innovations. He is the cunningly-wrought one, the crafty super-craftsman, whose tricks and artifices make ordinary mortals suspicious of him. In his primal form he symbolizes the monumental art and cunningly-wrought crafts produced for the aristocratic courts of archaic Greece. He is the hero both of a high art and a high technology that are not the concern of the common man, as Brueghel once made plain in his great painting *The Fall of Icarus*.

The early history of technology is thus personified in the dramatic activities of culture-heroes: charismatic innovators whose inventions are aided by divine support. I have drawn my examples from Greek mythology since it lies at the base of our own culture; but every society, during significant shifts in the development of its own technology has produced similar culture-heroes, such as the Tubal Cain of the Jews, the Emperor Huang Ti of the Chinese—the point need not be laboured. At times of

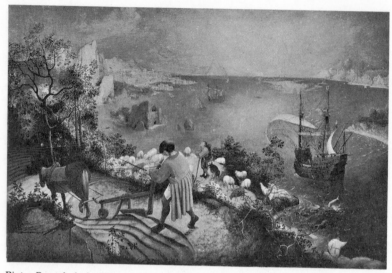

Pieter Brueghel, the Elder *Landscape with the Fall of Icarus*. Oil on canvas, 73.5 × 112 cm.

quickened pace, when the forces and relations of production are shifting, the more rapid accretion of inventions and skills in the work of *many* craftsmen is symbolized and personified in the mythical activities of a *few* charismatic heroes. Such myths personify the operation of evolutionary change symbolically, but discount the operation of rationality in the progress of invention and reduce the activities of many to the heroics of a few. The hero steals fire from the gods, or is taught his skills by a divine benefactor. But once these skills are recognized and socially related to production they are carried on, not by their charismatic innovators, but by crafts and trades within institutions such as guilds and corporations. Although the folk-memory tends to place a culture-hero upon each significant step in the techno-logical progress of a society, by the time such societies have entered upon their history, leaving material records, the routini-zation of the initial, heroic charisma is already well established.[1] So far as our own culture is concerned, from 3000 BC to 1400 AD technology is in the hands not of heroes but of artisans. During all that time, heroes in abundance were called from the ranks of the aggressive, in the form of warrior heroes, and from the devout, in the form of saints, but not from the ranks of those who made things with their hands.

The Second Occasion

The second occasion upon which artists came to assume the role of hero is associated with the separation of what later came to be called the fine or polite arts from the crafts and trades. This shift occurred, broadly speaking, between 1425 and 1525. After two thousand years of institutionalized continuity the crafts of building, sculpting and painting became 'progressive' again.[2] The change is associated with the names of a few famous artists and architects who broke from the conventions of the craft guilds. The new rules 'of the game called art' required that each unit of an artist's production should differ significantly from a previous unit; that it should solve a problem, or reveal personal originality. An early example of this new attitude is revealed in the changed character of the commission which the Signoria of Florence gave to Ghiberti for the design and construction of his second door for the Florence Baptistry in 1425. Vasari noted the change: 'They left the whole matter in his hands, saying that they gave him full liberty to do as he pleased and that he should make it as ornamental, rich, perfect and beautiful as he possibly could, or as could be imagined, without regard to time or expense and that as he had surpassed all other figure-makers up to that time, he should in this work surpass himself.'[3] Such a new problem-solving approach to art was severely opposed by the guilds. Filippo Brunelleschi, Ghiberti's famous contemporary and rival, was thrown into prison by the Arte de Maestri di Pietra e Legnami because he refused to pay his dues. His defiance was successful, and his great dome for the Cathedral of Florence succeeded in surpassing anything attempted by the ancients. 'It may safely be asserted', wrote Vasari, 'that the ancients never raised their buildings so high or incurred such risks in contending with the skies as this building appears to, for it rises to such a height that the mountains about Florence look like its fellows. Indeed one would say that the heavens are incensed against it since it is continually being struck by lightning.'[4] Brunelleschi is cast in the mould of Prometheus: his art is so skilful that he arouses the anger of the gods. Thus myth delivers its mantle to history.

In the writings of Alberti, the younger contemporary of Ghiberti and Brunelleschi, we glimpse the emergence of the physiognomy and character of the new type of Renaissance artist-hero. The antagonist of the new hero is no longer, as in the case of Prometheus, the chaos of Nature personified in the form of Zeus, exercising an unpredictable and uncontrolled tyranny over

humankind. The antagonist is now a human product: the routine, institutionalized production of the guilds. The guilds' mode of production is singled out as the obstacle to creative invention. The new Renaissance artist-hero realizes in history the myth of Daedalus, the clever, unscrupulous craftsman who outwits his enemies and gives pleasure and fame to his friends at court— many biographies of Renaissance artists recall the Daedalian myth. But it is now a Daedalus ennobled beyond recognition. In its original form the myth testifies to the high aspirations of the best architects, sculptors and painters of antiquity to be accepted as something more than mere craftsmen and their lack of success in achieving such aspirations: that is its paradox. Where antiquity failed a few, but only a few, of the most famous artists of the Renaissance succeeded. A functional division of labour, between invention on the one hand and craft skill on the other, is asserted and maintained in order to sustain a new and freer flow of progressive creativity. For Alberti architecture is 'a noble science not fit for every hand'.[5] The production of things immediately necessary were in his view the province of the common work-man; the architect, however, should be a man of science, possess-ing a 'tincture of the liberal arts' and a sound judgement. In his practice he should examine the best buildings of the ancients and of his contemporaries, and then set out to produce something admirable which is entirely his own invention. Such an artist may rightly expect to obtain fame and riches and have that fame handed down to posterity. Whereas craftsmen are held respon-sible for carrying on the continuity of the more mundane craft skills, the artist appropriates to himself the inventive, progressive aspects of the productive process.

The Renaissance concept of artistic progress is however *organic*. It proceeds within cycles: birth, youth, maturity, decline and death, followed by rebirth. It borrows from the Aristotelian account of the development of tragedy by which each phase of an art, each stage of the *genre* of an art, progresses until it reaches its entelechy—the potential form inherent within it. Then it declines. The Renaissance account of artistic progress, however, brought a measure of pathos to the role of the Renaissance artist as hero, since it had the effect of placing an account of personal develop-ment within two organic cycles with differential rates of growth: the growth-cycle of the art itself and the growth-cycle of the individual. The poignancy of the situation was noted on more than one occasion by Vasari, himself a noted exponent of organic progress—as when he described the work of Raffaellino del

Garbo. 'Generally artists progress from small beginnings to ever-greater attainments, until they reach the goal of perfection. But in art, as in nature, matters do not always follow the accustomed order, and this should give the censorious pause... Rafaellino began with extraordinary brilliance, the middle of his career was extremely mediocre, and his end wretched.'[6]

It is of some importance to note that by admitting the Fine Arts to be numbered among the liberal arts, the arts of the mind, the humanists and their followers among artists achieved an important extension of the principle of liberty to an area where it had not been previously applied. For the first time it began to dwell among those who worked by hand, even though at first it was applied to a small aristocracy of craftsmen only. By re-asserting, even if only in the small privileged area of the fine arts, the organic unity of mind and hand in material production, the Renaissance humanists began the restoration of a bridge that had been broken by the establishment of the institution of slavery upon the primal surplus in early times; that peculiar institution which had erected a formidable and enduring barrier between mental and manual labour. But this extension of the principle of liberty to manual production was achieved only at the cost of expropriating the spiritual form, invention, from the material form, craft skill, in the total process of production: and then offering 'genius' as an excuse for the expropriation.

The humanist identification of the Fine Arts as a Liberal Art was achieved with the assistance of two misleading or misunder-stood interpretations of the attitudes of the ancients to art and artists. First, the humanists believed that the visual arts were practised in Antiquity by the freeborn (often by princes) whereas in fact the practice of the arts was the normal province of bonds-men and slaves; second, they claimed that the ancients believed that architects, sculptors and painters (like poets and prophets) were inspired by the gods. This Renaissance cult of the divine origin of the visual arts reached its apogee in Vasari's biography of Michelangelo:

While industrious and choice spirits, aided by the light afforded by Giotto and his followers, strove to show the world the talent with which their happy stars and well-balanced humours had endowed them, and endeavoured to attain to the height of knowledge by imitating the greatness of Nature in all things, the great Ruler of Heaven looked down and, seeing these vain and fruitless efforts and the presumptuous opinions of man more removed from truth than light from darkness, resolved, in order to rid him of these errors, to send to earth a genius

universal in each art, to show single-handed the perfection of line and shadow, and who should give relief to his paintings, show a sound judgment in sculpture, and in architecture should render habitations convenient, safe, healthy, pleasant, well-proportioned, and enriched with various ornaments. He further endowed him with true moral philosophy and a sweet poetic spirit, so that the world should marvel at the singular eminence of his life and works and all his actions, seeming rather divine than earthly.[7]

In Vasari's image of Michelangelo, the entelechy of fine art is achieved; but his was a genius idiosyncratic, unpredictable, and given to whims. The contrary, unpredictable forces of nature, like the power of Zeus himself, or the volcano-demon Yahweh, appears in him embodied and internalized within one abnormally creative individual. It was, as Vasari intended it, an image of the artist as hero which has captured the imagination of succeeding centuries. 'He was sent into the world by God to help artists to learn from his life, his character and his works what a true artist should be.'

There can be no heroes without hero-worshippers; hero cults are basically cults of the dead and require objects associated with the hero for their ritual practice. The Greeks honoured their heroes in cult rituals at their tombs and Burckhardt tells us how the heroic cult of tombs and birthplaces revived during the Renaissance in the wake of the cult of saintly relics and saintly tombs; how Petrarch was taken as an old man by a group of his friends to his birthplace in Arezzo and told how a grateful city proposed to preserve it intact in gratitude to him. Since then birthplaces and tombs have become the objects of admiration cults of all kinds perpetuated by historians and the tourist agencies of cities, regions and nations keen to bathe in the profitable glory of their illustrious sons.

For the artist-hero, however, the most poignant relics are the works which survive him. They are admired not only for their intrinsic excellence, but also as the material embodiment of heroic achievement. Artists, critics, historians, have studied the works of their heroes in order not only to learn their profession but also to admire a way of life. At Michelangelo's obsequies 'art was to honour art'. That is to say the history of art came to be, in one sense, a study of sacred relics; the apparatus of a hero-cult. There is an element in aesthetic quality which is for this reason socially *given* from one generation to the next. To refuse this *givenness* in quality is in itself something of a heroic act, which distinguishes heroes from their worshippers.

For the worship of heroes is clearly not itself heroic. As on the

first occasion so on the second, a gradual routinization of the charisma of the hero sets in; the hero-worshippers seek vainly to imitate their heroes; a kind of (as Arnold Toynbee puts it in another context[8]) 'mechanicalness of mimesis' supervenes. In consequence, the sixteenth and seventeenth centuries did not generate heroes of the visual arts in the way the fifteenth and sixteenth centuries did. Significantly, during this period there was no fundamental shift in the role of the artist in production, but rather a steady consolidation of his recently-won role as a privileged producer, admired by princes, courts, nobility and gentry; the aristocrat of craftsmanship in the first phase of capitalism—the Age of Manufacture.

There were two ways in which the artists of that time came to imitate their Renaissance artist-heroes, and they were determined largely by the fact that, despite the efforts of men like Alberti, Leonardo and Michelangelo, the status of the artist as distinct from craftsman was never fully established—the battle for the distinction continued well into the eighteenth century. Artists sought to maintain their new status by creating new institutions, the academies of art, in opposition to the guilds. In the new situation one role of the artist was that of accomplished academician, a polished man of the world and courtly diplomat, learned, socially well-adjusted. It was the Albertian ideal of the artist, championed by Castiglione and embodied in the life and art of Raphael, and expressed again later in the achievements of Rubens, Lebrun, Bernini and Reynolds. The influence of this model lasted well into the nineteenth century—in the life of Lord Leighton for example—indeed so long as the academic ideal persisted.

The ideal of the artist as craftsman-aristocrat was not, of course, an heroic role but an accommodating one. In order to maintain their social success, such artists had to maintain a steady output of high quality, which involved the maintenance of large, complex workshops, and a division of labour typical of the Age of Manufacture. The master academician stood at the apex of a pyramid of manual work, supported by framers, guilders, drapery painters, engravers, and many apprentices; an aristocrat of manual work in 'that all-engrossing system of specialising and sorting men, that development in a man of one single faculty at the expense of all other faculties'.[9]

An alternative role for the artist, however, developed from those who resisted the institutionalization of their work, and preferred that it should not be divided by workshop specialization but be kept under their own personal control. It was from the magnificently wilful, capricious, non-conforming image of

Michelangelo—whom Raphael, in his *School of Athens* had placed apart from all others, brooding alone in magnificent solitude— that the Bohemian image of the artist emerged. The Wittkowers have traced its pre-history as far back as the late fourteenth century, and quote a painter's wife from one of Franco Sacchetti's *novelle* who exclaims: 'you painters are all whimsical and of ever-changing mind; you are constantly drunk and not even ashamed of yourselves'.[10] The new image was adumbrated, they point out, in the lives of Cellini, of whom Goethe wrote, 'our hero has the image of ethical perfection as something unattainable but con-stantly in mind';[11] of Caravaggio, whom Roger Fry described as the first artist 'to defy tradition and authority',[12] of Guido Reni, a gambler and spendthrift; of El Greco, who wasted a fortune in ostentatious living; of Franz Hals, an honoured member of his com-pany despite 'his drunkenness, his unruly life and his Bohemian household',[13] and in some respects at least, of Rembrandt. It was characteristic of most, if not all, such artists that they did not think of their art as an economic activity but as a calling. As Michelangelo himself put it: 'I have never been a painter or sculptor such as those who make a business of it'; or as Salvator Rosa, one of the outstanding proto-bohemians of the seventeenth century, said: 'I do not paint to enrich myself but purely for my own satisfaction. I must allow myself to be carried away by transports of enthusiasm and use my brushes only when I feel rapt.'[14]

These early Bohemians, by stressing the unity and individuality of art during the age of increasing specialization in manufacture (of which art was a part) which characterized the first phase of capitalism, kept alive the humanist faith in the artist as hero. Merging the Promethean myth with the idea of the second Adam, the *homo in potentia*, the artist became for them the persona of the creative individual who could by his own choosing become like the gods or decline into bestiality. For Ficino, man is not the slave of nature but its rival, completing, improving and refining its works. For Bovillus, 'reason is the power in man by which "mother nature" returns to herself, by which she completes her cycle and is led back to herself'.[15] What is significant in such humanism is that art is still seen as a 'progressive', problem-solving activity, but one which develops organically in response to the essential nature of life itself, and *not* in response to the forces of the inorganic universe.

Yet the desperate character of the lives of so many of these early Bohemian artists, the personal insecurity of their social situation, reveals to us a paradox at the heart of the humanist myth of the artist

as hero. Such heroic individualism could only be entertained by the most exceptionally endowed. As an ideology of hope and inspiration for a time when all men might become artists it possessed a value for the future; but its transcendental orientation, its explanation of genius as a divine gift, led to a fatal separation of the artist's practice from its ever-fertile source in craft skill, the true mother of invention.

The Third Occasion

The third occasion upon which the artist again appears in the role of hero is associated with the political and industrial revolutions of the late eighteenth century. On this occasion the role which the artist plays as hero differs radically from that which he played on the two earlier occasions. On those two occasions, as we have seen, the artist was cast in the role of a progressive technologist: on the first occasion by opposing nature in the dual guise of wilderness and humanoid animality; on the second occasion by opposing the rigid constraints of craft production (which since men were reduced therein to the automatic mechanisms of nature, can be seen as a regression towards the first occasion) in order to champion a more individual, more humanized mode of production. On the third occasion, however, the social role of the artist is subject to a radical inversion.

The industrial factory, by replacing the workshop based upon manufacture, had the effect of displacing the artist-academician as the aristocrat of production-by-hand. A new, highly-deterministic division of labour replaces the division of labour flowing from manual work.

In handicrafts and manufacture, the workman makes use of a tool, in the factory, the machine makes use of him. There the movements of labour proceed from him, here it is the movements of the machine that he must follow. In manufacture the workmen are parts of a living mechanism. In the factory we have a lifeless mechanism independent of the workman, who becomes its mere living appendage.[16]

In the new industrial situation the artist is thrust from the privileged apex of production towards its eccentric edge; his activities come to be viewed increasingly not as an exceptional kind of work but as an exceptional kind of play. This radical shift has the effect of forcing the artist's role in society once again into an heroic mould. But the tragic element, always present in the heroic role, now comes to occupy an increasing share of the heroic

enactment, at the expense of that element of skill, mastery and achievement, which was the privilege of the artist in the ages of handicraft and manufacture. He now finds himself, as he clings to his own personalized mode of production, increasingly estranged from technological man. His achievements take on an increasingly fictive, ideological form. His activities become a psychological surrogate for mechanized man; he becomes the living persona of that human freedom which lingered in the productive process until the forces of inorganic nature were controlled and substituted for man as the prime mover in production.

The engineers, those craftsmen whom the Renaissance humanists ignored, now emerge as the champions of the new modes of production. They no longer perform their feats of invention under the guidance of the stars or the divine powers of genius, but under that of the empirical procedures championed by the Royal Society. Under the auspices of Descartes, Nature as the object of mind came to be conceived no longer in organic but in mechanical terms; a new generation of artisan-craftsmen turned engineers began, with hints and aids from Newtonian physics, to control the forces of *inorganic* nature. They also learnt how to apply similar controls to human labour; treating the organic as if it were inorganic. The ultimate question which came to impose itself ever so slowly upon artists, was not the theoretical one of whether the laws which determine the nature of life can be reduced to the same laws which determine the inorganic universe and ultimately be reduced to mathematics, but the practical one of whether the application of techniques efficient for the control of inorganic nature to the problems of human production, that is to say, the reduction of human labour to controls which govern the operation of machines, can be said to be beneficial to man; and whether in the long term (and this was realized only in recent times) the industrial mechanization of production might not lead to the destruction of the biosphere—that curious and exceptional envelope only within which life appears to be possible.

If we are to understand the new role of the artist in the industrial society, we must seek to understand the character of his new antagonist. For whatever ideological claims the artist may have made in the past about his work, its unique perception, its sensibility, its prophetic inspiration, its divine origins and so forth, the work itself was personal, labour-intensive, and brought with it a high measure of personal satisfaction. The artist normally owned his own tools and possessed a high measure of control over the production process. It was a way of working

highly suited to human beings. In consequence the artist clung desperately (and this is a matter of some significance) to his craft procedures and small-scale production processes while on all sides of him, during the two hundred or so years of modern industrial society, the crafts were replaced by industrial production. The artist, his grandiose ideologies notwithstanding, is the last of the craftsmen; and it was in this survival situation that he survived into the industrial society as a new mutation of the culture-hero, in order (it would seem) to sustain an old-fashioned, but human, mode of production in an increasingly inhuman, increasingly inorganic situation.

Anyone who has set out to read Adam Smith's *Inquiry into the Nature and Causes of the Wealth of Nations* will remember his graphic description of a pin factory, in which he saw ten men produce forty-eight thousand pins a day. 'If they all wrought separately,' Smith observed, 'they could not each of them have made twenty, perhaps not one pin a day.'[17]

For Adam Smith, the growth of material wealth depends primarily upon the division of labour. It encourages manual dexterity and advances invention, since the drudgery of routine manual movements stimulates the bright mind wonderfully to find appropriate mechanical equivalents. Indeed for more than a century young millwrights and factory hands applied themselves to inventing machines with an assiduity comparable only to the way in which they now learn to play electric guitars. Poets and artists likewise, for a brief moment, greeted the new industrial age with a similar enthusiasm. Erasmus Darwin eulogized steam, and his friend, the painter Joseph Wright, painted that much-esteemed picture *An Experiment on a bird in the Air Pump*. It testifies to the enthusiasm with which lectures in popular science were greeted up and down Britain. The new self-confidence of science is delightfully captured by the way in which the demon-strator's assistant comforts the little girl. 'The bird', he seems to be saying to her, 'will probably survive and even if it doesn't its death will advance man's knowledge of nature'.

For artists, however, this initial enthusiasm for the new science and its industrial child was brief. The moral position which the best art of the next two hundred years came to occupy is fore-shadowed in the young girl's fears. She doesn't really want the bird to die so that men can consume more abundantly. Artists began to draw their strength from a moral flaw at the heart of industrial society: its excessive division of labour. Adam Smith himself was one of the first to notice its dehumanizing effects:

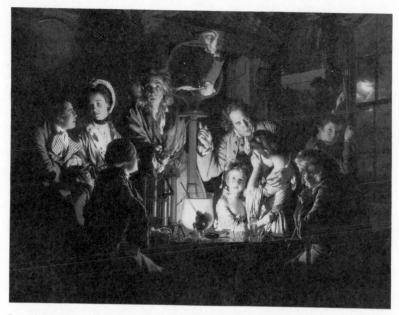

Joseph Wright *An Experiment on a bird in the Air Pump*. Oil on canvas, 184.1 × 243.8 cm, 1767–68.

The understandings of the greater part of men are necessarily formed by their ordinary employments. The man whose whole life is spent in performing a few simple operations, of which the effects too are, perhaps, always the same...generally becomes as stupid and torpid and ignorant as it is possible to become.[18]

Smith isn't here really contradicting his earlier statement about the division of labour promoting invention, he's saying that for a favoured few, the division of labour stimulates invention, but for the majority it promotes stupidity. In dividing labour it divides men. Now there were at that time two ways in which an enterprising young craftsman could escape the physical and mental prison of the factory floor. One was the way of technological invention. This was the way the young scientific-instrument craftsman James Watt, took to become a highly successful entrepreneur. It is with Watt that the myth of Daedalus, the machinator, at last comes fully into its own. The other way was the way of art. This was the way the young engraver William Blake took, at a time

when his craft was in decline under the early impact of industrial-
ized forms of management. Blake hated industrialized labour. He
believed that it turned men into animals, and he cried out against
it:

> . . .*all the Arts of Life they have chang'd into Arts of Death in Albion*
> *The hour-glass contemn'd because its simple workmanship*
> *Was like the workmanship of the plowman, and the water wheel*
> *That raises water in cisterns, broken and burn'd with fire,*
> *Because its workmanship was like the workmanship of the shepherd;*
> *And in their stead, intricate wheels invented, wheel within wheel,*
> *To perplex youth in their outgoings and to bind to labours in Albion.*[19]

It was against such evils that Blake raised his own image of the
artist as a hero; and on the engraving of it, added the lines:

> *Albion rose, from where he laboured at the mill with slaves*
> *Giving himself to the Nations, he danced the dance of Eternal Death.*

The engraving records both Blake's ardent support of the American
Revolution and his hatred of industrialization. Albion is his *per-
sona*, not only for England, but also for the creative imagination
of Everyman. The position which Blake takes here of Everyman
as artist and creator is total and intractable. By contrast, all of the
many positions taken by artists who came after him seem con-
cessions that compromise Blake's absolute renunciation of societies
that constrain and limit human potential by the manipulation of
rational thought.

I think it is possible to distinguish three distinct ways in
which the artist's heroic role came to be acted out, from Blake's
time on. The first is a political or revolutionary role; the second is
a technical role; and the third we might call a reified role, one in
which the artist becomes identified in the public mind with the
monetary value of his products.

'Without contraries', as Blake put it, 'there is no progression';
and it's of interest to note that though most of the early romantic
artists distrusted the industrialized division of labour, which
they saw as a threat to their personalized mode of production,
none the less they became eloquent champions of those new pol-
itical states (then coming into existence or attempting to) which
were legally modelled on the Declaration of American Indepen-
dence and the French Declaration of the Rights of Man, declara-
tions which were, in the event, to provide the political and legal
superstructure of the new industrial society.

This, for the artist, is the central paradox of the third occasion:

William Blake *'Albion Arose'*. Colour-printed engraving, *c.* 1800.

on the one hand the political revolution held out the promise of a universal liberty in which the humanists' dream of a man realizing his creative potential to become like the gods would become available to all men and all women; and on the other, the sinister temptation of an industrial society which promised a material paradise of cheap goods in return for a new kind of slavery.[20]

Jacques Louis David is the archetype of the new political revolutionary artist-hero. David advanced the cause of the French Revolution, both as an artist and as an active politician, voted for the death of the king, then later immortalized his master Napoleon in great paintings, only to fall with him and spend his last days a lonely exile in Brussels. After he died a few of his friends attempted to smuggle the body back to Paris, but were stopped by the Bourbon government at the frontier. Today, his canvases are the pride of the Louvre. Goya painted pictures with strong political implications, satirized superstition and pretension, condemned war. He too, in fear of his life, spent his last years, in Bordeaux, in exile. Today his paintings are the pride of the Prado. Géricault castigated political corruption, and Delacroix, though by nature of an aristocratic disposition, supported both the Greek War of Independence and the 1830 Revolution. The artist as political hero reaches its peak of achievement in Courbet, who gave himself with unremitting courage to politics, moving beyond the romantic liberalism of his predecessors to the socialism of Proudhon and his circle. For the part he played in the destruction of the Vendôme Column in 1870 he was required by a vindictive Government to pay the full cost of the re-erection personally, 323 091 francs 68 centimes. It destroyed him both as an artist and as a person. Hunted by the secret police and driven into exile in Switzerland, he drank himself to death in 1877 at the age of 58. Forty-two years later they brought his bones back to Ornans, his birthplace, and the Louvre began to hang his paintings.

After Courbet there's a change. Perhaps Bohemia noted what happens to artists who take on the state single-handed. During the late nineteenth century painters tended to avoid active participation in politics, or if they were active, they kept it out of their art. It is the time of the technical hero. They were supported in this by an influential aesthetic theory developed by Kant in his *Critique of Judgement* of 1790. Kant argued that an aesthetic judgement was at once personal, universal and disinterested. 'Fine Art and the sciences', he wrote, 'if they do not make man morally better, yet by conveying a pleasure that admits of universal communication and by introducing polish and refinement to

society, make him civilised.'[21] Art was moving from Blake's workshop into Kant's drawing room. Kant's voice was one of the first from influential philistines who have slowly destroyed art by turning it from a kind of work into a kind of play. But the immediate future was certainly with them. A popular form of the new doctrine *l'art pour l'art* developed in France from the 1830s onwards. Manet is the new kind of technical hero. 'He knows neither how to sing nor how to philosophise', said his friend Zola, 'he knows how to paint—that's all.'[22] He certainly did. Manet is the first of the quiet ones, whose commitment is to painting alone. From Manet to Bonnard, such artist-heroes paint canvases of supreme beauty that are the aesthetic glory of the nineteenth century. They paint leisure, recreation and entertainment, the fashions and manners of the bourgeoisie. Art, in Kant's words, comes to be about pleasure, polish and refinement. They are probably the finest paintings to come from our industrial society, yet they were produced by artists who felt estranged from bourgeois values. Though Manet longed for official recognition and acceptance by the Salon, he was not prepared to compromise his style. Claude Monet is also typical of the new heroes of technical commitment. In 1875, when living in desperate poverty and in fear of eviction, he was painting some of his most enchanting paintings such as that of Camille and their son in the garden. A few months later Camille was dead. That death-bed scene is now famous. 'I caught myself', he explained later to a friend,

in the act of mechanically analysing the succession of appropriate colour gradations which death was imposing upon her immobile face. Tones of blue, of yellow, of grey... This is the point I had reached...my organism automatically reacted to the colour stimuli, and my reflexes caught me up in spite of myself, in an unconscious operation which was the daily course of my life—like an animal turning his mill.[23]

Here then was the Albion who found his own work too compelling to rise from his mill for the liberation of the American nations. Kant's separation of art and morals is here complete. So it was also in the art and life of Paul Cézanne, who devoted himself to the realization of his *petit sensation*.

But the technical heroics were difficult to sustain in extreme poverty. Although it was a complete technical commitment to painting that helped drive van Gogh insane, he dreamed of a community of artists who might assist one another through hard

times. 'If you are a painter,' he wrote to Theo, 'they think you are either a fool or a rich man; a cup of milk costs you a franc, a slice of bread two, and meanwhile your pictures are not selling. That is what makes it necessary to combine as the old monks did, and the Moravian Brothers of our Dutch heaths.'[24] Gauguin sought the community of a simpler life in Polynesia, but spent the last year of his own life, none the less, assisting the native cause against the colonial administration. He was fined a thousand francs and sentenced to three months' imprisonment. 'My worries are killing me', he wrote to his friend, Daniel de Monfreid. When he died a few days later his only friend was a Marquesan witch-doctor who tried to revive the corpse with his native magic.

The twentieth century gradually brought with it a significant change. In 1903, the year Gauguin died, a young anarchist from Barcelona was painting those blue paintings of poverty and melancholy which made his first reputation. Much later, in 1940, he joined the French Communist Party as a tribute to its bravery during the Resistance. But Picasso made a clear distinction between his political and his artistic allegiance. 'If I paint a hammer and sickle people may think it's a representation of Communism, but for me it's only a hammer and sickle. I just want to reproduce the objects for what they are and not for what they mean.'[25] The Kantian separation of art and moral action, you will note, is here as strong as ever. We have now entered upon the last phase of the artist as hero: the reified hero, an ambiguous hero, a hero with two heads. Picasso must have been one of the first artists to learn the trick that Tom Wolfe has called double-tracking between the Bo-Ho dance of Bohemia and the consummation of the *culturati*.[26] When he died he was one of the richest men in the world, the paintings remaining in his estate alone being worth over two hundred million dollars.

This last stance of the hero is a kind of death by luxury: the consumer's death, to be recognized by the media and the market as if by a Medusa's head, and turned to stone. The new heroes are caught and frozen with their transcendental jeans down, pitifully pleading their other-worldliness all the way to the bank. It was the abstract expressionists who were called upon to endure this, in some ways, most humiliating of all the heroic deaths. The nature of their end is so well described by B. H. Friedman in the last paragraph of his sympathetic biography of Jackson Pollock that I can do no better than quote it:

Towards the end of World War II there had been a moment in which Lee and Jackson Pollock thanked God that they were painters rather than writers. Then all the writers were seemingly being devoured by America—more specifically Hollywood—or destroying themselves in the struggle not to be devoured. In Hollywood, never having completed a successful film script, Nathaniel West had died in an automobile accident and Scott Fitzgerald had drunk himself to death, and William Faulkner, drinking just as hard, was writing tough movie dialogue in order to do his other writing in Mississippi... Of the best fiction writers, only Hemingway was dealing with Hollywood at long distance, writing his own scripts and starring in it, but paying the same terrible price as his colleagues in alcoholism and creative frustration. Yet during World War II and for a short time after, the new generation of painters had seemed comparatively lucky and free, unbothered by mass media. But now, as we look back on the lives of the abstract expressionists, as we think about the suicides of Gorky and Rothko, the car accident of Pollock and the truck accident of David Smith, the premature deaths of Tomlin, Kline, Baziotes, Reinhardt, Newman, the heavy drinking (at once self-destructive and protective) of most of these artists and several others who survive, it becomes impossibly naive to use words like 'accident' and 'premature'. As with the brilliant but vulnerable writers of the previous generation, at the same time as we appreciate the uniqueness of their gifts, we must face the typicalness of their fates in a society which wastes lives and automobiles with equal callousness.[27]

Is it possible to discern in all this artistic activity from Blake to Pollock, beneath the grand revolutionary gestures and the narrow technical obsessions, some underlying significance? It may be discerned surely in the fact that the artist, by clinging to a craft mode in order to cling to freedom in his work, became a manifest symbol of freedom to the industrial society—a kind of surviving human monument, a Gilbert or a George, whom the citizens of our industrial society could admire, envy or detest, as they so wished; yet also venerated as the embodiment of a lost freedom, since its assertion by the artist has become a kind of (more or less acceptable) irresponsibility. For this reason artists were given special consideration, like animals in a zoo. Their precious productions were regarded with admiration and purchased by the captains of industry and such others who could afford them, because those objects embodied a folk-memory of freedom in the productive process. Furthermore, their monetary value could be expected in the long term (and often in the short) to appreciate, whereas industrial productions not only depreciated in value but increasingly were built to be jettisoned in order to keep the enormous oil-tanker of industry precariously afloat.

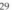

Arthur Boyd *Chained Figure and Bent Tree*. Oil on canvas 152.4 × 122 cm, 1972–73.

Art and Society

3
Art and Industry: a Systematic Approach
—1974—

My central question may be stated thus: in what ways has the industrialization of production affected the history of visual art since 1750? Perhaps we might agree that the effects, whatever they are, have been wide-ranging. This suggests a general approach to the question, one that keeps the whole field of production constantly in view, a general history, with industrialization as its focus. In this paper I shall not propose an answer to the question but will suggest some lines of approach that may help us to find better answers than those at present available.

The Movement Model
The present model favoured by art historians who write general histories of Western art since 1750 is not particularly helpful—I shall call this period, perhaps a little loosely, for the sake of brevity, the post-Enlightenment. The model favoured might be described as a movement sequence. A typical account will begin with neo-Classicism and proceed through accounts of Romanticism, Realism and Impressionism, to whatever is the present movement of the present moment. I have several objections to this model. For one thing the movements described do not belong to the same order of explanation. Neo-classicism, it seems to me, is primarily a programme for producing works of art; romanticism is a kind of sensibility originating in literature and thought; impressionism, primarily a pictorial style. When used to structure a general history such movements become *ad hoc* explanations which involve a constant shifting of the order of discourse. During the florescence of neo-Classicism the historian interprets all contemporary art from a neo-Classical point of view; he then proceeds to become a romantic with the Romantics, an impressionist with the Impressionists. This reduces history to

the advocacy of the successful; it becomes taste history or *Zeitgeist* history. True, sensitive historians know how to modify the distortion effects of inadequate framing concepts; true, we must seek to understand styles and movements; but we should also keep an eye out for the long-term changes of history. We might ask, for example, in what way as a whole does post-Enlightenment art differ from pre-Enlightenment art. The answer could be: industrialization. If it is, the current models available for writing general art history do not provide for an adequate historical account. We describe waves and ignore currents.

Nor are the waves themselves described fully. General historians of post-Enlightenment art concentrate upon the emergence of movements to the neglect of their later phases, stressing discontinuity at the expense of continuity. They might be compared to one who photographs dolphins from the back of a ship sailing in an ocean that has developed a steady swell. What the photographer waits for, and with luck catches, is the splendid glint of sunlit water on the backs of the fish in their magnificent upward curve: aesthetically pleasing beyond question; but a sequence of such photographs will provide a misleading account of the ways dolphins swim. Lest you suspect determinist implications to lie beneath my metaphor let me remind you that the dolphin is a highly intelligent fish. It prefers to swim in shoals, but can also swim against the current and can swim alone.

I have criticized the movement model in general terms. Let me cite two specific instances wherein it fails to provide an adequate account of matters of some importance. The first is the persistence of classicism in nineteenth-century art. It is awkward, when one attempts to expound history within the terms of the movement model, to have to account for the widespread acceptance of the classical tradition in civil and domestic architecture, in the work of Schinkel and Barry for example, at the height of the Romantic movement. The awkwardness is often glossed over by invoking a theory of decorum: one style for state, another for church, a third or fourth for domestic architecture. Again the device is *ad hoc*. The decorum sub-plot remains precariously attached to the movement main plot. My point can be underlined by recalling how the pejorative term pseudo-classicism has retreated within a generation from the Carracci to Lord Leighton, where it is still to be found, on occasion, at the moment.

Secondly, the movement model does not come to grips with the problem of industrial art. I shall not dwell on the point since it is the reason for this paper, beyond saying that it is highly

embarrassing, when teaching the subject, to have to break into a movement sequence at the mid-point of the nineteenth century in order to introduce a short history of structural engineering to prepare a context for the Crystal Palace.

I strongly suspect that the historiographical reason for the prevalence of the movement model is due to the fact that the history of post-Enlightenment art has come to be written largely in the form of recovered criticism. Avant-garde movements write their justifications and we, the historians, adopt, adapt or recover them. But it seems to me that, although the recovery of criticism *is* an important part of art-historical writing, as is the delineation of avant-garde movements, the acceptance of their values at face value results in superficial history.

A Marxian Model

Francis Klingender's *Art and the Industrial Revolution* (1947) is the only book which deals in some detail with our subject. It is an admirable book which has drawn attention to a sadly neglected area of research. My main criticism of it is that, oddly enough, Klingender's use of the Marxian model, art as ideological superstructure upon an economic base, unduly narrows the field. The book's particular attraction lies in the way Klingender reveals how art imaged industrial production, first in a celebratory fashion, in Wright of Derby and others, then critically, in Blake and others. Yet since visual art in the nineteenth century was largely devoted to the imitation of the world of appearances this is precisely what we would expect. If the factories are there, depict them; if the factories produce, in Marx's phrase, 'new fangled men', depict them too. Klingender reduces the problem of art and industry to an iconographic problem; to a level of discourse similar, say, to the place of the image of the sovereign state in Baroque art.

Certainly the new images of industry are fascinating. But the heart of the problem does not, surely, lie there. It lies, I would suggest, in the scope that we are prepared to give the subject: for industry has not only been imaged by art, it has influenced art and influenced our ideas of art, and produced its own arts, such as film. In order to confront our subject therefore we have need of a broad and generous definition of art that will embrace at least two of its most powerful historical connotations: art in the general sense as skill, and art in the special sense as style. We need a generous definition of art in order to allow all man-made objects

to be entered in what might be called the big art competition. This surely is a common-sense view. I doubt whether many of us would be prepared today to withhold the term 'work of art' from even the most utilitarian object if we found it to possess colours, textures and formal relations which delight or intrigue us. Such a definition makes it possible for us to include in our discussion not only the 'ready-mades' of Marcel Duchamp but also works by the anonymous artists who made Marcel Duchamp's 'ready-mades'.

My dissatisfaction with movement models and Marxian models has led me to seek an alternative. Although the model that I shall now describe may be said to be sociological, I am less interested in its sociological implications, as explanatory of social structure, than in its potential value for providing a balanced and adequate account of art and the industrial society.

The Three Art Systems

The model or conceptual framework that I propose for a historical account of the subject posits the presence in England since the mid-eighteenth century and in most, if not all, advanced industrial countries since the nineteenth century, of two distinguishable and interacting art systems in the general sense. Since the term 'art system' is not, to my knowledge, much in use among art historians, let me explain. By art system I am here referring to associated groups of professional people who are concerned with the production, interpretation and distribution of works of art. An art system, it seems to me, develops from and maintains its historical continuity by means of the participation in and contribution of its members to a more or less coherent set of beliefs, values, dispositions and expectations. Consistent with these beliefs the system evolves specialized components which often develop institutionalized forms. Perhaps I should add that the existence of such systems depends entirely upon normalizations of behaviour, that is to say they are created and changed only by their individual members.

The three art systems (in the general sense) relevant to our considerations are first, the craft or guild system, second, the fine-art system, or art system in the special sense, and third, the industrial system considered not as an economic system but as an art system in the general sense as in the usages, industrial art, art manufactures and so forth. Since all production is by its nature a sequential process, one way to distinguish these three

systems from one another might be to consider the ways in which the units (the works of art of each system) are produced and how they are linked within their respective sequences of production.

The craft system. The craftsman reveals his skill in reproducing an artifact from a prototype by direct imitation. He follows and interprets the design or prototype that is before him. Since human skill is not, as Ruskin significantly pointed out, perfect, the craftsman's units may differ from their prototype. We might describe this possible range of imperfection or variation as the craftsman's skill variable.

Crafts sequences may be distinguished according to their mode of employment of the prototype. If the same prototype is used in the production of a sequence each unit will be as like the prototype as the craftsman can make it, variations being limited to the limits of the skill available. In such sequences, assuming the craftsman's skill to be constant, the last unit of a sequence will not differ from the first by at most, the limit of the skill variable. We might call such a sequence a static sequence, because the sequential process of production does not increase the difference between the prototype and each succeeding unit. A craftsman may, however, adopt the practice of using each unit of a sequence as the prototype for the next unit. In this case variations produced by the skill variable will be compounded by the production process. Since this method bears a resemblance to an organic process of multiplication we might by analogy describe it as an organic craft sequence.

In both static and organic sequences the craft variable is, however, not consciously introduced into the production process; it is simply given as a characteristic of human skill. But a third move is still available to the craftsman as craftsman. In copying his prototype he may become aware of an accident or mistake which pleases him and which he decides to incorporate into the production process by using the affected unit as his new prototype. That is to say he becomes aware of the possibility of making use of his skill variable. Since this bears an analogy to an evolutionary process we might by analogy describe it as a mutational craft sequence.

The craft sequences we have discussed all have one thing in common: the craftsman does not seek to vary his units in order to develop variety, and although he will certainly interpret the prototype design according to his skills and workmanship, he

seeks to maintain or to improve the quality of his sequence as a whole, either by improving his skill or by taking advantage of occasional accidents.

The fine-art system. In contradistinction to craft sequences, fine-art sequences are not produced with the intention of maintaining or improving the quality of a sequence-as-a-whole. The quality of fine-art sequences may indeed be maintained and improved by the fine-art process of production, but this is not the intention of the artist—in the special sense. His intention is to achieve excellence in the unit rather than maintain excellence in the sequence. In consequence fine-art sequences vary much more widely from unit to unit than craft sequences. For the artist rejects the craftsman's method of replicating from a single design or prototype. Although the artist makes use of skill in the production of his units—and there is an element (perhaps ineliminable) of skill in all fine art—he rejects skill as the principle by which units are linked. He replaces skill by style. Style, though it contains elements of repetition and imitation, rejects replication from a single prototype. In order to move from a craft sequence to an art sequence the craftsman-turned-fine-artist must learn to employ what we might call, for the sake of this discussion, plural prototypes. Whereas the craftsman seeks to maintain excellence in a craft sequence by employing one prototype in the production of each of his units, the artist—in the special sense—seeks to achieve excellence by the employment of at least two and often many prototypes in the production of one unit of a sequence.

This ability of the artist as distinct from the craftsman enables him to invent a method of procedure by means of plural prototypes which gives to each of his units a variety one from another, and a linkage only by participation in the artist's style. Failure to achieve a personal synthesis by means of the use of plural prototypes might be described as an eclectic style, success as a mature style.

An artist—in the special sense—may pluralize prototypes in various ways. He might symbolize, i.e. take an object and imagine it to be something else which is or was, or is not nor never was, in the world. Here the prototype is transformed into art by conflating it or identifying it with an image in the mind. The identification between prototypical object and image does not have to be complete for the transfigured prototype to function as a work of art. But awareness of an apparent difference between the 'look' of the physical prototype and the 'look' of the envisaged

image, by which it has been transfigured, may cause the artist to make a second move, and to fashion his art from the kind of comparative activity which Gombrich has described as making and matching. Or yet again, he might take one or more works by other artists and match them against preceding units of his own making, working that is to say by means of influences. If we had occasion to find names for these three processes, we might call the first the magical process; the second the naturalistic process; and the third, the academic process of art production.

Admittedly the term 'plurality of prototypes' is self-contradictory: by definition there can be only one prototype. I have used the locution here in order to bring out the contrast between the artist's method and the craftsman's, and the artist's capacity to sustain a continuous and personal unity while working from a number of sources or prototypes in the production of each unit of an art—in the special sense—sequence.

We have been directing our attention at the reasons for change and variety in craft and fine-art sequences. But there are also forceful reasons why sequences should not vary from unit to unit. The sequential nature of all production arises in response to demand; and the primary effect of an increase in demand is to increase the demand for static sequences, since, normally, only that which is known is desired. Now the perennial factors affecting demand are an increase in wealth and in population. The operation of both factors throughout history has resulted in a corresponding demand for static sequences. The production of such sequences has been rendered more efficient by the invention of tools and machines; the initial effect of which has been to increase the efficacy of replication. Whilst tools and machines may be utilized by artists in order to develop and sustain a personal style, it would seem that this is possible only with such tools and machines as allow the intervention of changing purposes and intentions at various stages of the productive process. The overall effect of the invention of tools and machines has been to increase the efficiency (and economy) of repetitive acts and so increase the production of static sequences.

The industrial art system. Mechanical invention transforms craft sequences into industrial product sequences, which vary not by a skill variable but by a (mechanical) precision variable. Mechanical invention has also attached static craft sequences and increasingly, since the Industrial Revolution, industrial product sequences, on to fine-art sequences. In such cases individual works of art (the

units in question) will vary according to two parameters: (1) style in a fine-art sequence, and (2) a skill variable in a static craft sequence, or a precision variable in an industrial product sequence. An example from antiquity of a static craft sequence attached to an art work might be the production of terra-cotta figurines of a cult image; an example from more recent times, the reproduction of a painting by line engraving, or photo-lithography.

In considering industrial production there are two types of sequence to keep in mind: machine sequences and industrial-product sequences. By machine sequences I refer to the relationship by which one mechanical invention is linked to another in the train of inventions directed toward the solution, progressively, of problems associated with a continuing need. Thus the bullock-dray, the coach-and-four, the locomotive and the automobile are linked in a machine sequence directed towards the solution of problems associated with land transportation; the clay-tablet, the reed-pen, the wood-block and the lino-type machine with communication by a written script.

Machine sequences are similar to fine-art sequences in that any unit of such a sequence must differ from preceding units; otherwise it will not be put into production; and each unit is based on several prototypes, drawn perhaps from previous technology, from scientific principles, even from analogies with nature's mechanisms. On the other hand machine sequences differ from fine-art sequences in that each new unit of a machine sequence renders previous units obsolete: locomotives drive out mail coaches, automobiles drive out locomotives. Machine sequences also differ from fine-art sequences in that they are not linked by personal style. True, it is not at all unusual for one inventor to make a series of major contributions to one machine sequence. But considering the long span of time during which machine sequences continue, the personal contribution is of a brief duration. It is perfectly reasonable to speak of an inventor's personal style; but evidence for such a style must be sought among all his inventions, and there is no reason why these inventions should be confined to a single machine sequence, as described above. Indeed there are good reasons why they should not be. For a successful contribution by invention to a machine sequence may satisfy, during the inventor's life-time, the initial needs and demands which prompted it. What links the units of a machine sequence is not a personal style (nor even a period style, except in a purely visual sense, i.e. machine object *qua* art object) but the continuous transformation of a human intention or human

purpose into increasingly efficient mechanical terms. In this sense machines are imitations of will, and may thus become both substitutes for and symbols of human volition and human performance. Furthermore, it is to be noted that machine sequences co-ordinate the work of many inventors towards a common goal. A machine sequence is therefore unlike an art sequence—in the special sense—being neither a personal sequence, nor a personal substitute for performance, nor a personal symbol. It satisfies generalized needs. To the extent that the machine is expressive it expresses corporate needs and corporate intentions; becomes a kind of symbol of 'general will' in its area of operation.

Professional Support Systems

We have been considering craft, fine-art and industrial sequences mainly with respect to the mimetic processes involved in their production and their characteristic unit-linkages. In order to obtain an understanding of how these three modes of production operate in society it will be useful to consider the professional systems which support each of these modes of production. It is to be expected that a professional support system will bear a close functional relationship to a production sequence. This may be conceded without assuming Marx's contention that modes of production in themselves create their appropriate ideological superstructures. Whether the mode of production generates the professional system or vice versa is not relevant to this point of the discussion. What concerns us is the functional interaction of the production sequence in question and the relevant professional system.

I argued at the beginning of this paper that an art system develops from a set of beliefs, values, dispositions and expectations, and that consistent with those beliefs it evolves specialized components which often take on institutionalized forms. By means of the transmission and dispersion of such beliefs and values the system maintains its coherence and continuity. To set down the beliefs and values of the fine-art system with any hope of success would be virtually impossible, since the system we are considering is a dynamic system and its beliefs and values change in response to the social environment within which it is located. Christianity took several centuries and many councils to set down its beliefs, and these even when set down have, notoriously, not met with a consensus among all those claiming to be Christians. Now it may be argued that an art

system maintains a looser and more open structure than a religious system; and this openness and looseness may render it less socially 'visible'; but its social translucency should not mislead us into believing it not to be there.

Some of the central values of the fine-art system may be inferred from the nature of fine-art sequences of production and then, to avoid circularity, be tested empirically against relevant fact. We have noted that fine-art units are more varied than craft or industrial units; in a sense their capacity for variety makes them unique among types of production. Fine-art units therefore become general symbols, whatever else they may be symbols of in particular, of the imaginative capacity of the artists who invented them; and they also become in a more general sense still, symbols of human imaginative capacity. For this reason works of art come to be recognized as precious objects which are appropriately conserved as part of a general human heritage. And since works of fine art, as we have seen, have their source in plural prototypes, some drawn from the mind, some from nature, and some from other art, the preservation of the art unit leads by association increasingly towards claims for the preservation of its sources and prototypes. Thus the production of each new work of art (in the special sense) leads to the emergence of an increasingly complex and functionally-interrelated structure of art works, sources and prototypes, in the form of heritage.

Around this structure there has developed a system of supporting components by which the fine-art mode of production functions in society. Among these components may be noted an educational component which transmits beliefs, attitudes and methods not without modification, from one generation to another; a group of intellectual disciplines and techniques, such as archaeology, anthropology, connoisseurship, art history and art criticism, by means of which the quality of past achievement is recovered and valued; a group of public and private institutions such as museums and galleries where works of art are stored, conserved and made public; a series of techniques, such as engraving, by means of which works of art are made available by reproduction; and commercial organizations such as art dealers and auction houses, by means of which, in a monetary economy, works of art are normally transferred from one owner to another. These components interpret, modify and elaborate the central beliefs and values of the system according to modes appropriate to their functioning. For the beliefs and values of the system are

not maintained with a doctrinal rigidity; although the hypostatization of belief may occur in specific instances, as in the case of some academies of art. In normal practice, however, the beliefs and values of the system are subject to revision by means of disputation, elaboration and changes of taste, as a result of contact with component parts of the art system and also with external factors which may act both upon the components and upon the system as a whole.

The Fine-Art System as a Functioning Process

Now you might well ask, to what extent can such a system be shown to be coherent and functional and not a mere congeries of loosely related activities? To answer that I would ask you first to reflect upon the ways in which the components of the system are drawn into play by what we might describe as a typical act within the system. This takes place whenever an artist, influenced by another work of art, proceeds to produce a work of his own and then sells, exchanges or gives it away. Consider how many components of the system are drawn into play up to that point. Later the work may change hands, get lost, be found again. Unless it is destroyed it will go on calling components of the system into activity; and even if it is destroyed it will continue, if it has influenced existing works, to go on setting up echoes in the system, especially if it has left a few material traces.

I have suggested that components of an art system evaluate according to their functioning. The practising artist may value past and present achievement in a condition of inspiration or heightened enthusiasm, or whatever, that is conducive to personal invention. Archaeologists, historians and critics evaluate within the contexts of their respective disciplines; dealers and auction houses evaluate in terms of the contemporary art market. But all these values, it seems to me, are mediated by what we might describe as the interacting beliefs and values of the art system as a whole. If this is so, values are acquired by individual works of art by a process of accretion and mediation. Works of art are subject, of course, in the market to the general economic factors which affect the market at large. But the value of a work of art *qua* art is not determined solely by its competitive market relationship with products which are desired for utilitarian reasons. It is determined by the resolution within the art system, by interaction and mediation of the values it has acquired in contact with

component parts of the system during its effective 'life' or duration within the system, and in competition with other art works in the system.

In order to assess some of the ways by which the fine-art system functions coherently we might devise some empirical tests. I shall outline three: the education, the institution, and the art-language test.

The education test. A child discovers a talent for drawing at school and is enrolled in an art school only to find that artistic production is not for him or for her. Yet the world of art continues to hold an attraction. In the logic of the situation such a person endeavours to find a niche in the system according to talent, disposition, expectancy. Even in cases where the components of the system have developed educational institutions peculiar to them, a considerable movement of students within the art system as a whole may still be found. That is to say, to a considerable degree the fine-art system functions educationally as a complementary world.

The institution test. Fully-developed fine-art systems tend to function in cities large enough to sustain heterogeneous professional populations. Components of a system tend to be urban-based, even when the influence of the system is national or international in its range. A historical investigation as to the ways by which the establishment of one institutionalized component stimulates the establishment of another such component would be of interest, as would the pattern of temporal succession or geographical dispersion of such components. In universities, for example, an endowment which results in the establishment of one component of the system, such as a gallery, stimulates a demand for the establishment of associated components.

The art-language test. I have mentioned something similar to this earlier. One might take, as one does for other reasons, a work of art from the time it enters the art system and trace its contacts with various components of the system with regard to the records it produces in its path through the system. It is this path of units through the system which, more than perhaps anything else, calls the components into functional interaction.

The Industrial Art System as a Functioning Process

I want to turn now to a consideration of the industrial system. But first a few comments on the pre-industrial situation. Prior to

the Industrial Revolution most works of art were handicrafted in the workshops of craftsmen or of artists under the aegis of guilds or academies. Despite conflict on social and economic matters the guilds and academies usually succeeded in establishing a *modus vivendi* based on the ideal of the handicrafted masterpiece. The difference between the craft masterpiece and the art masterpiece is, however, as we have already seen, not only a matter of status. It resides in the distinctive modes of sequential production employed by the craftsman and by the artist. The artist's mode of differential production flourished mainly in what we might call the academic triad of the visual arts: architecture, sculpture and painting. Theoretically, there is no reason why the differential mode might not be applied to the minor arts, such as tapestry, ceramics, carpentry and joinery; and of course it quite often was. It is well to remember that empirically there is always something of the artist in the craftsman; and that in the best artists there is often much of the craftsman. Nevertheless in the minor arts the fine-art mode of differential production did not become the typical mode. The reason, doubtless, is in part economic. Compared with the craft mode, unit for unit, the fine-art mode of production requires more time and more experience. The patrons of the academic triad of arts were able and willing to pay for the extra cost in time, experience and materials that the fine-art mode of production required whereas the patrons of the minor arts were not. For useful objects the craft mode sufficed. There may be a sociological reason also. Traditionally architecture, sculpture and painting developed as the arts by means of which tribes, churches and states sought to consciously express their corporate beliefs and values. Perhaps it is to be expected that conscious individual expression should first appear in those arts where conscious corporate expression had long been the rule.

During the Industrial Revolution a major shift occurred in the proportion of human talent devoted to the production of craft, fine-art, and machine sequences of production. During an unprecedented period of history, two or three generations of craftsmen-turned-engineers, often stimulated by scientists, developed a passionate enthusiasm for inventing machines. Mechanical invention, of course, possesses a venerable history. It was not the novelty but the intensity with which the passion for mechanical invention swept Britain in the eighteenth and nineteenth centuries that is remarkable. The new industrial system replaced the craftsman and his handicrafted sequences of production, though

vestiges of the system which supported him, that is to say the guilds, remained.

The Emergence of a Two-Tier Situation

The industrial system has not, however, replaced the fine-art system. They have developed, it seems to me, parallel to one another in a two-tier situation; the art system sustained by beliefs and values associated with the production of objects which have become symbols of human freedom, the industrial system sustained by beliefs and values associated with the production of objects which provide for demonstrable human needs.

Let us consider briefly some of the central values of the industrial system, as we did in connection with the fine-art system, by reference to its mode of sequential production. First, we have noted that mechanical invention operates within and along long-standing trains of assumption concerning generalized human needs and aspirations. Inventions, for example, in the field of transportation assume a general need and a general aspiration to travel faster. The industrial system therefore gains coherence from a belief in its capacity first to generalize concerning needs and by then providing mechanical inventions to satisfy those needs. Around this central core of belief a cluster of aesthetic values, comparable but distinct from those associated with the fine-art system, has emerged. These emergent values appear to have their origin in certain necessary conditions which must be fulfilled in successful machine invention and the successful maintenance of machine sequences.

A successful new mechanical invention must introduce a machine to the market which renders its predecessors obsolete, or at least, seriously disadvantaged. Furthermore, since the machine itself is invented to be replicated it must be demonstrably replicable in a form cheap enough to render its competitors obsolete or seriously disadvantaged whilst remaining equally or more efficient. One of the ways of achieving economy and efficiency in replicated objects is by means of the standardization of parts. Again, since machines, whether designed for performance or the production of industrial product sequences, place great demands upon the raw materials of which they are themselves composed and the raw materials which they are designed to process, mechanical invention calls for a special knowledge of the composition, durability and strength of materials.

From such necessary conditions for successful mechanical invention there emerged, during the time when the industrial system was developing as an art system (in the general sense) and replacing the craft system, an interrelated group of aesthetic values by means of which the standards of machine sequences and industrial product sequences are maintained and improved. These include: novelty, obsolescence, functional efficiency, economy in the use of materials, the standardization of parts (in the use, for example, of modular proportions), and both a knowledge of and feeling for the nature of materials. It is true, of course, that most of these values possess a history which antedates the Industrial Revolution; but it is without doubt the conditions of industrialism and the industrial society that have endowed them with their contemporary significance.

Around the central values and beliefs of the industrial system and its modes of invention there have developed appropriate new methods of drawing and designing, a supporting educational philosophy and programme, and its own forms of marketing. Since both the industrial system and the fine-art system are involved in the sequential production of material products which are valued and marketed it is to be expected *a priori* that the two systems will possess common features. The degree to which they function independently, interact, conflate, and overlap in the functioning of their component parts must be a matter for empirical investigation.

What seems, however, to be indubitably clear is that the industrial system, although it has largely destroyed the craft system, has not destroyed or even replaced the fine-art system. The fine-art system and the industrial system have developed beside one another in a two-tier situation. In seeking to understand this situation it is important, methodologically, to keep the whole range of productive activity constantly in view in order to ascertain at any given time how the two systems are sharing the total social range of production between them; not, for example, architecture only, but the whole range of building activity; not painting only, but all forms of depictive activity. By means of such a method we may be able to distinguish more precisely where the two systems conflict, where they interact, or conflate, or reinforce each other.

For example, during the nineteenth century conflict of belief between the two systems was most marked in architecture, the art of the academic triad most involved with utility, and utility,

as we have noted, emerged as an important value in the industrial system. The history of this conflict has been written in recent years with a strong prejudice in favour of industrial values over fine-art values: functionalism, for example, in preference to historicism. This may indeed be a fair verdict; but I would suggest that a conceptual framework which posits the continuing presence of the two systems, and the inevitable triumph of neither, may provide a better balance and a deeper perspective.

In the depictive arts the industrial system developed new forms of visual art, notably photography, film and television. They too have come into conflict with the existing fine-art forms, painting and the associated graphic arts. But in this instance a greater degree of independence and interaction appears to have developed. Two forms of depictive art, an industrialized form and a handicrafted form, developed more or less consistently within their respective belief-structures, while maintaining a mimetic relationship. My point about method is that in this instance again a more balanced account of post-Enlightenment art might emerge if, instead of writing separate accounts of, say, the influence of photography upon painting, or of painting upon photography we kept constantly in mind the interaction of both arts in their sharing of the total depictive demands of society at any particular time. An account of the development of the film as an art form sharing the depictive field with painting might well put a two-tier approach to a crucial test because it can fairly be argued, it seems to me, that the film is the one unique and unquestioned artistic achievement of industrialism.

A balanced account of change in post-Enlightenment art might arise from a study of interaction between the two systems. For creative persons, dissatisfied with the beliefs and values of the system within which they work, the beliefs and values of the alternative system might be found to hold special attractions. On the fine art side we find, for example, Joseph Wright of Derby's positive response to early industrialism, and much later the continued attraction of industrialism in its later phases for such avant-garde movements as Constructivism, Futurism and Pop Art. On the industrial side is Josiah Wedgwood's and Matthew Boulton's positive response to the fine-art system of their day, and much later Eisenstein's realization of the importance of painting methods in the development of cinematic techniques.

I began this enquiry with the conviction that the critique of industrial society developed by John Ruskin and his followers

had never been answered convincingly by even the most thoughtful champions of industrial art. But it also seemed to me that if this critique were to be taken seriously it would have to be re-examined within the terms of a reservation that Ruskin would not have been prepared to make, that is, that industrialization was one of the supreme achievements of mankind. For it is surely beyond question that industry in its alliance with science has for the first time in history provided the technological preconditions for freeing human society from the imperatives of necessity, from poverty and disease, so that life need not be for the bulk of mankind, in Hobbes's phrase, 'nasty, brutish and short'. Yet for many, if not most, members of the advanced industrial societies the promise has not been realized and the values upon which it has been established are perhaps now more seriously questioned than ever.

Any account of the effects of industrialism would have to consider the emergence of a critique of industry by artists from the moment it appeared, in Blake or wherever. If written in the terms of a two-tier account it would be desirable to establish the degree to which it was an artistic response to industrialization, the degree to which it was due to moves for reform within industry and the degree to which it developed ideas about the nature of art which cannot be shown to be contained within either system. I suspect that a good deal of the Ruskinian critique is capable of being explained within the terms of the fine-art system—the mediaeval context of Morris and the Arts and Crafts Movement for example. For Morris could not revive the guild system. Rather, he held up models of mediaeval excellence to inspire studio-craftsmen. This was surely an extension of the academic mode of art production to the minor arts of personal adornment and domestic living. Morris, we might say, succeeded in elevating a select groups of crafts to the level of academic art, and so performed for them what the Renaissance masters had achieved earlier for the academic triad. In broad terms this might be seen as a successful academic response to an industrial challenge. Instead of being produced solely by industrial methods a number of favoured crafts came to be produced in two modes: a cheap industrial mode and a more expensive studio-handicraft mode. Although this elevation of some crafts into the realm of the fine arts did not, as Morris ruefully realized, provide an answer to the problems which so troubled him, its significance is not to be underestimated. The arts and crafts movement cannot be said

to be in a state of decline. Certain social and psychological con-
sequences of industrialization have continued to promote its
development on a world-wide scale.

I suspect that there are some aspects of the critique of indus-
trialism that cannot be subsumed within the system of beliefs
and values of either the fine-art or the industrial system of beliefs.
They are linked with Schiller's contention that art originates in
play and Ruskin's contention that art is a kind of fulfilment in
work. The critique certainly owes a good deal to the fine-art
system itself with its stress upon the liberating aspects of the
free play of invention. But the fine-art system also stresses both
the pursuit of excellence in the making of art works and the
associated conviction that creative invention springs only from
genius, or at least from a gifted few. So the burden of the
Ruskinian critique becomes a proposal for the democratization of
invention and production, even if that process is to be achieved
at the expense in some degree of excellence on the one hand or of
utility on the other.

This conceptual framework is intended only to provide possible
guide-lines of an historical enquiry and would be doubtless
modified in the light of such an enquiry. It would concern itself
with the formation of the two systems, the role of patronage in
their formation and development, and their response to external
factors of perennial significance emanating from science, religion
and the natural environment.

4
Art, Craft and Community
—1975—

During the past twenty years public interest in the arts and crafts in Australia has increased remarkably. It developed in two waves; first in the arts, then in the crafts. A widespread interest in the arts first showed itself in the early 1960s and affected painting mostly. A fairly small number of Australian artists, after years of comparative neglect, began to find their work sought after by collectors and they began to obtain high prices for their work. It came increasingly to be realized, first by private patrons and then by some public corporations, that a collection of original paintings not only conferred social prestige but could also act effectively as a hedge against inflation, since good paintings do not depreciate in the way that industrial productions do, and even though they may go out of fashion for a decade or two they are capable of appreciating steadily in monetary value at a rate greater, whatever the point in time, than the current rate of inflation.

The growth of interest in painting during the 1960s was a function of the general growth in our wealth and cultural affluence. It owed much to the increased importance that educationalists began to give to art in education after the Second World War. In this matter the late Sir Herbert Read's internationally-based education through art campaign was highly influential in this country during the 1950s and 1960s. But the proximate cause of the widening public interest sprang from the rapid growth and more dynamic methods adopted by the private galleries and commercial dealers. In educating a public that could afford to buy they played a highly effective role. I would guess, in the absence of relevant statistics, that more painters can live a full-time professional life from their work in Australia than in any other country of comparable population. This by no means insignificant achievement has been attained very largely by the dealers' and auctioneers' practice of forcing up the prices for the works of

the best-known. The possession of a Nolan, Dobell, Drysdale, Whiteley, Fairweather, and so forth, became a symbol, in Veblen's phrase, of 'conspicuous consumption' and also a successful investment. But the practice of forcing up the prices of the best-known has forced up the prices of all; so that today the values set upon the work of young artists, a year or so out of college, is well beyond the pockets of ninety per cent of the population. Painting has priced itself out of the popular market.

The second major wave of public interest, that which has occurred in the crafts, is a more recent phenomenon, confined largely to the last ten years. Unlike the dealer-promoted interest in painting, the growth of interest in the crafts is more broadly based. Affecting city and rural districts alike it would appear to have sprung (on the wealth of evidence provided by the Crafts Enquiry, 1975) from people who are seeking to develop a secondary skill, or competence, to supplement their income and at the same time give them a greater degree of job satisfaction than does their primary employment and, secondly, from those who are seeking more satisfying and self-fulfilling ways of employing leisure. This second wave of public interest is still widening throughout the Australian community.

Now despite these two great waves of interest the way we train our professional artists, and our notions as to what we expect artists and craftspeople to do in the community, have remained relatively static. We need, it seems to me, a thoroughgoing theoretic, structural and fiscal appraisal of the way we train professional artists and craftspeople. The theoretical consideration should consider closely what a modern post-industrial society expects of artists and craftspeople, and give more thought to the ways art and craft are marketed and related to community needs. My own proposal is a radical one, but it may be stated quite simply. It seems to me that the new, advanced technologies are, paradoxically, throwing up new countervailing needs for the arts and crafts along a very broad front. These needs could best be met by the development throughout the country of networks of small, decentralized workshops in which artists and craftspeople would to a large extent be trained, and where the work itself would be both produced and marketed.

An objection may be advanced at this point. What's so radical about art and craft workshops? They've been around for years. That's certainly true. But they still inhabit the edge of the art system, and play no real part in the central structures of art administration.

It is not the workshop that determines what we expect of the artist but a tighter, more constricting, old-fashioned and debilitating system. We need a theory and philosophy of the arts and crafts which is based upon actual community needs. The most effective centre I would argue can be found in neighbourhood workshops with their creative potential for training artists, relating art to the community and marketing the products.

Before the workshop can be established as the effective unit and centre of arts activities there are two fatally divisive factors, by which the full impact of the arts and crafts upon the community is blocked. These have to be faced and removed if possible.

The first is the division between art and craft. There are few professional artists and professional craftspeople who would want strongly to defend this distinction today. It is absurd and anachronistic to insist that those who paint or sculpt or engage in the production of graphic art be called artists while those who work creatively in ceramics, weaving, wood, metal and so forth, be called craftsmen—or craftspeople to placate the feminists. And it is equally anachronistic, apart from being élitist, to argue that the useless things be called art, and the useful, craft. These distinctions are reflections in the art world of older, more hieratic, class societies, and have no place in a modern democratic society.

But if we abandon the distinction between art and craft in theory we should proceed to remove it in practice. In professional training, for example, no distinction should be made between the training of artists and craftspeople. One practical way that is available to us to hasten the eradication of the distinction would be to insist that all graduates of full diploma courses in our present art colleges should specialize in at least one (as they are presently described) art and one craft. I would prefer one art and two crafts, for in order to survive in the post-industrial society it will be necessary for the professional artist-craftsperson to be flexible and adaptable.

The second major divisive factor that must be eradicated is the distinction that has grown up between the professional artist or craftsperson on the one hand and the professional art teacher or craft teacher on the other—in training, status and job expectancies. Granted that there are always some in every profession who are temperamentally unsuited to teaching, I would still maintain that those who have enjoyed a full professional training in the arts and crafts are also those who are the best equipped to teach it. In all professions which our society takes seriously (medicine, law, engineering) there is no separate professional training for the

teachers as distinct from the practitioners of the profession. The invidious practice that presently dominates in which professionals are trained in one way and art teachers in another is wholly undesirable. It tends to drive a wedge between the professional and the lay community, and creates a kind of second-class art citizen known as an art teacher who seeks to defend his or her professional existence by dubious theories derived from psychology.

I am aware that in some Australian colleges such as the Tasmanian College of Advanced Education and the Canberra School of Art very real efforts have been made to remove these distinctions between artist and craftsperson and the art teacher, and no doubt efforts are being made elsewhere.

The division which has grown up between a professional training in the arts and art teacher training stems, like so many other educational theories, from a faculty psychology: the notion that certain subjects in the curriculum are better suited than others to inculcate certain skills in general and certain faculties or powers of mind. Similarly it was argued during the nineteenth century that though Greek and Latin possessed little practical contemporary use they were particularly good for the development of the rationality of the student. Experimental psychology has long ago shown this belief, known as formal discipline, to have no basis in real-life situations. But most educational theories advanced to justify the teaching of art are variations on the formal discipline case.

In his highly influential book, *Education Through Art*, published in 1943, the late Sir Herbert Read succeeded in launching a highly influential reform in art education which spread into general educational theory. Read argued that by educating through art, which in practice meant giving a higher status to the art lesson in the curriculum, it would be possible to train a different power of mind than rationality—creativity in general. This was a variant of the formal discipline doctrine. The fallacy lies in ascribing to the subject or activity, art, special inherent powers, whereas I think that it is unquestionable that creativity in education lies not in the subject but in the manner in which a subject, any subject, is taught. Kids splashing about with paint can be just as much a reflex action to what is demanded of them as standing up whenever a visitor enters the room. Read's false theory has led teachers of art and craft to make false claims for their subject that cannot be sustained. And it has led to a damaging distinction between professionalism in art, which is concerned with skills in the production of a special kind of object,

and the proposal by art teachers that their business is to draw out creativity in general. It has led to the art teacher becoming a kind of second-class citizen of the art world who is expected to be a servant to the creativity of others but not worthy of the full professional training required for the practising artist.

In this area we need more precise information. Let me advert at this point again to the splendid Crafts Enquiry recently concluded and tabled in parliament in September last. This, it seems to me, is one of the most important documents which has yet appeared concerning the arts and crafts in this country. It might be compared with the McCulloch Ministry's Enquiry into the Fine Arts undertaken in 1863 which led to the establishment of the National Art Gallery of Victoria and the Art Gallery School of Victoria. The McCulloch Enquiry did much to set the mould into which tertiary art education developed in this country, and the formal structure is still largely determined by that mould. One would hope that the Crafts Enquiry might form the basis of a thoroughgoing enquiry into the needs for new and more appropriate structures for art production and art education in a modern post-industrial Australia. For example, it would be interesting to know why some pupils embark upon a professional art training and others upon a training in art education. The reason, I suspect, lies not so much in differences of temperament as in differences in socio-economic and family background. It is likely that those who opt for professional training come from a somewhat more privileged economic and family background than those who opt for art teacher training. But in the absence of an adequate enquiry this must remain a speculation. There is certainly a difference in status attitudes. Art and Design students in the professional colleges tend to contemplate a life of art teaching with distaste; art teachers with real ability do seek to break into the small ranks of the successful professional artists.

This affectation of a distaste for teaching among professional artists-in-training should not be encouraged. So long as the arts remained a genuine profession even the greatest of artists took pupils, and this is still the practice in the art of architecture. All the most creative architects of the twentieth century seem to have taken pupils, usually as assistants. Henry Moore, during a long lifetime, took many Australians as assistants. The notion that art cannot be taught, that teaching is a distasteful and degrading activity for the professional—this romantic fallacy will have to be eradicated if the artist is ever to develop real connections with his community again. He or she cannot leave it to half-trained people bemused by psychological fallacies. But it will not be

easy, because it is an aspect of the ruling romantic syndrome that art is inspiration, cannot be taught, and that the artist is a hopelessly impractical person who must be nursed and coddled by others, his wife or a mistress, whom he has a perfect right to exploit in the name of art. And because he is so hopeless in the practical concerns of life he must never be charged with responsibilities. So some practical person should conduct and control his studio, manage his accounts, sell his works, rear his children—and above all, ensure he is not asked to teach the subject.

Now while it is true that the romantic syndrome provides the artist with a persona by means of which he is given permission as often as not to shamelessly exploit his family and social circle, it is also a syndrome by means of which he himself is exploited shamelessly. The romantic myths of irresponsibility and impracticality make it possible for so-called practical people to dominate the artist's concerns. Since the beginnings of modern industrial society an increasing number of middle-men have entered the art system: critics, art historians, art teachers, art dealers, art museum curators, and now arts administrators, regional arts consultants and 'catalysts'. Every other year seems to spawn a new professional type for the art world. To some extent this is inevitable given the increasingly complex requirements of modern society. But many of the most adverse effects of these specializations upon the life and productions of the artist could be alleviated if artists were trained in response to the changing needs of the community, instead of trained in conformity to a nineteenth-century myth.

I don't think that in a democratic society we should attempt to train more artists than the society can sustain. And we should attempt to estimate what those needs are. A graduate from a college of arts and crafts should have as much right to expect to be able to practise in his or her own workshop within say twelve months of graduation as any other professional person embarking on a career.

To summarize to this point. We should cease to train artists on the one hand and craftspeople on the other. We should set out to train one body of professionals who are both artists and craftspeople, practitioners and teachers. They should be trained to cope with administrative responsibility, maintain a workshop, keep accounts, and be competent in the promotion and marketing of their own products.

The first need of the young professional is a space to work effectively. The professional artist requires his or her own workshop or one suitable for a small community of professionals

working on a co-operative basis. There is nothing idealistic about this. Thousands of such workshops exist in many parts of the world. But they are contingent upon, not central to, the art educational systems of most countries. In order to relate the arts more closely to the community we need to develop a theoretical structure and a practice which will bring the neighbourhood workshop to the centre of the situation.

What I am *not* referring to here are those community art and cultural centres which seek to bring all the arts—music, theatre, dance, the visual arts—under one corporate roof and serve a region of say ten or twenty thousand people. To think in such terms does not come to grips with the real situation. It spreads the arts too thinly. Such centres touch only a small proportion of the population, and they usually demand some kind of centralized administration in which the informal, creative atmosphere of a small workshop is impossible to sustain. Too often they are expressions of municipal pride rather than a genuine response to the aesthetic needs of the community. They reflect a corporate or municipal image of culture which is not congenial for continuing creative activity.

The artist-craftsperson needs workshop space but also needs time. Time for the prosecution of personal work. Young professional artists, from the outset of their career, should have at least half the working week for their own work. The other half should also be involved with their profession, such as teaching, workshop administration, developing contacts with the community and the media. To many young artists, victims of the romantic syndrome, such activities may seem an awful chore. Romantic artists prefer to clean lavatories, work with the local garbo, do an office job, anything rather than involve themselves with any but the production side of the art system. But having left all the other aspects of the art system to others they begin to see these people as conspiring against them: charging too much commission, writing bad criticism, giving them a wrong place in history, above all misunderstanding them. What I am getting at is: we do not train artists today to be able to manage the complex responsibilities of relating their work to the community without depending unduly upon others.

We should not regard a situation in which an artist gives half his or her time to other aspects of the art system as an unfortunate but unavoidable compromise, but as a means by which he or she develops important relationships with the art community and the community at large. And of course in practice the division of time in an artist's day will be much more complex than I have

suggested. It is simply the recognition of a responsibility for the other aspects of the art situation that is important here. Artists who have become accustomed to hoard all their time, have never attempted to teach others their profession, or involve themselves with other aspects of their profession become spiritually-displaced persons.

But if the professional artist is going to teach he or she must first confront the old romantic notion that art cannot be taught. What this really means is that intuition, insight, invention, imagination, cannot be taught. Of course they cannot be taught because by definition, they cannot be taught. That, largely, is what such words stand for. But intuition, insight, invention, imagination, are present in all forms of human activity, in medicine, law, mathematics, politics and so forth. But that is not to say that the skills associated with these matters cannot be taught. And it is pretentious to argue that in teaching art we teach something quite different from what is taught in the other professions. Art manifests itself in sensory form, by which it becomes available to us, and the working of these sensory forms in order to reveal the insights, inventions, etc. of art involves special modes of perception and special skills, and such things are teachable.

If we agree that the skills of the arts and crafts can and should be taught, we may go on to enquire to whom they should be taught. There are two traditional positions to the question. One asserts that there are two kinds of persons: those who are born potentially creative and those who are born incapable of crea-tivity. This is the conventional view and it is backed by powerful tradition. It is the Greek view as to how good poetry comes to be spoken. The poet speaks not for himself but for the gods. So too the prophet speaks not for himself but for the God who speaks through him. But since artists in our modern society have decided to speak for themselves and not for the gods the voice of the gods cannot be heard through the air-conditioning. In any case the claim that only a selected few are capable of creative activity is untestable, and an élitist view not suited to the expectations and usages of a democratic society. A more acceptable, and more testable, view is that all children possess creative potential. We might note the views, for example, of Martin Buber and Noam Chomsky, that all children are creative in the way they learn their own language, but that fluency of invention in their own language also involves the acquisition of socially acquired skills. If this is indeed so, then speech is a paradigm for universal

creative activity. Now if the artist recognizes that all are potentially creative and that these potentialities may be assisted and encouraged in a teaching process, then there is, it seems to me, a moral responsibility upon the professional artist to see that the skills and modes of perception and expression of art are taught and transmitted to later generations. If, on the other hand, he believes that in being an artist he is possessed by some unique demonic power that will not let him rest, and would not wish others to become possessed by it—then it is appropriate that he should work in isolation where he will not infect others.

I am suggesting that the artist-teacher should be the norm rather than the exception. Not so much that all artists should teach but that art teaching should not be the responsibility of a sub-species described as art teachers: people required to teach most of the time with little time for their own work. Such people sustain themselves by the myth that they are society's catalysts— or whatever is the vogue word of the time—for the crystallization of that mysterious, disembodied faculty described as creativeness in general. This is mystification. The justification of the artist is that he embodies his creativity in works of art; entities which possess sensory form.

But to return to the neighbourhood workshop. In its teaching function it should seek to cater for a limited number of people who live in the local area and have need of its services. It should concentrate upon a small, immediate neighbourhood rather than seek an intake from a wide region. Because spread will produce thinness, an inadequate proportion of the population will be served. The smaller the neighbourhood served while maintaining a fully effective professional workshop the more potent the workshop becomes as a model for the involvement of the community in the processes of the arts and crafts as a whole. Rather than expand in size, workshops should divide and seek to develop networks throughout the community. In that way specializations can increasingly be catered for.

In any neighbourhood situation a number of fairly well-defined art community needs will be found to exist, needs which a workshop might seek to provide for. First, there is the part-time practitioner. It is a significant fact of the arts that a high proportion of professionals come to art not as a first but as a second or third occupation, because they become dissatisfied with the earlier chosen occupation. Such people are not readily absorbed into the day courses of technical and other colleges. The neighbourhood workshop should provide for them. And rather than be

'taught' according to the romantic syndrome—'I can't teach you art. But here are some materials. They will cost you x and y. Go away over there and see what you can do. Then we can get together and talk about it'—they might be asked to be of some use about the place, work as an assistant, help in getting something done, in the manner of an apprentice. They should expect to see work on which they have been engaged signed and sold under the name of their teacher. This is one way in which the problem of quality and standards may be maintained. To maintain the notion that the newcomer should be treated as a completely independent artist, spinning inventions from mind and body from the moment he or she enters the workshop is to place a premium upon hobbyism. It is true that the inventive will invent, and as often as not by the rejection of the skills of their teachers. But they require a teaching situation from which invention may spring.

Secondly, there are those who wish to develop skills in the arts and crafts as a leisure-time occupation—again, possibly with the hope of developing it as a second form of income. The housewife, for example, who wants to escape from the house, at least on some days of the week, and can find the workshop a congenial place to meet friends and develop a craft that may be of value in the house. It is largely through such women that art as a way of life can be transmitted from the workshop into the homes of the neighbourhood. One would expect a neighbourhood workshop to provide some after-school and vacation classes for at least some of the children of the neighbourhood. People in retirement form another potential component. Such people can provide a useful fund of service and provide a better knowledge of the neighbourhood; assist with cleaning, caretaking, even to some extent with administration. A workshop can also provide some therapeutic services in the arts and crafts for those convalescing from medical care, to road-accident victims, paraplegics.

Obviously such a neighbourhood workshop has to be kept quite small in the numbers it serves if the master-craftsman character and its professionalism are to be sustained and it is not to become an over-worked art school. It should seek to serve a vertical rather than a horizontal social service: enrol *some* serious part-timers, *some* housewives, *some* pensioners, *some* children, *some* convalescents, so that it provides art services at the various levels of definable art needs thrown up by our modern society.

This means that the workshop cannot be available to all comers. The relationships should as far as possible be a committed and

contractual relationship and not a free, social community hand-out approach. Everyone should pay a fee, however modest some fees may have to be.

The workshop should not only address its services to the neighbourhood. It should seek a market for its products in the neighbourhood. By means of the *local* press, by street video, etc., it should inform other community organizations of its activities. If the workshop possesses a courtyard space, it might market its products there on certain days of the week, weekends perhaps, or through local shops or galleries, local fairs and markets. The professionals should seek to develop a community reputation for themselves and for their works, before they reach out, if such is their ambition, after national and international reputations.

Much of what I have been discussing, as I remarked earlier, is in active operation already. But these workshops are at the edge of the official art teaching and marketing system and also at the edge of art theory. It is time that they were placed at the centre of our thought about art for a modern post-industrial society.

How could such a system get off the ground? What moves could provide the initial dynamics? They might come from several sources. First and foremost they might come from young artists and architects who are interested in community issues and also wish to set up a professional co-operative through which they might develop their own art and find a market for it. They would need to identify the specific art needs of the neighbourhood in which they are proposing to work, not only through residents' organizations but also through discussions with schools, hospitals, municipal and shire councils.

Neighbourhood workshops might also emerge from a gradual devolution of the present over-centralized structures used for art-teaching and art-marketing. In Victoria for example some architects have planned the arts and crafts room in the grounds of schools away from the other classes. They can then, it is argued, be run more easily on a workshop plan. Art teachers should be given time to produce their own work in such studio spaces, and they should be available for after-class activities, and not only for school-children.

Enlightened art teachers and artists in colleges and universities might encourage their institutions to establish workshops outside the college grounds in neighbourhood areas and seek to develop neighbourhood art services while also using the workshops for the professional training of their graduates. The servicing of neighbourhoods should become a part of art-school

training. Enlightened principals of schools might be encouraged to allow art classes to be taken on occasion not in the art class itself but in the local neighbourhood workshop.

My basic point is this. There are an increasing number of people in our post-industrial society who have need of the arts as a way to a more balanced and a more self-fulfilling life. Artists and craftspeople possess attitudes to life and professional skills which can be of direct benefit to these people. Unfortunately, our society, in its insistence upon specialization, creates an increasing number of middle-men between the practice of the arts and the needs of the community: psychologists, childcare-specialists, welfare workers, art administrators and consultants. The greater part of their therapy is concerned with talk and advice. The artist can do more. He or she can provide the perceptions, attitudes and skills of a better way of life. But at present the artist is not encouraged to do this.

5
The Writer and the Bomb
—1986—

Among its many functions, art possesses a prophetic function that is not wholly under the control of its producers. By imagining the real we are in danger of helping to create it. The results of the literary imagination, like the results of the scientific imagination, as Einstein came to realize, cannot be predicted. It is a dangerously ambiguous weapon to use in a cause. Perhaps it is not the devious and unpredictable products of our imaginations as writers that are now called for, but our own considered views as citizens.

I stress again that I speak here for myself. Perhaps a Patrick White, a Thea Astley, a Judith Wright, a David Malouf, or some quite unknown writer may yet produce a compelling work of the imagination that will alert the electorate to the dangers of nuclear annihilation. But that kind of influence makes its presence felt only over time, and we may not be given time. I doubt whether those of you who work in film and television are in a better position. Certainly the popular impact is much more immediate, but it is also readily forgotten.

Nevertheless remarkable things are happening. Until a few weeks ago I doubted whether the nuclear crisis could ever be addressed successfully in Australian painting because of the aesthetic problems involved. But my views have been radically changed since a week or so ago when I saw Robert Boynes's profoundly moving exhibition in the Solander Galleries in Canberra. For me at least, Boynes has produced a vision of the world after the bomb that is not compromised by melodrama, sensationalism or self-pity. His *Faith and Empire* is the most powerful painting that I have seen in the past ten years, and it lends support to Peter Fuller's contention that Australian painters are creating a new vision of landscape that possesses universal significance.

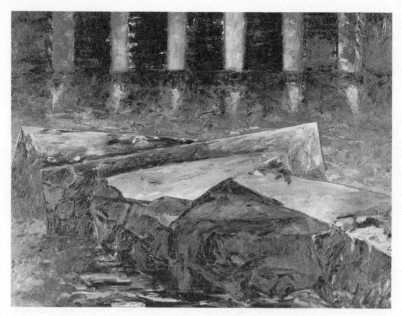

Robert Boynes *Faith and Empire*. Oil on canvas, 180 × 244 cm, 1986.

But I don't think Boynes's work will change anyone's convictions. In my experience, art acts, if it acts at all, when it acts most traditionally, to deepen the convictions of the convinced. Through them it acts on the public domain of thought and action. As writers, as artists, works like that of Robert Boynes present us with a dilemma. For most of us the imagination works best in a condition of privacy, and the devices of art, of irony, parody, satire, dialogue, metaphor and metonymy are devices that have been developed to protect that privacy, so that we are in a more secure position to get on with the job. They have emerged to a large extent over time, in the history of the human imagination, to enable us to elude the censors, both the omnipresent censors of the public arena in all societies and those internalized censors that worry us about how our minds behave. Unfortunately these images of speech and vision, these distancing devices, also operate to cover up, and privatize the imagination, so that we seem to be constantly saying to the public: 'These are not my own views, these are the views of the artefacts of my imagination.'

This is not to say that we should abandon our professional work even for what is perceived as a life or death cause, but it is to say that in the face of the nuclear crisis we should be prepared to give a tithe of our time to act as concerned citizens in the public sphere, without figures of speech or parliamentary privilege to cover us.

So let me briefly present my own views as an Australian citizen on the nuclear question. For me as an Australian it all focuses on the presence of American bases at the North West Cape, Pine Gap, Nurrungar and elsewhere. Their presence is incompatible with our existence as a sovereign, independent nation. Their presence threatens our survival. I agree with David Martin that a policy of armed neutrality has become essential to that survival.[1] Though this would involve a considerably increased proportion of annual expenditure on defence, I see no alternative. For many years I have been haunted by the fear that David Martin now informs me is called a 'value strike'[2]—another of those lethal buzz words. Let me explain. In the game of devil's chess that the super powers are playing to the limits of brinkmanship, there is an increasing possibility that one of them may decide to drop a nuclear bomb on a comparatively defenceless ally or associate of the other: from America a bomb on Libya or Syria to teach the terrorists a lesson; in return the Russians might well decide to take out, as our sporting commentators say, Sydney or Melbourne in reply. It need only be a mini nuclear war in which both the Soviets and America, and their decision makers, remained intact. But we should be taught on the first day, perhaps the first hour of that war, those of us who survived, that our future on this planet lies in neutrality.

My fear is no more than a fear. But it is around such fears, such perceived possibilities, that every nation's armed defence is constructed. I believe that my fear is a more realistic fear than the fear of Indonesian invasion, or that old chestnut the yellow peril, or the odd notion that the Russians would mount a naval invasion.

Many Australians share my view that the American bases should be closed down and that we should evolve a policy of armed neutrality. But it is still a minority view and it will not be easy, short of a nuclear attack, to change that view. Ever since the Sudan campaign of 1885 Australians have been taught to believe that they can best defend themselves by fighting other people's wars. In that respect we are locked deeply, perhaps fatally, into our colonial, dependent history. No Australian government is

going to change that history until a clearly perceived majority demands a closure of the bases and the construction of a more realistic defence policy. It is therefore pointless to inveigh against the present federal Labor government. We have to go out and, if we can, get the numbers. One possible way to begin, as individuals, would be to open up a personal correspondence on these issues with our own representative in the federal parliament and encourage our friends to do so.

Art and History

6
History as Criticism
—1985—

History, as I understand it, is a kind of criticism. It seeks to correct prevailing views about what has occurred and to tell truthfully and explain more convincingly the nature of those occurrences. There is a presumption that the truth about the past is accessible and that it can be told as narrative and explanation. It is often a criticism of silence, of that story which has not been told and now must be told.

History, therefore, is to be distinguished from myth. Myth tells a story that both the myth-teller and audience assume to be true. Although a myth may emerge and be conflated into others it does not build into its construction the critical techniques that distinguish history as an art form.

One of my former teachers, Professor Ernst Gombrich, was fond of quoting from Marc Bloch's *Apology for History*, an essay that was never finished because its author was killed by the Nazis.[1] Bloch began his essay with a question that had been put to him by his son: 'Papa, explique-moi donc à quoi sert l'histoire'. Bloch then went on to argue that if good history is not written bad history will be. I was probably influenced by both Gombrich and Bloch when I put the matter this way in the early 1960s:

The historian is to myth what the ferret is to the rabbit. The historian burrows down after myth, hunts it down and destroys it if he can. He is Jack the myth-killer. If he should create myth in seeking to bring coherence to the chaos of past events then he will himself become fair game for the historians who come after him.[2]

Some of you may feel that I am making immodest claims for history. A good deal of recent structuralist and semiotic theory, and some recent kinds of Marxism, if I've read them correctly, would seem to suggest that the historian's claim to access to what has actually occurred is illusory; that no story about the past can

ever possibly be the true story; that Jack the myth-killer produces
new myths in the very act of destroying old ones. The most the
historian can do is to tell the story from a point of view that is no
more privileged, possesses no better access to the truth than any
other. I won't attempt here to refute that position. But let me, at
least, express my own personal moral repugnance to the sugges-
tion that the truth about the past cannot be told. I should have
thought that it is only about the past that the truth can be told.

And if it can't, why take the trouble to try? Surely more often
than not the historian gains the energy and intent to practise the
art out of the blistering and angry conviction that it is high time
the truth was told, for it is a long and laborious business at the
best of times, marshalling evidence, checking sources and inter-
rogating them in the hope that they will yield their secrets,
dealing with inadequate librarians, or bureaucrats who guard the
state's mysteries. It's quite different from writing the first thing,
or even the second and third thing that comes into your head, as
the poets and novelists do. But their claim, I take it, is only to a
personal truth. The historian's aim, by the nature of the art, is
more ambitious than that. The historical truth is crafted both
about and for others. To aim at less, isn't that, in a sense, to join
the party of those who murdered Marc Bloch?

Well, that's the way I see it, and we've been asked to speak
from personal experience. When I was writing my first book
(*Place, Taste and Tradition*) during 1943–44 I was impelled by the
angry conviction that an Australian cultural history of a totally
evil kind was being written from the perspective of a nationalism
that has soured gradually from the first Anzac Day and had gone
rotten. By the late 1930s it was stinking to high heaven, and
nowhere more so than in our high art circles. The two most
influential writers on Australian art at that time were James
Stuart MacDonald and Lionel Lindsay, both personal friends of
Robert Menzies. Both were racists and both were anti-semitic,
and they were then in the process of manufacturing an account of
Australian culture that seemed to me, and to many of my genera-
tion, not only evil in itself but possessed of a great potential for
the corruption of culture in Australia. As early as 1931 Mac-
Donald had written, in a eulogy of Streeton's work: 'If we so
choose we can yet be the elect of the world, the last of the
pastoralists, the thoroughbred Aryans in all their nobility.'[3]
When MacDonald retired his friend Menzies secured him a Liter-
ary Fund grant to write a history that would consider, to quote
the letter he wrote to Menzies at the time, 'the causes, effects,

relationships, implications; the reciprocal action of art and society and its pictorial terms'.[4] Mercifully for everyone, including Mac-Donald, it was never written. In 1942 however, Lionel Lindsay did publish his *Addled Art*, a virulent anti-semitic attack upon modern art. Let me however quote from a long letter that he wrote to the *Sydney Morning Herald*, two years before, after viewing the first exhibition of the Contemporary Art Society to be held in Sydney:

The Australian public is perhaps unaware that modernism was organised in Paris by the Jew dealers, whose first care was to corrupt criticism, originate propaganda—in this infinitely superior to Goebbels, for it worked—and undermine accepted standards so that there should be more merchandise to handle. It was Uhde, the Jewish art critic, who proudly boasted that three-fourths of the dealers, critics and collectors were Jews, whilst to mystify the public a jargon was employed which no art of the past has needed to establish its bona fides.

A little later in the letter, Lindsay continued:

But what relationship exists between the 'Ecole de Paris'...and Australian character, conditions, and viewpoint? One third of the Contemporary Art Society's exhibitors bear foreign names, which in view of the influx of refugees, is significant enough. These are Hartog, Haefliger, Danciger, Dorn, Daniel Kohenhagen, Cardamatis, Cohen, Bellette, Lymburner, Orban, Herman, Thake, Rodriguez, Rubbo, Ebert and St Nicholay.

After naming this infamous set of potential corrupters of pure Australian culture, Lindsay concluded: 'True art grows like a tree from its native soil not from the sludge of decadent civilisations.'[5]

By the time Lindsay wrote his letter many of the artists he named were already my personal friends. A small group of us had set up an art society within the NSW Teachers Federation and from 1939 on had been organizing regular fortnightly discussions on art history and modernism. Many of them came, as Orban said to me, to learn something about Australian art. For me it was a delightful surprise to come from three years' teaching in the country and be able to move among such intelligent, civilized and well-informed people. We all learned a great deal from them.

In my experience then, history begins in criticism. But it is not conducted as criticism *per se*. It does not confront the antagonist directly or concern itself with a criticism of the antagonist's data and presuppositions. Of course the historian acting as critic *per se* may do such things, in reviews and critical articles. But the

criticism of history itself operates indirectly. It distances itself from the antagonist, seeks for another vantage point, a different perspective, appeals to different kinds of data, develops alternative models, and is activated, more often than not, by alternative ideologies. The historian, one might say, is a gladiator with a net but not a sword. The aim is to enmesh the antagonist and render him innocuous by understanding his position from the perspective of a better vantage point and an appeal to a greater range of evidence. The art of history has at least this in common with the art of scientists in that they seek to encompass the work of their predecessors within a wider understanding; as I take it, Einstein encompassed Newton, and Newton encompassed Copernicus, and Copernicus, Ptolmey.

In my own case I had to construct an alternative model to Lindsay's model of Australian art as a vigorous young tree in danger of being blighted by an infestation of foreigners. Lindsay's model was both static and racist, in which the landscape vision of the Australian-born Streeton was held to be both the ideal and the exemplar. Neither the colonial artists nor the modernists, being foreign-born, possessed unimpeded access to it. In place of Lindsay's model I constructed one which was developmental in character and open-ended. It was based upon changing class and institutional relationships developing between the European settlers of Australia and the traditions they brought with them, and their relationship to the land. Their relationship to the Aboriginal inhabitants was largely ignored, but at least hinted at as a problem within my model that remained to be investigated. At the time, however, I was content to write an account of Australian art in terms of what might be called, in an Hegelian sense, three moments: the colonial, the Heidelberg and the modern. I argued that colonial art, rather than being an inadequate introduction to Heidelberg, possessed its own justifications. I sought to switch the admiration which I shared with Lindsay for the Heidelberg artists, from the later manifestations of the mature Streeton to its earlier phase, and to present Roberts rather than Streeton as its pathfinder. I stressed the ethical diversity of Australian art, noting for example, that it was a Jewish business man, Montefiore, who was a prime-mover in the foundation of both the Victorian National Art Gallery and the Art Gallery of New South Wales. I defended modernism but proceeded to develop a critique of its irrational features, such as surrealism, since it seemed to me that there was evidence that those elements could be used as an ideological prop to Fascism, perhaps even

more effectively in the future than the blood and soil conservatism of Lindsay and MacDonald.

The criticism of history is conducted across a social terrain that is entirely encompassed by conflicting ideologies. It is out of this conflict that the historian constructs the most promising position available from which to view the grounds of his or her special concern. I am reminded of one of those terrifyingly memorable aphorisms of Kafka: 'The hunting dogs are playing in the courtyard but the hare will not escape them no matter how fast it flies through the wood.' Well, sometimes the hare of history does succeed in escaping the ideological hounds, but not by imagining they are not close behind. The historian needs both a deep burrow and a good point of view.

In writing *Place, Taste and Tradition* I chose a Marxian burrow and point of view. Between 1938 and 1943 I read everything I could then get hold of in English by Marx, Engels, Lenin and Stalin. I say Marxian rather than Marxist because although I wrote the book within the broad guidelines of historical materialism there were also considerable countervailing influences at work, such as a voracious interest in Toynbee as each of his green volumes appeared, and a fascination with Heinrich Wölfflin's account of art in terms of style. Nor did I attempt to write the book within the terminology of Marxism: proletariat and bourgeoisie, base and superstructure, alienation and the labour theory of value. To have done so, even in 1945, would have been to court non-publication. As it was Sydney Ure Smith refused to publish those sections of the book that challenged MacDonald's and Lindsay's view head-on. 'Lionel's a very old friend', Syd Smith said to me. 'He's done a lot for Australian art. But I agree he has gone a bit crazy lately. It does happen you know.' I could only agree if I wanted publication. The mild censorship did not concern me unduly, it was criticism *per se*, as I said earlier, rather than history; and History (I'm referring to big H this time, the dynamic monster that scares the wits out of the likes of Sir Frank Popper), History with the capital H had already passed Lindsay and MacDonald by. But I assuaged my sense of guilt at the compromise by publishing the excised portions in the *Communist Review* under a pseudonym.[6]

I believe that my Marxian vantage point provided a better perspective on the development of Australian art than MacDonald and Lindsay's organic nationalism. It also provided more aesthetic space within which it was possible to revalue colonial and modern work. Perhaps that is all I mean when I say that I believe

I provided a more truthful account of the development of Australian art than either Lindsay or MacDonald. I believe that I did it better for two reasons: first my Marxian vantage point was superior to their organic nationalism; and secondly because I did more historical work and called upon more and a greater diversity of material.

This last point is important. It is only because of the existence of a growing body of potentially historical data that the art and science of history can be said to progress; and I believe that it can be said to progress, so that historians in a way quite different from that of, say, poets and novelists can be said to stand upon the shoulders of their predecessors. For to see history simply as a contest with antagonists of opposing points of view is to oversimplify what actually occurs. It is all much more complex than that. In the processes of research and writing both vantage point and antagonist become problematic. The work is activated decreasingly by contestation and increasingly by the problem of relating inadequate models and inadequate theory to the queer bits and pieces of data that turn up in the dredging net. It is the complexity, density, variety and quantification of the data available that makes it possible (or at least potentially possible), for the historians of one generation to supersede the work of their predecessors.

This point was neatly made by Professor Gombrich in his inaugural lecture as During Lawrence Professor of the History of Art at University College, London in 1957. 'Let me mount the soap box for a moment', he said,

and tell you that with all the drive for higher education [he was speaking in February 1957 when the level of British civilization was higher than it is today] £35,000 per annum cannot be spared to keep the library of the British Museum open in the evening. The greatest power house of knowledge must remain inaccessible to all who work in the daytime; though one of the few things which everyone knows about its history is that it was here that two exiles, Marx and Lenin, concocted that explosive which exceeds in range even the most astounding devices of science. Apparently it has not yet struck anyone that where the myth originated it might also be rendered innocuous, through more accurate work in the quarry of books.[7]

No doubt those of you who believe that it is better to be red than dead will be grateful for Professor's Gombrich's assurance that the explosive concocted by Marx and Lenin does exceed in range even the most astounding devices of science, but it is grossly misleading of him, it seems to me, to reduce their work to

the status of myth. In the first place their work emerged as a powerful and influential critique of the work of less talented theorists and historians; in the second place their critique, as Gombrich somewhat poignantly admits, has not itself been superseded. By which I mean that social theorists and historians still work to a large extent within a Marxian paradigm (if I may borrow for a moment Thomas Kuhn's term) just as biologists continue to work largely within a Darwinian paradigm. Which is not to say that both biology and social theory have developed in both their range and sophistication since the days of Marx and Darwin. If it can be said that philosophy is a footnote to Plato, it might be said, probably has been said, that modern social theory is a footnote to Marx. Indeed the amazing pace at which the great publishing houses of the western capitalist world continue to put out works on Marx and Marxism is in itself an amazing phenomenon. The dialectical contradiction—that mystical component of Marx's thought as some see it—seems to be grinding away still in 1985 like a gaudy merry-go-round. In this bizarre situation, even the most cogent refutations of Marx, the highly important work of men like Popper and Kolakówski, are perhaps best compared with the work of those great heresiarchs of the third century, Arius and Manichaeus who, in seeking to subvert the growth of Christianity, only assisted the process of refining and diversifying it. Not that I would want to deny that Professor Gombrich's mythical night worker in the British Library may one day produce an account of human social behaviour that will render Marx innocuous. For the refutation of Marx, though a puzzling question, like the name Achilles wore when he dwelt among women, must not be held to be beyond all conjecture.

In the meantime, however, good technical work remains to be done within the parameters of that controversial paradigm. In concluding, let me mention a couple of local examples. In December 1981 Anne Bickford published an article in *Australian Archaeology* entitled 'The Patina of Nostalgia'. After studying the restoration and conservation techniques employed upon a number of well-known historic buildings—the Hyde Park Barracks, Elizabeth Farm, and Elizabeth Bay House in New South Wales, and some at Port Arthur in Tasmania—she came to this conclusion:

not only the convict sites, but also the 19th century colonial houses surviving from our colonial day are swathed in a nostalgic vision of a romantic past. In this picture of gracious living in grand rooms, the workers—the servants and the convicts, all the support staff who kept the farm running—are absent. The rooms exemplifying their life are

made into the new offices and toilets. We are presented with romantic images of ruling class life. A fantasy of hope for the upwardly mobile and for the working class who can only dream.[8]

A parallel to this tendency for National Trust restoration techniques to present a distorted image of the past may be found, I believe, in the uncritical adulation that for at least the past two decades has greeted the landscape paintings of the late Fred Williams. They afford us an illuminating parallel to the work of the mature and ageing Streeton. There can be no question that both were painters of the highest talent, yet there is an important component in the later work of both men that lends itself admirably to the promotion of an organic nationalism that is both uncritical and romantic and far removed from the historical reality. Both Streeton and Williams have been said to be painters of the heroic Australian landscape. But in their mature work neither heroes nor anti-heroes are present. No evidence is provided that human beings, either black or white, ever worked and transformed the land. The rural worker is as absent from these landscapes as is the presence of the domestic labourer in our heritage houses. Yet as a young man Williams revealed a brilliant talent for the depiction of common people, and even Streeton recognized their existence from time to time. It is interesting perhaps to note in this context that people began to disappear from Heidelberg landscape paintings after the trauma of the First World War; and they began to disappear from the paintings of that second great school of Australian art that emerged during the Second World War after the trauma of the Cold War of the 1950s. Perhaps it is indeed true, as John Barrell has suggested,[9] that there are times when those who can afford to collect paintings find it disconcerting to have images of those who work and transform the land, upon which wealth depends, on the walls of their private rooms.

I suspect that until such irritating contradictions cease the Marxian paradigm will still be put to good critical use, and perhaps even by those who may eventually work at night in the British Library. But for those who fear the production of yet more radical scenarios for the democratization of human society and the liberation of the repressed of the earth, those fearful possibilities might constitute not only sufficient reason for refusing to open the place at night but for closing it up altogether.

7
Art Objects and Historical Usage
—1983—

Question invites question. 'Who owns the past?' invites 'What is the past?' Is it a class of one or of many members? An abstract universal of but one instance, or a dying god whose sole obsession is to devour the future, its children. 'What is time?' said Augustine, 'when I do not ask myself, I know.' If the past then, like time, is so difficult to conceive, our question looks like one that does not admit of an answer.

So perhaps we should try a psychological rather than a metaphysical approach. We listen to a melody anticipating notes still to be played, even if we have never heard it before, while others fade away into memory. All perception seems to be like that; not an instant of time but a duration, filled and experienced, an irreducible mix of memory, sensation and expectation. Out of such experiences I become aware of my identity; a 'possessable' past, built out of memories. And though my memory selects and distorts the things remembered, and also forgets, it is the only direct access to the past I possess.

But if we should substitute an indirect approach for this subjective and fragile, yet direct, access to the past, we may construct quite complex pictures of the past. By observing the behaviour of perceptible things we may construct accounts of the past in terms of events. Yet it is almost as difficult to talk about an event as to talk about the past. The problem is this: an event not only possesses a beginning and an end, it also possesses a middle that does not necessarily occur half-way through. Although events are located in time they're not purely temporal structures, like days and years, but conceptual units constructed by historians and others to give the past a kind of visibility. Built out of sensory perception they stand in, as it were, for time. To envisage the past, therefore, in terms of events, is to adopt a metaphorical approach to it.

Now metaphors gain their colour from their components, but in this case only one is visible. So the pictures of the past we construct for ourselves will be determined by the nature of the objects chosen to stand in for the past. So it is that the sun, moon and stars have been observed and a sidereal past constructed, measured in light years and populated with events such as the creation and dissolution of stellar universes. The nature of this sidereal past is cyclical, regular, like the behaviour of the bodies perceived and the mathematical methods used in constructing it. The geological past, derived from the study of rocks, is also of a highly recurrent character, consisting of Ice and other kinds of Ages, but more attention in that case is now given to linear processes such as the cooling of the earth and the story of life contained in the fossil record. The biological past again stresses cyclical behaviour, but with a new interest in identity, mutation and conflict. When, however, we turn to the study of the human past less attention is given to recurrent behaviour as we move from the archaeological record towards history in the generally accepted sense, the art of using written records to construct a past. Should historians reveal a degree of regularity, even a low degree, their discipline experiences a kind of parturition and a new social science is born: economic theory, demography, sociology, and so forth. The study of recurrent human behaviour, it seems, is for others.

In this passionate preoccupation with the particular the historian affords an interesting parallel with the fine artist. I stress the word 'fine' because I shall introduce a broader definition of art in a moment. The fine artist also possesses this passion for the particular. Unlike the craftsman and the industrialist who seek to maintain a regularity of quality and form in their productive sequences, the fine artist tries to ensure that each unit is as original as it can be made.[1] The fine artist, one might say, constructs original works, the historian constructs original events.

I shall not press the parallel, beyond noting that the historian's struggle with originality is just as difficult as the artist's. It was none other than von Ranke who wrote, 'the event in its human intelligibility, its unity, and its diversity; this should be within one's reach. One tries, one strives, but in the end it is not attained'.[2] What a *cri de coeur* from one of the most confident of historians! Well, what's the problem with events?

They're constructed, we might agree, from selected facts linked in causal networks. Palaeontologists and prehistorians, more often than not, suffer from a paucity of them: inorganic traces of

a human presence, bone fragments and the like. The historian, on the other hand, selects facts largely, though not exclusively, from objects constructed by human beings, and, as he or she moves towards the study of the present, may be embarrassed by a surfeit of them.

Human productions have long been described, and, I suggest, are best described, as art objects. Art objects, that is, whether of a physical or mental character, as distinct from natural objects. 'Nature hath made one World and Art another', wrote Sir Thomas Browne.[3] Some of the more specific distinctions, such as that made between art and science, need not detain us, because for our purpose all human productions that embody an element of conceptualization, purpose and skill may be classed as art objects. The natural sciences, for example, would be viewed as arts developed for the purpose of revealing truths—or must I say falsifiable hypotheses—about the natural world. Nor need we concern ourselves unduly with that conventional distinction between fine art, craft and industrial production, for all three demand high degrees of conceptualization, purpose and skill, either from individuals or from groups.

Now it is to art objects, in this broad sense, that historians turn mostly for their sources. To the primary usage of art objects historians add a secondary usage, an historical usage. But because such objects are constructed for purposes and by skills that differ from those of the historian, methods of interpretation must be developed that take cognisance of the original skills and purposes. It is in this sense that all historians are art historians; they must learn to interpret and understand art objects. To take an obvious example: those historians who must direct their attention mainly to written sources, will often need to satisfy themselves as to the nature and age of the paper and ink of their documents—as we have been reminded recently in the affair of the so-called 'Hitler diaries'. And in dealing with a written text an historian confronts a linguistic art form of great complexity, of which the techniques of interpretation themselves possess a history reaching back to the earliest successful distinctions between myth and legend on the one hand, and history, as an objective enquiry, on the other. There is a latent artistry in the historian's sources that lies in wait to trap the unwary.

At this point it will be useful to recall the well-known ambiguity of the word 'history'. We say 'that's all history', or 'that's past history', referring to something that's happened. But we also describe as 'history' what historians produce. The two views are

complementary rather than contradictory. One describes the whole field of historical enquiry, the other, the process of enquiry. But there is a significant difference. The first view assumes that history, as the perceptible presence of the past, is accessible without mediation. The second assumes that the past is mediated for us by historians, those artists whose skill it is to tell us the truth about a chosen event or a chosen portion of the past.

Artists, however, who undertake to tell the truth must work within the limitations of their *genre*, their medium and their technique. A novelist usually undertakes to tell a typical kind of truth. 'Everything is copied from the Book of Nature', wrote Henry Fielding, in his preface to *Joseph Andrews*, 'and scarce a character or action produced that I have not taken from my own observations and experience, yet I have used the utmost care to obscure the persons by such different circumstances and colours, that it will be impossible to guess at them with any degree of certainty'. A portraitist may seek a higher degree of specificity than is available to the novelist. William Dobell portrayed the philosopher, John Anderson, at a particular time of life, yet even then there was an opportunity for summary generalization; for not everything can be said even about the life of a face. As Lord Macaulay put it: 'No picture, then, and no history, can present us with the whole truth: but those are the best pictures and the best histories which exhibit such parts of the truth as most nearly produce the effect of the whole.'[4]

Macaulay's judgement is in the nature of an aesthetic one, and I believe he is right in this. For the effects of a whole are not something that can be falsified. They can only be assessed by personal judgement. This is one of the paradoxes of historical writing. The more the historian conceptualizes, and conceptualization lies at the heart of the art, the less the work becomes available to tests of falsification. It should be possible to exchange most of the facts in a fine historical work, such as Huizinga's *Waning of the Middle Ages*, for a parallel set, and for them to sustain similar conclusions, the main events of the book remaining relatively unimpaired. Yet it wouldn't be the same book, for though facts tend to be typical and events unique, they do much, linked as they are in an intricate network of causation, to determine the character of the whole. The historian is involved in what has been called a hermeneutic circle.

Yet there is much in the historian's art that is falsifiable. Unitary occurrences, such as when and where a death occurred, are readily falsifiable. 'It's a duty not a virtue', someone said, 'to get the facts right'. A causal relation can be disputed and shown to be false. Yet

historical works that are more than annals of events resist falsification. We would not be likely to say that Joseph Needham's *Science and Civilisation in China* is true; we might want to say it's the best book on the subject. Because, although a history is a work whose purpose it is to tell the truth, it's also a work of art; and we do not judge a work of art wholly in terms of its intentions. It might be more honest to say that we judge it in terms of our intentions or, less cynically, by its value for us and others.

The problem of truth and history brings us close to the question 'Who owns the past?' For it is precisely those who would claim that an historical work, such as the *Authorized Version* or the *Short History of the Communist Party of the Soviet Union* (Bolshevik), contains the whole truth, who are inclined to lay proprietorial claims upon the interpretation of the past, in the hope of thereby controlling the future, with the aid of their history.

But I must leave that question with you and turn to one distinction in the arts that may further help us clarify the historian's relation to the past. This is the distinction between art objects that exist in material form, such as a building or a battleship, and art objects, like a poem or a scientific theory, that transcend material form. These latter cannot exist wholly in the minds of their producers, or at least not for long; yet neither do they exist wholly in the texts, scores, and performances in which they are recorded or by which they are re-enacted. They survive in a transcendent form between the mental and physical worlds, like an electric current between two terminals.

Transcendent works elude possession. A poet cannot physically possess his poem after he has written it down, though he may have some claims on its subsequent use. It will begin a transcendent life in its readings, as indeed may anything which has been written down. But a painter does possess his painting and may sell it. Destroy it and something essential is destroyed. Yet I would not want to make a sharp distinction between transcendent and physical art. Both may and do take on both physical and transcendent aspects in order to survive. If Warsaw is destroyed it can be built much as it was; if the François Vase is smashed to pieces it can be put together again and reproduced in innumerable books and reproductions. If Courbet's *Stonebreakers* disappears in the Dresden raid we have at least reproductions, so that something is preserved. Increased technological power in the replication of art has weakened the distinction between its physical and transcendent forms, so that they are better seen as two aspects of art rather than as two kinds of art.

Now these two aspects of art may help us understand the

secondary usages to which historians put works of art in the process of creating their own.

For the historian, the transcendent reveals itself in tradition; which is what is left after all the listening and learning, the looking and the reading has ended. It is a kind of perception in which the past is perceived in the disguise of the present. When Gibbon heard the friars singing he heard the past in the present, which is a different thing from going to the past for one's sources. Gibbon's awareness of the past became immediately available to him in the act of perception. In one respect it was like any other act of perception in which concepts acquired in the past are associated with sense impressions in order to plan a course of action. And it is to tradition that the historian turns to plan his or her kind of action; that is to say, it is the conceptualizing, generative side of the art. In a formal sense only is the historian's medium language, which is shared with several other kinds of literary artist. In a substantial sense the historian's medium is tradition, an inchoate apprehension of the past in the present that has to be worked in order to provide the insights, inspirations, intuitions that mould and shape the history. I don't want to suggest that it's homogeneous. It may be perceived as sacred, to be defended against heresy; as tribal or national, to be defended against the intruder or foreigner; as the triumph or decline of order and good government; as the oppressive hegemony of a dominant class, or as a kind of communion with heroes and liberators. To put it simply, tradition provides the historian with a point of view and it cannot be avoided any more than the air he or she breathes. As William Blake might have put it: the potter, clay; the historian, tradition.

But you can't prove a thing with a point of view. In order to assemble those networks of causation that provide the scientific groundwork of the art, the historian must turn to the physical aspects of the art objects available, to what has come to be called heritage; to texts, statistical tables, pictures and monuments, that can be used as evidence and quoted in the footnotes. It is to heritage that the historian turns for the facts. Myth and legend may be evolved entirely from tradition; to write history one has recourse to heritage.

With these distinctions in mind let us return to the question, 'Who owns the past?' Consider tradition. Traditions are normally perceived as corporate and integrated structures, so that claims on a traditional past are rarely made by individuals. But groups, tribes, sects, nations, international organizations do

claim the right to own or protect particular traditions. A sect may claim sole right to the performance of certain rituals and ceremonies and proscribe their performance by outsiders as profanation or blasphemy. A nation may perceive itself to be the god-selected protector of freedom and liberty and condemn other nations possessed of different political systems as tyrannous. But traditions, because of their transcendent character, are difficult to withhold from others. It's like trying to own the wind. So all technologically advanced societies have tended to transform their traditions into possessible entities, largely through the establishment of institutions, of which law is perhaps the prime example. By means of codes, case-law, constitutions, legislation and so forth, law as an institution transforms tradition into art objects, which in their totality become potent rationalizations of past behaviour, by means of which it is possible both to predict and, in some measure, control future behaviour. In this law is the archetypal human institution. All other institutions, whether political, cultural or religious, are engaged, in accord with their own practices, in similar activities. Seen in this light, 'Who owns the past?' is another way of asking 'Who makes claims to order and control the future?'

At this point we might consider the question whether the writing of history exercises an influence upon the future. Some years ago Sir Karl Popper developed an influential argument to show that it is impossible on logical grounds to predict the course of history. This has been taken in some quarters to mean that history can exercise little or no influence at all, or even make rough but useful guesses as to what might occur in the future. Popper argued that 'if there is such a thing as growing human knowledge, then we cannot anticipate today what we shall know only tomorrow'.[5] Put in that way the statement is not so much a truth as a tautology. But there is also an implicit assumption that innovative knowledge operates uniformly over the whole field of knowledge. But this is not so, and where innovative knowledge does not operate there lies the possibility for recurrent human behaviour. Furthermore, innovative knowledge is itself often inspired and promoted in order to forestall and block undesired predictables. Much social history in alliance with medical science and social legislation could be explained in this way; as in the health control of socially related diseases. It was this application of new knowledge to undesired recurrent behaviour that Marx, surely, had in mind when he talked about progress from the realm of necessity to the realm of freedom.[6]

Popper's arguments are not to be taken as proof that history cannot influence events but as a salutory warning to historians that they should not allow their hopes and fears for the future to affect the quality of their judgements. This is a question of honesty or dishonesty in the workplace. But if they possess no hopes or fears for the future I doubt whether their work will ever be worth much. Both the Day of Judgement and the Golden Age are buried deeply in most traditions, and the historians who catch an occasional glimpse of them write the influential and powerful histories.

Some historians, it is true, believe that historical writing should be confined to the explanation of unique events, avoid long-term trends and recurrent social behaviour, maintaining that this is the concern of the sociologist or some other social scientist. But as I hinted earlier I do not take these opinions seriously. They sound to me like demarcation disputes between the members of rival trade unions.

Historians cannot predict the future and should not attempt to. Nor should they deny that their work will affect the way the future is perceived and planned for, and possible occurrences confronted if they do occur, with the knowledge of the past that historians provide. We don't know precisely when wars or revolutions will occur, but we can expect them to occur. And it would be hopelessly naive to imagine that military strategists and revolutionaries do not study the histories of war and revolution in an attempt to mould the course of new ones. They are doing it all the time.

Existing is to a very large extent predicting. When I wait on the pavement for the traffic to pass I predict what will happen if I don't, automatically. Most historians begin writing history by predicting that if they do it well a university will give them a higher degree. Between that kind of prediction and the influence of Augustine's *City of God* on the course of European history there is a great gulf, but it is a matter of degree not of kind. The reason, I suspect, why this question of the historian's influence is so misunderstood is because history is not a blueprint for the future, like an annual budget. The work enters tradition and becomes a part of it; and, as I said earlier, you cannot quote tradition in the footnotes.

It is interesting to survey historical explanation in terms of the competing claims of tradition and heritage. Explanations embodied in myth, legend and epic are sustained largely by oral transmission in which physical objects play a smaller role, which

is not to say that sacred sites and sacred objects are not of the greatest importance in the reinforcement of belief. But in such cases, tradition does not appeal to heritage to prove the truth; both are bound within a common belief structure. By contrast, written history depends upon a heritage of written records to sustain its veracity. This is not surprising, because throughout written history most historians have preferred, following the potent example set by the compilers of myth, legend and history, to tell the story of man as actor: as warrior, ruler, legislator or powerful cleric; and such men of action characteristically leave written records, records that record their actions. Indeed this has remained the dominant kind of historical writing down to the present day.

During the Enlightenment, however, some historians began to write history not as the history of greatness and power, but as the history of production. There may well have been a liberation ethic at work here, if not a certain narcissism, for historians were themselves artists and producers rather than actors on the world stage. These new historians began to write economic and social history, archaeologists began to study the material remains of the past, becoming historians of production, *faute de mieux*, and others began to write the history of literature, philosophy, the arts, and so forth. In consequence a much more representative account of the human past came to be assembled. For in a world in which the vast majority were illiterate, historians who had depended exclusively upon written records had tended to write histories for the literate and, more often than not, about the literate.

It was the economic historians who first effectively broke through this linguistic monopoly by making effective use of mathematics, that most precise of arts, in their investigations. And the colour of their accounts began to take on the colour of their techniques. Like the astronomers who found cyclic behaviour in the economic past, trade cycles and long term trends, it began a new phase of predictive social investigation that continues.

For the economic historian, however, production is a means to an end. Indeed, someone defined economics as the study of ends and scarce means. The events of economic history are expressed in terms of market forces within a framework (a grammar if you like) of production, exchange and distribution. Neither the formative or imaginative design aspects of production nor its technical aspects *per se* are of central concern to the economic

historian. The economist's approach to production is instru-mentalist: things are produced because they are needed. It was left to the historians of the arts to approach the act of production aesthetically, as a pleasant activity, a shaping and forming activity, of value and interest as human behaviour apart from the fulfil-ment of needs. To take acts of production themselves as historic events was something of a novelty.

But their model, it could be claimed, lay in an archetypal event of some historic significance, if indeed it is true that *Homo erectus* became human in the long process of learning to make things and teaching himself and herself to speak.

There's so much misunderstanding, however, about the use of art objects as historic events that a few comments may be helpful. It's not the art historian's business to worship the icon or even to admire it. It's not the art historian's business to frame set pieces of art criticism within a loose chronological framework, though such hybrids between history and criticism may possess some pedagogical value. It is because of such misunderstandings that art historians are sometimes viewed as philistines devoted to unweaving human rainbows. But historians in general have always at their best maintained a tough-minded attitude to their material ever since they began to distinguish the practice of their own art from that of myth-making. As with all historians, the art historian's values are implicit in the choice of events and the facts advanced in their construction. If the art historians' values as a whole are in question they are best discerned in their choice of art objects, as distinct from other forms of human activity, from which to construct events and write their histories.

This is not to say that the activities of production that end in art objects are any more admirable in themselves than other kinds of human activity. One does not avoid moral issues by focusing on the production process. Art is what art is for. For even in the very processes of production the purpose remains visible in the design though sometimes one must look hard and long for it; the function gives rise to the form in nuclear war-heads as in Renaissance *cassoni*.

The extension of historical interest from men as warriors, rulers and legislators to a wider interest in humankind as producers has provided a more representative and diverse picture of human activity. But with this benefit has come attendant cost. History studied as a scientific pursuit and history as production have greatly increased the need for collecting art objects of all kinds

because it is from heritage, as we noted, that historians derive their evidence. In the process an increasing reification of tradition and of morality has set in. Art historians, archaeologists, anthropologists and others who make universalist claims can and do destroy the traditions of technologically weaker societies. The traditional history of one society is thus absorbed into the universal heritage history of the more powerful society.

I have argued (when I have not simply asserted) that through memory we possess direct access to a personal past. That tradition provides an indirect and metaphorical means by which that personal past may be extended into a social past, by means of which we become aware of that sociality we share with others. It is by means of tradition that we commune with the myths of our society—or must I say the social formations from which we emerge and to which we adhere. But it is only through heritage that myth is provided with the acceptable scientific face that modern societies demand. By means of heritage as our field and history as our process of enquiry we set out to construct coherent and more or less testable accounts of the past.

Historians need access to heritage in order to write their histories. But as modern society becomes increasingly conscious of its historic past the art objects that constitute heritage undergo a strange transformation, a transformation that takes place at the moment of displacement from art object to historic object. That is why aesthetic valuing appropriate to the primary act of production is so often confused with the historian's secondary usage of art objects. In the cause of their secondary usage art objects are removed from the temporal flux and every attempt is made to retain them in their condition at the moment of their displacement from art to heritage—like a foetus taken from a womb and put in ice. Curators and conservators are then employed to guard the objects in their acquired, timeless conditions.

At this point accessibility, so essential to historians, begins to become problematic. Sometimes the historic objects will be removed from the eyes of laymen because the dirt in their fingers or the warmth in their bodies might damage the objects. They become available only in their replications or in the artfully and historically devised settings created by their guardians. Safeguarded by thermostatic controls and high security provisions they approach the new sanctity of pricelessness. In such situations the writing of history becomes increasingly the history of sacred and timeless property. The heroic traditions of myth are

exchanged for the priceless heritage of history, an art that in its turn becomes increasingly a function of the laws relating to property.

I would not want to make too much of these encroaching dangers but they are worth noting. One of my most cherished memories is of a fine, still morning of late autumn in the Dordogne when my wife and I, mere tourists, were conducted around the Lascaux Caves by its two young discoverers. But I expect that if I wanted to return today I should have to attempt to establish the fact that I too have a right to be numbered among the Guardians.

I've not attempted to comment on the specific problems outlined in our brief to contributors because it seems to me that the relative claims of the sacred versus the secular, the needs of science and of tradition, the national versus the international, and so on, are empirical matters that cannot be decided by general principle but can only be resolved after a careful consideration of particular contexts and circumstances. Tact, caution, the effort to understand is needed on both sides.

8
History and the Architect
—1982—

As I speak my words flow into the past. They are, you might say, history now. That's the simplest sense of the word: what's past. But it's not history even in the simplest sense unless we can recover it: bring it back into the present. There could be a leather bag holding Portugese coins of the early seventeenth century hidden in the sand deep under this building. But they won't enter history unless they're recovered. We may recover the past by memory, by writing, by tapes, by microchips. And we can check the accuracy of what we call events or 'facts' by the rules of evidence. These are the assumptions upon which the empirical historian works, and I would defend this position, though I do not see myself as a naïve empiricist.

The position is this: the past can be made known, given the appropriate tools and techniques of enquiry. It is only the past that *can* be made known. We cannot know the future; we can only with more or less accuracy, predict it. We use our knowledge of the past to plan and predict the future. There is no real problem here. We all do it every day. I put in my pocket diary that I had to come here today. I am here, I predicted it. People often say that historians cannot predict the future. And of course they are right in the sense that they say it. But in the simple sense in which I am using the word, the colloquial sense, we are using our knowledge of the past to predict the future all the time: calendars, timetables, work schedules. At least we can impose a regularity upon the future, within which and constrained by which, events in the future occur. Because all knowledge is knowledge of past events, all knowledge takes on an historical cast or character. There can be a history of everything, even of nature.

But it is only the objects of our knowing that possess a historical character. We, the knowers, who seek to recover the

past for our own uses are also the creations of history, of our genetic history, our social history. My sense of my own identity, character, personality, is not, as I perceive it, something I was born with, or can step outside of time with, and grasp to myself as my very own; it is rather a kind of palimpsest of all that has happened to me genetically and socially. This means that I am a mixed-up, rag-bag of thoughts, moral and political attitudes, opinions, and feelings. It is with this mixture of mind and feeling that I perceive the world; and I perceive it primarily to ensure my own survival in the world, and to the extent that I'm still potent, the survival of my species.

If this is so I'm bound, if I should write history, to write it—in the broadest sense—to further my own purposes though I might identify those purposes with a place, a class, a time, a region. This is why, though an empiricist, I am not a naïve empiricist. Those who believe that by applying the correct historical techniques and methods they can write what they call neutral, objective history, are the victims of a delusion. It is nevertheless a magnificent delusion. The ideal of writing objective history is to be admired; what is to be even more admired are those historians who, knowing that their discipline is at heart a critical discipline, reveal the biases and prejudices at the heart of those histories which purport to be neutral.

How then is a historian who believes in the reality of the facts, events of history, and yet is also aware that such facts are chosen to suit the interests of the historian, to answer the sceptic who wrote (to encourage today's discussion) that 'history is only made by the person who writes it'? This is not merely a criticism of history, it is at heart a criticism, it seems to me, of the realist view of the nature of knowledge: that there is a world distinct from the knower that can be known, and the accuracy of the knowledge can be tested by the rules of evidence. Historians continually assert that certain events occurred, that certain demographic, political, even moral trends have emerged. These events, trends, etc. can be and are scrutinized by other historians. History is a self-critical discipline; one might say it is a self-correcting discipline, though not automatically self-correcting.

For this reason it is essential that we preserve the distinctions that must be made between myth, legend, fiction, ideology and history. History can and has served the purposes of all these, but to that extent it has been defective history. It is the business of the historian to separate, in his criticism, the mythical, legendary, fictional and ideological from the historical core.

This historical core consists of facts that can be shown to have occurred, linkages between one event and another, as causes and effects, together with models and theories, which establish regularities between events. A good history is not the last word on the subject; it will stand until a better one is written. In this it is akin to a scientific theory which will only stand until it is disproven.

What is the status of facts and events in historical writing? Of course they are chosen by the historian and in a sense by the scale and nature of the topic. How would, for example, a history of our discussion this afternoon be written? There are certain relevant facts that would probably *have* to be included: the time and place of meeting, the speakers and sequence of speaking, the main issues raised in discussion. If none of these appeared it could hardly be called a history. So that the historian does not simply choose his facts, the subject and scale of the enquiry make some facts indubitably relevant. Of course we could tape the whole show. But we could not tape the wider context of the history of your group which brought the meeting into existence. Obviously the history could be written from several points of view; if someone were to write a short account or history for the Catholic press, another for the communist press and another for ASIO, they would all be written from different points of view, they would all be more interesting to read than listening to the whole of the tape, and they would all treat a number of facts, relevant to the meeting, though in different ways, and some facts considered important by some, would be ignored by others.

Such facts achieve the status of facts only in relation to the purpose of the historian and nature and scale of the historical discourse. My first sentence 'As I speak my words flow into the past', could be such a fact in such a history. But at another level of discourse, the physics of sound, they are just so many vibrations of irregular and recurrent frequencies. They only become meaningful when we choose to interpret them as such and only become historical fact when chosen by an historian to incorporate them in a history. What cannot be denied, however, is that I *said those words*, and that they are recoverable.

Perhaps now we should attempt to answer the first question on the agenda: what is the nature of the relationship between past and present which history implies? In part I have already answered it. The pursuit of history assumes that we can possess a knowledge of, and understanding of, the past, and that we can assemble that knowledge in ways that are of value in coping with the

future. The historian may speculate about historical problems but it is not in itself a speculative discipline; at heart it is critical rather than speculative. I would agree that the historian is not a passive agent, though he is not a wholly free one either. The chief characteristic of the historian is *understanding*. The main object of history is what Karl Popper has called the Third World, that which is neither nature nor consciousness, but the world which humankind has made, that is to say, all human institutions, languages, science, art, etc. This Third World, though it is susceptible to the modes of investigation of the natural scientist where that world partakes of natural science (for example, the stresses and torsions of building materials), cannot be known in the way that the natural world is known. The Third World is a reflexive world and it acts on the knower as the knower acts on that world.

The historical mode of enquiry is better described as understanding. This does not give us knowledge which possesses the regularities of natural science, of natural laws, but understanding is of greater value none the less in ordering our future. Understanding is based upon the assumption that because we are similarly constituted, physically and psychologically, we can understand why it is that others behave as they do. Why did Gropius reject the teaching of the history of architecture in the Bauhaus? We can only attempt to answer that question if we assume that we can, given a thorough attempt to recover the situation, provide an answer in terms of his motives and his situation.

Now to the second question. Is there a relationship between history and architecture or are they two distinct disciplines? There is no doubt in my mind that they are two distinct disciplines *and* that a relationship exists between them. Architecture may be defined as a profession or as the buildings produced by that profession. Sometimes, even buildings not produced by the profession are said to be architecture. Both the profession and the buildings, like everything else constructed by humankind, possess a history. What the architect plans falls away into history as he plans it. But in enacting his role as an architect he is certainly not an historian. His business, I take it, is to solve problems by plans, designs, the estimation of quantities and supervision. Precedent, history if you like, will suggest many ready-made solutions, indeed building regulations, laws, the kind of materials available, social conventions, the National Trust, will all suggest predictable solutions. He may choose to follow such precedents or, believing the problem has features that are not best solved by a resort to the

past, invent a novel solution. The question of whether following tradition and precedent or introducing innovation is better, is an empirical question of evaluation that can only be solved in terms of the specific event. Not by principle.

Does history provide the architect with a cache of types which can be appropriated at will? Indeed it does, and they will continue to be appropriated. I remember sitting in the Capitol Theatre Sydney in the late 1930s, a theatre filled with the new modernist aesthetic, and looking up at the little gilded Corinthian columns around the balcony boxes and wondering, will this really be the very last use, after more than two thousand years, that architects will have for the classic orders. Or will they come back again?

Is it the business of history to fix or define the routes that are no longer passable? This is an innovator's use or excuse for history. It was, incidentally, the excuse for history that was always invoked by the first professor of Architecture in this country, Leslie Wilkinson. Wilkinson always used to say to his students when they jacked up about learning architectural history: 'So you all want to be original do you? But how is it possible to be original? What you have to do first is to find out what all the old boys have done before you: they just possibly might have thought of it before you did.'

But of course *pace* Wilkinson, no original architect ever worked quite in this way. The innovator does not block himself out from the past nor does he respect the past. He raids it and mixes what he has obtained with his own innovations.

Why did Gropius banish architectural history from Bauhaus teaching? The short answer is, he was essentially a propagandist, a codifier, a man whose mission it was to establish modernism in architecture as an unquestioned faith. The basic theoretical underpinnings of modernism had been achieved a century earlier, beginning in 1750 with the emergence of functionalist theory. It was men like Pugin and Viollet le Duc interpreting, or misinterpreting, Gothic architecture as stone engineering which provided the new aesthetic needed for the use of iron, glass and concrete. They raided history for their own contemporary theoretical needs. Gropius banished it because he did not want his gospel questioned. He wanted it propagated.

Architects at their best are great innovators; they produce new things despite the fact that they have to live within what James Joyce described as 'the nightmare of history from which I am trying to awake'. Historians at their best are great critics. They erode dogmatisms. The historians of the Benedictine Order, for

the best of motives, developed what is known as the 'Higher Criticism': the hermeneutics by which the veracity of the Christian gospels came under increasing scrutiny. Historians have been nibbling away for years at the assumptions of modernism until it is now one historical style among others. But that does not mean that the architect should take orders from the historian, or the historian his orders from the architect.

9

History and the Collector

—1974—

We are assembled here this evening to honour one of the National Library's greatest benefactors. Rex Nan Kivell, it seems to me, is a man in whom two stars, two kinds of personality, have found a happy conjunction. One is very much of the present day. In his capacity as Director of the Redfern Gallery and art dealer in London for over half a century, Rex Nan Kivell promoted and supported young artists and new ideas about art. Through the connections which he established with Paris and the world of contemporary French art he made the Redfern one of the most influential agencies by means of which England was brought into contact with the best art of Europe, and by so doing he, as much as any man of his time, helped to change London from a centre dominated, in the years before the First World War, by a provincial Anglo-Saxon taste to the position it now holds as the largest international art market in the world. In all this Rex Nan Kivell has been a Londoner, a man of excellent taste and shrewd judgement, a specialist and professional; a man, you might say, of the twentieth century.

But there's another Nan Kivell. This dealer in contemporary art is also a man profoundly interested in the past. In the early 1920s, while still a young man, he developed a keen interest in the archaeology of Bronze Age and Roman Britain; and was decorated by King Christian of Denmark for his published work on the La Tène settlement in Britain. He later presented his British archaeological collection to the Devizes Museum, Wiltshire. Yet even in these archaeological interests, he is still a man of his time examining a specialized field in depth.

It's not until we turn to Rex Nan Kivell's passion for collecting items of New Zealand, Australian and Pacific interest that one becomes aware of a different aspect of his personality. Here the net of curiosity is spread widely to cover one-third of the globe

and more than three centuries. During a period of over forty years he has gathered together a collection containing some 15 000 items, and it's still growing. I shan't attempt, indeed I could not describe it in the time at my disposal. Let me simply state the bare facts: that at present it contains 2690 original paintings, 4107 prints, 166 early maps, 184 manuscripts, 5041 books and pamphlets, 65 objects and 650 photographs; that it ranges from missionary pamphlets to mounted and engraved emu eggs, from the silver tea-kettle which Queen Charlotte gave to Sir Joseph Banks to ensure that a cup of tea was always available during his illness, to many fine paintings. It contains portraits of almost every personage, famous or infamous, in any way associated with the European penetration, opening and colonization of the Pacific during the eighteenth and nineteenth centuries. For this section of the collection Rex Nan Kivell is himself preparing a comprehensive dictionary.

It's the inclusiveness, the grand scale and generous breadth that Nan Kivell has brought to his collection of Pacific material that reminds one of those great Renaissance collectors of the sixteenth century: such as the Grand Duke Francesco Medici, whose enormous cabinet of rare and precious things was based upon a classification which set objects from nature in contrast to parallel objects from art; or of Emperor Rudolph II, whose cabinet at Prague was the wonder of all Europe. In it Rudolph sought to create a systematic collection of all nature, all art, all knowledge. Rex Nan Kivell's collection of Pacific material reveals a similar passion: nothing that is human is alien to his curiosity. There is surely a good reason for this. For in this Pacific collection the collector is a man in search of his own origins.

Rex Nan Kivell was born in New Brighton near Christchurch, New Zealand. It was a Christchurch bookseller who awakened his interest in collecting. By giving a false age he became an Anzac at sixteen in the First World War. He managed to survive a gas attack and was then invalided out of the army. That event saved his life, for shortly afterwards his company was annihilated at Messines. Perhaps it was that wartime experience which aroused in him, as it aroused in the poet Herbert Read, and the Dadaists of Zurich, a desire to help reshape the values of the society into which he had been born.

Well, all that, as I have said, is one side of the man, the twentieth-century Londoner: a side that has certainly helped to reshape aesthetic values in England. And the Australasian side,

embodied in this collection, is bound, I believe, to assist in the reshaping of historical values in this part of the world.

For I have no doubt that this collection, and others formed in a similar manner, will come to exercise an influence upon Australasian historical scholarship comparable to that exercised by the great collections of the Renaissance. In more ways than one, the situation is similar. Before the Medici, before Rudolph II, and the great archaeological collections of the Vatican came to be formed, European scholarship, including its historical scholarship, was dominated by the supremacy of the word. Mediaeval scholarship, although it grew out of, also grew in extreme distrust of, the values of pagan antiquity—that antiquity which was expressed in the ruins of Rome then still visible throughout mediaeval Europe. True, the devout mediaeval craftsman could be given a place, closely and jealously defined, in the service of the word. But the sensuous enjoyment of material things, the delight in textures, forms and colours, for their intrinsic quality, was not the kind of experience to be trusted; nor indeed was the mute and enigmatic evidence which such things provided about a past that was neither Christian nor Judaic.

When history first came to be written in this country by John West of Tasmania and others, it was largely a neo-mediaeval tradition which historians inherited, and the distrust and fear of sensation which that tradition embodies has become a leading characteristic of our own intellectual tradition, the popular counterpart of which has been a prevailing philistinism. Just how prevailing it is cannot be better assessed than in the recent popular and political reactions to the courageous and historic decision of the Australian Government to purchase Jackson Pollock's masterpiece, *Blue Poles*. To spend real money on art comes as a form of 'culture shock' to Australians.

Professor Manning Clark has assured us that we have inherited a culture derived largely from Irish Catholicism, Evangelical Protestantism and secular humanism, but the humanism to which he is obviously referring developed from a nineteenth-century concern with social welfare. He refers not, that is to say, to humanism in any strict sense of the word, which is concerned not with a programme for the mind but with a state of mind; that balance which ancient Greek society first achieved between intellect, sensation and emotion; a balance never yet achieved in Australasia.

This prevailing philistinism, to which Irish Catholics, Evangelical Protestants and secular humanists—in Professor Clark's

sense—have all strongly contributed, is surely the conspicuous hallmark of our culture. And it's misleading, it seems to me, to attribute its source wholly to the neo-mediaeval intellectualism of nineteenth-century industrial Britain. Our own antipodean situation also contributed much. Pioneering Australia in the nineteenth century bears some interesting comparisons with pioneering Europe in the Dark Ages. Both took place in a wilderness in which the only signs of material culture were interpreted as portents of the devious ways of the devil. In Europe it was pagan antiquity, in Australasia the art of primitive, unchristian savages.

Our historians have sometimes treated those nineteenth-century travellers who complained, as John Ruskin complained of America, that a country without a visible past could not possess a history, as men of little imagination. But perhaps it is time we took the travellers more seriously. Our European-based culture came to us in small transportable things that could be carried in ships, such as minds and books. And our history has been written largely as a kind of dialogue between the two. The lack of evidence of a visual or material past, and of a serious concern with what there is of it, has given a curiously philistine cast to our intellectual life and our heritage. When the historian chooses to use visual material at all, he uses it, in the same way Pope Gregory the Great recommended the use of paintings in churches, only in order to illustrate the Word.

It is, I think, notable that the men who have sought through their collections to redress this imbalance have not stood, as it were, at the centre of action in our society, as the Medici, or the Third Earl of Burlington, or Henry Clay Frick, have done in their societies; they are men, rather, who have been recluses, even eccentrics, or have, as expatriates, sought to lead a more complete life elsewhere; Sir William Dixson, Alfred Felton, Dr John Power, Rex Nan Kivell. It is not until the collections of such men are formed and made available to historians that the material, archaeological side of our history can be written. Yet until we do include, seriously, in our historical considerations man in his arts and his industries as producer and not only man as hero, or as an actor upon the stages of religion, commerce, finance and politics, we shall continue to present an over-intellectualized account of our origins and our world.

It is for this reason that I have here chosen to stress the Renaissance side, the humanist side of Rex Nan Kivell's personality. For we need in this country not only the temperament that is capable of a direct sensuous response to material things, but also the

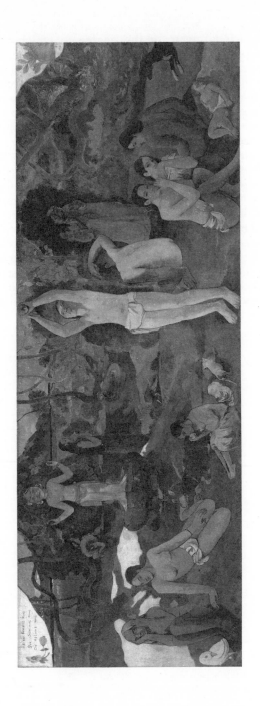

Paul Gauguin *Where do we come from? What are we? Where are we going?* Oil on canvas, 139.1 × 374.6 cm, 1898.

temperament which is aware of the degree to which material things have shaped our heritage, and both temperaments Nan Kivell possesses in full measure. Although he has revealed himself as a person who can enjoy art for its own sake, the collection housed in the National Library of Australia was not assembled according to those values, but by a man using art and the values of art to go in search of his own origins. His collection might be fittingly symbolized by the title which Paul Gauguin gave to one of his greatest paintings, now in the Museum of Fine Arts, Boston: *'D'ou Venons-Nous? Que Sommes-Nous? Ou Allons-Nous?'* ('Where Do We Come From? What Are We? Where Are We Going?') Gauguin painted his masterpiece as a kind of *cri de coeur* against the neo-mediaevalism, the philistinism, which he found prevailing both in Paris and in Tahiti. Although he detested what the West had done to the classical tradition, Gauguin, like the Greeks, strove for a balance between mind, sensation and emotion. It seems to me that Nan Kivell's great Pacific collection is one of the important agencies by means of which Australasian historians may be encouraged to seek a more balanced, a more archaeological, a more humanist view of our history.

Art and Marxism

Art and Adorism

10
Jack Lindsay
—1983—

It's a daunting task even to attempt to summarize Jack Lindsay's astounding literary achievement. I certainly don't possess the qualifications to do so, for his creative mind has ranged in depth and variety over classical, medieval and modern literature. It has explored the relationships between science and culture, the origins of alchemy, of astrology, and of the history of science. He has written important works on the history of Europe at critical turning points in that history. His more strictly literary achievement ranges across poetry, the novel, drama, biography and criticism. He has made an important contribution to the history of art. I've only taken on the task because it's high time that his work became better known than it presently is in Australia.

Let me begin with a few statistics that may help to provide a quantitative measure of his achievement. In 1917 Jack Lindsay edited his first magazine, *The Brisbane Grammar School Magazine*, and published his first poems. That was sixty-six years ago. He has been writing regularly, almost daily, ever since. His prolific energy began early. John Arnold, Lindsay's bibliographer, has identified 174 items: books, poems, critical articles which he wrote *before* he left Australia at the age of twenty-six in 1926. Now aged eighty-three, Lindsay has published, Arnold assures us, 153 books of which he is the sole author, edited another 18, has been the editor of 4 magazines, and of 3 series of books. This output obviously exceeds the output of any Australian author living or dead. He is probably the most prolific author in the field of serious writing, as distinct from the popular novel or journalism, active in any language today.

Yet if we look at the three major reference texts on Australian literature, and they include expatriate as well as resident writers, a curious fact emerges. The more Lindsay writes the less he seems to be noticed. In the two-volume text on *Australian Literature*

published by Morris Miller in 1940, over ten pages are devoted to Lindsay. They summarize his contribution to poetry, drama, fiction, classical and modern literature, to 1939; and he is described as 'probably the most versatile of the younger generation of Australian authors'.

H. M. Green, in his *History of Australian Literature*, published twenty years later in 1961, devotes less than half a page to Lindsay's work, and this is mostly biographical and bibliographical information. Already critical comment has begun to curdle and turn sour. Lindsay's first book *Fauns and Ladies* (Sydney, 1923) is described as 'a vigorous but monotonous celebration of Aphrodite Pandemos and her rites'[1] and in another place Green suggests that since Lindsay's move to England (he is referring to the novels) 'their literary characteristics have not really altered; they may be said to represent a projection of Lindsayism, of a particular variety of Australianism, overseas'.[2] It is such an odd comment that one cannot help wondering whether Green had read many of Lindsay's English novels.

It must also be pointed out that Green has whole sections of chapters entitled: 'Essays, Criticism, Scholarship, Philosophy, Psychology, Education, Religion, History, Biography' and so forth. Lindsay is not mentioned in any of them, though it can be shown without much difficulty that by 1960—with the possible exception of education—Lindsay had made significant and challenging contributions to all these fields.

If we turn now to the most recent attempt at an authoritative survey of our literature, *The Oxford History of Australian Literature* (1981) edited by Leonie Kramer, we find only one reference, and that of the briefest and most casual kind. It occurs in a passing reference, in association with his father Norman and Hugh McCrae to what is described as 'closet drama'.

In other words none of our standard works on Australian literature have made any serious attempt to assess Jack Lindsay's astounding literary achievement.

I do not want to suggest that Lindsay has been entirely neglected in Australia. The literary quarterlies *Meanjin* and *Overland* have maintained contact with him, published his criticism and poetry from time to time. The University of Queensland has awarded him an Hon. D. Litt. for his services to literature; the Australian Academy of the Humanities recently made him an Honorary Fellow. Last year (1982) Penguin republished his autobiographical trilogy *Life Rarely Tells, The Roaring Twenties*, and *Fanfrolico and After* under the title of the first. He has also received

overseas honours. He is a Fellow of the Royal Society of Literature and in 1968 he was awarded the Soviet Badge of Honour.

Is there, we might ask ourselves, any key that might help to unlock the secret of this man's unflagging energy? His ability to achieve distinction in so many diverse areas of literary activity? If there is I can't claim to have found it; but it's high time we went in search of it, began the process of characterizing the nature of his thought and assessing his contribution to the literature and ideas of the twentieth century.

We might well begin that search by noting that the young Lindsay while growing up in Brisbane read the English romantic poets voraciously and with a growing inner excitement: Keats, Shelley, Coleridge, Blake—above all Blake—and that he has never rejected the world of values that the romantics created, a world in which the creative imagination and the power of the poetic metaphor were seen not merely as mental processes appropriate to the art of poetry alone but as instruments that could unlock the nature of reality and change it. In *Life Rarely Tells* Lindsay describes how he read Shelley's *Defence of Poetry*, read it and re-read it: 'recited its sentences through the darkness of my meditations under the mosquito net on the verandah. Shelley's voice crying that poets are the trumpets which sing to battle...the unacknowledged legislators of the world'.[3]

It was the English romantic poets who converted Lindsay to an activist's view of the poet's role from which he has not deviated. Perhaps no other writer of his generation has attempted to work out the implications of this activist role for the poet at so many diverse levels of thought as Lindsay has. By which I do not mean that Lindsay is a romantic but that he began where the romantics began. From Keats he gained the conviction, never lost, that beauty was truth, truth beauty; from Blake he gained the profound intuition that 'without contraries there is no progression'.

Blake now became real for me... Pity born of anger became the organising force... I saw the world as it is...saw it as symbol. Saw it in the unity of process, with past-present-future as one, saw what-might-be moulding what-is, what-is determined by what-was, in an involved revolving sphere, that was simultaneously history, evolution, myself, life-and-death, and the eternal here and now. ... Poetic activity was a ceaseless fight against empire, against war, against all the cruelties and fears known as law and order, against the satanic mills of exploitation, against the money forces that deadened men into things. Jerusalem was the secure position of this activity, vitalising the self and redeeming the earth. It necessitated by its very nature a true relation between man and

his fellows—that is, a relation from which all lies and veils have been removed; and a common objective, a common humanity, discovered. Out of an unending crucifixion, the whole man proceeded, the poet, the lover, the revolutionary.[4]

Lindsay's loyalty to Keats, to Blake, to romantic activism, may help us to understand why his writings have not been fashionable in Australia during the past forty years. Eliot's poems and critical writings, F. R. Leavis's criticism, as is well known, wrought a profound change in literary values. Donne and the Metaphysicals, Pope and the Augustans, were in; the romantics, Keats, Blake and Shelley—above all Shelley—were out; and Jack Lindsay, we must remember, was one of the first and most vocal critics of modernism. Between Lindsay and Leavis there could be no rapport. Leavis with his pessimistic conviction about an organic pre-industrial culture that was lost and would not return; Lindsay, with his ceaseless quest for human fulfilment, for possibility and perfection. So it was Leavis, not surprisingly, who wrote one of the most intemperate reviews (and he has received many) that Lindsay ever received. The subject was Lindsay's biography of Bunyan, the value of which has since been recognized. But for Leavis there was a total opposition of mind. His intemperate review belittled Lindsay's reputation among a generation of students who had been trained to admire Leavis as a kind of literary demi-god. Among other forms of abuse he asserted that Lindsay was no scholar; yet Lindsay has access to levels of scholarship in which Leavis took little interest and which were probably not available to him.

For if the English romantics were Lindsay's heart the Greek and Latin classics were his head, his intellectual apparatus from which so much of his scholarship has issued. Abandoning all thought of an academic career, when it seemed to be the obvious choice, he quite consciously accepted the life and responsibilities, as he saw them, of the poet, came to Sydney and became his father Norman's first and most important disciple. They put their considerable energy and creative resources together in order to oppose the intrusion, among other things, of modernism into Australia. Their periodical *Vision*, which ran for four issues from 1923 to 1926, announced a re-birth of the classical values, of life and love under the Australian sun, an Australian renaissance. 'A flamboyant youthful extravagance'. H. M. Green called it. But it brought together a new generation of Australian writers; the first of those little magazines that nurtured Australian literary culture in this century.

It is this aspect of Lindsay's work which those of us who grew up under the influence of early modernism are likely to find the most antipathetic. But if we are seeking to understand his work as a whole it is something to come to terms with for there is nothing, as he has himself asserted, that might be described as a complete reversal of former values, or as a conversion, in his own literary and intellectual development. His movement to the Left in the 1930s is already adumbrated in the vitalistic energy of the *Vision* period. The controlling mind behind both Norman and Jack at this time, as has often been pointed out, was Nietzsche. The poet, the artist, is a member of a natural aristocracy of creators by means of which the humanity in man is preserved from the animality of the mob: the free spirit is in natural opposition to the servile mass.

But there were two strains to Nietzsche's thought, an evolutionary, dynamic, vitalistic element which could be developed as a kind of transcendent humanism, and a side which stressed the unbridgeable division between the creative individual and the common folk, a side that could be developed into an élitist and racialist ideology. In the event it was Jack who developed for himself the former aspect of Nietzsche's thought and his father, to the detriment of Australian culture during the 1920s and 1930s, who developed the latter. Noel McCainsh has distinguished two streams of Nietzschean thought in Australian culture, a stream proceeding via Baylebridge and P. R. Stephensen to the Australia First movement; and a stream passing through Norman Lindsay that influenced a range of poets including McCrae, Slessor, Fitz-Gerald and Stewart, which sought to transcend nationalism. Yet there is a sense in which Norman Lindsay lies at the source of both these Nietzschean streams, and there is also a sense in which both father and son embraced national as distinct from nationalist aspirations. This was in their opposition to modernism, first in Sydney and later in London, with the establishment of the Fanfrolico Press. Their new artistic renaissance would, they hoped, revive the old art of Europe that had become riddled with the corruptions of modernism. And Australia would provide the models. That was why Norman lavished such superlatives upon the modest talent of Elioth Gruner, the lyrics of McCrae and the music of Adolph Beutler. In retrospect the whole idea may sound laughable and it has given hostile critics a field day. But it is the laughter of colonial hollow men with no fire in their bellies. There was nothing historically absurd in the proposal that the values of the fringe, the edge, the province, might overturn the values of the centre. Cultural history is full of such phenomena.

Christianity, romanticism, even several aspects of modernism itself, might be offered as examples. At any rate from July 1928 until July 1929 Jack Lindsay collaborated with P. R. Stephensen in the publication of the *London Aphrodite*. It sought to carry Australian writing into the English scene. It published work by Jack, Phillip, and Norman Lindsay, Brian Penton, Hugh McCrae, and Ken Slessor, and the work of the Australian expatriates W. J. Turner, Bertram Higgins, and Rupert Atkinson. British contributions came from Rhys Davies, Phillip Owens, T. F. Powys and Liam O'Flaherty.

From his precarious Nietzschean perch in the *London Aphrodite*, Jack Lindsay launched a full-blooded critique of modernism:

I examined Wyndham Lewis, Bergson, Freud, Einstein, Blake, 19th Century poetry, Goya and Delacroix and the development of art from Cézanne (seen mainly as disintegrative), Mozart, Beethoven, Wagner, and the development of music from Scriabin to Schönberg. I praised the Sitwells, W. J. Turner, Roy Campbell, Yeats and Bottomley, then turned on D. H. Lawrence and Shaw.

Lindsay was twenty-eight at the time. Australian Renaissance Man, you might say, was beginning to flex his muscles.

No doubt much of the *London Aphrodite* criticism was immature and cocksure, but it was a vigorous attempt to weld together creative and dissident elements, Irish, Welsh, South African as well as Australian, that were opposed to modernism.

Lindsay has written his own critique of the magazine's impact:

in our Dadaism and our Integrations alike, in our Neo platonist individualism and our revolutionary glance at the proletariat, we were too violent, too intense, too out-of-step, behind the times and ahead of them, for any direct effects of our propaganda to be identifiable. We remained at root an Australian explosion in the English scene, which politely ignored the noise, held its nose, and went on with its own business.[5]

Lindsay has noted that American critics have taken more note of the role of the *London Aphrodite*, particularly as a vehicle of Nietzschean thought; and he makes the claim that P. R. Stephensen was responsible for the beginnings of Marxist literary criticism in England during 1928–29.

Jack Lindsay's writings have in part been neglected because he was an early and whole-hearted critic of modernism. Now that we have entered a period in which the whole modernist enterprise has become available to a historical and retrospective criticism it is time that the contributions to the *London Aphrodite* were re-scrutinized from less partisan positions.

The onset of the Depression resulted in the bankruptcy of the Fanfrolico Press, yet they succeeded in paying almost 20 shillings in the pound. Lindsay's first marriage in Sydney had broken down and in London he had formed an attachment to Elsa de Locre. His long relationship with Elsa, as told in *Fanfrolico and After* is basic to any understanding of Lindsay's emotional, intellectual and political development. During the 1930s Elsa's mental condition steadily deteriorated; it was, as Lindsay tells it, a classic case of manic depression. They moved from house to house, every two or three months at Elsa's insistence—there were rats, or rising damp, or some other terror. They lived mostly in the west country, existing on Lindsay's meagre royalties.

Living in Bloomsbury during the later 1920s Lindsay's literary production was devoted largely to translations from the Greek and Latin classics, verse, drama, and poetry. Under pressure, however, to earn a living from writing he began to turn his knowledge of the classical world to a series of historical novels: *Cressida's First Lover* (London, 1931) was followed by a trilogy, *Rome for Sale* (London, 1934), *Caesar is Dead* (London, 1934) and *Last Days with Cleopatra* (London, 1935). These novels did not seek merely to evoke a nostalgia for the past. 'It is history', as Michael Wilding has put it, 'that seeks analogies, points of insight, that sees that things are never exactly the same...the perspective is a dialectical one, one that sees simultaneously both identities and differences.' One pleasant side of this turn to history was a series of books Lindsay wrote for children and published by the Oxford University Press. One is called *Runaway* (London, 1936), and is set in the time of Spartacus, another was *Rebels of the Goldfields* (London, 1936) about Eureka, published by Lawrence and Wishart.

From 1934 onwards his publishing rate became prodigious, resulting in three to four books a year and a steady stream of articles; a rate he has maintained for some fifty years.

In 1936 Lindsay published *Adam of a New World* (London), a life of Giordano Bruno, the Renaissance philosopher burnt at the stake by the Roman inquisition in 1600. Lindsay found striking similarities between Bruno's thought and the development of his own thinking, with its stress on unity and emergence. The title of the book was taken from Bruno: 'A day when man will walk like a new Adam in the world of new creation.' The book's dedication throws light on the way Lindsay used the historical novel:

A definite link between Bruno and the victims of Fascism is provided by the fact that Gentile, the philosopher of Fascism and the Minister of

Education in Italy has directly attacked Bruno and defended the Act of Inquisition in burning him.

Under the emotional pressure of life with Elsa, the rise of Hitler, and the invasion of Spain by Franco, Lindsay's views were undergoing a fundamental transformation. 1936 was a special year for him. He published seven books that year and read all the books by Marx, Engels and Lenin he could get his hands on. Yet it would be a mistake to interpret his interest in these writers as a conversion. He had developed a dialectical habit of thought before he came to Marx. It derives from his practice as a poet; in the polarity of metaphor that creates a new unity and new reality. He found this same dialectic in Plato and Nietzsche, the Nietzsche who had written, 'man is great in that he is a bridge and not a goal: man can be loved in that he is a transition and a perishing. . . I love them that greatly scorn because they also greatly adore; they are the arrows of longing for the distant shore'. He found the dialectic also in Bergson's *Time and Free Will*, in the distinction between mechanical time and concrete time, time expressed as duration and as human experience. Because of this background, Lindsay's Marxism has retained a strong vitalistic quality that resists all attempts to tie it to abstractions and static concepts. It is obstinately humanist and it remains the thinking of a poet.

In 1937 Methuen published his *Anatomy of Spirit* (London). It was sub-titled 'An Enquiry into the Origins of Religious Emotion', and was an early attempt to search for a resolution of the ideas of Marx and Freud. Here the breadth of Lindsay's reading in psychology, cultural anthropology, mythology and religion, is already manifest. Certain ideas central to Lindsay's later thought make an appearance. The notion, for example, that it is the passage rite rather than the Oedipal complex by means of which the child achieves the full status of adult social being.

He [Freud] ignored the 'revolution' of puberty. At puberty, male or female, the individual steps forward into an existence qualitatively different from childhood. He or she is still organically the same individual, but the patterns of action and reaction in his or her being now take place on a new level, are directed to new ends. Sex is the signature and psychic centralization of this new birth.[6]

Here also we first encounter the idea that he was to develop so much more fully in *Blast-Power and Ballistics* (London, 1974) that flatus, blast-power, is at the centre of societies based upon force and oppression.

This is the type of thought and imagery that results where the belief in the 'creative word' is developed with any logical consistency. It expresses frankly the parassociations that the more abstract idealisms take such pains to obscure. It shows clearly the same delusions as those we traced in the ancient Egyptian theology: the belief that the digestive and generative functions are identical, and that the breath-blast is the motive and directive power of all activity.[7]

Such ideas Lindsay has subsequently tracked through religion, mythology and the beginnings of alchemical and astrological thought.

The year 1937 was also the year that he threw himself with great energy into the anti-fascist struggle. He had long been interested in popular verse. One of his earliest publications, *Loving Mad Tom: Bedlamite verses of the XVI and XVII centuries* (London, 1927) was a pathfinder. It anticipated, Christopher Hill has written, 'by a couple of decades an interest in madness as a possible form of social protest'. Now in 1937 Lindsay set himself the task of writing popular verse that could be declaimed at the great anti-fascist rallies then being organized throughout Britain. He argued the case for declamatory poetry in the *Left Review* of October 1937: 'The initial and primary form of our new poetry, for there we get the most direct contact with the new audience, for the peculiar nature of the social struggle of our day.'[8] His own declamation *On Guard for Spain* (London, 1937) was performed in Trafalgar Square and up and down Britain before hundreds of thousands at rallies and street processions. The declamations were a form of dramatised verse, with solo speakers, movement and costume. Their success led to the formation of the Left Book Club Poets' Group and the publication of *Poetry and the People*. It sought to 'restore the traditional link between poetry and the people... letting them hear poetry that has some connection with reality and their daily lives'.

Predictably, criticism of Lindsay's declamations came from the more cloistered members of the English Left. Spender argued that it was not good poetry because it did not handle individual experience adequately. It was like arguing that sea shanties were not good songs.

The poetry of Auden, Spender and C. Day Lewis has come to be regarded as *the* political poetry of the 1930s. Its retrospective fame may be due not a little to the fact that they all later disengaged themselves from political activism under the pressure, among other things, of the politics of the Cold War. Lindsay did

not. This may be the reason why his contribution to poetry since the 1930s has been largely ignored, particularly in Australia. It is not that it is unavailable. In 1981 the Chicago publisher, Chiron Press, produced a 600 page edition of Lindsay's *Collected Poems.* Now in 1983 I have still to read a considered review of the book.

In 1938, to support his own position, Lindsay published an anthology of popular verse entitled *Five Thousand Years of Poetry.* It was used for declamations at the Unity Theatre, Left Book Club weekends and elsewhere. With his friend Edgell Rickwood, he edited *A Handbook of Freedom.* Here is one entry from among five hundred. It is from the Diary of William Scawen Blunt, for 19 February 1905:

George Meredith has been appealing for funds to help the revolution in Russia and I have subscribed £10 and yesterday came the news that the Grand Duke Serge had been blown up with a bomb, so I am subscribing again.[9]

The Dictionary of National Biography describes Blunt as a traveller, politician, poet, a member of the diplomatic service from 1858 to 1869, a brilliant talker and an agreeable host. He kept a stud farm.

During the mid-thirties Lindsay returned to an old interest, cultural anthropology. In his adolescence he had read his father's copy of *Aboriginal Tribes of Central Australia* by Spencer and Gillen, and his classical studies had brought him in contact with Jane Harrison's books: *Themis, Prolegomena, Ancient Art and Ritual.* Talks in Brisbane with Gordon Childe had greatly stimulated his interest in prehistory and anthropology. Years later, during a brief break in his relationship with Elsa, he lived alone in a small timbered cottage in Buckinghamshire, the walls of which were richly lined with books on the history of religion and anthropology. The previous resident had been a melancholic recluse who had written under a pen name for the rationalist press. He had committed suicide and his relatives had still to decide what to do with his library. During the cold winter of 1933–34 Lindsay read through the library in a highly organized and consistent fashion. One of the important results which proceeded from these readings was his *Short History of Culture* (London, 1939). In the preface he noted four themes which he wished to develop:

1. The way in which the structural lines of consciousness, the underlying patterns of art and science, emerge from the fusion of organic and social patterns.

2. the relation of this process to the originating concepts of technique.
3. the mythological and anthropological material throwing light on the origin of technique.
4. the complex cultural sequences centring around totemism, sacrament and blood sacrifice...

What I have been seeking is the unifying factor, the correlation of all kinds of diverse human activities. And while the work in sections of the human territory has been fine indeed, the effort of correlation can hardly be declared to be even in its infancy...Here is a book which at least dares to ask what the issues are. Perhaps at the present stage that is a proud enough claim to make. I merely trust that I am not deluded in making it.[10]

When he was drafted in 1940 Lindsay asked to be put in the infantry but ended up in Signals. The war, however, did not inhibit his productivity. He published fourteen books between 1940 and 1945; and though he continued to write historical novels he turned increasingly to the problem of realism and the contemporary novel. He wrote one novel on the Dunkirk evacuation, another on the Cretan campaign, a third on women in war industry. These led to his important series known as the British Way novels, that took as their subject the life of Britain during the early post-war years. It was in these novels that Lindsay made a serious imaginative effort to work through the problems of social realism as they applied to the novel. It is of interest therefore to note that although the novels of other Australian expatriates such as Richardson, Stead and Boyd are dealt with at length in Adrian Mitchell's section on fiction in the *Oxford History of Australian Literature*, Lindsay's work is not mentioned.

The later 1940s brought an increasing involvement with anthropology and history. In the mid-thirties he had read through the *Origin of Species* carefully. What left a permanent impression was the careful way Darwin marshalled his material and advanced his arguments. Although Lindsay is well aware that all fact collecting is value laden, Darwin's method left a deep impression upon him. All his major works are carefully structured and formidably documented.

Let me refer to a few of his important works in history. In 1952 his *Byzantium in Europe: The Story of Byzantium as the First Europe (362–1204) and its Further Contribution till 1453*, was published. Christopher Hill has described the book as:

a masterly survey of over a thousand years of history. [Lindsay] traces the deep historical roots of the West's denigration of Byzantium—the need to justify the treacherous attack of the crusaders in 1204, the lasting

effects of the religious schism, the Renaissance condemnation of 'the dark ages'. In a masterly historiographical survey Lindsay shows that Gibbon's ambivalence towards Byzantium mirrors his ambivalence towards the British Empire which must also decline and fall; and that Toynbee's dismissal of Byzantium is not unrelated to his cold war desire to separate the civilisation of Eastern Europe from the 'Christian West'. So Lindsay's book ends with a passionate plea for seeing history, and in particular European history as a unity.[11]

Byzantium into Europe heralded a series of important books on the medieval world. These included *Arthur and his Times* (London, 1958), *The Normans and their World* (London, 1974), *The Troubadors and their World* (London, 1974).

From the later 1930s onwards Lindsay had also been giving considerable thought to and undertaking a great deal of research into the emergence of modern science. What struck him forcibly was 'the deadly gap between science and feeling, reason and imagination, which was the clearest mark of the alienating process'. From this sprang his major books of the early 1970s: *The Origins of Alchemy* (London, 1970); *The Origins of Astrology* (London, 1971); and *Blast-Power and Ballistics (Concepts of Force and Energy in the Ancient World)* (London, 1974). They are all books of approximately 500 pages, heavily documented, and draw deeply upon his masterly knowledge of classical culture.

Ten years before he had turned his interest to the history of art. Life itself had given him a wealth of experience for he had always lived among artists. The form he adopted was biography, a *genre* in which he was experienced, having already published books on Bunyan (London, 1937), Dickens (London, 1950) and Meredith (London, 1956). Later he was to produce biographies of a somewhat different kind: *Cleopatra* (London, 1971) and *Helen of Troy* (London, 1974). He adopted the biographical approach for his studies of artists because he argued that modern specialism was making it difficult to approach the work of artists in a unified fashion. So-called biographers of artists tended to write the lives and omit the art, and art historians and critics, bound to theories of various kinds, wrote studies of the art and neglected the lives: the personal, psychological and social underpinnings of the art. All of Lindsay's biographies of artists treat both the lives and the art in detail. The first to appear was *Death of the Hero* (London, 1960), largely a study of J. L. David. Then followed his book *J. M. W. Turner* (London, 1966), that won high praise from Kenneth Clark; on Cézanne (London, 1969), Courbet (Bath, 1973), Morris

(London, 1975), Hogarth (London, 1977), Blake (London, 1978) and Gainsborough (London, 1981).

I realize that this has been an inadequate and largely quantitative survey of Jack Lindsay's output. But do not make the mistake of thinking of him as little more than a popularizer, though he writes clearly and for an informed general public. I have only attempted to present the problem Lindsay presents to us. For there is so much that remains to be done. We need an account of the development of his thought in relation to twentieth-century thought as a whole, particularly twentieth-century Marxist thought. We need to have a better understanding of the reception of his thought not only by the political right but also the political left in Britain. The reception of his work in the USSR needs to be examined; and the reception of his work in Australia, and of the work of Clem Christesen, Stephen Murray-Smith and Michael Wilding, in maintaining a continuing Australian contact.

I should have liked to have been able to say more about Lindsay's Marxism, a curious, questing Marxism that is not dogmatic. He sees Marx as one of the supreme thinkers whose work has to be assessed in relation to the whole history of thought from Heraklitus to Darwin, Freud and beyond—an open-ended Marxism. This has got him into difficulties on more than one occasion. Those of you particularly interested in his Marxism might well read his *Crisis in Marxism* (Bradford on Avon, 1981). In it he devotes chapters to Lukacs, Ernst Bloch, Adorno and the Frankfurt Marxists, Marxism and Structuralism, and develops his own position in which he is critical of the pessimism of the Frankfurt school and of the formalism and determinism present in so much structuralist Marxism. His sympathies lie with the humanist and existentialist affinities with Marxism.

Michael Wilding has put the problem I mentioned earlier in this way.

One of the great thinkers, writers, men of letters of this century Jack Lindsay has received comparatively little serious discussion. He is so prolific, so formidably learned, that there are very few writers in a position to discuss the full range of his work. I certainly cannot hope to.[12]

So perhaps we should leave the last word to one of Lindsay's old friends, Sir Bernard Miles, the actor and founder of the Mermaid Theatre, who wrote a poem inspired by Lindsay's biography of Cleopatra.

Cleopatra: Her Latest Lover

She lies dreaming among cushions under a tasseled awning
In the stern of her golden barge
Rowed by eunuchs who dip their oars silently into the leaden river
Between her thighs she feels a delicious vibration, urgent, rhythmic,
 overpowering.
She thinks it is Mark Antony returned from Rome
From his passive milk-white wife and a haggle with his political rivals
To be caught once more in her toils.

But it is something more wonderful, more mysterious,
It is a foreshadowing of the miracle in which time past turns back on itself
To become time present.

In the shape of a 1936 portable Remington typewriter
Operated by an elderly Australian poet.
Her latest lover
Searching her darkest secrets.[13]

11
Jack Lindsay's Marxism
—1985—

Jack Lindsay is best known to Australians, if he is known at all, as a kind of youthful support figure for the cultural and aesthetic values of his father Norman, that is to say for the part he played in the establishment of the literary quarterly *Vision* in Sydney in the early 1920s and the Fanfrolico Press, in Bloomsbury, in the later 1920s as a bridgehead for the Lindsay aesthetic in London, that strange mixture of the *fin de siècle* and the vitalism of Nietzsche. But for most Australians, from the 1930s on Jack Lindsay's contribution to twentieth-century literature and thought remains a closed book. Yet he has a strong claim to being considered one of the most creative contributors to the theory and practice of Marxism of the present century, a writer whose work should be considered in the company of Lukács, Gramsci, Bloch, Goldmann, Benjamin, Althusser, Korsch, Sartre, Adorno and others who have made major contributions to Marxist theory and cultural practice.

His literary output is formidable and wide-ranging. He is now eighty-five and living in Cambridge. Since he published his first book sixty-two years ago he has published over 150 books of which he is the sole author, has edited another twenty, and has acted, at various times as editor of six magazines. His work has ranged over the writing of poetry, translations from the Greek and Latin classics, fiction, ancient, medieval and modern history, biographies of writers such as Bunyan, Dickens and Meredith, and biographies of artists such as Hogarth, Turner, Courbet and Cézanne, literary criticism, social anthropology and the history of science, including the history of astrology and alchemy, and translations from modern Russian, Czech and Polish writers. His work has been translated into French, Italian, German, Russian, Ukrainian, Czech, Slovak, Danish, Hungarian, Norwegian, Polish, Chinese and Japanese—yet, as I noted, his work remains virtually unknown in Australia.

About three years ago I began to feel that something should be done about it. So I got together a number of his friends and admirers to produce a book that would begin the enormous task of assessing Lindsay's contribution to twentieth-century thought and literature. What we have done was recently published by Hale and Iremonger under the title *Culture and History: Essays presented to Jack Lindsay*. It can only be said to be a beginning, but it does contain essays on Lindsay's poetry, fiction, histories, biographies, and his work in social anthropology and the history of science, and a full bibliography of his work. Although Lindsay has lived in England for many years he still considers himself to be an Australian and maintains an active interest in Australian writing through his contributions to periodicals such as *Meanjin* and *Overland*. If you are interested in Lindsay's work but admit to knowing little about it I strongly commend *Culture and History* to you; and I suggest that you should be interested because no other Australian—with the possible exception of Gordon Childe —has made anything like the contribution to the theory and cultural practice of Marxism that Jack Lindsay has during the past fifty years.

How can I best describe Lindsay's Marxism in the space at my disposal? Perhaps I could begin by comparing it with the work of the Hungarian Marxist, George Lukács. There are obvious contrasts of course. Lukács was fifteen years older than Lindsay, was more directly involved, particularly in his early life, in political activity, and more directly exposed than Lindsay was to the pervasive influence, the intellectual intimidation and the terror of Stalin and Stalinism. But these are matters of degree. A member of the British Communist Party since about 1940, Lindsay's creative writing has always been deeply concerned with and related to the great political issues of his time; and no communists who lived through the 1930s and 1940s could wholly escape the influence of Joseph Stalin. And not only communists. There is a sense in which it could be said that both Churchill and Roosevelt were Stalinists when it suited their purpose, when there was just no time to compare the evils of Hitler with the evils of Joseph Stalin—only time to give him reluctant but essential support. But the fact that those times coloured us all, Lukács and Lindsay included, with the same brush is not the point I want to make.

The point is that they both worked, Lukács in Eastern Europe, Lindsay in Britain, to free Marxism from determinism, that scientistic determinism into which it had lapsed as a result of the

writings of the later Engels and the Marxists of the Second International, such as Kautsky and Bernstein. Both Lukács and Lindsay, that is to say, may be described as Hegelian Marxists. They insist that Marxism cannot be reduced to cause and effect relationships, that it is grounded in dialectics, in the unity of opposites, the interdependence of contradictions.

As young men both Lindsay and Lukács came under the influence of those strong intellectual currents that had begun to flow against positivism and social Darwinism at the turn of the century. For Lukács that meant an involvement with the existentialism of Kierkegaard and the syndicalism of Sorel; for Lindsay it first centred, and has continued to centre, upon his practice as a poet, upon the authority of metaphor for his thinking. It led him to Blake, the poet who had written, 'without contraries there is no progression', and to Hegel, as he sought to come to terms with the philosophy of Nietzsche, whose work his father Norman admired so greatly. These formative influences meant that both Lukács and Lindsay were deeply attuned to dialectical thought, both deeply suspicious of empiricism, before they began to study Marx.

I do not want to suggest that Lindsay began as a disciple of Lukács. There were basic differences from the beginning. The only work of Lukács that Lindsay had read, prior to meeting him in Warsaw in 1948 and again in Paris in 1949, where they held long conversations together, was an essay by Lukács on the novels of Sir Walter Scott, published in the late 1930s in *International Literature*. There was rather an affinity of mind.

Both Lukács and Lindsay deeply questioned the central primacy of the economic motive for a materialist interpretation of history. In a book that revitalized Marxian theory, *History and Class Consciousness*, first published in 1923, Lukács wrote:

It is not the primacy of economic motives in historical explanation that constitutes the decisive difference between Marxism and bourgeois thought, but the point of view of totality. The category of totality, the all-pervasive supremacy of the whole over the parts is the essence of the method which Marx took over from Hegel and brilliantly transformed into the foundations of a wholly new science.[1]

Many years later, in 1939, but long before he was seriously acquainted with Lukács' work and at a time when economism still dominated Marxian theory and political practice, Lindsay came to a similar conclusion. For him it came as the product of applying his Marxism to the study of the work of Jane Harrison on Greek

mythology and the work of Spencer and Gillen on Australian Aboriginal society. His position was lucidly stated in the second chapter entitled 'Toolmaker' of his *Short History of Culture*, published in 1939.

Let me mention three statements from it. Firstly, *the facts of language show that the plural and other forms of number in grammar arise not by the multiplication of an original I but by selection and gradual exclusion from an original collective We. This We represents the aggregate personality of the food group. The procedure is from synthesis to analysis, from the group to the individual* (Ernest Crawley, *The Idea of the Soul*). Secondly, *the sense of the whole comes first, the analysis of the parts afterwards.* Thirdly, *the sense of unity, which is the creative leaven, continually bursts through the amassing of facts, of details of perception, moulding and transforming all the while, seeking for the statement which will embrace all the facts or details in a comprehensive definition.*[2]

There is however a basic difference between the Lukácsian and Lindsayean view of Marxian totality. Lukács, following one of his principal mentors, the German cultural historian Dilthey, makes a sharp distinction between the natural and social sciences. For Lukács the Marxian dialectic applies only to the human world, not to natural science. The human studies, Dilthey wrote,

differ from the sciences because the latter deal with facts which present themselves to consciousness as external and separate phenomena, while the former deal with the living connections of reality experienced in the mind... We explain nature but we understand mental life.[3]

In short, for Dilthey and for Lukács, the belief in the neutral observer, induction, unilinear cause and effect relationships were appropriate to natural science. But for Lukács a different method, the Marxian dialectic, was appropriate to history and the human sciences.

For Lindsay, on the other hand, there can only be one kind of science, a social science that embraces both humankind and nature, because he sees humanity as one of nature's phenomena. In this regard Lindsay adopts both a more evolutionary and more Hegelian line than Lukács. Lindsay first stated his position in one of the first books ever written that sought to relate the works of Marx to the works of Freud, his *Anatomy of Spirit*, published in 1937:

By dialectics we mean the science of wholes, the method of apprehending process in its fullness... It follows that dialectics, while accepting the different sciences as valid in their areas of analysis, accepts no closed

compartments of knowledge. It sees how all the sciences merge in reality, in human concretion.[4]

Lindsay's position is similar to that of the young Marx of the *Economic and Philosophic Manuscripts* of 1844, when he wrote: 'Natural science will in time incorporate itself into the science of man, just as the science of man will incorporate itself into natural science; there will be *one* science.'[5]

The dangers arising from a narrowly economist interpretation of Marx are noticed by Lindsay in his earliest Marxist writings. He stresses, as Marx does in *Capital* and elsewhere, that economic necessity is determined by biological need: that biological man determines social man. As he puts it in *Anatomy of Spirit*: 'We see in all this a dialectical relation of biological and social: that is, the ideas derived from biological facts interact with productive relations to produce the full social organisation and its cultural super-structure.'[6]

This position has led Lindsay to champion the case for a dialectics of nature, and has led him to write such books as *Marxism and Contemporary Science* (London, 1949), *The Origins of Alchemy* (London, 1970), *The Origins of Astrology* (London, 1971), *Blast-Power and Ballistics* (London, 1974).

The growth of the conservation and anti-nuclear movements has brought Lindsay's insistence upon a dialectic of nature into prominence again. Wolf Schäfer, writing in a recent issue of *Praxis International*, in an article entitled 'Towards a Social Science of Nature' (Schäfer was for some years a member of the Max Planck Institute at Starnberg) has this to say:

The ideal of a pure, or undisturbed, cognitive process has been relativized by the discovery of the unavoidable limitations on the objectivity of the act of measurement (indeterminacy in quantum theory). The ideal of the full replicability of experimentally secured knowledge has been contradicted by the reaction of natural objects to the technological application of such knowledge (such as the selection of DDT-resistant strains of insects). Finally nature itself, the supposedly atemporal object of knowledge, has been increasingly historicized through such disciplines as geology, cosmology, thermo-dynamics, and Darwinism.

Schäfer concludes,

in the eighteenth century work began on the conscious development of the human history of society...we now bear the responsibility for setting rational goals for [the] human history of nature.[7]

The need for such a human history of nature is pursued at length in Lindsay's *Blast-Power and Ballistics*. In his view Western

science took a fatal turn in the seventeenth century, when it abandoned a human concept of energy, based on handicraft manufacture, for a mechanical concept of energy, based on the steam engine. One must not assume from this that Lindsay is a modern Luddite. He has asserted without qualification that 'only a universal use of automation can release human beings from the division of labour'. For him it is not technology itself but the distribution of technological power within society that is the concern. Nor does Lindsay deny the enormous quantitative achievements of modern science. He is concerned rather to pinpoint where and under what conditions scientists began to ally themselves with the production of weapons of destruction capable of annihilating all life on the planet.

I cannot even attempt to outline the complex argument of *Blast-Power and Ballistics*. But two dominant themes are pursued: one is concerned with the rational pursuit of knowledge, the other with the psychological origins of humanly-destructive fantasies of power. In developing his first theme Lindsay contrasts the classical conception of energy, best defined by Aristotle, with the modern conception of energy developed by Carnot and Joule in the early nineteenth century. In order to understand Aristotle's concept of energy (*energeia*) we must grasp, Lindsay explains, his fourfold explanation of causation. Take the case of a chair. First, says Aristotle, there is its material cause, its wood if it is a wooden chair; then its formal cause, its shape, without which it could not be a chair; then its efficient cause, its carpenter; and then its final cause, the idea of the chair which the carpenter has in mind as he works. What is significant about this fourfold classical system of causation is that human agency is built into it. The subject mediates in the construction of the object. The model is the handicraft model in which the artisan is still in control of his production.

The modern conception of energy is narrowed to one cause only, energy becomes the power of a body to do work by virtue of its motion. The model is the steam engine or the factory hand performing a mechanical process. Lindsay notes, as a poet alert to metaphor, that the second law of thermodynamics, which asserts that the whole universe will one day run out of energy, was based upon the model of the steam engine running out of steam. One is reminded of Marx's comment on Darwin's theory of natural selection, 'English society reflected in the world of nature'.

The second theme in *Blast-Power and Ballistics* derives from

Lindsay's long interest in psychoanalysis. It first appears in the *Anatomy of Spirit* in 1937, under a discussion on substitution fantasies. A man's spirit, his soul, his life after death is identified in the primitive's mind with the air he breathes. But this air is not only taken in through the mouth, it can be blown out the rear as a fart. So the breath fantasy takes on two forms. Breath taken in, inspiration, is power from the gods, from which all our greatest ideas in art and science flow. But breath blown out, the fart, is man-power. When it thunders all nature is farting. Lindsay traces the way witchdoctors and shamanists have used the fart as a power fantasy from the earliest times and how it has continued to minister to the development of objective science in the service of modern power fantasies. In consequence Lindsay concludes modern science has become

essentially dehumanized and alienated in its outlook...leading into ever more devastating weapons, into nuclear fission, and into universal pollution and destruction of the environment. Now, in a reaction against this line and its consequences, and as part of the work of building a world-society in which the harmony of man with man is only another aspect of his harmony with nature, we need to return to the unitary aspects of ancient thought. Without discarding what valuable lessons can be learned from the epoch of quantitative science.[8]

This talk of the harmony of man with nature will serve to indicate that Lindsay takes the utopian element in Marx's thought seriously. Lindsay therefore finds himself in close sympathy with the Marxism of Ernst Bloch. In his book, *The Crisis in Marxism* (Bradford on Avon, 1981) Lindsay discusses Bloch's work together with the work of Gramsci, Lukács, Althusser and the Frankfurt School. Through Bloch, Lindsay points out, Marxists can get a better appreciation of the purposive, teleological character of human life; that all human production, whether for good or ill, is a concretion of what once existed only in an 'ideal' mental world. Through Bloch, too, it was possible to take a more positive view of religion than was common to conventional Marxism. Without denying the power of Feuerbach's analysis of the role of religion in the alienation of human potentiality it was possible to see that Marx viewed the role of religion, as he viewed all problems, dialectically. That to quote the phrase 'the opium of the people' out of its context missed entirely the whole thrust of what Marx said in the introduction to his *Critique of Hegel's Philosophy of Right* (1844). To gain a balanced view of Marx's approach to religion it is useful therefore to recall what Marx wrote, in a letter to Ruge, in 1843:

our campaign slogan must be: reform of consciousness, not through dogma, but through the analysis of that mystical consciousness which has not yet become clear to itself. It will then turn out that the world has long dreamt of that which it had only to have a clear idea of to possess in reality. It will turn out that it is not a question of any conceptual rupture between past and present, but rather the *completion* of the thoughts of the past.[9]

By means of his principle of hope, Ernst Bloch sought to rehabilitate some aspects of religion, seeing it not merely as superstition but as incorporating an indestructible core of human potential that should be incorporated with Marxist tradition.

Lindsay however parts company with Bloch because of 'his inability to link his explorations of culture—his analysis of what it is in human beings that urges them towards new and more truly human goals—with the social and political world and its structures, its conflicts and contradictions...'[10]

The central problem for Lindsay became the Marxian analysis of culture. Like most Marxists he began with a general acceptance of the base–superstructure account of culture which Marx outlined in the preface to his *Critique of Political Economy* in 1859. In one of his first Marxist books, *The Anatomy of Spirit* (London, 1937), Lindsay wrote: 'No matter how complex society and its superstructure of ideas and emotional satisfactions may become, the economic foundations are the human bedrock. If our thought is to remain concrete, we must never lose sight of that truth.'[11] But even in that book he realized that culture could not be understood in Marxist terms wholly as a component of the superstructure. If a dialectical approach demanded that any complex situation, whether in society or nature, be viewed as a unity of interacting and contradictory components, then it was clear that cultural elements were deeply embedded in the so-called economic foundations in any given social situation. The key to the problem lay in the analysis of productive activity.

In 1945 Lindsay prepared a discussion paper on culture for the cultural committee of the Communist Party of Great Britain. At that time every communist party in the world, under the influence of Zhdanov's interpretation of culture as an aspect of Stalin's version of dialectical materialism, held quite rigidly to the view that culture was a component of the superstructure. Lindsay, basing his arguments on wide reading in social anthropology and psychoanalysis, argued differently.

In his 1945 paper he rejected the view that culture reflected the economic base, and after discussing a number of texts of Marx, Engels and Plekahnov, agreed that the base–superstructure

metaphor had some relevance if we were thinking in terms of social institutions; but that it was inadequate for any full analysis either of the origins of culture or the nature of productive activity. Let me quote from his discussion paper.

Culture emerges in the group when the productive activity, with its cooperative basis, develops a certain quantity of superabundant social energy. Then the new unity, the new quality, which we know as culture, appears. In short, production and culture are in a dialectical relation of conflict and unity, and if that is so, then one is being continually transformed into the other...the organization of personal and social energy on the new level increases enormously human powers: the individual achieves enormously enhanced powers of energization, powers that could never possibly have been achieved if all his outlets of energy can be conceived as having remained on the economic level pure and simple. These new energies return back into everyday life, giving increased consciousness for the daily task. He thus becomes a more efficient, a better organized productive agent; and from the higher level, the level of culture, spring ideas and impulses which are translated into techniques and new methods.[12]

Here then was a Marxist interpretation of culture which found cultural elements deeply embedded in the economic base: in the forces, the means and the relations of production. Years later other Marxists such as Althusser and Raymond Williams (in their own formulations) have argued a similar case. But in 1945 Lindsay was not taken seriously. He records, with irony, that no one in the discussion agreed with him, except a young man aged twenty-one who had just come back from a hiking trip in Yugoslavia and was named E. P. Thompson.

Lindsay argued his case from an anthropological point of view. But it can also be argued conceptually. In the *Grundrisse* and *Capital* Marx presents a conceptual and dialectical analysis of *material* production. Lindsay's subject was *cultural* production. But it can be argued that from the standpoint of Marxian dialectics there can be only one kind of production, social production that unites the material and the cultural. In social production, Marx demonstrates, we create commodities that possess two kinds of value, use value and exchange value. The use value of a commodity cannot come into existence until it is made; exchange value does not come into existence without a market. It can be argued however that Marx has overlooked a value, aesthetic value, that cannot be reduced to either use value or exchange value, and plays an essential part in productive activity itself. Aesthetic value here being defined as those concrete values that human

productions acquire in the process of being separated out from nature in productive activity. One way of grasping the problem is to realize that any human product is the result of a dialectical interaction of several mediations. Here Aristotle's fourfold system of causation can again be of some explanatory assistance. The material cause then is the raw materials out of which the object is constructed. The other three causes, the efficient cause, the energy of the labourer, the formal cause, the structuring of the product in a particular fashion, and the final cause, the mental image which directs the labour process, are all culturally determined. Formal values here constitute what I have described as aesthetic values; values for the producer, whether as a group or as individual, that are consumed in the formative acts of production. In Lindsay's formulation it is a form-creating social energy.

There are indications that Marx realized that he confronted a problem with aesthetic values in his analysis of production. In *Theories of Surplus Value*, he speaks of

Certain services, or the use values, resulting from certain forms of activity or labour are embodied in commodities; others on the contrary leave no tangible result existing apart from the persons themselves who perform them; in other words, their result is not a vendible commodity. For example the services a singer renders to me satisfies my aesthetic need; but what I enjoy exists only in an activity inseparable from the singer himself, and as soon as his labour, the singing is at an end, my enjoyment too is at an end. I enjoy the activity itself—its reverberation on my ear.[13]

Marx, however, proceeds to subsume aesthetic value under use value. But he has a problem here because on his own definition use value only operates after the production is complete. Yet on his own account of the matter, in this case the value, his enjoyment is at an end, so soon as the product, the song, is complete. Marx would be in still greater difficulty if his singer should say: 'I am singing to enjoy myself; indeed I can't sing unless I am enjoying my song; when it sounds awful I stop.'

My point is that aesthetic value cannot be subsumed to use values, and is conceptually prior to use value, in any dialectical account of production as a process, because production cannot proceed unless it is accompanied by the production of aesthetic values. On other occasions Marx appears to be subsuming aesthetic values to exchange values under the term commodity fetishism, by means of which 'the social character of men's labour appears to them as an objective character stamped upon

the product of that labour.'[14] But we must ask how is it that the social character of a human production becomes visible in the object produced. That surely is only possible by virtue of its sensible form and structure, by the ways in which it may be distinguished from a natural object. And the processes by which human work is fashioned is by means of the shaping and forming processes which human energy assumes in production. These aesthetic values come into operation in the process of production and are thus conceptually prior to both use values and exchange values. Marx certainly recognized the *traces* of aesthetic values in consumption and exchange but not their origin in production. But it is only in production that aesthetic values assume their primary form and function; later they appear disguised, more or less, as use values and exchange values.

No doubt the reason why Marx neglected the positive, aesthetic side of labour in the *Grundrisse* and *Capital* was because he was primarily concerned with describing alienated labour under capitalist society. But there is enough in his total work to make us realize that he appreciated the positive, aesthetic nature of human labour, as when he writes in the *Economic and Philosophical Manuscripts of 1844*: 'Man forms objects in accordance with the laws of beauty.'[15]

For Lindsay then art and science are to be seen as special kinds of production:

There is a release of energy...that occurs in a situation which expresses the stage reached by humanity in transforming nature through the productive mode. In art that situation involves on the one hand the level of tradition, of craft skills, of forms of reproduction; on the other hand the whole complex socio-economic development which makes possible the achieved stage. By analysing...the situation of any particular artist we can assess the limiting and releasing elements there present. We can show what he starts with in his art, what he adds, how he makes his breakthrough or rupture into a new level of integration (simultaneously aesthetic and social). His freedom is not an abstract matter. It is born from the dialectical union-and-conflict of his individuality and the entangled situation out of which that individuality grows, and reveals itself triumphantly in his Form.[16]

Lindsay has made use of such critical methods in the many biographies he has written: on Bunyan, Dickens, Meredith, Turner, Cézanne, Morris, Hogarth, Blake, Gainsborough, David, King Arthur, Cleopatra, and Helen of Troy. He is critical of those Marxist critics who, governed by the base—superstructure metaphor, labour at reducing the content of a work of art to its so-called

economic underpinnings. It has been said, even of Lukács, that he could not move beyond the limits of the bourgeois novel because he persisted in perceiving, in his Hegelian way, the economic base as essence, and the cultural superstructure as appearance. For similar reasons Lindsay is critical of Lucien Goldmann's mode of isomorphic criticism which works on similar assumptions. Both critics, Lindsay would admit, have made invaluable contributions to the Marxist critical tradition. But he would certainly take the view that Marxist critics should pay more attention to the socio-psychological origins of form and perhaps a little less attention to the social content of a work of art.

From what I have already said it must be clear that there are certain significantly influential areas of Marxist cultural theory with which Lindsay is out of sympathy. He is highly critical of the Frankfurt school for its pessimism and writes: 'Adorno and Horkheimer succumb to élitist values: they feel only contempt for the masses. All popular art is aimed at reconciling and enslaving audiences to the capitalist situation. There is no hope whatever in the working-class as an independent force, culturally or politically.'[17]

He is even more severe on Althusser and the structural Marxists. I cannot present his criticism in detail here but enough to say that he finds Althusser's Marxism academic in the worst sense of the term. His attack upon humanism as an ideology, like his conception of ideology itself are grotesque distortions of Marx's position. No one ever defined the humanist position better than Marx himself when he wrote: 'Mankind...sets itself only such tasks as it is able to solve.'[18] Of course humanism and Marxism can be and have been twisted into ideological forms. The problem with Althusser's Marxism is that it reinforces the idea of science as an ideology. Althusser has to ditch so much of Marx's own writings in order to present his own account of it, that (in this case at least) Kolakowski hit the nail on the head when he wrote: 'We begin to wonder if Marxism existed at all in Marx's day, or whether it was left to Althusser to invent it.'[19]

'What', writes Lindsay, 'can we learn from the work of Althusser and its powerful effects in the 1960s and 1970s. First, its success brings out how disastrously undeveloped Marxism has been on all the crucial issues we are treating in this book' (i.e. *The Crisis in Marxism*).

On the other hand, of course, Lindsay greatly admires the work of Gramsci—here is the Marxist with whom Lindsay finds himself most deeply in sympathy. Gramsci's concept of a cultural

hegemony produced continually by a class in dominance stressed the significance for communists of the cultural struggle. For any effective opposition to the cultural hegemony of capitalism the left, Gramsci said, had need of a special kind of intellectual whom he described as an organic intellectual. I do not know whether Jack Lindsay would be happy to be described as an 'organic' intellectual, but there is no doubt that for fifty years now, in his ceaseless outpouring of books and articles, a prodigality greater perhaps than that of any contemporary intellectual writing in any language, that is the task that Jack Lindsay (without fuss or fanfare) has set himself.

I conclude with a brief quotation from Lindsay taken from a short piece titled 'A note on my dialectic' which I asked him to write for *Culture and History*:

while continuing to attempt to 'apply' my Marxism in novels, poetry, history or anthropological works, in biographies of writers or artists and so on, I did my best to recast my direct formulations more effectively. In the 1960s I wrote two works on Alienation, Bureaucracy in Socialism, and allied topics, but could not get them published. Finally I put my ideas together in a book, *The Crisis in Marxism* (1981) that attempted to analyse the main expression of Marxist thought after 1917—Stalin, Althusser, Della Volpe, Colletti—and to present my version of an open Marxism, diametrically opposed to all closed systems: to the dogma of 'the complete, harmonious, consistent system of all the views and teachings of Marx' (Lenin), and to the various confused or one sided attempts to break through the dogmatic positions. In such a version the contradiction between a dialectic system expounding human history and a mechanistic system ruling in science is at last broken down. That at least is how I see it.[20]

You will find it difficult to get most of Jack Lindsay's books in the bookshops. They are mostly out of print. That, too, is part of the system. But the system we know has its contradictions. You will find them in our public libraries. There they do not collect Jack Lindsay's works because he is one of the most original thinkers of the present century, they collect them as a curious end-piece to our passion for Norman Lindsayana.

12
Jack Lindsay's Biographies of Artists
—1984—

Jack Lindsay has written eight biographies of artists. His *Death of the Hero* (1960), the first to appear, deals largely with the life of J. L. David but also includes brief accounts of the lives of Géricault and Delacroix. Then followed his books on Turner (1966), Cézanne (1969), Courbet (1973), Morris (1975), Hogarth (1977), Blake (1978) and Gainsborough (1981). He is at present preparing a book on Goya. This represents but a small part of his literary activity between 1960 and 1981 and is but one aspect of his contribution to biography. He has also written biographies of Bunyan (1937), Dickens (1950), Meredith (1956), Cleopatra (1971) and Helen of Troy (1974).

A full study of Lindsay's biographical methods would have to take into account insights he has gained from a lifetime's study of literature and history, psychology, anthropology and sociology, and from his practice of other literary genre, such as poetry, fiction, translation, history and criticism. Such a formidable undertaking is not contemplated here. I shall attempt only to outline and comment upon some of Lindsay's biographical methods and indicate how they have contributed to a better understanding of the lives and art of eight of the most original artists of the eighteenth and nineteenth centuries.

Why biographies of artists? There are quite personal reasons why, among his multifarious interests, Jack Lindsay should take a special interest in the lives of artists. He belongs to a family of artists. Uncle Percy and Uncle Daryl were painters, Uncle Lionel an able draughtsman and graphic artist, and a lucid art critic. His brother Ray became a highly competent painter and illustrator. His father Norman was probably the first person in Australia to act out fully the role and responsibilities of the artist alienated from modern bourgeois society. There were painters in Australia before Norman Lindsay but not, in the full sense of the word,

artists. And it is with this sense of the word that Jack Lindsay's biographies are particularly concerned. Furthermore, as he has noted upon more than one occasion, his own aesthetic, literary, intellectual and political values developed in dialectical relationship to those of his father. And what began as a prominent aspect of his childhood and youth continued in later life. *The Roaring Twenties* (London, 1960), Lindsay's autobiographical account of Bohemian life in Sydney in the early 1920s, opens with an account of his experiences while sharing a studio flat with a German expatriate painter, Gustave Pillig, and then with his brother Ray. That was in 1921. Since then he has numbered many artists among his personal friends, such as the Australians Elioth Gruner and Noel Counihan, and after his arrival in England in 1926 he became a close friend of Lionel Ellis, then later Leslie Hurry, and the Polish artist working in Wales, Josef Hermann.

The personal, informal knowledge so gained as to the ways artists behave, how they work, think and feel can only have been of incalculable value to Lindsay when writing his biographies, endowing them with a kind of understanding that has been reinforced by the experiences of the poet. For it must always be remembered that at the source of Lindsay's varied intellectual interests lies the unifying vision of the poet. *Ut Pictura Poesis*: Horace's famous tag is nowhere better illustrated in this poet's lives of artists he respects and admires. An awareness of the continuing problems that confront a practising poet, an appreciation of the technical difficulties faced in transforming the raw material of poetry into aesthetic form, have sharpened Lindsay's perception of similar problems faced by practising artists. Not surprisingly it is the artist-poets, Blake and Morris, who stand closest to the generative centre of his own aesthetic experience, and painters who have written poetry, such as Turner and Cézanne, have also exercised a deep appeal. Having first read Blake at the age of seventeen and written a little book about him in 1927, Lindsay could say with some pride when he published his biography of Blake fifty years later: 'I do not write as someone interested in Blake from the outside, but as someone for whom he has been a vitally formative influence throughout life.' To proceed, as far as humanly possible, from the inside, this has been a guiding principle for Lindsay in writing all his biographies. So that, as he recounts some crucial incident in the life of Turner, Morris, Cézanne, Blake, one is haunted by the feeling that Lindsay has experienced a similar situation; that in describing the artist's experience he is also describing his own.

It is no doubt because understanding born of personal experi-
ence guides his biographical practice that Lindsay refuses to
impose schematic structures upon his material. His lives are not
written to demonstrate a philosophy, as Sartre wrote his life of
Baudelaire to demonstrate the propositions of his existentialism
enunciated in *Being and Nothingness*. Lindsay's biographies,
though profoundly related to his Marxism, are not works of that
kind. He uses a Marxist aesthetic, to which he has given a
lifetime of original and fearless thought, rather in the form of a
handy implement in a tool-kit, as a set of guidelines that can be
called into play in order to solve the kinds of problem it has been
developed to solve. There are other tools in his kit, apart from
those derived and developed from Marx, from Plato and Blake,
Freud and Jane Harrison, and from alert, critical reading in the
broad fields of Classical and European culture. His Marxism is an
integral part of that culture.

It is not that Lindsay rejects the value of systematic methods.
Much sustained formal and iconographic analysis will be found
in his biographies, but it is never presented in isolation from
information of a quite different kind, personal, cultural, political,
and so forth. For Lindsay a work of art is a theatre of conflict and
action upon which the most unlikely characters may unexpectedly
appear. The reasons for their appearance must be grasped if the
work is to be fully appreciated and understood.

In writing a biography Lindsay sets out to master the available
known material in published and manuscript form and then,
when inexplicable problems remain, turns anew to the sources
for possible solutions, as he did most notably in his biography of
Turner, unquestionably the best yet written.

Few if any writers living today have succeeded in mastering
the specific texts and contexts upon which our knowledge of so
many front rank artists of the eighteenth and nineteenth centuries
depends. This doubtless proceeds from Lindsay's tireless curiosity
concerning the essential sociality of all modes of cultural produc-
tion and the impact of industrial capitalism and its supportive
bourgeois ideologies upon that production. These deeper interests
give his biographies their unity and consistency of interpretation.
But because he is a master at marshalling diversified material into a
rapidly moving narrative his biographies can be read profitably by
those who need a first acquaintance with an artist's life, largely for
informational value, without undue concern for the diversity of
intellectual tools that have been employed in the construction.
However, if we are to make the most of Lindsay's biographies it is

essential to possess at least an outline knowledge of his Marxist aesthetic.

Lindsay's Marxism is characterized by its humanism, vitalism and resistance to dogma. 'I am not', wrote Marx in 1844, 'in favour of raising any dogmatic banner. On the contrary we must help the dogmatists to clarify their propositions for themselves.'[1] Supporting Marx's statement has often landed Lindsay in continued difficulties with the dogmatic Left and the geriatric Right. Central to his aesthetic is his recognition of the unity of the life process, a view wholly compatible with his Marxism, but first grasped in his pre-Marxist days from his readings in Blake, Nietzsche, and the influence of his father Norman. The unity of life reveals itself always in conditions of dialectical change in which contradictions emerging from the original unity are either resolved for a time in a higher level of life or develop unresolved antagonistic contradictions that produce decay and death. At the social level change is effected by human productive activity that occurs in a complex totality revealed in many forms: economic, social, cultural, political, and so forth. Lindsay has long been critical of the so-called Marxist model of an economic base and an ideological superstructure. Marx's use of this architectural metaphor in the preface to the *Critique of Political Economy* was employed in a specific and limited context in which he was concerned to define the relationship between the economy of a society and its relationship to the state and to law. Its widespread use to explain Marx in a nutshell derives largely from Stalin's writings. Lindsay has long maintained that it cannot, and should not, be used to support the view that cultural production in general is an ideological reflection of the existing mode of production by which a society reproduces its primary economic needs. On the contrary, the human capacity to invent lies at the source of the forces of production whether material or cultural. In any social situation therefore art should be viewed as one particular mode of productive activity acting within a totality of others. 'Productive activity extends its scope to take in all cultural activities, all forms of expression.'[2]

Lindsay also rejects all types of Marxist theory which reduce the explanation of a work of art to the nature of its social content. In his view, a true Marxist aesthetic must face the problem of form; the ways in which aesthetic form is realized in productive activity and the way form is to be valued.

Aesthetic form, for Lindsay, is what is realized and resolved by the artist as he confronts the conflicts and contradictions of his situation in productive activity. The conflicts and contradictions

arise at personal, social, technical, cultural and political levels, and in complex interrelations. If the artist's aesthetic resolution of his material is successful a new concrete unity is achieved in his work which transcends his situation and is pregnant with possibilities—and further conflicts and contradictions—for the future. In this way the artist achieves his freedom. For Lindsay the freedom of the artist is not so much a conscious decision as it is for Sartre, though both consciousness and decision are involved in the process, but rather a condition which is achieved as the result of a release of constructive energy. This probably provides a superior account of the way artists' feel in such situations: few report a sense of self-conscious freedom during the actual processes of original artistic production; rather the reverse. They are inclined to feel bound by an energy which links them to their work. It is here that the vitalist strand in Lindsay's thought, present from the beginning, merges almost imperceptibly with his Marxism. If such an aesthetic is then brought to the understanding of the work of an individual artist:

We can show what he starts with in his art, what he adds, how he makes his breakthrough or rupture into a new level of integration (simultaneously aesthetic and social). The freedom won by his expression can be estimated by the degree and range of his definition, by the way in which the ceaseless union-and-conflict between his Form and the diverse factors making up his Situation works out. His freedom is not an abstract matter (the capacity to do anything he likes). It is born from the dialectical union-and-conflict of his individuality and the entangled situation out of which that individuality grows, and reveals itself triumphantly in his Form.[3]

For Lindsay then, aesthetic form is a dynamic resolution of contradictions at once personal and social. This is the general condition of all cultural production. But just as in the history of society revolutionary situations occur as a result of which the centre of power shifts from one class to another, so in the lives of artists situations of a revolutionary kind occur in which contradictions arise that threaten to destroy the unity of the artist's life. The successful resolution of such situations produces radical changes in the artist's productions and in his relation to society. It was in seeking to grasp the psycho-social significance of such situations that Lindsay's interest in the rites-of-passage rituals performed in tribal societies has come to influence his biographical practice. This is not to say that artists in modern societies experience such rites in any literal sense but that they

experience moments in their lives of a parallel kind as a result of which a breakthrough to a new kind of art or expression is achieved, moments which are triggered into activity by clusters of complex components in conflict: temperament, disposition, sexuality, class, religion, and so forth. Aware of the importance of such moments in heralding major changes, Lindsay is alert for signs of their appearance.

One is described in the second chapter of *Death of the Hero* (1960). After many years of resistance to the new taste for the antique, the young David, following a visit to Naples in 1779 and the enthusiasm of a friend, Quatremére de Quincy, reported a sense of illumination. 'I have been operated on for cataract' he exclaimed on his return to Rome. As Lindsay makes clear, many factors were responsible for David's conversion to neo-classicism after a long resistance. It was no superficial shift in his taste, but the beginnings of a fundamental change of loyalties in the process of which the neo-classical taste of the dying Bourbon court and the genre of history painting were transformed into potent visual instruments for the cause of the Revolution. David's life and art develop with logical but tragic consistency while rent within by intense and ceaseless conflict. His mythical heroes of Republican Rome, the Horatii and Brutus, are men torn by the conflict between public and private virtue. They foreshadow the actual political martyrs of the Revolution: Barra, Le Pelletier, Marat. David, as Lindsay perceptively notes, does not portray the enemy; it is within. A conflict lies between public duty and tribal or family ties. A similar conflict divides David's art. On the one side the stoic austerity of his history painting, on the other, the sensuous realism of his portraiture. Here are indications of a growing gulf at a personal level which will later determine the course of French nineteenth-century painting. It destroys Gros, leads Géricault towards a more painterly, expressive realism, tempts Delacroix towards dynamic, ambitious and colourful compositions in an endeavour to close the gulf. In such ways the unrealized contradictions in the work of one original artist may open up possible paths into the future which others may follow.

Lindsay claims it is only in biography that the dramatic contradictions, which lie at the root of such situations as David's conversion to neo-classicism, can be adequately considered and explored. Specialized studies of artists, *catalogues raisonnés*, formal and iconographical analyses, though quite indispensable to the biographer as to others, if taken by themselves all too often reductively distort the artist's problems, intentions, achievements:

'a biography enables one to bring together the personal aesthetic and social aspects in the development of an artist or writer as no directly critical study can do'.[4]

The biography of Turner (1966) triumphantly vindicated this claim. It made it possible, for the first time, to understand Turner in his complexity both as man and artist. By proceeding systematically through Turner's sketchbooks and working sensitively through his verse, fields which previous scholars had largely neglected, Lindsay produced the first fully-rounded biography of Turner at all adequate to his importance. It remains the best introduction to the man and his art. For the first time it discusses and interprets his childhood and youth in detail, unravels the mystery of Turner's relations with Sarah Danby, who bore him two children, discusses his sexuality and fears of marriage, and relates all these matters to the changing character of Turner's art.

Close attention to the experiences of childhood and youth are a feature of all Lindsay's biographies. The death of Turner's sister when he was almost eleven, his mother's ungovernable temper and growing insanity, his own unimpressive appearance and acute sense of social inadequacy are among the many personal factors which Lindsay considers in seeking an explanation for Turner's driving devotion to his art, where he found shelter from potentially threatening elements in his environment and a sense of creative release. Indeed the situation in which an artist is forced back on himself and his own resources by a hostile environment, which is then confronted by energetic and liberating productive activity, is a recurrent pattern which Lindsay finds in his biographies. A productive energy resolves problematic situations of personal, technical, social, cultural and political kinds into aesthetic form, into ever-widening concrete objectifications. Such a pattern is particularly prominent in the lives of Courbet and Morris.

All artists, as noted earlier, produce works at crucial stages of their lives that are prophetic of the future development of the artist and possibly of art itself. One such work for David was his portrait of Count Potocki; for Turner, perhaps above all others, it is *Hannibal and his Army crossing the Alps*. The painting achieves a triumphant aesthetic resolution of a personal crisis clearly revealed in his poetry of the two preceding years. The painting resolves and transforms problems latent in Turner's ambition to absorb and transcend the best art of the past, his sexuality, the work obsession that drove him to continued technical experimentation, and his hopes and fears for Britain's and for mankind's future.

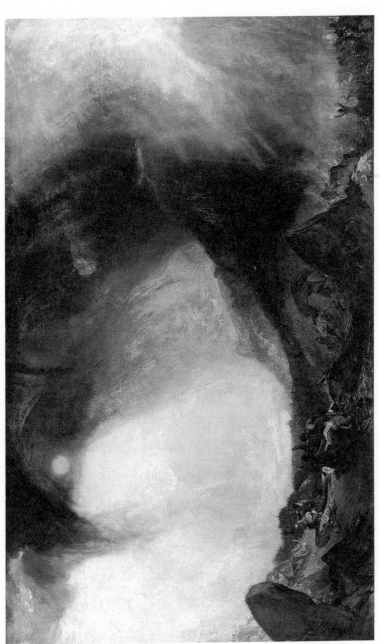

J. M. W. Turner *Snow Storm: Hannibal and his Army crossing the Alps*. Oil on canvas, 146 × 237.5 cm, 1812.

In Hannibal the artist for the first time works out with full logic his system of internal vortex stresses, and essentially throws aside all previous systems of holding the forms of the picture together... It has its own system, its own controls, but they function within a new concept of nature, a concept that totally rejects the old mechanistic system of connexions and relationships, and which sees instead a highly complicated field-of-force in action.[5]

In his analysis of Turner's *Hannibal*, Lindsay combines explanations drawn from the artist's personal life, the history of style, technique and image, the impact of contemporary criticism, and the social and political situation of the time. He thus redeems his pledge that a Marxist criticism should set out to explain not only the social content of a work of art but the generation of its form. *Hannibal* not only reveals new directions in Turner's art but, with its new dynamic approach to composition, opens up a line of approach that leads on to Cézanne, Picasso and the Cubists.

Viewed from one angle, all of Lindsay's biographies possess the character of rescue operations. He is well aware that poetry and painting, whatever else they may be, are crafts, modes of production issuing from the minds and hands of the artist while maintaining control, more or less, of the productive process. He is at pains to trace the craft links in the work of many artists. But industrial capitalism progressively destroys the craft basis of all the arts. The artist thus finds himself alienated from his craft roots in society. As Lindsay makes clear in his eight biographies, the result of this alienation of the artist during the eighteenth and nineteenth centuries was to transform the most original of them into revolutionaries. Some, like Courbet and Morris became politically active, others like Blake made a profound contribution to the revolutionary tradition of European art. Others still like Hogarth and Cézanne effected revolutionary change in art itself. All came to cherish a smouldering disgust for bourgeois values. But since their deaths the dialectics of social change have transformed the works of these dissidents into precious bourgeois commodities. They now function to enframe capital gain and hedge inflation. In such situations there arises a demand for tame-cat accounts of the lives of artists by which they may be, like their own productions, rendered respectable, moulded to flatter conservative prejudice and even justify reactionary movements in art which in life they would have opposed strongly. Thus the *embourgeoisement* of art and artist is completed. Lindsay's reaction is not to adopt a partial, combative, controversial tone in

his biographies but to allow the great span of text and context which he brings to the consideration of each life to speak largely for itself. His whole enterprise nonetheless provides an important alternative to those specialized studies which ignore or reduce the psychological, social and political complexities of aesthetic production.

Sometimes the artist must be rescued from moralists—Turner from the prudery of Ruskin and Finberg; sometimes from political reaction—Cézanne from the embrace of the symbolists Maurice Denis and Émile Bernard in search of founding fathers. It was Lindsay who first drew attention to Cézanne's sympathetic approval of the writings of the revolutionary Jules Vallés. Even in Courbet's case, despite the important work performed by Meyer Schapiro, T. J. Clark and Linda Nochlin, Lindsay's was the first full biography that did not gloss over or explain away his active involvement in radical politics. Lindsay's recent biography *Thomas Gainsborough* (1981) is one of the most appealing he has written, a tender tribute to the *genius loci* of a countryside in which he has lived for over thirty years. Yet here too Lindsay is able to modify the conventional view of Gainsborough as a passive servant of his noble clients by alerting us to the emotional distance which the artist maintained between himself and the great ones who sat for him. 'Damn Gentlemen there is not such a set of Enemies to a real artist in the world as they are, if not kept at a proper distance', the artist wrote to a friend.[6]

Such corrections of received opinion, recovery of reputations falsified through ignorance or deceit is not achieved by writing alternative accounts, themselves partial in their presentation. Lindsay strives for the whole view, sets out to assemble a detailed and complex picture of how the artist actually lived, the daily problems faced in life as in art. The testimony of rate books, directories, wills, correspondence is searched in order to assemble a concrete picture of the actualities of life. An excellent example of the way he constructs the image of a neighbourhood and relates it to the artist's emergent personality is to be found in his account of the home and locality in which the newly-married couple, William and Catherine Blake, lived:

The young couple seem to have gone to live at 23 Green Street, Leicester Fields, lodging with a T. Taylor; this is the address Blake gave in the R. A. Catalogue for 1784. In the same street lived the engraver Woollett, while round the corner was Reynolds. Leicester Fields was still a quiet open space where cocks could be heard crowing. In 1782, west of the family house in Broad Street, a School of Industry was opened where

older workhouse children were given a strict training, with religious discipline. The boys were apprenticed or sent to sea, the girls put out to service. Blake must have been strengthened in his hatred of authority.[7]

This sense of a concrete, specific neighbourhood, closely researched, marshalled with skill, is an important aspect of Lindsay's practice. For it presents the artist in his social being, and provides the changing environments that wait upon his aesthetic and cultural development. But it is important in another way. Such neighbourhoods, such scenes of early childhood, provide the artist with an inner vision of unity by which he protects his own identity against the alienating pressures of his society. So Lindsay with poetic skill creates an enchanting picture of the countryside around Walthamstow and Epping Forest, where William Morris roamed in childhood with his beloved sister Emma, and then proceeds throughout the biography to track the artist's complex set of responses to that *paradis perdu* which provided him with so much of the energy from which he wrote his poems, developed his design and craft skills, and the untiring political activity of his later years.

Considered as an interconnected series, Jack Lindsay's eight biographies provide a comprehensive view of the bourgeois world of the eighteenth and nineteenth centuries in their complex and contradictory cultural development. This view is not achieved by the imposition of a unilinear sequence of successive art styles upon the material reality but by depicting the whole scene in its dynamic interaction with the lives and art of eight of the most original and revolutionary artists of the two centuries. The life of each artist thus helps to illuminate 'one aspect or phase of the bourgeois world...with its liberation of sensibilities and its simultaneous limitation of possibilities'.

If taken chronologically, it is his book *William Hogarth* (1977) that opens the discussion. Hogarth is the first revolutionary artist of the modern world; he makes a decisive break with Renaissance tradition; both in style and image his works proclaim the new dynamic energies latent in the first stages of industrialism; he is the totally urban artist of the modern city; Bartholomew Close and Smithfield market, with their intense and bizarre human activity, provide him with his turbulent world. There depicted effectively for the first time appears the alienated individual in the city desert: the rake, the harlot, the idle apprentice. Here too, we first meet in fullness the self-made man in his selfishness.

Hogarth is the 'middle class critic of the aristocracy and its falsifying obsolete ideals' but 'he is also the plebian critic of the middle class and its subservience, its money ethic, its greeds, its oppressions. So in his depths he becomes simply the human critic of the whole situation'.[8]

Hogarth's defiant, independent views pressed hard upon the artistic conventions and institutions of his time and helped to change them. His moral histories, beginning with the *Harlot's Progress*, transform the role of engraving and he becomes known throughout Europe. He brings the cosmic theatre of the baroque down to earth and develops, in part out of his great love of theatre, a dramatic concept of life as a series of conflicts and crises; yet he profoundly accepts life, and thus achieves a new dramatic kind of realism. But he is rejected by the aristocratic establishment which controls the art of England. He is forced to explore new ways of exhibiting and marketing art, of teaching art. He thinks out art theory for himself anew. Central to his *Analysis of Beauty* is the idea that form cannot be separated from movement. In its radical break with the past, its determination to think out an aesthetic from first principles, it profoundly affects thought throughout Europe.

Yet Hogarth did not change the aristocratic supremacy of history painting, of the sublime and the ideal. In *Sigismunda* he 'accepted the values of his enemies and was so defeated before he started; he was hoping for the wrong kind of acceptance'.[9] Against his triumphs we must place his misdirections and frustrations. Although in an occasional painting such as *Shrimp Girl* and *Country Dance* he succeeded in giving full expression to his mastery of character and movement 'he could not imagine any basis on which to sustain an extended art expression embodying all the dynamic qualities of which he was capable as a painter'.[10] Nevertheless, as the most experimental artist of his age in Europe he opened out new paths which others were to follow.

In all his biographies Lindsay pays close attention to the changing interrelationships between the genres of painting: history, portraiture, the conversation piece, landscape, as they respond to social change. In this regard his book on Gainsborough is particularly revealing. It explores the deep personal conflict in Gainsborough engendered by his desire to escape from the drudgery of 'face-painting' to painting the landscapes he so deeply enjoyed. It not being possible to live by landscape alone, Gainsborough increasingly seeks to introduce the great freedoms

of handling possible in landscape painting and its freshness of vision into the staid conventions of portraiture. Viewed in this way the story of Gainsborough's career is an exciting one, an advance towards a new sensibility with the romantic feeling for lost nature at its core. In a sense, in whatever he painted he was seeking to return to his early Suffolk days, to the lost world of his childhood. 'He was thus a consistent rebel, but he never formulated his revolt in any direct political or social terms, apart from expressing his contempt for the Gentry.'[11]

Lindsay's assessment of Gainsborough's achievement reveals the subtlety of his Marxist aesthetic. It is the quality of the painting that is guiding the analysis. The work of Gainsborough, essentially an unpolitical man, is not here dismissed as merely a reflection of the property relations of his time. Lindsay's Marxism is not mechanistic.

The art of Hogarth and Gainsborough was principally influenced by *social* change. In *Death of the Hero* and *William Blake* Lindsay discusses the work of two artists deeply influenced by *political* change. Here we confront an important difference in the cultural situation of the early and the later eighteenth century. I have already discussed Lindsay's work on David. It remains only to add here that he sees David's central achievement as the transformation of history painting, as an ideological instrument in the control of the nobility into an instrument at the service of the revolutionary bourgeoisie. This, we have noted above, was precisely the transformation that, in his own time, Hogarth was unable to effect.

William Blake, though less *actively* involved in politics than David, is for Lindsay the more profoundly revolutionary artist. Here it is that we find the first expression of change expressed as a dialectic union of opposites that is later developed by his younger contemporary Hegel and, still later, given materialist form by Marx.

Without Contraries is no progression. Attraction and Repulsion, Reason and Energy, Love and Hate, are necessary to Human existence. From these contraries spring what the religious call Good and Evil.[12]

In Blake's thought, Lindsay argues, we find the poetic prefiguration of the thoughts of the Marx of the 1844 manuscripts, the conviction that human beings are capable of transcending the contradictions of their divided societies and their divided selves. 'As no poet before or since he was a total revolutionary.'[13] In his interpretation of Blake particularly, we encounter the strong

humanist element present in Lindsay's Marxism. Although the interpretation of Blake has become one of the multi-national industries of Anglo-Saxon scholarship this is probably the best introduction to his life and art. It contains a particularly important discussion of Blake's relation to the apocalyptic tradition of Christianity, to the Ranter and the Antinomian sects surviving from the seventeenth century.

Because of Lindsay's mastery of the context of social and political change against which all his biographies are written they interact and complement themselves in many fascinating ways. Thus the Turner book complements the Blake book for the later eighteenth century, as the Gainsborough book complements the Hogarth book for the earlier part. Hogarth and Blake are directly inspired by social and political change. With Gainsborough and Turner the changes occur much less directly but are just as fraught with significance for the future of art production. The new sense of the unity of light and colour which emerges in Turner is an indirect expression of new discoveries in the world of experimental science; the vortexes and fields of force which bring a new conception of pictorial composition, an indirect expression of the new forces changing industrial production.

If we turn now to the later nineteenth century we find that one theme underlies and unites Lindsay's biographies of Courbet, Morris and Cézanne: the widening division between the country and the city, between craft and industrial production, between the alienations of urban life and the older unities of rural society, all of which capitalism exacerbated as it spread throughout England and France.

Courbet's realism is born of a peasant discontent in this world of sharpening divisions and is carried forward as he responds turbulently but courageously to the speed of social and political change. Lindsay seeks to present all the complexity of his situation in defining the nature of his realism.

His objectivity reflects on the one hand the fragmentation and 'thingification' of man and the universe, everything reduced to a means (a prey, an exploitable victim) by the cash nexus, and on the other hand the total rejection of this process in terms of universal sympathy and communion. He represents thus the completed, the logically final state of bourgeois man, but also the first state of truly socialist man. The conflict appears throughout his life, driving him along his road of promiscuous sex, drink, and goodfellowship—enjoyment divorced from responsibility—and yet implicating him politically and aesthetically in a devotion to the struggle for the new life of socialist union, where an undeviating responsibility lies at the core. This conflict ended by tearing him to pieces

despite his strong frame, but while he was able to sustain it, he found its resolution in his art, where his spontaneous delight in life was fused with his deep social consciousness. Thus he lived constantly at the heart of the central struggles, political, moral, aesthetic, of his age; and because he found a concrete resolution of those struggles, he defined something that went beyond the historical limitations, into the realm of the human universal. All great art, one way or another, penetrates into that realm; what is significant in Courbet is the new way in which he arrives there, the new unity of social and aesthetic positions.[14]

Here again we encounter the humanism which informs Lindsay's Marxist aesthetic, preserving it from historicism and relativism.

There are many similarities between Morris and Courbet. Both were deeply drawn to the family unit and the countryside of their childhood, both experienced the city—country division sharply and both developed an increasingly active involvement in politics towards the end of their lives. The Morris book is one of the most important of all of Lindsay's lives. Apart from Blake, he is the artist who stands closest, one feels, to Lindsay's own position. Lindsay convincingly argues that Morris arrived at Marx's own conclusions, not merely by reading him as he did, but by the experience of his own life and art. In Morris's case it is not a conversion but a convergence of thought and practice with which we are concerned:

Marx and Engels were aware of the disastrous effects on nature that a society of commodity-production was liable to inflict; but for Morris, with his concrete sense of the immediate situation and of the forms that must resolve its conflicts, the awareness of this destructive tendency was central. It was strongly alive in his Ruskinian period, as he saw men losing all joy in work and at the same time wrecking what visible signs remained of the ages when that joy had been vitally present. As he watched the destruction and desecration of the art-heritage he also realised that nature was being spoiled, trampled, polluted by the competitive society all round him. His anger drove him on to understand just what the society was that did not merely permit such evils, but had at its heart the need to perpetuate them. When he moved on to join in the fight against war, he realised that in war was the same destructive and competitive spirit as that he had deplored in trade and industry at home. Having gone so far, he found it only a simple step to move on to socialism. Thus at the core of his socialism was the struggle against pollution and the destruction of the environment. He was pioneering a century ago in the comprehension of problems which have risen in the general consciousness, and even then imperfectly, only in the 1970s.[15]

Morris then was sustained and propelled forward politically by the vision of a rural paradise remembered from childhood but lost in adult life. Lindsay's book on Cézanne deals with a parallel

problem. It is remarkable for the way in which, in great detail, it recreates the youthful friendship in rural Aix, of Paul and Émile Zola and traces it through the alienating pressures of city life in Paris and of advanced writing and art to its ultimate breakdown. Through all this Cézanne is to be seen forever seeking to regain his own vision of unity by developing systems of pictorial order which would redeem nature from the flux of sensation imposed by impressionism. It is precisely at this point that Lindsay believes the intentions of Cézanne and the significance of his art for the future have been misreported and misinterpreted:

When we re-read Paul's repeated insistences to Bernard on the need to base any artistic vision on nature, we feel that in thus addressing the first important distorter of his method and message, he was addressing the posterity of artists who were to carry on from him in ways that he would have disliked. The contrast of his work with Cubism is particularly to be stressed; for here are the root-levels from which the key-developments of modern art proceed. In his work he was grappling with the time-process because time is at the core of all growth, not as a passive thing measured like a line in space, but as the ceaseless assertion of the symmetry–asymmetry conflict... Like Turner, he was grappling in all his mature work with space-time as process; and his particular system of perspective, of defining a sensuous space-continuum in all its complex arabesque and curvilinear subtleties, was derived from that struggle. In Cubism this problem was abstracted and the solution found in the mechanical combination of several views of an object all more or less super-imposed. The Futurist notion of a simultaneity of various stages of an object in motion showed a similar sort of approach. But Cubism proved incapable of development except in the direction of ever increased abstraction. For the true and dynamic expression of time-space the artist must return to Cézanne and pick up the struggle from his work, even if he cannot but be aware, while so doing, of the way in which Cubism froze the problem, re-invoking mechanism to get rid of the vital issues. That is, he would have to include Cubism in some way, while dismissing and transcending it.[16]

That challenging conclusion was published in 1969 at a time when contemporary art critics and historians were first beginning to talk about the 'end of the avant-garde'. Published at any time earlier than the 1970s Lindsay's views might have been dismissed as reactionary. But criticism also possesses its dialectic. Today when avant-garde 'movements' are often no more than promotion gimmicks, it is time to reconsider the revolutionary roots of modern art in the eighteenth and nineteenth centuries. Lindsay's eight biographies, with their view of the artist as whole man, provide a magnificently comprehensive base from which such a reconsideration may begin.

13
Marx and Aesthetic Value
—1986—

Running through Marx's writings there is abundant evidence that at times he considered art to be an aspect of production and at other times to be a kind of ideology. Evidence for both points of view can be found in his early and later writings but he never resolved them into a unified position. Since then a great deal has been written by Marxists that does not, it seems to me, resolve the tensions that arise for the understanding of art from a Marxian viewpoint, because of these contrasting and apparently conflicting viewpoints. In the introduction to the *Grundrisse* (1857) Marx was at some pains to analyse in detail the concepts of production, distribution, exchange and consumption that he was to apply later, with developments and modifications, in his analysis of the capitalist mode of production in *Capital*.[1] This suggests that one way into the unresolved problem as to the nature of art in his thinking, is to develop a concept of *aesthetic* value that is related to and compatible with the concepts of *use* value and *exchange* value as defined in the opening chapter of *Capital*.

But let us consider briefly the two contrasted positions: positions that are at times described as the productivist aesthetic and the ideological aesthetic.

A Productivist Aesthetic

In the document now known as the *Economic and Philosophic Manuscripts of 1844* Marx developed a critique of capitalist production as it had been formulated by the founders of political economy in Britain, Adam Smith and David Ricardo. The two main analytical tools which he used to construct his critique were derived from Feuerbach's humanism and Hegel's dialectic. Feuerbach had taken over Hegel's concept of alienation and used it to develop a devastating critique of religion. The victims of

religious belief, he argued, transferred that which was essentially human in their own nature to the gods whom they worshipped and in so doing became less than human; separated from their true nature they became incapable of realizing the potential latent in being human.

In the *Manuscripts* Marx transfers Feuerbach's notion of religious alienation to the economic sphere and demonstrates how human beings are alienated from the true nature of work (that activity through which their humanity is realized) by the prevailing conditions of capitalist production. The greater part of the *Manuscripts* is concerned with the alienated nature of work under capitalism. There is a section, however, where he has occasion to consider production in a more general sense. It involves making a distinction between human and animal production:

The animal is immediately one with its life activity. It does not distinguish itself from it. It is *its life activity*. Man makes his life activity itself the object of his will and of his consciousness. He has conscious life activity. It is not a determination with which he directly merges. Conscious life activity distinguishes man immediately from animal life activity.

Then he adds a little later:

In creating *a world of objects* by his practical activity, in his *work* upon inorganic nature, man proves himself a conscious species-being i.e. as a being that treats the species as its own essential being... Admittedly animals also produce. They build themselves nests, dwellings like the bees, beavers, ants, etc. But an animal only produces what it immediately needs for itself or its young... It produces only under the dominion of immediate physical need, whilst man produces even when he is free from physical need and only truly produces in freedom therefrom. An animal produces only itself, while man reproduces the whole of nature. An animal's product belongs immediately to its physical body, whilst man freely confronts his product. An animal forms objects only in accordance with the standard and the need of the species to which it belongs, whilst man knows how to produce in accordance with the standard of every species, and knows how to apply everywhere the inherent standard to the object. Man therefore also forms objects in accordance with the laws of beauty.[2]

Here Marx gives voice to a productivist aesthetic, and it runs like a silken thread through all his writings. Marx here asserts that a sense of aesthetic order lies at the root of all human production. Indeed his argument does not really discount the possibility of some sense of aesthetic order in animal production also, but the important point he makes is that whereas animal production is related to the animal's direct physical needs, human

production is capable of applying the sense of aesthetic order to the whole of nature.

An Ideological Aesthetic

Far better known and much more influential, however, is the famous statement in the preface to the *Contribution to the Critique of Political Economy* (1859) in which Marx designates art as one of the ideological forms in which men become conscious of class conflict in society:

The mode of production of material life conditions the general process of social, political and intellectual life. It is not the consciousness of men that determines their existence, but their social existence that determines their consciousness. At a certain stage of development, the material productive forces of society come into conflict with the existing relations of production or—this merely expresses the same thing in legal terms— with the property relations within the framework of which they have operated hitherto. From forms of development of the productive forces these relations turn into their fetters. Then begins an era of social revolution. The changes in the economic foundation lead sooner or later to the transformation of the whole immense superstructure. In studying such transformations it is always necessary to distinguish between the material transformation of the economic conditions of production, which can be determined with the precision of natural science, and the legal, political, religious, artistic or philosophic—in short, ideological forms in which men become conscious of this conflict and fight it out.[3]

Primal Production

Can these two positions be resolved within the parameters of Marx's theories of production and ideology? Can it be shown, within the presuppositions of historical materialism, that aesthetic value is invariably present in one kind or another in all material production and is also invariably present in the ideological forms by which men become conscious of class, and other kinds of conflict, in society?

The first point that must be made is this: if we are to obtain a sure grasp of the nature of the role that aesthetic value plays in production we must seek to establish an adequate model of the nature of the labour process, in a primary sense of the concept, *sui generis*, and distinct from the specifically alienating conditions of production in class society. Or to put it more simply, just as it is essential to possess an adequate concept of society before we can understand the nature of class society, so it is

necessary to possess an adequate concept of the role art plays in production in society before we can appreciate the role it plays in class society.

Marx himself was aware of the need for such a model of, as I shall call it, *primal* production. But because his dominant interest was the condition of labour under capitalism he constantly slides from descriptions of primal to descriptions of alienated production under capitalism.

Marx's most detailed description of the primal condition of labour occurs in *Capital*:

Labour is, in the first place, a process in which both man and Nature participate, and in which man of his own accord starts, regulates, and controls the material re-actions between himself and Nature. He opposes himself to Nature as one of her own forces, setting in motion arms and legs, head and hands, the natural forces of his body, in order to appropriate Nature's productions in a form adapted to his own wants. By thus acting on the external world and changing it, he at the same time changes his own nature. He develops his slumbering powers and compels them to act in obedience to his sway. We are not now dealing with those primitive instinctive forms of labour that remind us of the mere animal. An immeasurable interval of time separates the state of things in which a man brings his labour-power to market for sale as a commodity, from that state in which human labour was still in its first instinctive stage. We presuppose labour in a form that stamps it as exclusively human. A spider conducts operations that resemble those of a weaver, and a bee puts to shame many an architect in the construction of her cells. But what distinguishes the worst architect from the best of bees is this, that the architect raises his structure in his imagination before he erects it in reality. At the end of every labour process, we get a result that already existed in the imagination of the labourer at its commencement. He not only effects a change of form in the material on which he works, but he also realises a purpose of his own that gives the law to his *modus operandi*, and to which he must subordinate his will. And this subordination is no momentary act. Besides the exertion of the bodily organs, the process demands that, during the whole operation the workman's will be steadily in consonance with his purpose. This means close attention. The less he is attracted by the nature of the work, and the mode in which it is carried on, and the less, therefore, he enjoys it as something which gives play to his bodily and mental powers, the more close his attention is forced to be.[4]

Impressive as this account of the work process is, it tends to slide from a description of primal labour to a description of labour under the conditions of class society. The components essential to a description of primal production become mingled

towards the end of the account with concepts that imply a division of labour characteristic of developed societies capable of producing a surplus. It is only in developed societies, for example, that an architect can erect his structure in imagination before he erects it in reality. And in such societies it is not the architect but a range of builder's labourers who erect his structure according to his plan. Nor is it true to say, even when the planner and the constructor are the same person, that 'at the end of every labour process, we get a result that already existed in the imagination of the labourer at its commencement'. Not all production ends up the way that was intended. Some are faulty and may be treated as discards. This trivial point directs attention to an important fact about the work process. It is not adequately described as an invention or plan that is then crafted into material form. Both inventiveness and vulnerability may lead to a change in the original plan. A model that places imaginative activity at the initial planning stage, followed by purposeful craft procedures that end in the production of a useful object, already implies the existence of a high level of the division of labour. A model of primal labour requires one in which the labourer's imagination may enter at all stages into the work process and thus creates possible mutations in the original plan. If this is not possible then the work process may become a routine process that does not engage the labourer's faculties as a human being but approximates either to the instinctive character of animal production or the mechanical character of machine production. This is not a trivial objection. It reaches to the heart of Marx's problem over aesthetic value. That the problem was present in Marx's mind while writing the passage above is clear from the stress he places on the labourer's need for *attention* if he is to accord with the original plan, an attention that decreases his sense of enjoyment in his work 'as something which gives play to his bodily and mental powers'; which is another way of saying, surely, that primal labour is a kind of labour that is enjoyed because it does *give play* to bodily and mental powers. But it is obviously a kind of play that has a purpose in mind even though that purpose cannot be adequately described or defined until made manifest in objective material form. Such purposeful play calls into activity a sequence of judgements that arise directly from the sensuous perception of the materials of nature that are being transformed by the production process, judgements that have for their object, in Marx's words, 'a form adapted to his [i.e. the producer's]

wants'. These judgements are best described as aesthetic judgements and the verdicts which they impose upon the producer's materials express his aesthetic values, those formal values by means of which nature's materials are transformed into objects suited to human use.

The Production Cycle

Because his attention was concentrated upon the alienated conditions of labour prevailing under capitalism Marx did not however present aesthetic value as an inseparable component of the production process. Instead, in the first chapter of *Capital* he turned immediately to establishing a distinction between use-value and exchange-value. Use-values, he informs us, are values that are specific to classes of objects.[5] The use-value of a spade lies in its capacity to assist digging; the use of a word in its capacity to convey specific meanings. Exchange-values, on the other hand, are not specific but generalized values that are expressed in quantitative relationships (usually monetary relationships in developed societies) by means of which use-values of one kind are exchanged for use-values of other kinds.[6] Objects subject to exchange become commodities. Marx however notes that any labourer who satisfies his wants by his own labour creates use-values but not commodities. A product of labour may thus possess a use-value but not an exchange-value; it may be useful without being a commodity. But commodities are productions perceived to be useful, for that is why they are exchanged. Therefore, it may be said, use-values, in terms of Marx's schema of production, are conceptually prior to exchange-values; though it must be kept in mind, as he makes abundantly clear in the introduction to the *Grundrisse*, that in actual practice in developed societies the cycle of production, exchange, distribution and consumption is a circular process.[7]

In his production—consumption cycle Marx provides no functional role for the operation of aesthetic value; yet it can be argued without introducing elements foreign to the spirit of Marx's analysis that aesthetic values are conceptually prior to the other functional values of the cycle. For use-value can only come into operation at the end or intended fulfilment of the process of primal production. That which is not yet made cannot be used. But aesthetic values, as we have seen, are called into operation during the production process and production cannot proceed

without them. On Marx's own description of them they are essentially *formal* judgements by means of which nature's productions are transformed for human use. In primitive forms of production, for example, aesthetic values operate in the processes of cutting, shaping, smoothing and polishing. Such are not mechanical or routine craft procedures but ones involving judgement at each stage of the process.

Marx ignores the functional significance of aesthetic decisions in the production process because his functional concepts, such as use, exchange and commodity values, already assume the existence of a developed cycle of production which is characteristic only of developed societies in which class conflict and other forms of domination have already appeared. In such cycles the initiating aesthetic decisions which make technique possible have already been obscured by their routinization into established craft procedures.

The Matrix of Primal Production

In order to grasp the ubiquity of aesthetic judgement in the production process it is better to approach the problem of human production by establishing a model in the form of a centre rather than a circle, an archetypal and dynamic centre, a libidinous matrix of energy that, because it is essentially a problem-solving and conscious activity, rather than the product of inherited instinctive behaviour, is to be distinguished from animal behaviour and the animal modes of production. It was from such a matrix of socially-controlled human energy that the cycle of production, as Marx and other political economists have described it, emerged into historic time.

We must presuppose some such archetypal matrix of human productive energy if we are going to grasp the role of the aesthetic in the emergence of human production from the productions of animals. For human production is infused with feeling, not only a feeling for the process but a feeling for the natural materials worked upon. There is an important sense in which it can be said that producers anthropomorphize the materials of their production. In the making of aesthetic judgements the materials seem to take on a life of their own. Aesthetic evaluation is a reflexive process, a dialectical process in which a continuing dialogue is instituted between man and nature. Indeed if the producer is working with wood or animal products such as skins, he is in fact working with organic or once sentient beings. He becomes aware that in transforming Nature he must also humiliate, rape,

wound or destroy her. And though he has placed her in his servitude he is yet dependent upon her bounty. So that the heightened sense of satisfaction and achievement associated with primal production is accompanied by a sense of guilt. Nature, outraged, must be atoned by some form of propitiation. In primal production human beings become conscious that they are strangers in nature. Nature becomes another, who may return and destroy the producers. Thus the primal acts of production bring in their train the primal forms of alienation. Nor should this result be seen only in a prehistoric or anthropological context. It has been present throughout history. The same concern for a Nature wounded by human production animates much contemporary conservation and animal liberation thinking. The guilt attendant upon primal production is embodied of course in such myths as the expulsion from Eden. So as soon as man, one might say, ceased to be one animal among others in the garden of Eden, the libidinous energies inaugurated by the expulsion broke out into increasingly divided forms of labour. Production itself divided into institutionalized craft sequences on the one hand, and on the other, supporting rituals, codified in magical and religious practices, by which an outraged Nature might be propitiated; gestures by which men came to terms reluctantly with the fact that they themselves were productions of nature.

Although the sense of joy and achievement and the attendant states of anxiety and guilt intrinsic to the primal production process have revealed themselves most vividly and dramatically in the higher arts of literature, dance, theatre, music and painting, it is, of course, not confined to them. Nor are they characteristic features only of early and pre-industrial work processes. The sense of satisfaction that is gained from work is one of the characteristics of the human condition, as are the anxieties that arise from work and the results of work. As Marx noted, the work process itself brings brain and body into activity, and the sense both of satisfaction and strain that the work process generates is comparable to the sense of well-being and of exhaustion gained from physical exercise and sporting activities. Indeed it might be said that sport and exercise are themselves mirror images, second-order, epiphenomenal productions of the work process.

Play and Intention

A good deal of what I have said about the nature of primal production is akin to Schiller's theory of art as play,[8] and Schiller, whom he constantly quoted, was never far from Marx's mind

when he was considering art as a component of production.[9] This is as it should be, because any developed concept of primal production does require a vision of human activity as a kind of playfulness, the mind and hand playing over the materials in hand in search of a good outcome—an outcome that can be put to some use in the widest sense of use, a kind of teleological playfulness. It is in the nature of such playfulness that it constantly alters original intentions. Materials and the state of the process constantly suggest new possibilities. John Ruskin's insight into the consequences of the intrinsic imperfection of human work is also akin to the views already expressed.[10] Its very imperfection provides human work with a creative space in the production process, from which unintended but valued novelties may arise and mutate, as it were, the conscious processes of production. This is particularly significant in craft procedures, where imperfect handling or misdirected skill may give rise to new products, new uses. Aesthetic decisions, it must always be stressed, are not made wholly in terms of preconceived plans for they are not determined wholly by cognition, they adapt what might have been seen in terms of planning as a mistake, for they act constantly as problem-solvers in the process at the interface between the work activity and the material.

Consumption and Ideology

Like most aesthetic theory grounded in Marxian thought, in a number of important respects what I have said above parts company with Kant's view of aesthetic judgement as the judgement of taste.[11] Judgements of taste like judgements of use can be made only after the processes of production have been completed. That which is being made is neither one thing nor another. For the workman the unfinished work is not an object of taste, it is a challenge, something to be made. By means of his aesthetic judgements in practice he transforms his material. It is just when he judges the product to be tasteful, or beautiful or to possess significant form, or to serve adequately a particular function, that he ceases working on it. It becomes a product. It is at that stage that Kant's view of the aesthetic as the judgement of taste characterized by its subjectivity, disinterestedness and universality, becomes relevant. It is a consumer's view of the nature of aesthetic judgement, but it is a distorting view because it obscures the primal role of the aesthetic in production.

At the end of production are products embodying use-values.

All such human productions are best described as art objects (or artefacts) to distinguish them from natural objects, for they all involve artistry (aesthetic evaluation and craft skill) in their production. Behind all human products lies a history of the active imagination, of feeling, intuition and cognition; human inventiveness concretized in material form. It is also true that all human productions are capable of possessing use values, for example direct use, as food to be consumed, or as tools to aid other kinds of production, or to communicate, or give pleasure. All human productions, apart from such relatively immediate usages, may also develop symbolic usages. A sickle for cutting grain may come to be used to symbolize a 'liberated' peasantry. A cross for torturing and destroying dissidents may become a religious symbol. Since all human productions possess the capacity to communicate symbolically they may all be used to serve the needs of ideologies. Ideological value is a special kind of use value.

It is important to realize, however, that the aesthetic values and indeed the craft skills that the producer activates in production are not in themselves ideological in nature. There is, for example, no feudal, capitalist, or socialist way of cutting, turning, or polishing wood. This does not mean that the producer avoids the impact of ideological forces while actively producing, but that the work relationship, so far as aesthetic values are concerned, is a relationship between man and nature, rather than a social relationship between people. Indeed it is for this very reason that, as Marx stresses, the economic forces of production possess the capacity to transform ideological superstructures. If it were not so, if productive processes were nothing more than functional relationships of ideology, human society would have to be envisaged as an eternal nightmare of power relationships. This has always been a prevalent view. It was Machiavelli's and it was Hobbes's view. It is not a Marxian view.

Art emerges from production as an inseparable aspect of man's social being. The ideological forms that art may assume are not an aspect of his social existence but an aspect of his existence in class society. With the development of society there is also a corresponding development in the division of labour. One fundamental division of labour is that between those arts which serve the direct material needs of mankind such as food, clothing and shelter, and those arts of communication, above all language and the so-called fine arts, such as dance, music and the visual arts. It is in the practical arts that the essentially *formal* nature of aesthetic judgements express themselves, since it is in these areas where

basic human needs are served that form normally arises from the realization of function. In the arts of communication however— which are essentially symbolic arts, serving the relationships between individuals and groups in society—a *mimetic* element is normally combined with the formal elements of production. That which is enacted in reality in material production is acted out at the level of fantasy and imagination. Such arts, the arts of representation it would seem, originate from the desire to propitiate Nature that has been wounded or destroyed in the material act of production.

Second-order Aesthetic Valuing

At this stage it becomes possible to consider a second order of aesthetic value. It is, we might say, an epi-phenomenal aesthetic, an aesthetic of the consumer, an aesthetic applied to the objects rather than to the processes of production. Products may be perceived as satisfying a direct need. If we are extremely hungry we are unlikely to consider the ways in which the food was collected and cooked. But consumers may also distance themselves from such direct acts of consumption. We test the spade for its weight, its shape and durability, the way the handle is joined to the blade. In this we reconstruct in our imagination the aesthetic judgements and craft skills employed in the spade's construction. This second order of valuing aesthetically is often closely associated with the perception of use, and cannot be divorced from it in practice. It is the normal way in which intelligent consumer choices are made.

However, second-order aesthetic valuing may be distanced still further than that from use-values. The perceiver may seek to appraise the object purely in terms of the evaluations and skills objectified in its production. Obviously even the most useful and practical object, such as a spade, may take a great variety of forms, and yet each of them possess, use-value. Aesthetic valuing of this kind is concerned with distinguishing between such varieties and assessing them in formal terms. For a spade may please by its shape just as it may please by its capacity to assist digging.

Second-order aesthetic valuing of this distanced kind is in fact the mode normally applied in modern times to all human productions concerned with communication, particularly those described (in the narrower sense) as works of art: literature, architecture, sculpture, painting, etc. It may be conducted in many ways. One way is to attempt to reconstruct the aesthetic

evaluations and craft skills that went into the original production. This is implicitly an undertaking historical in character. Another way is for the perceiver to bring his own perception of aesthetic values (of necessity second-order perceptions) to the evaluation of the object. Yet a third way is to use the aesthetic qualities of the product for the construction of another work of art. In this way the original object is placed in the position of raw material to be worked on and with, *as if it were* a production of nature. A great deal of production, both of art designed for practical use, or for communication and pleasure, is developed in this way. Scientific theory for example (which is an art object or artefact of a special kind) builds by criticism on scientific theory; art works, more often than not, are constructed out of the reconsideration, criticism and development of earlier art works. There are no firm lines to be drawn between creation, interpretation and criticism in production. They are but some of the ways in which the cycle of production, exchange, distribution and consumption is expressed at the level of aesthetic valuation.

Commodity Fetishism

It is this apprehension of the traces of aesthetic values and craft skills concretized in actual products, though overlaid by use-values and exchange-values, that Marx seems to have had in mind when he developed the concept of the fetishism of commodities. Again, as in the case of alienation it was a case of appropriating from a religious context and applying the idea to the nature of commodities. 'A commodity', Marx noted,' is a mysterious thing, simply because in it the social character of men's labour appears to them as an objective character stamped upon the product of that labour.'[12] Here it is not the use-value or exchange-value as such but the value of the product as a symbol of social labour. The process of distinguishing the aesthetic values and craft skills from use-values, exchange values and ideological values is both an analytical and an historical process. It is furthermore one to which there can be no end, no finality. Because the product now constitutes itself as an historical event—and to the explanation of historical events there can be no end—only further processes of historical analyses, hence perhaps Marx's apt comment: 'A commodity is therefore a mysterious thing.' Part of its mystery is due to the fact that its value as a product of primal labour is overlaid by the values which it serves and for which it is exchanged.

Art and Ideology

It is not possible here to discuss in any detail the role of art as ideology, though a great deal of confusion remains to be cleared away.[13] We still lack a comprehensive sociology of ideology. What needs to be stressed is that ideological values are a special kind of use-value; they are embodied in the product not in the process. Work precedes power though it may become the object of power. Here the role of language is pre-eminent. Language emerges with consciousness in the primal act of production, together with mime, song and dance, and the visual arts, and is pre-eminently suited to become an instrument of domination, since it lies at the heart of all the arts of communication, by which production itself is sustained as a social activity. It is language and the other communicative arts that figure forth and ritualize that sense of estrangement from nature attendant upon the primal acts of production. And it is by means of these arts that the sense of guilt attendant upon production is either expiated or aggravated. They are thus admirably placed to serve as instruments by means of which some sections of society are able to take it upon themselves, as a result of the new possibilities arising from the division of labour, to stand in for and represent that very Nature outraged and defiled by the act of production. They attach themselves to the natural order of things; present themselves as an unchanging natural order. To this end, not only language but all human productions may be called into the service of domination. Although human society as a whole benefits from production the producers are called upon to bear the guilt that attends production in all societies where asymmetrical relations of power whether of class, gender, ethnicity or nationality exist.

But this is not to say that art must serve, either as process or as product, the functions of ideology. When men become conscious of the ideological forms that art may take, or in which art may be presented, they may oppose and reject them. That is what conflict means. For to use art as ideology is to corrupt it. Which is, perhaps, another way of saying that human production in the form of science and technics may contribute to our knowledge of the natural world and in the form of language the arts of communication may contribute to our understanding of the social relationships between people, including relationships of power.

Art and the Museum

14
The Social Role of the Art Museum
—1946—

In countries older than Australia the public art museum originated from the great private collections of the eighteenth and nineteenth centuries. It was the private collection turned to an educational purpose, and its professed aim was the improvement of public taste and the promotion of art. The educative function of museums has always been stressed by their founders. Sir Henry Tate bequeathed his collection to the English nation 'for the encouragement and development of British art'. The London National Gallery was founded when the British Government purchased the Angerstein Collection in 1824 for a somewhat similar purpose. And Lord Loftus at the official opening of the National Art Gallery of New South Wales urged that others should continue 'the endeavour to advance taste in Art among the community'.

There is no reason to doubt the honesty of Victorian philanthropists and well-meaning governments who saw in the creation of official institutions the salvation of a degenerating public taste. But since then we have gained sufficient evidence of the futility of art galleries. If art museums have not actively contributed toward the degeneration of aesthetic standards they have certainly done little or nothing to arrest it. As often as not they have been barometers whereby the degeneration has been made hideously manifest. A comment by Sir John Rothenstein may be applied as much to galleries in Australia as to any provincial gallery in England: 'Today, almost every gallery that was in existence during the latter part of the nineteenth century is embarrassed by the possession of a superfluity of oversized presentations of shaggy Highland cattle, monks carousing, cavaliers conspiring, and lugubrious acres of heather and bracken, and sentimental glens.'

The nineteenth-century art museum, although originating from some of the best intentions in the world, became a peculiar

species of civic or national monument. A pretentious pseudo-classical exterior was erected as a symbol of civic or national maturity. But once the museums were built and staffed—usually inadequately—governments felt that they had done the right thing for the arts, and beyond an annual sum for their upkeep and maintenance these institutions and their professed function and purpose were forgotten. Perhaps at least they continued to exist, if we consider the problem from the standpoint of social psychology, as a kind of civic compensation for a society which had forsaken art values for other values, and for the satisfaction of citizens 'who knew nothing about art but knew what they liked' and at the same time felt that they should do the right thing for the 'culture' of the city and the nation. National galleries, to put the matter bluntly, have been expressions of pride rather than expressions of the love of art. And it is not often that the expression of pride is anything but the expression of vulgarity. These galleries with their towering Roman façades, their 'palace of art' courts, and finally their temporary galleries which degenerated into outhouses and slum-like oddities in the rear, became excellent examples in themselves of most of the qualities of bad art. The haphazard planning was evidence of haphazard thinking, a product of the inability to decide whether an art museum should be a civic monument or should perform a specific educational function.

Art museums, that is to say, have not fulfilled the intentions of their founders. At least not if we take them seriously. The general decline of standards of public taste which has continued without interruption for a century has proved the impotence of the nineteenth-century conception of the art museum, a conception summed up in the words purchasing, displaying, storing and—though often indifferently—conserving.

Many solutions of the problem have been attempted. The art museum—art school fusion, first advocated by Gottfried Semper and first practised at South Kensington, was one of the most successful of the early attempts to link the function of an art museum with the needs of life. Gradually the need to transform art museums into active educational agencies was realized. But it was in America and in certain continental museums rather than in England or the British Dominions that the need was realized to any great extent.

The function of the art museum today is a far more complicated one than that of the art museum of a century ago. Today syndicated comic strips, the film and popular magazines, whether for good or for bad, are far more powerful factors in the formation of

the public taste than are art museums. If they retreat before the flood of bad art the museums become impotent, cultural anachronisms. An age of high pressure advertising, in what usually amounts to the cultivation of the atrocious, demands from art museums new educational techniques. The first requirement is the recognition of the museum as an educational agency. This means a far closer connection on the one hand with other educational agencies, such as schools and universities, and closer contact with those whom the gallery is theoretically supposed to affect: the home, in the realm of domestic design; the factory, in the realm of industrial design; the town at large, in the realm of town and community planning.

Such a re-orientation of outlook involves the extension of the art museum's activities by the assembling of art exhibitions for country centres and for schools. It requires the cultivation of art scholarship by the establishment of art reference libraries, lecture courses, travelling exhibitions of domestic and industrial design, of domestic architecture, and in factory, office and municipal loan exhibitions.

A change in the policy of art museums should mean a change in the way they are planned and built. Adequate attention must be paid to the lighting and air-conditioning of exhibits in order that they may be well displayed and preserved against extremes of heat and cold. Apart from the permanent collection special rooms should be provided for the display of temporary exhibits. The continuous removal of parts of the permanent collection in order that temporary exhibits may be shown results in continual disorganization of the collection, endangers canvases and frames, and creates unnecessary and wasteful clerical work. On the other hand, the temporary exhibition is the life-blood of the modern art museum for it maintains and develops public interest. The large barn-like 'palace of art' type of court should be dispensed with. Smaller courts can be used far more effectively for the arrangement of the collection into schools and periods, media, and so on.

Provision should be made for school children to visit the art museum regularly. It is desirable that the parties of children should attend at regular periods and that some sort of prepared syllabus of instruction should be pursued. While this may be difficult in large cities where a very large school population is embraced, it is a practice that could be introduced into provincial centres.

It is most desirable that an art museum should embrace the various forms of artistic expression. Far too often in Australia an

art museum has been conceived as a gallery of oil and water-colour paintings, with an occasional piece of sculpture. In addition to painting and sculpture in stone, wood, and metal, house furniture, fabrics, pottery, typography, and photography should be included.

Australia's cultural development in the plastic arts has drawn almost exclusively upon the English and French traditions for inspiration and sustenance. This has been reflected in the purchases made for the collections of our galleries. Whether through a misguided sense of imperial patriotism or through preoccupation with our cultural ancestry, this policy has unduly proscribed Australian collections. It is perhaps not too much to say that there are artists neither Australian, English nor French who have produced work of merit and interest. Certainly collections of the arts of Pacific countries such as the United States, Latin America, and China, would increase the diversity and improve the value of our present collections. If trustees would set before themselves the ideals of the trained anthropologist rather than the prejudices of professional artists we would probably have collections that were more unified, and yet more diverse, more representative, and, in the final analysis, probably of higher aesthetic merit.

Sidney Markham, who visited Australia in 1945, in his report on the art galleries and museums of the British Isles made a significant concluding statement:

The art galleries of the future will have a policy based on the fact that the man in the street is the greatest purchaser of art the world has ever known, and that almost every object in the average home is in some way an art object with its influence for beauty or otherwise upon the family. Art galleries must endeavour to educate our democracy not only in pictorial art and in pottery, but also in the selection of its wall papers, radio sets, tablecloths and furniture.

Markham, in his report on Australian museums and art galleries made for the Carnegie Corporation some four years earlier, pointed to the lack of extra-gallery activities in Australia. In some centres, he stated, 'the most pathetic attempts are made by teachers themselves to do the work that should be done by museums'. Since that time there has been some improvement, mainly in Victoria. Most Australian art galleries, however, are beginning to realize that they have an educational function to fulfil, but the strange belief that an art museum is a sacred and aloof national monument preserving against the outer darkness the aesthetic standards of the state, like all irrational beliefs, is one that is not easily altered.

15

The Art Museum and Public Accountability

—1985—

For some time now, whenever the appropriate opportunity has arisen, I have done what I could to draw attention to the comparative absence of catalogues of works of art and crafted objects in the permanent collections of our public galleries and art museums.[1] I have argued that it is high time that Trustees, Directors and Curators gave a higher priority to cataloguing permanent collections than they have been doing in Australia during the past thirty-odd years. In all but the smallest of our public collections this, in practice, would mean the compilation and publication of sectional catalogues dealing with the major components of the collections. Just how these components are distinguished and divided will depend in part upon the size of the collection and in part upon the anticipated use of the catalogue, but it has become conventional in the visual arts to divide collections first into national divisions, for example, Australian art, British art, European art; and make further subdivisions according to medium, for example, European drawings, Islamic ceramics, or whatever. Or again between periodic groupings as in the distinction between, say, contemporary art and nineteenth-century art. Such divisions of the whole cake have to be made in terms of the perceived size and range of the total collection. In a large gallery it may depend upon the range of the responsibility with which a curator is charged. What we do need in Australia, and need urgently, is a programme that embraces total collections, a plan that entails the publication of all the objects held, and a programme that includes a means by which such published catalogues may be kept constantly up to date, for example, their complete republication within, say, five- or ten-year cycles.

If our public galleries ignore the need for up-to-date catalogues of their permanent collections, then it seems to me that they are failing on the question of public accountability. Catalogues are

the best, the most efficient and still the cheapest way of representing at the state, the national and the international level, a gallery's commitment—if it is a public gallery, publicly funded—to the freedom of information.

That said, of course it must also be said that such things take time and cost money, and many will argue that there are more pressing concerns. Perhaps the development since the war of cataloguing both as an art and a science has proved to be an inhibiting factor. Superb catalogues such as those which Martin Davies began to publish for the National Gallery of Art in London during the early post-war years were of such a high standard that they have deterred, I believe, many galleries throughout the world, particularly those in small, provincial nations such as Australia that simply did not possess expertise comparable with that of Martin Davies. Indeed, I suspect his catalogues terrified many curators by the degree of connoisseurship and breadth of knowledge they revealed. The standard was too high.

In the short term, however, what we stand in need of in Australia are not catalogues of the Martin Davies kind but good summary catalogues that tell us quickly and efficiently just what is held in our public collections. Such summary catalogues would at least answer the immediate need for public accountability, for a free flow of basic information to the public. So perhaps at this stage it would be sensible for me to distinguish between the two types of catalogues I have in mind. First the summary or short list catalogue that provides basic information, and second the full descriptive catalogue that provides the information that specialists now find themselves increasingly in need of.

The short list catalogue is the kind that provides the name of the artist or craftsperson, the title of the work, the medium, the dimensions, and may also provide the date of execution, the date of acquisition of the work, and the nature of the acquisition by purchase or by gift together with the name of the benefactor. The short list catalogue, that is to say, answers about six questions that might commonly be asked of any item and to which the public might expect to obtain an immediate, correct, and complete answer.

The other type of catalogue, the descriptive and annotated catalogue, is a more ambitious and at the same time (for curators) a more personally rewarding undertaking. The long-term preparation and the continual addition of information to the items of such catalogues should certainly be a normal part of curatorial activity in any self-respecting art museum. Descriptive catalogues

of this kind, in addition to the information I have already listed for summary catalogues, normally provide extra information of at least six separate kinds. Firstly, information concerning provenance. That is to say, concerning the history of the possession and ownership of the item prior to its acquisition by the institution, ideally with a continuous pedigree from the time it left the studio or workshop. Secondly, information concerning the physical history of the item; that is to say, its present physical condition, including blemishes such as the presence of moulds, foxing, paint losses, areas of sunken paint, pentimenti and so forth, and also the history (to the extent that it is known) of any retouchings, renovations, relining and so on. Whether this material is actually published or not will depend, I suppose, upon gallery policy. Some galleries may want the viewer to assume that everything they show is immaculate. My own attitude of course is that it is desirable that, as far as possible, both the past history and the present physical condition of any work should be made known to the public. Thirdly, notes concerning the history of the item as a public object, such as its appearance in exhibitions; texts and reviews in which it is prominently discussed; and magazines and newspapers and so on in which it has been reproduced. Fourthly, an account of other, related versions of the item such as sketches, drawings and replicas with an account of their relation to the item catalogued. Fifthly, iconographical information and possibly a brief verbal description of the subject matter. Such is invaluable if it is not proposed to publish a complete illustrated supplement to the catalogue and is often of great value even when a complete photographic supplement is published.

I suppose, regrettably, the days are long past when we can any longer expect such beautifully brief and apt descriptions as those with which Laurence Binyon graced his great catalogues of the British drawings and water-colours in the Department of Prints and Drawings of the British Museum during the early years of the twentieth century. They were classics of their kind; it is doubtful if we shall ever see their like again, but then Binyon was a poet, and a good one. Even when a full verbal description seems not to be called for because the information can be read visually from a photograph, verbal descriptions are still invaluable in calling attention to special features, say of an anthropological, emblematic or mythological significance. Of course, iconographical comment leads into the whole complex meaning of a work, but there is no reason why curators should not open out or even summarize known opinions concerning meaning, though it is an

aspect of cataloguing in which it is impossible, surely, for the last word ever to be said, nor should we expect it to be said. Finally, I might add that all these sections should also include references to relevant texts. One last comment on this. I do not think comments of an aesthetic, valuing kind should appear in a catalogue. That is the critic's concern, not the cataloguer's.

Why is the continual preparation of catalogues vital to the preservation of the intellectual and aesthetic vitality of an art museum?

First and foremost it accepts and recognizes the public account-ability of the museum and the public's right to know. It does not treat the public as something of a nuisance, to be patronized or to be fobbed off with less than the best. Of course there is a place for those pretty booklets universally described as the master-pieces of the Malincoota Museum, but the intelligent public—and there is always more of it than you think—do not want so much to be told what the Director or one of his many curators in the Malincoota Museum considers to be the stunning master-pieces of the place. It wants an account of what the collection holds because there just might be something of special personal interest to a particular member of the public apart from that which happens to personally interest the Director and the Curators. It is even possible that a member of the public might be able to provide the museum with information it does not hold. Anything less than a full summary catalogue implies a patronizing position *vis-à-vis* the public. This attitude assumes that we will tell them only what it is good for them to know or, worse, what we believe they should feel about this or that item.

Secondly, it recognizes an implicit obligation to the national and international community of museums. That is to say, it makes available in a readily accessible form, information about what it holds. It is only by reference to such immediate and readily available sources of reference that special exhibitions for circu-lation can be assembled. The temporary, circulating exhibition is ultimately dependent, however blockbusterish it may be, upon the existence of catalogues of permanent collections. If the cata-logues have not been published how are we to know what is held? Temporary exhibitions are in this sense, as it were, in a large measure parasitic upon permanent collections and per-manent collections are only publicly revealed through catalogues.

Thirdly, it is only by continuing to contribute to the assembling of catalogues of the permanent collections that curators begin to

assemble and to master a useful knowledge of their own collections. In almost every case, a permanent collection is much older than its current curator. Curators arrive in a state of comparative ignorance of the collection and if the bulk of their activities is given to the assembling of current shows, they may remain in ignorance or lack any kind of close knowledge of the bulk of the collection. The compilation of a full descriptive catalogue is the way towards *exact* knowledge, towards connoisseurship, upon which both museum work and art-historical work depend. It should not be regarded as a job of low priority best left to a junior. Far too many younger curators, and some not so young, are strong on opinion but weaker in that disinterested intellectual curiosity which makes for the tone of a good art museum. They will tell you, even before you ask, that in their personal view, most of the collection is tripe and might better be sold or perhaps burnt. People with such views should never be appointed to be curators of anything at all, let alone of precious objects.

The word curator, as I trust we all remind ourselves from time to time, comes from the Latin verb *curare*, to take care of. In practice, of course, in modern times the business of taking care of works of art is distributed widely over the whole staff of a museum, from the planning of security arrangements in a new building to their registration and documentation so that their physical location in a museum is known and their physical absence can be reported without undue delay. In this actual physical care modern curators, more often than not, play only a supplementary role or at least there are assistants to help them. So what do curators do? What is their function? One of the ways they can help to care for a collection is to gain a good knowledge of it. There will be some items one hopes that they will find aesthetically pleasing, many that they will not, but that is where the true excitement and relish of curatorial work begins. There are so many ways in which all works of art are of interest apart from their manifest aesthetic qualities. They are from another country, like refugees in a sense, displaced persons. To appreciate them you have to have the historical sensibility, the imaginative capacity, to restore them to their original contexts, to see them within the contexts from which the process of turning them into museum pieces has robbed them. In this way, dull objects can become exciting and new, and can be invested with new values. Furthermore such values, whether historical or whatever, can never in practice be firmly separated from aesthetic values. They

always mix and intermingle. The seventeenth-century English poet and diplomat Sir Henry Wotten once advised the aspiring but hesitant connoisseur of the new or the bizarre to 'feign a relish till a relish come'. That sounds like a kind of self-deceit, but many of us will recall personal instances, perhaps as children or adolescents, of doing precisely that, gingerly experimenting with some more exotic food or drink though it might initially have revolted us. What I am suggesting is that curators should become increasingly curious about, become excited by, not only the aesthetic highlights of their collections but about all of it: the reasons for the fluctuations in taste that it reveals, the ways and means by which it was acquired, the variety of judgements that went into its formation. In other words, what does it all mean for Australian culture? Because it is the Australian culture that we are centrally involved with whether we like it or not, even though the item may be a medieval illuminated manuscript or a painting by, say, Arshile Gorky.

What does concern me is the degree of energy and expertise that goes into the preparation of the temporary exhibitions, so that interest in our permanent collections becomes increasingly neglected. I do not question the need to keep our galleries lively places with a continuing succession of shows. We are committed to that, and it must go on. But we do need a better balance than we have. There is a place for the carefully prepared retrospective exhibition, and for the memorial exhibition; they possess not only an immediate value but also a value for history if they are well researched. But the danger is that a curator tends to see his or her role increasingly in the light of a taste-maker or a rediscoverer of that which has been ignored. Again, much of that is unavoidable and certainly not undesirable. But in all this flurry of attention to the passing scene one wonders whether curatorial work is not becoming an increasingly complacent appendage of the commercial world, enhancing the market values of the art of the living or the recently dead. Again, much of that is inevitable. But it is worth while realizing how much things have changed. I am old enough to remember what I believe to be the first exhibition of the work of living artists ever held in an Australian public gallery. This was the joint exhibition of the work of Margaret Preston and William Dobell that Will Ashton mounted in March 1942 in the Art Gallery of New South Wales. That was a historic innovation. Never before, to my knowledge, was a special exhibition of work by living Australian artists held within a *public* gallery. It caused some comment, I recall, at the time. Was the

gallery, as some argued, usurping the function of the private galleries? On the other hand, was the gallery, as others argued, using a publicly-owned space to enhance the market reputations of living artists? If those, then why not others, less known, less favoured?

Since then the use of galleries to show the work of the illustrious living has proceeded apace and is the normal practice. I suppose that more has been gained than has been lost, but it has certainly meant that the apparatus of the installations of the state has become much more closely associated with the vagaries of the contemporary scene, the market, and the taste variations of the commercial gallery world. There have been benefits but there have also been costs. One of the costs has been a comparative loss of interest in researching and presenting the permanent collections of our galleries to the Australian public and the international audience of connoisseurs, historians and critics who should possess a much better knowledge than they do of what is actually held in our Australian collections.

Let me give you one example. (Any specialist could probably cite scores.) In 1962 I happened to be in London and attended an exhibition at the Redfern Gallery of the art of Harold Gilman and Spencer Gore. There was a magnificent painting there by Gore entitled the *Icknield Way*. Although I had no brief to advise, I got in touch with Hal Missingham, then Director of the Sydney Gallery, and said that it should be bought, and eventually it was. I strongly recommended it not only because I could see that it was a superb painting but also because I was interested in the origins of Australian post-impressionism at the time and was looking out for its various sources, and Gore was someone to look out for. After the painting arrived in Sydney it sank into a kind of oblivion so far as the rest of the world was concerned. Apart from a very brief note in the Art Gallery of New South Wales's *Quarterly Bulletin* of April 1963 it remained under cover, for the Art Gallery of New South Wales has not published any catalogues of its non-Australian holdings in the permanent collection since 1928. Happily this sad state of affairs will soon improve. The gallery is about to publish a fine catalogue of its collection of British paintings, the work of Renée Free and her colleagues. But to revert to the *Icknield Way* for a moment. When Wendy Baron published her book on the Camden Town School she made it clear that the painting was one of the central masterpieces of early-British modernism. Just how many other paintings of a similar significance lie virtually unknown in our permanent

collections I do not know, but they are an important and neglected quarry to which our curators should pay more attention than they do.

There will, of course, be losses as well as gains. Many pictures will turn out to be a good deal less than they claim to be. But that is all a part of the curatorial process; identifying fakes or poor versions and so forth should be a significant aspect of our own education. It we do not seek to obtain a mastery over our permanent collections we shall never develop that expertise and connoisseurship upon which the quality of our public collections ultimately depends. Instead we will try to make do by means of bluff, and hope for the best. In any case, in these days of high specializing it is only possible for most of us to gain genuine expertise in the work of one or two artists at best. The production of a *catalogue raisonné* of the whole *oeuvre* of a major artist usually takes a lifetime. If I were a young curator starting out today I would seek to make myself the master (if that is the word) of at least one Australian artist and one non-Australian artist. That would mean the compilation and eventual publication of a full descriptive catalogue of their work. I would see that commitment, so far as I could, not as a tiresome task, but as a way of improving my general knowledge, my general education in art. That, I might add, was the way connoisseurship began in this country. Sir Lionel Lindsay, born with no particular advantages in Creswick, Victoria, but like all the Lindsays possessed of a voracious capacity to get up and go, made himself a world expert on the drawings of Charles Keene, the late nineteenth-century English draughtsman, and also assembled what was perhaps the best collection of Keene's work in the world. He also made important collections of the etchings of Rembrandt and Meryon and was able to give the Art Gallery of New South Wales excellent advice in these fields.

When I was studying in London on a British Council scholarship between 1948 and 1950, one of the things that greatly impressed me was the quality of the post-war catalogues of the National Gallery, then being published by Martin Davies. I had never seen anything like them before and marvelled at the scholarship that went into their production. When I remarked on the fact to Anthony Blunt, then Director of the Courtauld Institute, I recall that he said that the art historian had to be prepared to take on that kind of work but also had to train to take in a more general (that is to say a more contextual) view as well. He would have known, because he was himself a master of both modes: on the one hand, the catalogues of Nicholas Poussin's drawings at

Windsor and elsewhere and on the other, the small but masterly and lucid book *Artistic Theory in Italy 1450–1600*. When I got back to Sydney in early 1951 I found that my work on travelling art exhibitions had been taken over by someone else. Fortunately, I was able, in a critical situation that I need not go into here, to convince the president of the trustees (it was the Trust that held all the power in those days) that I should stay on and produce a catalogue of the Australian oil paintings and then proceed to catalogue the water-colours and the drawings.

The catalogue of the oils was published in 1953 and was modelled on Martin Davies's methods. I did not have anything like the problems that Davies had because I was not cataloguing old masters with centuries of history behind them. But at least I used his model, and in doing so developed a good knowledge of the collection. Shortly after it appeared, Dr Ursula Hoff, at the request of Daryl Lindsay, the Director of the National Gallery of Victoria, embarked on a Martin Davies-type catalogue of the Melbourne Old Masters collection, the first edition of which appeared in 1961. I think that both of us at the time felt that our catalogues might set new models for the cataloguing of the permanent collections in our galleries. How wrong we were! Because although the standard of cataloguing used for temporary exhibitions has certainly improved enormously, in-house interest in the permanent collections has declined. To the extent that they have been researched at all, they have been researched in order to be reshuffled, to create temporary exhibitions that might accord in some way with contemporary interests and contemporary taste. Again there have been benefits in this trend, but there have also been costs. One suspects that here, too, curators have tended to function increasingly as taste-makers, rather than seeing their work as laying the foundations, preparing the groundwork, upon which others might build. This feeling that they belong to a community, a republic of scholars which extends beyond the walls of a museum and beyond the immediate needs of their local public, seems to have been largely lost in Australia, in favour of the more breathless pursuit of trend setting.

I am not sure why this has occurred, but there are some long-term trends that might help us to understand it. The first is the effects of modernism. When I first came to work in the Art Gallery of New South Wales in mid-1944, modernism had not yet reached the Australian art museum world. Power was effectively in the hands of ageing trustees who possessed life tenure and who put up a very effective rearguard action against modernist

values that lasted a good ten years. One attitude which many of them adopted, led by Sir Lionel Lindsay, was opposition to any development of educational activities by art galleries. It was unwise, they said, to talk about art and undesirable to attempt to win a large mass audience for art. There were, so the argument went, two kinds of people interested in art: those who were naturally artists and those who were born perceivers of quality in art: the artist and his patrons. The public galleries existed solely for these two kinds of persons and the trustees of the Sydney gallery, to the extent that they followed the Lindsay philosophy, sought to keep it that way.

The achievement of educational activities and the achievement of a mass audience for art are great achievements, and I should be last to deny it. But something has been lost in the process. So much energy has been devoted to getting people into the galleries that galleries have neglected the responsibilities that they also owe to scholarship, to the continual revision and advancement of knowledge. There is still a great deal of anti-intellectualism rampant in the art-museum community and it does not enhance the quality of the profession.

Modernism in the gallery has brought structural changes with it. The old trustees who were painters or played at being connoisseurs and true gentlemen of taste have largely gone, or if not, their power has gone. Curators acting in consort with the director now play a greater part in the role of acquisition. On balance, I think this has been a considerable advance. But the desire to acquire, to play a part in the acquisition process, has begun to bulk largely in the activities of curators in comparison with their more traditional roles, such as cataloguing and the mastery of a knowledge of their collections. It is on the knowledge that they acquire in this field, their capacity to know the collection as a whole, both aesthetically and historically, that their capacity to make wise acquisition judgements largely depends.

The role of trustees and governing councils, too, has changed. As a result of a long succession of conservative governments during and after the Menzies regime, both in the state and federal spheres, it has become conventional wisdom that those most needed as trustees are not artists and would-be connoisseurs but businessmen, preferably businessmen with a manifest interest in collecting. I have no doubt that considerable advantages have accrued from these changes also. But again there have been costs. There has been a steady pressure to treat the public gallery as if it

were a corporation that must show a profit. Hence the proliferation of little booklets and handouts that present the collection in a ready and easily digestible form for those who want a smattering of what is in the place. Again these can be valuable, as the magnificent publication programme of the Victoria and Albert Museum in London shows constantly. But beneath the V and A, to name but one of the numerous great museums which run an enviable educational policy, there is also a continuing process of scholarship and research being pursued. To what extent can we confidently say that about our own galleries? I do not want to suggest that little is being done. I am sure much is. But to what extent do our new-brand trustees recognize the central importance of such scholarly activities for the vitality of their institutions?

One of the reasons I am often told that catalogues of the permanent collection are not published is that the businessmen on the trust or council argue that they will not sell. Well the answer to this is that if they know anything at all about marketing it is surely their business to find ways in which they can be sold. Frankly, I think that many of our gallery councils and directors seriously underestimate the range of aesthetic, intellectual and historical interests of the Australian art public. Catalogues do sell. The first two volumes of *The Art of Captain Cook's Voyages*, which I have been involved with intermittently since 1949, recently sold out on the day of publication. Helen Topliss's admirable Catalogue of the Work of *Tom Roberts* is also selling far more quickly than the publishers anticipated. Of course these are comparatively expensive and highly-illustrated catalogues. They are not the kind of catalogue I have in mind in talking about catalogues of our permanent collections.

We urgently need summary catalogues that exhaust the field they deal with, and are published inexpensively, together with, if possible, full illustrated supplements, even if these only involve small black and white plates, suitable at least for the purposes of recognition. As I see it, a typical case might be the publication of an unillustrated summary catalogue at around, say, $10 and a full illustrated supplement for $15 to $20. Both may require financial subsidy at that price. They should be published for sale over a period of five years, during which a new edition would have been prepared to replace them. Marketing processes could be devised to assist sales initially, for example, an exhibition of related work to show the highlights of the catalogue. In this case the exhibition would be supporting the catalogue rather than the

catalogue supporting the exhibition. But such a show could reveal not only unexpected facets of the collection, but also teach its audience the value of possessing a complete catalogue of the collection. It would be equally important to ensure that sufficient quantities are produced to keep the catalogue in print for five years. It is frustrating, for example, for visiting specialists (and there are an increasing number of them moving about the country) to be told that the catalogue is out of print. Now, I assume, they are fobbed off by being told (as they have been told for the past thirty or forty years) that it is in preparation, but 'you know, we are awfully understaffed here'. It is by such underestimation of the museum-visiting public that we earn the kind of reputation abroad that provides Barry Humphries with a good living. We allow ourselves to be sold short in such matters. Our Australian Cultural Attaché to the Court of St James, Sir Les Patterson, would never want to buy a catalogue of a whole collection; he just wants a booklet with a few pretty pictures. So we do not produce catalogues.

But that is not the only reason. All we have to do, it is said, is to wait for the union catalogue of all the art works in the country, wait for it all to be programmed on that universal computer. Catalogues, we are assured, will be out of date. They will not be needed. What fantasies we feed upon, in order to avoid a little work! Computers, I have no doubt, will change things radically, particularly in the field of in-service, in-house, retrieval of information. But I am not arguing here for the use of hi-tech to further entrench an art bureaucracy that can forget readily, as it exchanges information between one institution and another, that it also owes major responsibilities to the public at large, to the regional, the state, the national, and the international public. You will not provide the basic information that this varied public may call upon you to provide (on the grounds of freedom of information) by asking them to switch into a computer terminal. For the great majority of that public the terminal will not be available. I have no doubt that during our lifetime and the lifetime of our grand-children, if we should have any, the book will continue to be the main disseminator of information. Even if it should not be, the basic information will still have to be assembled by people like you and me, whether it is published in book form or pro-grammed into a computer.

I have done what I could to give this paper a controversial edge, and perhaps I have exaggerated in places, perhaps even given false ideas about the present situation. If so, my excuse is

that my intention has been to open one theme for discussion: documentation and accountability to the art-museum public.

Coda: In the discussion of this paper some members of the seminar suggested that I might be somewhat old-fashioned in demanding (what is the jargon?) *hard-copy* information in this electronic age. A letter that I received a few days later from my colleague, Dr Rüdiger Joppien, who is collaborating with me in preparing a complete catalogue of the work of artists who sailed with Captain Cook, reminded me of our discussion. He was then curator in the Kunstgewerbemuseum, Cologne, and he explained, among other things, why he had been delayed in completing the manuscript of the third volume of our catalogue during the northern summer. I do not think that West Germany can be said (at least by Australian standards) to be out-of-date in its relation to modern electronic technology. This is what he had to say:

The museum has just published a two-volume, 1,000 page thick catalogue of our complete holdings in jewellery.[2] The work was divided between a colleague and myself, but the colleague, being on temporary contract, left Cologne in the early spring. So immediately after racing through Cook, I had to shift and continue with her research, finish the catalogue and see it through the press. In most German museums we have no special publication department, so from the costing at the beginning, listing of the number of photographs of what size, etc. we have to do the layout, measuring of photographs, proof-reading, etc. At the same time 900 objects had to be displayed, pinned against shelves, provided with explanatory texts, etc... Finally last week the exhibition was opened and the catalogue ushered in from the printers while the press conference was running. It is quite a relief that this is all over now.

If any of the jewellery of the Kunstgewerbemuseum, Cologne, is stolen from its present permanent collection, not only the museum, but the local police, dealers, collectors and the interested public will possess a complete verbal and visual record of what has been lost—and one that is immediately available. Contrast the situation at present prevailing at the National Gallery of Victoria. There an audit made this year (1986) revealed some thirty-odd paintings missing and much more, it was feared, from other sections of the collection. None of the gallery staff were in a position to say whether the paintings had been stolen or still existed in some unexplored corner of the gallery's premises. The answer to such problems is not yet more audits and an increase in the number of security staff employed, but the employment of curators who set out to obtain a full knowledge of the collections

within their trust and the ability to make them known to the public in the form of complete and reliable catalogues.

Too many curators in Australian museums see themselves as taste-makers rather than guardians. At least our librarians have not yet come to believe that their prime function is to tell us what we should read.

*Abstract Art and the
Antipodean Intervention*

16
Notes on Abstract Art
—1983—

One important question is this: are abstract painting and abstract sculpture the best kinds of painting and sculpture that can be produced? My own reservations about abstract art have always been based upon the personal response that I find myself making to this question. It is essentially an aesthetic one concerning the differences that exist between the arts.

For me, neither painting nor sculpture are at their best when they are wholly abstract. My response to music and architecture is quite different. For me these are the great abstract arts. When I listen to Bach I perceive the music as a wholly abstract fabrication of sound possessing its own self-contained existence. I have no need to know what it may possibly represent, for the music itself possesses the capacity to convince me that it only represents—if that is the word—itself. And for me at least, when music carries this conviction of its self-contained, abstract existence, it is music at its best. Which is not to say that I am incapable of enjoying other forms of music.

It is the same with architecture. When I look at the Parthenon, even in ruins, or Balthasar Neumann's Vierzehnheiligen church, although I am aware that they are also great religious monuments, I approach them as essentially abstract compositions, depending for their expressive power upon the abstract arrangement of their forms.

But the arts are not the same in the power or nature of their appeal. It is one of the hardest of lessons to learn. All the arts do not aspire to the condition of music and architecture; or if they do they weaken their capacities to express. Attempts by Edgar Allen Poe and Edith Sitwell to reduce their poetry to sound only succeeded in weakening it. In poetry, perhaps more than in any other art, the meanings shine powerfully through the abstracted form—when it is at its best.

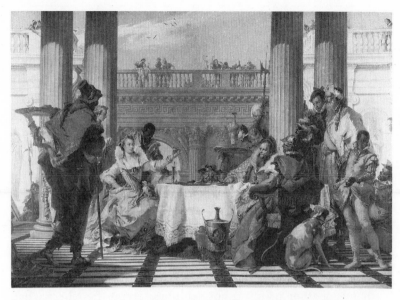

Giovanni Battista Tiepolo *The Banquet of Cleopatra*. Oil on canvas, 248.2 × 357.8 cm, 1743−44. Felton Bequest, 1933, National Gallery of Victoria, Melbourne.

Painting is rather like poetry in this: *ut pictura poesis* (as a painting, so a poem). To separate painting from meaning is to weaken it, because the two, in this art, adhere so closely together. When I compare Pollock's *Blue Poles* with Tiepolo's *The Banquet of Cleopatra* I just seem to know, instinctively almost, which is the better painting. Because for me painting is at its best when it does not obliterate meaningful references to things beyond its own structure, whereas architecture and music may do this and be better for it. Yet I do not think that painting and poetry are equal in the degree of abstracting that they can endure. Painting, it seems to me, can be taken to a greater pitch of abstraction than can words and the art will still be enhanced. That is perhaps because graphic forms and colours possess a more sensuous appeal than the sounds of words when they are rendered meaningless.

Because sculpture, like architecture, is a three-dimensional art it can be brought, it seems to me, to a higher pitch of abstraction than painting and be the better for it. That is why perhaps the archaic sculptures of Greece, pre-Columbian sculpture, and

the work of Henry Moore, to take a twentieth-century example, have exercised a wide general appeal. But to push sculpture to the full limit of abstraction is to weaken it. This is why the work of David Smith and Anthony Caro is unlikely ever to achieve more than a cult appeal. It is not necessary to reject the human form in order to create good sculpture. When I look at one of David Smith's *Sentinels* and a sculpture by Michelangelo such as the *Moses*, I know which is the better sculpture and who is the better sculptor.

These are the hard but essential decisions that everyone who takes the arts seriously must make. There is no point in invoking history as a subterfuge; to say that it is impossible to compare sixteenth-century work with twentieth-century work. Of course it is possible. Otherwise it would not be possible to compare work completed in 1983 with work completed in 1982. The passing of time is irrelevant when we are making judgements of aesthetic value.

To say that painting and sculpture are not at their best when they are wholly abstract is not to say that, as in all arts, an abstracting process is not involved in their creation. But the pitch of abstraction differs for the different arts; and it will for each of the arts at different times reach different levels. Then it is up to each of us to make our judgements as best we can. One of the most common mistakes of criticism is to assume that the aesthetic principles that govern one art can be applied without translation to another. So it has been said that 'all art aspires to music' or that 'architecture is the mother of all the arts'; out of which emerge programmes to 'enmusicalize' or 'enarchitecturalize' the arts as a whole. Indeed arts, like nations, from time to time, develop imperial pretensions, and seek to dominate and destroy the independence of the other arts.

To say, however, that painting and sculpture are not at their best when they become wholly abstract is not to say that there is no place for a wholly abstract visual art. There is and there always has been. For there is nothing new about abstract visual art. If figural art is a product of the palaeolithic, abstract art is a product of the neolithic, in basketry, applied ceramic design and so on. The strength of visual abstraction lies in its great decorative potential. Its very nature adapts it to a secondary role within a larger aesthetic environment. It is not itself; its purpose is to wait upon the arts of furnishing and architecture. Although the heart and soul of the abstract painter may bleed with a profound metaphysical intensity the work, more likely than not, will be

chosen because it suits the colour of the curtains and the floor coverings. And says nothing out of place. This is one of the reasons why abstract sculpture and painting have always been so attractive to architects. They find in them useful embellishments for their own art. On this view, totally abstract visual art is a kind of second-order visual art. That is not to say that it does not serve invaluable functions. But there is also a place for an independent visual art and an independent visual aesthetic that is not subservient to the aesthetics of music or architecture.

Because I played a leading part in the Antipodean exhibition of August 1959 it is sometimes thought that I am totally opposed to abstract art and can find few redeeming features in it. But this is not so. I have always accepted abstract painting and abstract sculpture as important aspects of modernism. On the other hand I have never taken the view that the whole drive of modernism was inevitable, have always taken a pluralist attitude towards modernism and have held to the view that there should be an open and continuous debate, both in the production of work and the production of criticism, between the various forms and styles cohabiting within modernism.

A most unfortunate mistake by Richard Haese, in his book *Rebels and Precursors* (1981) has tended to lend force to the view that in the early 1940s I held to dogmatic views about art.[1] What he was actually quoting were the words of Max Harris but he attributed them to me. I understand that the mistake has been corrected in the second edition.

This needs to be made clear because as an early advocate of modernism I found myself frequently in the position of making the case for abstract art when few were supporting abstraction including some critics who were held to be champions of modernism. For example, in 1947, in an effort to combat what I regarded (and still regard) as the narrow neo-romantic taste of Paul Haefliger, then the *Sydney Morning Herald* art critic, I wrote:

Painting in Sydney is becoming increasingly romantic and the tendency is being aided by 'romantic' criticism. Whether or not this movement towards romanticism will produce finer paintings we do not know. But it is certain that in the present situation some other valid forms of artistic conception, such as the impressionist, the abstract, the realist and the classical, are likely to be discredited because of the power of fashion.[2]

I was arguing here for the same pluralist position that I had argued with Max Harris in the misquoted letter of July 1943

already mentioned above. Furthermore, as organizer of the Travelling Art Exhibitions of the Art Gallery of New South Wales between 1944 and 1948 I put this pluralism into practice at a time when a majority of the trustees of the gallery were distrustful of modernism in all its forms and every one of them, with the exception of Mary Alice Evatt, was strongly opposed to abstract art. In December 1944, with Mrs Evatt's active assistance, I arranged an exhibition in the Scout's Hall, Canberra (the federal capital possessed few cultural facilities in those days), entitled 'Some Recent Australian Painting'. Consisting of one hundred paintings it ranged over the whole field of Sydney modernist art at that time: expressionism, surrealism, social realism, constructivism, cubism. Most of the paintings had to be borrowed because the gallery did not contain such works in its own collection. The exhibition included two *Constructive Paintings* by Ralph Balson and two by Grace Crowley. This was most probably the first time that either artist had been shown under the auspices of a public gallery, and years before any public gallery purchased examples of their work. The Travelling Art Exhibitions Scheme, the first fully developed scheme of its kind in Australia, was also the vehicle by which advanced modernist paintings began to enter the Art Gallery of New South Wales collection. For example, Eric Wilson's painting *Hospital Theme, The Sterilizer*, stylistically the most advanced painting at that time in the collection, was acquired in this way in 1945.

During the early 1940s, despite all the internal tensions that existed between one style and another, modernism in Australia was a genuinely pluralist movement. Artists from social realist to wholly abstract exhibited in the one society, the Contemporary Art Society of Australia. At that time an audience still had to be won for modernism in all its forms.

But ten years later the situation had altered radically. The Cold War polarized modernism. Art inspired by the politics of the left had in the early years taken various forms, sometimes surrealist, sometimes expressionist, sometimes realist. But after 1947 (in Australia) politically-inspired art came increasingly under pressure from the theories of socialist realism, long promulgated by Zhdanov and others in the USSR. The main trouble with socialist realism both as a theory and as a practice was that it was dogmatic and historicist. It claimed to be the only true art of the future: all other forms were decadent.

Something similar happened to abstract art in the USA during the Cold War years. Highly influential American critics, like

Clement Greenberg and Harold Rosenberg, each in their own way, and backed by equally influential institutions such as the Museum of Modern Art, succeeded in convincing themselves that a group of American artists had discovered a new language of art that made all other forms increasingly irrelevant and out-moded. Like socialist realism, abstract expressionism developed historicist and determinist pretensions. In the dogmas of abstract expressionism I found myself confronted with a mirror image of the dogmas of socialist realism. The extremes had met.

I must have been one of the first Australians to witness the emergence of the new American dogma and live through its growing intransigence. In July 1950, while studying in London at the Warburg Institute, I was able to visit the Venice Biennale and see an exhibition of paintings by Gorky, Pollock and de Kooning. It was apparent that these works—three drip paintings by Pollock, four black and whites by de Kooning, and five by Gorky—judged from a narrow technical and stylistic point of view, were the most experimental in the Biennale. But when compared with the magnificent paintings by Picasso, Matisse, Boccioni and the Mexicans Orozco, Rivera and Siqueiros, not to mention the magnificent sculpture by Medardo Rosso and superb drawings by Seurat (for the 1950 Biennale was one of the greatest of the post-war Biennales when it reached the peak of its fame and influence) the work of the three Americans appeared to be chaotic and brash. Pollock later achieved a lyricism and cohesion in his best work that was not present on that occasion. Arshile Gorky has always been for me by far the best of them. De Kooning's savagery of attack never seemed to add up to much and was brash and rather boring.

It was however Pollock's work to which I reacted most strongly, and with an intense dislike. It seemed to me that he was forcing painting to a pitch of abstraction beyond which it could only destroy its own traditions. Nor did the experiments possess anything like the grandeur of *Finnegan's Wake*, a parallel situation in another art. So in my catalogue beside the Pollocks I scribbled two comments. The first was that famous statement alleged to have been made by Madame Roland, 'O Liberty what crimes are committed in thy name'; the second comment was more prosaic, 'Like Alan Davie'.

Pollock's style (though still virtually unknown in Europe at that time, as Lawrence Alloway has pointed out) was not, because of a curious accident, unknown to me. Two years before Peggy Guggenheim had exhibited some paintings by Pollock in her

own collection which was exhibited in the Pavilion of Decorative Arts at the 1948 Biennale. It was there that Alan Davie saw them and was quite overwhelmed by them.[3] In the winter of 1949 he must have been one of the first painters in Europe, if not the first, to start painting imitation Pollocks. Later he developed a much more vital, emblematic style of his own.

During 1949–50 I lived with my family at The Abbey, New Barnet, where a number of other Australian artists also resided during the late 1940s and early 1950s, including James Gleeson, Robert Klippel, Grahame and Inge King, Leonard French, Noel Counihan and some others—though not all during the same years. Alan Davie also had his studio upstairs in the large house. It was there that I first saw Pollock-type painting and spent many nights arguing with him during the winter of 1949, though we remained good friends, about his new-found manner of painting and about art in general. 'It destroys too much', I would argue. 'You can't go on from there, you can only go back.' It seemed to me then, and it still seems to me, that abstract expressionism (though they hadn't agreed on any name at that time) was a *pis-aller*, that what it promised it could not deliver, that is, was wholly destructive of the painterly tradition. A point of no return.

Alan accepted that. 'But we must destroy first', he would say, 'before we can go forward.' It was an attitude that I profoundly distrusted. The futurists had said it before, even more stridently. My arguments with Alan Davie turned my attention and interest at that time to the historical sources of abstract art within the modernist movement. And here once again, circumstances were oddly fortuitous. My brother-in-law, Francis Edmunds, happened to be a well-known anthroposophist. For many years he was the principal of Emerson College, Sussex, where young teachers were trained for Rudolph Steiner schools in many parts of the world. I began to read everything I could find on Steiner, including his own varied works. One day it struck me with all the force of an illumination. Here of course lay the source, power and influence of modern abstract art. It was the *religious* art of the twentieth century and its origins lay not in the great traditional religions, but in the new syncretic religions such as spiritualism, theosophy, and anthroposophy, that had begun to emerge in the later nineteenth century with the decline of Christianity. I became aware how deeply Kandinsky had been involved in anthroposophy; and of Mondrian's involvement with theosophy. This was many years before Sixten Ringbom published his seminal article on the whole question of abstraction and the occult.[4]

One of the most fascinating and crucial parts of Ringbom's article was the way in which he documented Kandinsky's indebtedness to the little book entitled *Thought Forms* (1901), by Annie Besant and C. W. Leadbeater, in his movement from figurative expressionism to complete abstraction.

It is rather surprising therefore, having regard for Leadbeater's crucial influence on Kandinsky, that no one has taken the trouble to study his likely influence on the development of abstract art in Sydney, where he arrived in 1914, and later with his young protégé Krishnamurti established the new Liberal Catholic Church and built the Star Amphitheatre at Mosman where the faithful bought seats to sit and await the Second Coming of Christ. That was in 1926.[5]

In the 1920s the Sydney Theosophical Lodge, with a membership of up to 800, was reputed to be the largest in the world. I find it difficult to believe that the strength of the spiritualist and theosophical presence in Australia in the 1920s had little influence upon the movements within modernism towards abstraction in art here. It always seemed symptomatic that for many years the Sydney branch of the Contemporary Art Society met in Adyar Hall, the Sydney headquarters of the Theosophical Society. Yet artists who have been touched by or who have dabbled in the occult are often excessively shy about their links with these modernist religions. Writing about Mondrian, Michel Seuphor observed:

Mondrian was long interested in theosophical speculations. As late as 1916 the portrait of Mme Blavatsky hung on the wall of his studio. Yet in his writings he made no mention of his theosophical sympathies. Even in private conversation he avoided religious topics and closed up at the slightest hint of them.[6]

Until Ringbom's important research the historians of abstraction maintained a similar reticence, perhaps through ignorance. A full investigation between spiritualism, theosophy and anthropology and their links with modernism is long overdue in Australia. One might well begin with the work of Georgiana Houghton, the spiritualist medium who produced wholly abstract art in England in the late nineteenth century and later sent many of them to Australia.[7] That was many years before its 'official' birth as noted in the art history textbooks. Was Georgiana the first abstract artist? Probably not. Spiritualist mediums may have produced abstract drawings and paintings even earlier in the

USA and Europe. The matter awaits investigation, but it is time we discarded the official art history version that it all began some time around 1910.

My gradual realization during the 1950s that the strong drive towards abstraction that was clearly present within modernism had its ultimate source in, and derived its ideological support from, the modernist religions did not mean that abstract art became any more attractive to me. I had spent a difficult adolescence liberating myself first from the Calvinism of my foster parents and then from my mother's Catholicism, so I possessed no predisposition to become involved in syncretic religions. It all began to make sense. Abstract art was the modernist mode of iconoclasm. The fear of the image was the fear of the human. The great metaphysical power that had always resided in the traditional forms of abstract art (in Islam, Jewry and the iconoclastic phases of the Orthodox Church) was directed towards the reduction of humankind towards a condition of abjection when confronted by unknown spiritual forces within the cosmos and within the self. A dialectic had always existed within the great religions between an abasement and an exaltation of humanity. The basic contradictions within the dialectic are beautifully expressed in St John's Gospel. On the one hand we read: 'God is a spirit and those that worship Him must worship Him in spirit and in truth' (IV.24). That, in a nutshell, represents the iconoclast's position. But we also read: 'And the Word was made flesh, and dwelt among us (and we beheld his glory, the glory as of the only begotten son of the Father), full of grace and truth' (1.14). That, also in a nutshell, is the theological justification for the figural art that has prevailed in Western Christendom. And to this latter position I still adhered while recognizing the need for some continuing tension between humility and pride. But I rejected the notion of humility before the Unknown. Before the Unknown, one had a duty to enquire.

So for me at any rate a totally abstract art became in metaphysical as well as in aesthetic terms a kind of second-order art, one that was not itself but served the decorative or spiritual needs of more powerful Others. But even so it had its acknowledged place within the plurality of modernism. So I have continued to enjoy abstract art, have added examples of it to my own small collection from time to time.

Abstract art as one mode among many was a perfectly acceptable situation. But during the 1950s, as is well known, a special

Jackson Pollock *Blue Poles*. Oil, enamel and aluminium paint, glass on canvas, 212 × 489 cm, 1952.

Georgiana Houghton *The Holy Trinity*. Water-colour, 32.5 × 23.5 cm, 1861. One of the earliest modern abstract paintings.

variety of abstraction that came to be known as abstract expressionism began to be strongly promoted by some extremely powerful and influential art museums in New York, and equally powerful and influential New York families, art dealers and critics. This style, and this style alone, was the rightful heir to the art of all the past and was creating the new language of art for the future. It was in one sense New York's answer to Moscow's socialist realism; and the arguments were couched in those unilinear, determinist and historicist terms that were all too familiar. Unfortunately in the fabrication of this artificial hegemony of values the reputations of many second-, and even third-rate artists, like Robert Motherwell, Ad Reinhardt and Phillip Guston, to name but a few, were rated far above much better American artists, such as Edward Hopper, who did not conform to the hegemonic style.

I was extremely lucky to be able to see prime examples of abstract expressionism in Venice in 1950 at a time when the mythological packaging had barely begun, and I could see the paintings without being brain-washed by the reputations of the artists. So much has already been written about that packaging process, its relation to the Cold War and so on, that it is unnecessary to add much here. But it is perhaps worth mentioning the brilliant review article recently written by Fred Orton and Giselda Pollock, which demonstrates how photography was used to promote the Jackson Pollock myth.[8] But the most powerful argument in the armoury that launched abstract expressionism on its flight into the aesthetic stratosphere was the historicist one. Alfred H. Barr junior, then Director of the Museum of Modern Art, was already making good use of it in the introductory notes to the work of Gorky, Pollock, and de Kooning in Venice in 1950.

Diverse names have been chosen in America to describe this predominant avant garde: symbolic abstraction, abstract expressionism, subjectivism, abstract surrealism. In a general sense the movement descends from Gauguin, Van Gogh, and Redon, passes through the Fauves, Kandinsky and Klee, and then by Arp, Miro, Masson and the Americans Dove and Tobey, finally to the young generation of today. In the United States three of these young leaders are Gorky, Pollock and de Kooning.[9]

Greenberg altered the patrimony a little, brought in Manet and the late Monet, tipped out the surrealists, and so forth, but used the same unilinear device. It was a superbly successful exercise in the use of history to create an aesthetic national mythology.

The package complete, the Museum of Modern Art, through its

International Programme, began to export the thing. I watched the process, intermittently, for almost ten years with a growing sense of irritation and impatience, and then in February 1959 took the first steps that led to the creation of the short-lived Antipodean group.

It is not possible to assess the significance or effects of the Antipodean intervention here. That must await another occasion. But two points can be made briefly. First, that nationalism was never a real issue. The intervention took place in order to re-assert the plurality, diversity and vitality of art in the twentieth century. What the Antipodean artists were asserting, young British and American artists were also beginning to assert in a parallel but different way: their right to define the character of their own contemporary cultures. In that case it took the form of Pop Art. No one has yet taken the trouble to place the 'Antipodean' exhibition and manifesto in its international context.[10] The wrong questions have always been asked. Who were the first group of artists to publicly challenge the aesthetic values of the New York hegemony: were they Italians, French, Mexicans, Australians? The second point that must be noted was that in Australia the issues that the *Antipodean Manifesto* raised were for the most part not debated. Abstract art? Figurative art? What did it matter. The only thing that mattered was whether it was good or bad art. Why disturb the great Australian cultural slumber with such ridiculous questions? Most of our so-called critics went soundly to sleep again until the same questions began to be asked in New York itself. Then, provincial to the backbone, they began to sit up and take notice.

What then of the future of abstract art? A mode that can trace its history back to neolithic times and has received a tremendous boost in the twentieth century will surely possess an increasingly important future. There are bound to be—perhaps the time is already upon us—neo-abstract and perhaps even neo neo-abstract movements. For there is such an enormous quantity of it about still, in artists' studios and the back rooms of dealers' galleries, lying half-forgotten but steadily acquiring the acceptable historical patina. The art forms that set out to destroy the past will be accepted as part of the past. Abstract art will become one of the categories of art like portraiture, landscape, still-life, one among others in the academic hierarchy. But it is unlikely that the attempt to devour all others with the help of History will be tried a second time.

17
The Antipodean Manifesto
—1959—

Let it be said in the first place that we have all played a part in that movement which has sought for a better understanding of the work of contemporary artists both here and abroad. Indeed, we are, in no uncertain sense, members of the modern movement in art. We take cognisance of all that has happened in art during the past fifty years—not to do so would be folly.

But today we believe, like many others, that the existence of painting as an independent art is in danger. Today *tachistes*, action painters, geometric abstractionists, abstract expressionists and their innumerable band of camp followers threaten to benumb the intellect and wit of art with their bland and pretentious mysteries. The art which they champion is not an art sufficient for our time; it is not an art for living men. It reveals, it seems to us, a death of the mind and spirit.

And yet wherever we look, New York, Paris, London, San Francisco or Sydney, we see young artists dazzled by the luxurious pageantry and colour of non-figuration. It has become necessary therefore for us to point out, as clearly and as unmistakably as we can, that the great Tachiste Emperor has no clothes—nor has he a body. He is only a blot—a most colourful, elegant and shapely blot.

Modern art has liberated the artist from his bondage to the world of natural appearances, it has not imposed upon him the need to withdraw from life. The widespread desire, as it is claimed, to 'purify' painting has led many artists to claim that they have invented a new language. We see no evidence at all of the emergence of such a new language nor any likelihood of its appearance. Painting for us is more than paint. Certainly the non-figurative arts can express moods and attitudes, but they are not capable of producing a new artistic language. We are not, it seems to us, witnessing in non-figuration the emergence of an

utterly new form of art. We are witnessing yet another attempt by puritan and iconoclast to reduce the living speech of art to the silence of decoration.

Art is, for the artist, his speech, his way of communication. And the image, the recognizable shape, the meaningful symbol, is the basic unit of his language. Lines, shapes and colours though they may be beautiful and expressive are by no means images. For us the image is a figured shape or symbol fashioned by the artist from his perceptions and imaginative experience. It is born of past experience and refers back to past experience— and it communicates. It communicates because it has the capacity to refer to experiences the artist shares with his audience.

Art is willed. No matter how much the artist may draw upon the instinctive and unconscious levels of his experience a work of art remains a purposive act, a humanization of nature. The artist's purpose achieves vitality and power in his images. Take the great black bull of Lascaux, for example, an old beast and a powerful one, who has watched over the birth of many arts and many mythologies. He is endowed with a vitality which is an emblem of life itself. Destroy the living power of the image and you have humbled and humiliated the artist, have made him a blind and powerless Samson fit only to grind the corn of Philistines.

As Antipodeans we accept the image as representing some form of acceptance of, and involvement in life. For the image has always been concerned with life, whether of the flesh or of the spirit. Art cannot live much longer feeding upon the disillusions of the generation of 1914. Today Dada is as dead as the dodo and it is time we buried this antique hobby-horse of our fathers.

When we look about us there still seems much to be done in art worth doing. People, their surroundings and the past that made them are still subjects, we should like to point out, worthy of the consideration of the artist. We are not, of course, seeking to create a national style. But we do seek to draw inspiration from our own lives and the lives of those about us. Life here in this country has similarities to life elsewhere and also significant differences. Our experience of this life must be our material. We believe that we have both a right and a duty to draw upon our experience both of society and nature in Australia for the materials of our art. For Europeans this country has always been a primordial and curious land. To the ancients the antipodes was a kind of nether world, to the peoples of the Middle Ages its forms of life were monstrous, and for us, Europeans by heritage (but not by birth) much of this strangeness lingers. It is natural therefore that

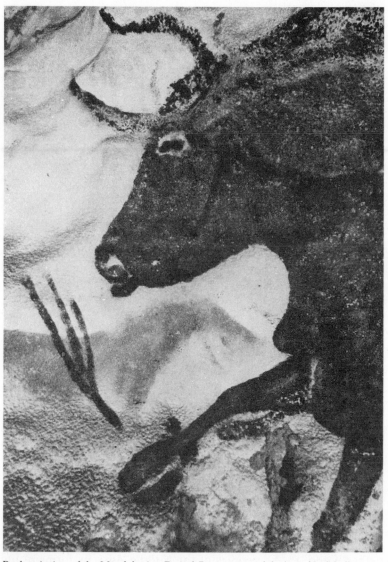

Rock painting of the Magdalenian Period *Forequarters of the large black bull*, c. 30 000 BC.

we should see and experience nature differently in some degree from the artists of the northern hemisphere.

We live in a young society still making its myths. The emergence of myth is a continuous social activity. In the growth and transformation of its myths a society achieves its own sense of identity. In this process the artist may play a creative and liberating role. The ways in which a society images its own feelings and attitudes in myth provides him with one of the deepest sources of art.

Nevertheless our final obligation is neither to place nor nation. So far as we are concerned the society of man is indivisible and we are in it. When we think of all that has happened to people like ourselves during the last fifty years we know that we do not fully understand them—and we want to. How can they bear living? But they do. So we want to ask questions. If such an aim is impure then we would say that purism leads to puritanism, puritanism to image-smashing, and image-smashing, after an Indian summer of decorative luxury, to the death of art.

If the triumph of non-figurative art in the West fills us with concern so, too, does the dominance of socialist realism in the East. Socialist realism, as we understand it, places too many restraints upon the independent creative activity of the artist for it to produce work of vitality and power. We wish to stress that in defending the image we are not seeking to return to naturalistic forms of painting and sculpture but are defending something which is vital to the life of art itself.

We want to say, finally, that we are more directly concerned with our own art, more involved in it, than in anything else. This is not escapism. It is simply a recognition that the first loyalty of an artist is to his art. Today that loyalty requires, beyond all else, the defence of the image.

Charles Blackman, Arthur Boyd, David Boyd, John Brack, Bob Dickerson, John Perceval, Clifton Pugh, Bernard Smith

18
The Truth about the Antipodeans
—1984—

It is twenty-five years now since the Antipodeans exhibition was held in August 1959 at the Victorian Artists Society's galleries at Albert Street, East Melbourne. Six artists then resident in Melbourne—Charles Blackman, Arthur Boyd, David Boyd, John Brack, John Perceval and Clifton Pugh, and one Sydney artist, Robert Dickerson—participated. My own name also appeared on the catalogue because I played a central part in the formation of the group and because I was given the task of preparing a manifesto from a number of discussions and written statements prepared by some of the artists. This manifesto was designed to support and defend the kinds of figural art within which these artists worked and oppose those kinds of abstract art which we perceived at the time to be threatening to become the dominant language of contemporary painting and to render all others *démodé*.

Although the exhibition created a great stir at the time and provided a word that has come to be used, quite misleadingly, for a whole generation of figural artists of the 1940s and 1950s, surprisingly little curiosity has been shown concerning the actual events that led to the creation of the Antipodean group, of relating their aims as a group to their aspirations as individuals, of assessing their influence in promoting a knowledge of Australian art in London during the 1960s, or of the after-effects of the Antipodean exhibition upon the history of pictorial taste since 1959.

Most who have occasion to refer to the Antipodeans at all rely upon hearsay to support their own, usually highly prejudiced, views or have, at best, turned to the one readily available source, Barbara Blackman's article entitled 'The Antipodean Affair' published in *Art and Australia* in 1968, nine years after the event.[1] Barbara's article is sensitive to the issues involved and contains some acute judgements but it is written from the viewpoint of an

apprehensive wife (and there was more than one of them) who was not privy to the group's formal meetings. Furthermore her account relies excessively on an unpublished statement written by David Boyd in February 1967 based on his memory of what occurred seven years before. Neither Barbara nor David chose to check their accounts with the actual documents that relate to the group's meetings and decisions.

I must bear some responsibility for this state of affairs, because many of the key documents have remained in my possession, though I have made them available to those who have had a good reason to consult them. But, personally, I have found it better to let the tempers cool and time pass. My teacher and friend, the late Professor J. W. Davidson, in his inaugural lecture to the Chair of Pacific History in the Australian National University in 1955, summed up my feelings in an epigram that I have always kept in mind. 'The historian is like the farmer', he said, 'he must wait upon the seasons.'

During the later 1950s John Perceval, Charles Blackman, and Clif Pugh sometimes painted together. One day in early 1959 they worked together in the countryside near Strathewen (Victoria), then returned to Clif Pugh's home at Cottle's Bridge for dinner. Over drinks they looked at their work together with David Boyd who had been looking around the area with a view to buying a block of land. They came to the conclusion that it would be interesting to have a group show that revealed how each of them had responded differently to the same or similar scenes.

Meanwhile, however, opinion among most of Australia's influential art critics had begun to swing strongly in favour of abstract art. I viewed all this with increasing concern. I became involved in the local art scene in 1939 just as the second wave of modernism began to break onto Australian shores. Unlike the first wave, the post-impressionist wave, it was essentially plural in character, combining as it did surrealism, expressionism, social realism, and the more advanced styles that had developed from the post-impressionist heritage, such as cubism and constructivism. Unlike post-impressionism, second-wave modernism brought a new sense of liberation and vitality to Australian art because it provided, in the realm of high art, a certain degree of social and aesthetic space for moral and political involvement. And the maintenance of this social and aesthetic space depended to a very large extent upon the pluralist nature of second-wave modernism. If however, as the critics were then beginning to

proclaim, the future now lay entirely with abstraction, it was clear that this space would be seriously threatened if not destroyed. Artists would be faced with a new and highly insidious kind of censorship proceeding not from a moral or religious point of view—that kind of censorship modernism had learned to combat successfully—but a censorship that had been constructed within the aesthetic realm itself and to which artists working figurally had no ready answer.

I felt a high degree of loyalty to the contemporary figural artists who first began to exhibit in the early 1940s. By 1959 I already knew John Perceval and Arthur and David Boyd as close friends for some years. But my involvement with their work went back much earlier than that. Arthur Boyd and John Perceval exhibited with the Contemporary Art Society for the first time in its third exhibition in 1942. I saw their work in that exhibition for the first time when it was shown in Sydney, and reviewed it at length in one of my first essays in art criticism, which was published in *Education*, the journal of the New South Wales Teachers' Federation, in February 1943. In my review I suggested that the work of Arthur Boyd, John Perceval, Josl Bergner and a little-known Sydney artist, Nan Hortin, constituted an important new grouping within Australian contemporary art and after discussing what I considered to be some of its deficiencies concluded that it was nevertheless 'the most vital movement in Australian art today'.

In 1959, some seventeen years later, however, that same movement—if we may call the uneasy mix of surrealism, expressionism and realism a movement—was under serious threat, just at a time when some of the artists concerned had begun to produce their best work. It seemed to me that something should be done about it, and done quickly. With that end in view my wife and I asked David and Hermia Boyd over for drinks on the Sunday afternoon of 15 February 1959 at our home at Beach Road, Sandringham. I knew that David would be interested. He was enthusiastic about my plan for a group show of artists at which some statement could also be made defending figural art; but he also told me of the plan for a group show that had arisen a week or so before at Clif Pugh's place. The day following I discussed our plan with John Brack. He too was keen that something should be done to assert the continued vitality of figural art. Then three days later we held our first meeting (as indeed we held all our meetings) at John Perceval's home in Canterbury. All the members who later came to constitute the Antipodean group were present

at that first meeting. So it could be said that it came into exist-
ence as the result of two distinct initiatives: first the idea of a
group show decided upon at Cottle's Bridge and the agreement
reached by David Boyd and me at Sandringham, and supported
by Brack, that some defence of figural art should be undertaken.
The only artist added to the group was the Sydney artist Bob
Dickerson.

At that first meeting I was elected chairman and John Brack, a
little reluctantly, agreed to act as secretary and treasurer *pro tem*.
John's minutes of the meeting, more a résumé, were brief, dry
and to the point. But they give something of its flavour. I quote:
'An inconclusive argument about beliefs. Everyone to set out
some form of credo on a teeny piece of paper within a fortnight.
A name—Antipodean Brotherhood (BS's suggestion) tentatively—
because "Brotherhood" not universally accepted.' That was one
of John's characteristic understatements. When I suggested 'Anti-
podean Brotherhood', John Perceval broke out in a raucous guffaw
and quickly laughed the proposal out of court. He wasn't a monk
he said. Then it began to tickle his fancy and he insisted on
calling me 'brother' wherever we went. It wasn't the brightest of
notions I admit; I must have been lecturing on the Pre-Raphaelite
Brotherhood overmuch the year before. But at least it does reveal
what I had in mind: a small group with a defined position.
Additional members were discussed at that meeting, though
John Brack's minutes do not record them. The names of Leonard
French, Noel Counihan and Fred Williams were certainly can-
vassed. I was personally not in favour of any additions. This had
nothing to do with the quality of the work of these artists. I had a
closer and longer connection with both Noel Counihan and
Leonard French, and a greater personal interest in their art than
in that of Clif Pugh or Bob Dickerson. But I felt that both the
work of Fred Williams and Leonard French were sufficiently
semi-abstract at that time to make it highly unlikely that they
would commit themselves to a head-on criticism of abstraction;
and that is what I had in mind. As to Noel Counihan, I felt that it
would be essential to the success of our undertaking to include a
statement that was critical of socialist realism as the orthodox art
of the Eastern-bloc countries. I had no idea how Noel would react
to such a proposal and I did not want to be placed in the position
of having to test it. For me there has always been a clear distinc-
tion between social realism and socialist realism; one is an art of
criticism, the other an art of hero-worship, a kind of classicism.

202 Abstract Art and the Antipodean Intervention

But I did not know whether Noel Counihan was prepared to make the distinction sufficiently to be critical of socialist realism. To this extent the *Antipodean Manifesto* became, as Terry Smith has suggested, a Cold War document. But I trust in the best sense. It confronted two kinds of art that were both claiming to be the exclusive art of the future; but the immediate danger to the vitality of Australian art was coming not from socialist realism, which had been virtually eliminated under the pressure of the Cold War from Australia's high art scene, but from the unthinking and naïve champions of abstraction.

My basic reason, however, for not wanting to enlarge the group was wholly pragmatic. The more members we had, it seemed to me, the more the manifesto would be reduced to the lowest common denominator of group opinion, a set of platitudes; not a manifesto at all.

In the end we agreed not to add to our number and the question of new members was not discussed until about twelve months later. It was also agreed the exhibition should be held at the Vic Arts, and that members should feel bound by some solidarity and should keep our proceedings 'confidential' until at least the next meeting. In fact as soon as we left most of us began to leak like sieves, to our wives and everyone else. The element of parody and self-parody about the whole Antipodean affair should not be underestimated. We also discussed a London exhibition which was my main objective; and I was asked to write to Sir Kenneth Clark, and seek suggestions as to the most suitable gallery. This second exhibition, it was agreed, might first be shown in Adelaide on its way to London. The letters I wrote to Clark and Kym Bonython at that time provide a more complete idea of our plans than John Brack's cryptic minutes.

'The London exhibition which we have in mind', I wrote to Bonython on 21 February,

is, I am sure the kind of work that can do most to make Australian art known abroad. For this will be a group small enough and coherent enough to make a single impact on British opinion. It will follow up and develop the impression created by artists like Nolan, Tucker and Drysdale. Whilst I like some local abstract and semi-abstract work here quite a lot, I am sure that the overseas public will not be interested in the work of our local non-representational painters. For the great bulk of it simply cannot compare with the best kind of work done in England and America—they are looking for something original from the Antipodes—not pale reflections of the things they are familiar with.

Prior to the second meeting, held on 7 March, I received state-
ments from Brack, David Boyd, Pugh and Blackman. From them I
wrote a first draft of the manifesto, which I read at the meeting.
Approval was given to the general substance and various sug-
gestions for changes made. The rest of the meeting was given
over to plans for the August exhibition. At the third meeting, on
the 22 March, it was agreed that the name of the group should be
Antipodeans and there was much dispute, all inconclusive, over
the manifesto. I read a reply from Clark who had said that he was
interested in the formation of the new group. 'I think', he wrote,
'the best suggestion [for a gallery] is already contained in your
letter: Whitechapel Art Gallery. Bryan Robertson, the director, is
an unusually intelligent and enterprising man.'

A few days after the third meeting I received a note from John
Perceval. 'I asked Tim Burstall', he wrote, 'to write some of his
ideas out on this matter. There is nothing new from yours. And
certainly no disagreements. There are perhaps some quite nice
phrases you may or may not use.' Now I had been sweating over
various drafts of the manifesto for over a month and trying to
reach a consensus at the meetings. Our proceedings were sup-
posed to be confidential, though I knew that they were beginning
to be discussed at well-known artists' watering holes both in
Melbourne and Sydney such as the Swanston Family and the
Newcastle. But it annoyed me to think that even the written
drafts of a manifesto we had not yet agreed upon were being
shown around. Tim Burstall was not a member of our group, did
not attend any of our meetings, and I felt that his statement was
no more than a rather dull paraphrase of what I had already
written. So I came to the fourth meeting, held on 3 May, deter-
mined that we should talk it out and reach a conclusion. John
Brack's cryptic minutes provide a summary of the ensuing dis-
cussion: 'Manifesto. 2nd version. Charles Blackman. no objection.
Arthur Boyd. no objection. David Boyd. Objection to the omission
of the sentence *the artist is a moralist who does not moralise*'. (I had
removed the sentence to satisfy Brack.) The minutes continue:

A good deal of fratricidal argument. John Brack. Objection about myth
paragraph. Enough change made to satisfy John Brack. John Perceval.
Objection about *death of image*—this condoned to some extent by
B. S. Clif Pugh. Objection to *we too have eaten the apples of Paul Cézanne*.
A great deal of argument.

His note then concludes 'The manifesto passed!' It was also

agreed that the manifesto should be first published in the exhi-
bition catalogue and not shown around before the opening day.

The manifesto is thus best seen as a syncretic document in
which I tried to include varied, at times conflicting, points of
view. The biggest problem was to reconcile the views of John
Brack and David Boyd. I succeeded in convincing John that it was
better the varied points of view were asserted than that we
should be reduced to the lowest common denominator of our
opinions. But I also saw the manifesto as my special contribution
to the show; my work of art if you like. And I was aware of it as a
literary form, and as having the stridency and assertion of the
classics of the genre, the Communist Manifesto and the futurist
manifestos much in mind. This recognition of the manifesto as a
literary form has completely escaped its critics as has the element
of self-parody present in the Antipodean affair, despite the high
seriousness at the heart of the matter. Robert Hughes, for ex-
ample, complained that I hadn't defined 'life' or 'art'. I wasn't
writing a dictionary. When I wrote 'Dada is as dead as the dodo
and it is time that we buried this antique hobby horse of our
grandfathers', others complained that I was ignorant of neo-Dada.
It was precisely neo-Dada that I had in mind. It seemed to me
that the true anarchy of the First World War Dada was now
being revamped for sordid commercial reasons in the large glass
cabinets of the international art museum establishment.

No more formal meetings of the group were held prior to our
exhibition, which was managed effectively by Elizabeth Sum-
mons. Blackman designed an attractive poster inspired by images
of mediaeval Antipodeans racing about intent upon stabbing other
fellow artists and perhaps even themselves in the back. We heard
rumours of a backlash developing in Sydney. I was born in
Sydney and had spent most of my life there and had known
Elwyn Lynn since 1939. I maintained a friendly correspondence
with him through 1959, even though I knew that by that time he
was the most effective, if somewhat cautious, protagonist of the
American modes of abstraction then at last becoming better
known in Sydney. In a letter to me of 29 June 1959, he told me
that he had already seen a copy of the draft manifesto that Boyd
had sent to Dickerson. I realized that trouble was brewing, that
we had begun to stir the possum.

David Boyd has captured the excitement of the opening very
well: 'At last the great day arrived. It was a mighty impressive
exhibition. The Vic Arts had never seen such a crowd. The gal-
leries, balconies, and stairs were packed with an unusually

Charles Blackman *Antipodeans*. Exhibition poster, 35.5 × 43 cm, 1959.

animated assembly. The response was tumultuous.' For Charles Blackman the show was a personal triumph. He had never shown better paintings. Let me quote from the statement he sent for the manifesto:

It is important for the artist to journey into the unknown. There is no real challenge in the non-figural art of today. It is often difficult for people to understand the difference between the extremely achieved balance and aesthetic of non-figural art and the concentration on the image by the artist more concerned with the search for an unknown fresh image, and by preoccupation with the psychologically potent aspects of the visual arts, he often sacrifices an obvious realization.

John Brack exhibited a series of paintings of children playing at school. 'When we look about us', he wrote in his statement for me,

there still seems much to be done, the people, their surroundings, and the past that made them. The painter may ask questions, and there seem many to ask. We do not of course have any aspirations to create a national style—such things are now, in any case, an anachronism—but we do draw inspiration from our own life and the life we see about us. It has similarities to life elsewhere and also significant differences. Our experience must be our material.

John Perceval exhibited five paintings of Williamstown port and nine of his ceramic angels. My colleague Franz Philipp (in the Department of Fine Arts, University of Melbourne, at that time) who wrote the only detailed and considered review of the exhibition, said: 'Perceval's ceramic craftsmanship is both dazzling and sensitive, especially in his handling of oscillating glazes and pierced forms. These small figures have a sculptural vitality, an impish exuberance which reminds me of South German rococo.'[2]

Bob Dickerson exhibited five quite moving paintings of lonely, socially alienated people. 'My aim in painting', he wrote in a note to me, 'is to paint life as I see it or feel it around me, people and their reactions towards living today. That is all, except that I like painting, it gives me a very real purpose which I never had before.'

Clif Pugh exhibited nine paintings mostly of figures in land-scape. 'I believe', he wrote in his statement to me,

art must be indigenous...arising out of the environment and back-ground of a particular place and time. This could be nationalistic but I prefer to call it geographical art. For instance, Chinese art and Mexican art reflect the background and the 'soul' of the country but are also universal. Even Picasso though he lived in France most of his life, is very

Spanish in form and feeling—perhaps not so much Spanish as a particular area of Spain (Basque, etc.). I therefore believe very much in the development of an Australian art—it is the only truth for us to express to the rest of the world.

I was myself particularly interested in the kind of work Arthur and David Boyd were doing at that time. Arthur did not provide any notes for the manifesto, but he attended all meetings, took part in them, and has always said to me that he wholly approved of the manifesto. Franz Philipp, who was a close friend of Arthur, was deeply impressed by the work in this show. Comparing the works with earlier works of the same bride and bridegroom series he wrote: 'the figures are more plastically conceived, the drawing is firmer, the image acquires new monumentality... He has never stood still'.[3]

David Boyd's work, considered from a purely aesthetic point of view, was less successful. As Philipp rightly pointed out: 'myth-making is not a light-hearted adventure. There have been many wrecks on the cliffs of melodrama and David Boyd in his Tasmanian Aboriginal series has not always avoided them...' In one painting however, *Truganini, the last of the Tasmanian Aborigines*, Philipp conceded, 'the tragic image comes true'.

David Boyd's capabilities as an artist had been established in the high quality of his ceramics. The problems with his Antipodean paintings derived rather from the intractable character of the subject matter he was dealing with. He had begun to fish in the deep, troubled waters of the Australian psyche and chose to make his intentions more patently clear than his brother Arthur. Philipp noticed the element of melodrama but missed I think the elements of parody and almost self-parody by which David Boyd was attempting to maintain a grip on the subject. He sent me three pages of notes for the manifesto. I quote the two opening sentences:

I believe the artist to be a kind of moralist. Through his awareness and vision, yet without moralising or prophecy, he communicates images, that reflect not only the achievements but also the weakness and suffering of man. By moralist I mean the artist's function to continually remind the community of the need to adhere to human values.

The response of the newspaper critics ranged from coolly neutral to dismissive; sales did not much more than cover expenses. Some did better than others. We had polarized attitudes; and tension began to run high in the art world. We all felt it personally. One morning I ran into Len French in the vestibule of

Spencer Street station. It must have been just before the opening. We were old friends, having lived in the same art community at the Abbey, Barnet, London during 1950 and a few months before I had played a part in securing him an important commission at Melbourne University. But now Len greeted me in a state of suppressed anger. 'First', he said, 'you got on the backs of the social realists and now you're on the back of these boys.' Len may have felt outraged at not being asked to join, for he knew most of us well. A few days after the opening Dickerson, down for the show, phoned me. Len French had convinced him that he should resign from the group. I could not dissuade him, though only a few weeks before Dicko had written to John Perceval: 'to sum up the whole thing. I'm delighted and if we all pull together we stand a much better chance than on our own'. Doubtless as the sole Sydney member he felt vulnerable and had not had the same opportunity as we had had to participate in the discussions prior to the exhibition.

The tensions that attended the aftermath of the exhibition have been beautifully captured by Barbara Blackman:[4]

On the crisis day of the hanging, the catalogue arrived from the printer and there before them undersigned by each was the undeniable testament. The art was done and there on the walls to be judged, the Manifesto was there in print to be preyed on by the press then and thereafter... This was the trauma. The group now took on the character of a gang who, having planned a raid and concentrated the preparations on the mechanics of tool, timing and terrain, suddenly at a report stand back to find that the watchman has been shot and lies dead at their feet. The printed Manifesto lay there like a *corpus delicti*. Each recoiled, retreated in guilt and confusion, and has ever afterwards sought to find extenuating circumstances for his regrettable irresponsibility.

The last sentence is somewhat overstated. No member of the group to my knowledge has ever publicly dissociated himself from the manifesto, though most members chose to distance themselves from the event for a variety of associated reasons: none wished to appear intolerant of other kinds of art, or to set themselves up as a self-appointed academy; they wished to sustain their network of friendships and perceived their complicity in the affair as a possible threat to their reputations; and since most had families to support they could not afford to allow that to happen. 'An unexpected and not unamusing aftermath', David Boyd wrote,

was that many admirers of Arthur, Charles, John Perceval, John Brack, Clif and Bob, who were displeased with the artists' part in the affair, and

wishing to keep unvarnished their admiration, solved their problem by placing the entire blame on Bernard's and my shoulders. The others were forgiven and we two likened to evil persuaders who led gentle souls like Arthur and Charles away.

The manifesto certainly became an obvious scapegoat for the whole exercise. Views about it differed sharply. The most favourable came from abroad. 'Thank you for your letter and for sending me the Antipodean Manifesto', wrote Sir Kenneth Clark to me on 26 August. 'I agree with a great deal that the Manifesto contains, and I like the vigorous way in which it is worded. Sometimes it seems to go a little bit outside the proper scope of a group of painters...however, I suppose that such comprehensiveness is really part of the group's aims.' About the same time that I received the letter from Clark, John Perceval's wife Mary (now Lady Nolan) received a letter from her uncle, the novelist Martin Boyd:

This is just to say that the Antipodeans' catalogue and the photographs of John's figures arrived today. It is very good of you to send them and I am delighted to have them. First of all I must say how *absolutely* I agree with the *splendid* manifesto in the catalogue. It is a complete knock-out blow for the hoaxes and deathly humbugs. It is brilliantly expressed. Who wrote it? Of course it will provoke a host of enemies. Every word tells, and the diagnosis is penetrating. I have never read so much sense in so few words! It is more than sense. It is wisdom. It is the truth, and unanswerable...

And towards the end of the letter he wrote, 'I am always trying to point out the puritan origin of the cult of death, which the manifesto does so emphatically'.

On the other hand Tim Burstall, the film-maker, found 'too many anomalies and approximations to condone', and David Armstrong, the philosopher, who possessed a friendly relationship with several members of the group, is said to have confided to Clif Pugh that 'he could not render the verbiage into academically acceptable English'. So far as I know David hadn't been asked to.

The one thing that held the group together during the tense months that followed their Vic Arts show was the possibility of an exhibition in London. And this brings me to the curious end game of the affair that was played out, and about which so little is publicly known. I wrote to Robertson, Curator of Whitechapel Gallery, first in April and then again in early September 1959. To neither letter did he reply. When I explained the situation to him, Sir Kenneth Clark replied, 'Robertson is very elusive'. And so

indeed I was to find. I asked Dr Ursula Hoff, who was in London at the time, whether she could possibly contact Robertson, tell him something about the Antipodeans, and take up the question of a show at Whitechapel. On 21 October Dr Hoff replied, 'I have made several more attempts at getting in touch with Mr Robertson at the Whitechapel and am always told he is: a) away b) will come in later c) has not come in after all d) is ill e) is involved in a book.'

Reasons can be found for Robertson's failure to reply. He was trying desperately to finish a book, and Hal Missingham, the Director of the Art Gallery of New South Wales, having learnt through the artists' grapevine that the Antipodeans were planning a London show, had apparently written to Robertson suggesting an exhibition of contemporary Australian art. With two requests from Australia, he was able to convince the British Council, no doubt with Sir Kenneth's support, that he should visit Australia, give some lectures on contemporary British art, and there himself make a representative selection of contemporary Australian art for the Whitechapel.

At that time in Australia and England, to most people in any way involved, it must have seemed only too apparent that a representative collection of contemporary Australian art, chosen by an Englishman with a high reputation in his field and, as Clark himself had observed, 'an unusually intelligent and enterprising man', would be far better equipped to assemble a show that would impress the sophisticated London audience than a small group of Melbourne-based figural artists accompanied by a highly provocative and contentious manifesto. But I realized that a fatal mistake, in all probability, was about to be made so far as the reception of contemporary Australian art in London was concerned.

It was at that stage that the last of the formal meetings of the Antipodean group was held on 29 January 1960. John Brack's brief minutes record only that new members were considered: Jon Molvig, Albert Tucker, Sidney Nolan and Fred Williams. It was hoped that it would still be possible to obtain a London venue for an Antipodean group show even if the Whitechapel Gallery was not made available. Considering the intensity of the criticism during the previous six months none of us felt very confident that any of the new members might join but I think that we felt that at least the possibility of a London show might tempt them. In the event, however, this was never an issue for them, for they were all included, as were all the members of the

Antipodean group, in Robertson's Whitechapel exhibition of con-
temporary Australian art held in 1961. All our invitees, except
perhaps Molvig, sent a polite letter of refusal.

My reasons for distrusting the effects of the kind of show
Bryan Robertson had in mind are best understood from the letter
I wrote to Sidney Nolan on 2 February 1960, seeking his member-
ship of the group:

we were keen to hold a show at the Whitechapel Gallery but Bryan
Robertson is coming out to Australia this year, and our plans have cut
across a plan for an exhibition of contemporary Australian art. Such a
show may well be what is needed—but I cannot help thinking that a
show which is based on a genuine artistic principle or issue is of more
moment than one which must be based on national lines. It is not
because the Italians were Futurists that we remember them but because
they had certain notions about dynamic movement and modern
industrial life, or that the Impressionists were French, but because they
had certain ideas about painting the effects of light. And if a group of
Australian artists are prepared to stand up for the image, and paint so,
and say so, that is not nationalism but something every artist in the
Western world can understand and agree with or disagree with. But the
paintings have to be good and the painters have to suppress their own
natural tendencies towards anarchic individualism sufficiently only to
support this one idea that the image is worth defending.

Robertson came to Australia later in 1960 and, apart from one
very uncomfortable formal dinner at Melbourne University, care-
fully avoided me. However, he assembled an excellent exhibition
of predominantly figural work in which all the Antipodeans,
among others, were represented. But the point of view from
which he presented it became a long-term disaster for the recep-
tion of Australian art in Europe. For according to Robertson, and
a bright young undergraduate in architecture from Sydney
University named Robert Hughes, whom Robertson had asked to
write the introduction, Australian art was an art which had
developed in total ignorance of the Renaissance tradition. It was
of course the most utter nonsense but the kind of nonsense
Europeans would love to hear. Australian art, Robertson explain-
ed, possessed the uncouth vitality of innocence; it was adorable
exotica, the art of noble savages. I knew the symptoms well
enough. I had been studying the ways eighteenth-century
Europeans viewed art from the Pacific in some detail. Robertson
convinced me that there had been no substantial change in two
centuries. They saw what they wanted to see.

Robertson indeed seemed to see all non-European art in that

way. He was very strong on primitivism. When Dr Hoff was trying to see him he was desperately trying to finish a book. It was called *Jackson Pollock*, and a most extraordinary publication it is. Pollock is presented as a kind of Greenwich village Tarzan. In the first twelve pages before the title page he is depicted doing violent balletic tricks with a can of paint. Then a couple of pages of biography are devoted almost exclusively to Jackson's violence, alcoholism and interest in the archetypal. This is followed by seven pages of ecstatic praise for just one painting, our own beloved *Blue Poles*. It is all presented in the high purple prose of Robertson's primitivism. Pollock, he concludes with triumph, has proven to us all that painting is 'a primitive activity'.

Robertson's shows of American abstract expressionism were undoubtedly one of the main avenues by which the American forms of non-figural art were made available to an English audience. So it is understandable that he might have felt it inconsistent of him to present an exhibition from Australia with a manifesto that stressed painting as a social and civilizing activity. So at Whitechapel the English public were invited to enjoy two kinds of noble savagery: the one from America, the other from Australia. Perhaps it is a little unfair to recall that the Whitechapel Gallery had been established to bring the *civilizing* effects of art to the 'ignoble savages' of London's East End.

So the Antipodeans lost the opportunity that, so far as I was concerned, was their central object: of carrying to Europe a critique of modernism generated by the kind of art that developed in Australia during the Second World War, and at that crucial time when the first serious cracks were beginning to appear on the monolithic surface of modernism itself. Instead we were packaged as exotica and became, like Omai the Tahitian, high fashion for a season and then discarded. What was intended to be a serious intervention at the level of art was twisted into becoming a big national and commercial deal. Indeed, at the national level, which so far as I was concerned was a side issue, the Antipodeans were successful beyond their dreams. None of the group lost faith in the vitality of their kind of art. The leading dealers were encouraged to support them: Kym Bonython in Adelaide, Rudy Komon in Sydney, Brian Johnson in Brisbane. Monographs were published on their work. From being disregarded as 'cottage industry' Melbourne, they became national figures and all the major creative artists of their own generation, including those who made *gestures* of opposition—John Olsen, Leonard French, Brett Whiteley, and Fred Williams—continued to make creative

use of the image in their art and as it was defined in the manifesto. True, there was a last gasp of mainstream abstraction during the 1960s, the unfortunate Field and Colour Field generation, but their extremely narrow mainstream views did not greatly affect the vitality and diversity of Australian painting. And by 1970 it was becoming increasingly difficult to convince even art students that less is more.

I have been telling you a story as truthfully as I can tell it, not engaging in myth-making. But let me by way of concluding make one or two more theoretical points of an aesthetic nature. There is of course an abstract component in all painting, just as there is an accidental and conceptual component in all painting. It was the reductive, primitivistic fallacy of setting up one component as the whole and calling it the new language of twentieth-century art that rendered all other kinds of art obsolete, to which the Antipodeans were in opposition. If you want to see abstraction working at its best in painting, don't look at the work of an artist like Jackson Pollock, look at the work of an artist like Jan Vermeer. So to sum up, the Antipodean exhibition was not Melbourne figuration versus Sydney abstraction, or nationalism versus internationalism, or provincial art versus metropolitan art, or an older generation digging its toes in against a younger upcoming generation. It was concerned with a central question in the aesthetics of painting, not the aesthetics of music or architecture or of linguistics, but the aesthetics of painting. And the question that we raised in 1959 is just as relevant today as it was then.

In 1983 I attended the preview of the magnificent retrospective exhibition of John Perceval's work held at Heide in Melbourne— where so much of the work began that is now loosely described as Antipodean by McCulloch and others who have grabbed the word to define a whole trend in Australian art. In short we have been mythologized.[5]

John Perceval was there with his attendant nurse. I went over and greeted him and after some conventional pleasantries he looked at me and said: 'Do you remember the Antipos, Brother Bernard?' 'Of course I do John', I said. 'They were great times', he said. I could only agree.

Reflections on
Australian Art

19
The Myth of Isolation
—1962—

It is barely a month now since an Exhibition of Recent Australian Paintings concluded at the Whitechapel Gallery, London. It was quite a large exhibition of some one hundred and eleven paintings selected largely by Mr Bryan Robertson during a lecture tour here for the British Council last year. The exhibition received high praise from London art critics and aroused great interest. It may well come to constitute, therefore, something of a landmark in the history of our painting. For the first time Australian art has found a large receptive audience outside its own country.

Now it is pleasant to be told by others so enthusiastically that our art has grown up, heartening to realize that a critical audience not directly involved in the Australian milieu is in the process of formation. For the quality of a culture is best judged, in the long run, by informed critics separated from it both in time and space. But if Australian art has indeed reached international standing it is due, as I hope to show later, to a generation of painters who have been at work immediately prior to, during and since the war. Maturity however is one thing, recognition another; and our first reaction to Whitechapel must be one of gratitude to those who successfully introduced our art to its new English audience. Of course, the recognition of our painting falls into a wider context of recognition in which Patrick White's novels and Ray Lawler's *The Summer of the Seventeenth Doll*, for example, have all played a part. The deeper reasons for all this may best be left for a later generation to reveal. More specifically however, the recognition of our painting in London has been due to a few Australian artists and some English critics and connoisseurs. Three artists have been largely responsible: Russell Drysdale, Sidney Nolan and Albert Tucker, through their shows in London during the 1950s. But the interest which their work aroused was greatly augmented by a new receptiveness to Australian art pioneered by

the interest and enthusiasm of a group of well-informed English-men: Sir Colin Anderson, who has collected Australian paintings for many years; Sir Kenneth Clark, who developed a great interest in Australian painting during a visit to Australia in 1949; John Douglas Pringle of the *Observer*, who acquired a discriminating knowledge of Australian art during his years as editor of the *Sydney Morning Herald*; and Mr Bryan Robertson, whose great enthusiasm for Australian painting in recent years has been largely responsible for launching it so smoothly into the pool of London opinion.

Actually, the situation at the moment is an odd and somewhat amusing one. Ever since the war our own art critics have been telling us that Australian art is by world standards hopelessly provincial. Suddenly our artists find their work high fashion, *le dernier cri*, in London. It is a little confusing.

Our local critics have tended to attribute the weaknesses they find in Australian art to our isolation from international centres: Paris, New York, London. Whenever an exhibition has reached these shores during the past ten years from France, Italy, Japan, critics have quite commonly prefaced their remarks with much wailing and beating of the breast about our cultural isolation. Art advisory boards, gallery directors, Commonwealth and state governments have been exhorted to bestir themselves in order that we may have more and more exhibitions that are more and more contemporary. This desire to keep up at all costs with the international Joneses of the art of the moment is in my view an infallible sign of the provincial mind, of artists and critics uncer-tain of what they are doing or where they are going. Of course the channels of communication must, and I have no doubt will, be kept open, our galleries must buy contemporary paintings, both overseas and local, our artists must study and work overseas if they want to, we must have exhibitions from abroad, and not only contemporary exhibitions—for that reveals the temporal parochialism so common today—but also of the art of the past. Because, for the artist of true worth, all art is contemporary art, all is available and accessible to his imagination.

I would argue that this obsession with the idea of our cultural isolation so common among critics is nurtured by a deep sense of inferiority in our own values. We do not have to say, if I may quote two homely examples, that our tennis is poor because we live so far from Forest Hills and Wimbledon, that we cannot play cricket because we live so far from Lords and the playing fields of Eton. The situation of the artist is not so different from that of the

sportsman. He perfects his form in an active competition with his compatriots, and gains more from drawing upon his personal situation and his own society than upon the exotic stimulus of cultures less familiar to him. This is precisely what belonging to a tradition means in practice. But in order to belong to a tradition it is not necessary to have one's nose rubbed in it three times a day: it is necessary rather to know where one came from, have some idea where one is going, and not be haunted by the fear of isolation.

Now, oddly enough, whereas until recently isolation was advanced as an explanation of the supposed weaknesses of Australian art, it is now being advanced, since the exhibition at Whitechapel, to explain its apparent strength. I believe this isolation to be myth, based upon half-truth (like so much myth) so perhaps I should say something first about myth in general.

The relation of the historian to myth is a simple one. The historian is to myth what the ferret is to the rabbit. The historian burrows down after myth, hunts it out and destroys it if he can. He is Jack the myth-killer. If he should create myths in seeking to bring coherence to the chaos of past events then he will himself become fair game for the historians who come after him. Take but one familiar example. The true history of England came to be written when antiquaries first began to hunt down the myth that English history began with King Arthur. But the legend of Arthur has maintained, be it noted, a vigorous life in art long after it had been removed from history. For the artist, unlike the historian, is not pledged to the destruction of myth. Indeed it is impossible for him to do so, for myth cannot be rooted out of the burrows of the imagination in the way that it can from the burrows of history. The artist can only take myth or the raw material of myth, turn it to his own purpose and perhaps endow it, if he has the ability, with a universal value. If we could go back to Mycenaean times and watch hordes of Achaeans sacking the seventh city of Troy we might witness a campaign quite as unpleasant as that which occurred on the other side of the Dardanelles in 1916. But Troy found its Homer and lives, after 3000 years, a more vigorous life than ever in poetry and art.

Today, then, if artists like Nolan should turn to Gallipoli for their material, it reveals an ignorance of the relation between art and mythology to accuse them of myth-making. Nolan did not create the Ned Kelly myth nor the Gallipoli myth; the myths were modifying national character by polarizing attitudes into dramatic stereotypes long before Nolan began to paint. Often, as Alan

Seymour has shown in his fine play *The One Day of the Year*, such myths can bestialize the people influenced by them. They can only be penetrated and transfigured by art. So that it is most unwise to say, as some do, that living in a scientific age the artist should no longer concern himself with mythology. Today, when the vehicles of 'admass' persuasion are so readily available to governments touchy and self-conscious about the national image of which they feel themselves the guardians, and so readily available, too, to the public relations people who will put a pleasant face on almost anything for a price, it has never been more important for the artistic imagination to continue to concern itself with myth. Because in the hands of the artist myth can still be made to serve sweetness and light, and because the artist, to the extent that he continues to be an artist, is less readily corrupted by the pursuit of influence, position, power and wealth and that most subtle form of all, corruption in the name of good causes.

My concern here, however, is not so much with the artist's relation to myth but the historian's relation to it, and with this particular myth of our isolation from the sources of European culture. A special form of it has arisen in connection with the Whitechapel exhibition. This form of the myth asserts that the strength and vitality of Australian art lies in its complete isolation from the Renaissance tradition.

The Whitechapel Catalogue possesses three separate introductions—one by Sir Kenneth Clark, one by Mr Bryan Robertson and one by Mr Robert Hughes, an architectural student of Sydney University who manages to combine some cartooning for the press, some painting, and a good deal of art criticism into a busy undergraduate life. I have no wish to impugn Mr Hughes as a critic in general. If he is not the most responsible critic writing in our newspapers at the moment he is at least one of the most concerned with what is going on in Australian art today. 'What pressures', asks Mr Hughes in his introduction to the Whitechapel Catalogue, 'have formed the Australian sensibility?' He continues, 'The first that springs to mind is our complete isolation from the Renaissance tradition, and, parallel with that, a similar isolation from most of what happens now in world art.'[1] In *his* introduction Mr Bryan Robertson repeats Mr Hughes's odd notion. One of the gruelling ordeals of the early years of an Australian artist is his isolation from the main patterns of art, he assures us: 'The Renaissance tradition is utterly remote from them.'[2] The art critics of the London *Times*, in his review of the exhibition, proceeded to expand these suggestions: 'An art', he wrote with much warmth

and enthusiasm, 'built out of its own vital resources, isolated from any European tradition older than Impressionism and out of direct contact with most developments since'.[3]

Mr Eric Newton, writing for the *Guardian*, was equally enthusiastic about the quality of the work shown but added a further twist to the now rapidly emerging myth. 'We know', he wrote,

that their achievements are considerable—emphatic, and sometimes monumental, often a little frightening because they pay no lip-service to the grace and refinement that we, in Europe, have inherited from the Renaissance and beyond that from Greece—and we know that in order to feel at home with them we must shed our Renaissance prejudice and attempt to identify ourselves with a continent we vaguely connect with desert and drought and decay and human pioneers.[4]

Now Mr Newton is not so far off the mark as his colleagues because I can well imagine from what I know of the work of the artists chosen to exhibit at Whitechapel that grace and refinement would not be the leading qualities of the work exhibited. And yet although grace and refinement have never been typical qualities of Australian art, they are by no means uncommon to it. To take but one example, the refined and graceful art of Justin O'Brien, inspired in some measure by the art of the early Renaissance. But there was, of course, no work of O'Brien's at Whitechapel; and we must remember that Mr Bryan Robertson's selection and that of his Australian advisers was determined to a considerable extent by the London-born image of Australian painting which has grown so vigorously from exhibitions held in London of the work of Drysdale, Nolan and Tucker.

O'Brien's one-man show at the Hanover Galleries, London, of 1949 contained grace and refinement but neither deserts nor banditti. But London critics paid little attention to it. That which cannot be readily accommodated to a preconceived pattern, an existing mental set, is usually not seen, much less enjoyed. Yet an understanding of O'Brien's art may yet be found to be as relevant to an understanding of the Australian tradition as Drysdale's or Nolan's. Grace and refinement are not foreign to Australian art though they are certainly not the principal aesthetic virtues which Australian art, or for that matter European art, has inherited from the Renaissance. The art of Giotto and Masaccio, for example, is less elegant and refined than that international Gothic art which they themselves did so much to replace: the greatness of their art lies elsewhere. For one thing it is more vital or, in Berenson's phrase, more 'life-enhancing'. Michelangelo is more thoroughly

of the Renaissance than Botticelli in whom something of the grace and refinement of international Gothic still lingers.

I have quoted these London statements to indicate how quickly myth can arise and spread; in this case to distort both the historical nature and the qualities of Australian painting.

The notion that we are isolated from Renaissance tradition is but one variety of the notion that our art has been isolated from European art in general, or special aspects of that tradition, from impressionism, or post-impressionism or more the recent avant-garde forms.

I believe the notion, as I said, to be a myth, and I shall give my reasons. But before I do I want to stress that an historian is likely to be suspicious from the beginning of any talk of total isolation, and for several reasons. Firstly, because it smells of exceptionalism: an endeavour to prove that Australian culture for better or worse is in some way únique. Upon the lips of Australians it is likely to be followed by an orgy of self-praise or self-abasement. You will be told how tough and vigorous our culture is because it has grown straight and strong from behind the old black stump. Or you will be told how thin and weedy it is for lack of nourishment from the sweet wells of old Europe, from whence so many nice people have decamped during the past two hundred years. But total cultural isolation is, of course, a thing of the past. The penetration of the central highlands of New Guinea brought, perhaps, the last primitive community within the orbit of European culture.

Secondly, the historian is suspicious because the concept of isolation can only describe an historical situation in terms of something which, it is alleged, has not occurred, rather than in terms of events which have produced effects. Even if it be indeed true that Australian art were isolated from Renaissance tradition, the fact would tell us very little about the nature of Australian art, any more than to say that X has not influenced Y tells us much about the nature of Y. But if a logical fallacy only were involved the matter would be barely worth discussing. In most cases, however, that fallacy of historical reasoning, the *argumentum ex silentio*, is involved. It is assumed that, for example, because no Australian artist working between, say, the years 1910 and 1920 reveals any trace of the influence of the work of Picasso, Australian artists of that time knew nothing of his work. But artists are not mirrors automatically reflecting everything in front of them. They exercise choice. I trust that no London—or Australian—critic will argue, a century hence, that Mr William Dargie had never seen a cubist painting because he shows no cubist influence in his

portraits and continues to paint portraits in the way he does. Artists select and reject. And this, I think, provides us with an important clue to what is often called the isolation of Australian art from European tradition. What appears at first sight to be isolation often turns out, it seems to me, to be a process of selection and rejection. This, after all, is precisely what one might expect of an art like Australian art closely affiliated with European culture yet displaying distinct qualities of its own.

At the beginning, however, this process of selection and rejection is not apparent to any extent. That is not surprising. Our colonial painters, despite the time and distance from Europe, were certainly not isolated from the European tradition, for most of them were English and identified themselves with their homeland all their lives. The conventions which they applied to the depiction of man and nature in this country, picturesque, romantic, classicist, and so forth, they had learnt in European art schools. For one hundred years no artist in this country seriously considered himself to be a member of a society which had developed different points of view in many ways from the societies of Europe. Colonial artists were European artists in Australia. There was no essential isolation in the colonial situation, for, despite the distance, ideas 'and styles come through. The paintings of Conrad Martens are couched in the romantic language of Turner's water-colours, and if Martens is provincial when measured against the best like Turner, Girtin and Cotman, he certainly achieves the level of the Fieldings and Varleys of his time.

But it is grossly untrue to say, as Mr Bryan Robertson says in his introduction to the Whitechapel Catalogue, that 'From the early nineteenth century onwards, Australian art reveals a natural and instinctive feeling for the sensuality and plasticity of paint. This is more in evidence, than in English painting during a comparable period'.[5] I think it is most confusing to talk about a distinctively Australian form of painting of any kind before 1885. Our colonial painting is essentially a branch of English painting, and the colonial painters worked within a topographical and a linear tradition. Nothing that remotely resembles 'plasticity or sensuality of paint' appears in Australian painting prior to the Heidelberg school. Admittedly, English painting in the nineteenth century is not distinguished by its plasticity or sensuality either, but to compare a Constable with a Glover, or a Sir Thomas Lawrence, with its crisp and fluid brushwork, with the tight lines and close painting of Augustus Earle, is to become aware immediately of the eccentricity of Mr Robertson's judgement.

A distinctively Australian school of painting came into existence

during the 1880s. Tom Roberts's *Bourke Street* (1886) may be taken as an example of the new interest in local problems of light and colour. The men who created the Australian school of painting during the 1880s and 1890s were in fairly close contact with European art. They began their training under teachers trained in the art schools of London, Paris, Brussels, Antwerp and Rome, and the best of them went to Paris and London to complete their training.

This first Australian school of painting was, of course, not simply the product of gum trees and heat. French *plein air* painting, Whistler, impressionism and *art nouveau* all contributed to its development. It began as an avant-garde expression opposed to a Victorian taste based upon Pre-Raphaelite romanticism, Ruskinian ideals, and English and German academic painting. But the artists were caught up, as so many others of that time were caught up, by the surge of optimistic and idealistic nationalism that led to Federation.

The links with Europe, however, were never broken. Between 1885 and 1900 there was a constant coming and going of artists between Sydney, Melbourne, Paris and London. Artists overseas maintained links with their friends here by correspondence. Roberts, for example, continued to write to John Russell, the Sydney artist who became a close friend of Vincent Van Gogh when they were fellow students together in Fernand Cormon's studio. Russell discussed painting techniques, among other things, in his letters. I suspect that other Australian artists in Paris during the 'eighties did likewise: Bertram MacKennal, G. Douglas Richardson, Phillips Fox, Walter Withers. It would be surprising, surely, if none of these artists saw French impressionist paintings during their years in Paris. None the less the Heidelberg painters did not embrace that interest in colour science and divisionist techniques adopted by the French impressionists. This is sometimes used to prove that the Heidelberg school was ignorant of French impressionism. I doubt this. I think it more likely that they adopted one half of the impressionist programme and rejected the other. How many French painters resident in Paris had adopted divisionism before 1890? Only a small minority. And the reason? Not isolation but rejection: the impressionists were avant-garde. Indeed I would suggest that if one is endeavouring to assess just what is individual, what distinguishes the work of the Heidelberg school from work being done in England and France at this time, the key is to be found in the acceptance of some aspects of the impressionist programme and not others. Acceptance without

question is the essence of provincialism: the colonial painters accepted picturesque and romantic conventions without question. An indigenous tradition, on the other hand, not only assimilates, it also rejects. Indeed it must exercise choice if it is going to be more than a pale imitation of the metropolitan culture to which it is affiliated.

Even so, by 1900 most of the founders of the Heidelberg School found the claims of Europe and tradition greater than the claims of Australia and nationalism. 'After the Genesis', wrote William Moore in 1905, 'came the Exodus'.[6] For Australian art the first decade of the twentieth century was the time of the Edwardian expatriates. Most of them remained overseas in London or Paris for twenty years; some, like Rupert Bunny, were away for over forty. They all became closely associated with the academic and conservative tradition of the time embodied in the Royal Academy and the Paris Salons: and they rejected the modern movement to a man. The myth of isolation is frequently invoked here too, in order to explain what occurred. It has been claimed that they had little knowledge of the *École de Paris*. But in the case of the Edwardian expatriates it was not isolation but a wholesale rejection of the modern movement that occurred. We know, for example, that Roberts, Lambert, George Bell and others saw the first Post-Impressionists exhibition in London, organized by Roger Fry at the Grafton Galleries in 1910. They thought it a joke. 'I think it's a real gag and very amusing' wrote Roberts to Alfred Deakin.[7] Indeed they held, George Bell has informed me, a little comic post-impressionist show of their own at the Chelsea Arts Club. In Paris, likewise, Australians such as Rupert Bunny and Max Meldrum had ample opportunity to witness the growth of fauvism, cubism and the beginnings of abstract painting. Again it was not isolation but rejection that occurred. Even Bunny, who enjoyed Van Gogh and Gauguin and was the least antagonistic to the modern movement was very cautious. 'I cannot', he remarked when he visited Australia in 1911, 'consider Matisse anything but a humbug'.[8]

After the First World War the Edwardian expatriates all came back; howling reactionaries almost to a man. Of that generation only George Bell in his mid-forties experienced a change of heart and came to understand Cézanne, and what sprang from Cézanne; and in the 1930s, through his teaching, his press criticism and the art societies he founded, Bell became the leader of modern art in Australia. But, if the rest of Bell's generation were reactionary we cannot in truth assert, at the same time, that they were isolated

from Renaissance tradition. Indeed, they saw the modern movement as an attack upon that tradition. And who will say they were wrong? Certainly, the modern movement in art springs from one of the deepest qualities in European art, an abiding interest in experiment and change, a quality that goes back to the Greeks. But the champions of the modern movement in Europe attacked Renaissance tradition. They attacked, for example, the search for an ideal harmony in pictorial composition, which Renaissance artists had inherited from Platonic thought, in favour of personal expression. True, something of these ideals lingered on in geometric abstraction, but the individualism at the heart of modern art has been against it; and in recent years the Renaissance heritage lingering on in geometric abstraction has been overwhelmed by the more expressive and romantic forms of abstraction: tachisme, abstract expressionism, action painting, and so forth.

Furthermore, the modern movement attacked that central achievement of Renaissance art, the creation of an illusory world by linear perspective, and the manipulation of tone and colour. With cubism the picture became autonomous, possessing its own construction, its own space and colour, like a building or a jewel. Again, the Renaissance painters were responsible for inventing and perfecting two of the basic categories of European painting: the portrait and the landscape, and that important mixed category, the landscape with figures. Modern art has blurred these categories, because they have become of less importance to its central doctrine, the work of art as a thing in itself. For both portraiture and landscape are, of course, essentially mimetic; categories developed for the purpose of representing man and nature.

Following their return to Australia, the Edwardian expatriates dominated art and art criticism in Australia during the period between the wars. The expatriates became patriots, became trustees, directors of galleries, art critics, and received official honours; became, in short, the Establishment in painting. During this period Australia was indeed isolated, not from Renaissance tradition, but from contemporary art and thought in Europe. It was not so much isolation however but *isolationism* which operated, a conscious endeavour on the part of the Establishment to cut Australian art off from the influence of the contemporary movement. Exhibitions from Europe virtually ceased. Indeed between 1923 and 1932 I do not know of any significant exhibition, academic or modern, to reach Australia, whereas during the 1880s and 1890s they had been fairly frequent.

But the isolationist attitude of the 1920s is not, in itself, a sufficient reason for our lack of contact with the contemporary movement. The First World War is probably more important. Sixty thousand dead and 226 000 casualties was not a small proportion of the young men of a nation of less than 5 million people.[9] For those who survived the war and wished to turn to art, training was not so easy to come by as after the Second World War. And those of the war generation who did complete an art training were in no position to influence taste in art until the 1930s. This becomes clear if one studies the biographies of artists like Sir Daryl Lindsay and Rah Fizelle who were in service during what in normal times might well have been their student years. It is, I believe, no accident that during the 1920s and much of the 1930s women artists played a greater part in forming contemporary taste in Australia than they have before or since: Norah Simpson, Grace Cossington Smith, Margaret Preston, Thea Proctor, Daphne Mayo, Grace Crowley, Vida Lahey, Dorrit Black— the list is a long one. It is at least a reasonable speculation, surely, that had there been no war a student body who had made direct contact with fauvism, cubism and abstract art, would have come back from their art studies in Paris and London and that this generation would have produced leaders able enough to challenge the ideals and authority of the Edwardian generation. But in the event that authority was not seriously challenged until 1939, the year the Second World War began, and the first large exhibition of contemporary and British modern art was shown in Australia.

But if we accuse the established artists of the 1920s of isolating Australian art from the revitalizing effects of the modern movement, we cannot in truth also accuse them of isolating us from Renaissance tradition. Rather the reverse. The artists and critics who fought the crucial battle for the recognition of contemporary art here inherited a situation in which Renaissance tradition was strongly entrenched. You may call it a debased and degraded tradition or a fine one according to your taste, but it was certainly there: perspective and tonal illusionism taught by Hall and Meldrum in their influential schools in Melbourne; and the Renaissance categories, portraiture, landscape, and landscape with figures remained intact. Now it was within these very categories that the most significant achievements of Australian painting during the 1940s and most of the 1950s was to be realized. Indeed it was not until the years 1956−57 that the last vestiges of Renaissance tradition began to disappear in the experimental work of a group of Sydney painters influenced by the more informal types of postwar abstraction.

If my reading of the record is correct then the history of Australian painting since 1880 is precisely opposite to that which the Whitechapel Catalogue and many London critics are today confidently asserting. Australian art has always been highly conservative in its movement and growth, and testifies to a survival of Renaissance tradition. The waves flow outwards. Astronomers tell us that if we are only far enough away from them it is possible to see the light of the dead stars.

The American experience has been remarkably different. American artists came in contact with fauvism and cubism from the beginning. Gertrude Stein and her brother were among the first patrons of Matisse and Picasso. Her Saturday night receptions brought many American art students in Paris into direct contact with the leaders of the School of Paris. By 1912 two young American painters, Morgan Russell and MacDonald Wright, had created their own form of abstract art, which they called synchromism. It was through the book written by Wright's brother[10] that abstract art, I believe, made its first impact in 1919 upon Australian art. The famous Armory Show of 1913 introduced the American public to modern painting. The Australian public had to wait until Sir Keith Murdoch's exhibition of 1939. From 1913 onwards contemporary art found fertile soil in America and was greatly stimulated by the arrival during the 1930s and the Second World War of artists like Mondrian and Masson from Europe.

By 1950 American art was rapidly becoming a highly expressive and abstract vehicle in which the artist sought to translate the tumult of his emotions and sub-conscious drives directly into paint. It was an art relying entirely upon colour, texture and movement to convey moods and feelings. It was perhaps the first art of the West to discard the last remnants of the Renaissance tradition still surviving in contemporary painting. By contrast, Australian contemporary art has preserved many elements of the tradition, but has remained only partially exposed to the full force of the modern movement. The blend of innovation and tradition which is the result has, in my view, been responsible for the vitality which the London critics so widely applaud.

There is, of course, usually some core of truth at the heart of any myth. The element of truth in the isolation myth is our partial isolation from the full effects of the modern movement. This has been twisted into a belief in our isolation from the traditional sources of European culture as a whole. But why, we might well ask in concluding, are London critics so ready to believe in the myth of our isolation? The reasons are not far to seek. From its beginnings around 1900 the modern movement

has been stimulated largely by exotic arts unrelated to Renaissance tradition, or by pre-Renaissance European art: mediaeval stained glass, Catalan and Negro sculpture, the Japanese print, Persian painting and textiles, South Sea Island masks, and so forth. At the same time the movement has sought to penetrate below the rational level of the mind to the instinctive and sub-conscious levels of human behaviour. All this has widened the frontiers of art, enriched it and made it international as never before. Indeed in some of its aspects the modern movement is explicable in terms of the frontier theory of history developed by the American historian Turner. With the expansion of European culture over the globe it is the exotic frontier cultures which have to a large extent determined taste and much of the movement of style. But there is always a last frontier beyond which no truly exotic cultures lie. Have we reached that point today in contemporary art?

It is clear at least that today, in London, Australian art is being interpreted as if it were an exotic art, as an art standing outside Renaissance tradition. But it is not. And that to my mind is the most interesting thing about its reception. The hands are the hands of Esau but the voice is Jacob's voice. Has the wave begun to flow back? It is impossible to say and foolish to prophesy. But I could not agree more with Mr Hughes when he writes: 'To think of Australia as a *jardin exotique* is a fashionable way of missing the point, for to its painters it is not an exotic garden. It is the place where we live.'[11] But it is also a place where Renaissance tradition has lived.

All this could possibly mean that the reception of Australian art in London could be of more than national interest, more than a swing of the pendulum of fashion. This is suggested in a cryptic comment by Sir Kenneth Clark at the beginning of his introduction to the Whitechapel Catalogue. 'The sudden appearance of an Australian School of painting', he writes, 'is one of these blessed events which help to free the arts from the iron grip of historical determinism.'[12] Well, if there is such a thing as historical determinism—and I doubt it—Australian art is as much in its iron grip as any other. But if anything has determined the dynamic of modern art it is the iron grip of the primitivistic. The exaltation of the primitive, the ethnologically primitive and the psychologically primitive has been a tremendous formative power upon all opinion in art. Is that grip weakening? I do not know and shall not guess. But a preference for the apparent or even fake primitive in place of the truly primitive may mean that the passion for the primitive itself is at last waning.

20

Is there a Radical Tradition in Australian Art?

—1984—

Let me begin by explaining what I mean by four words: conservatism, innovation, radicalism and tradition. Conservatism is a predisposition to support and protect a society's social, political and cultural institutions. All societies are by their nature conservative because social life is inconceivable without institutions. But the conservative is convinced that society's institutions are so fragile that any substantial change will destroy them and chaos will result.

There are special reasons why Australian society is, and will continue to be, more conservative than most. It began as a gaol and a bridgehead. Law enforcement was harsh not only to control a large convict population but also to support a colonial psychology adapted for seizing the country from its original inhabitants. This initial colonial conservatism has been reinforced from generation to generation by migrants escaping from radical social and political changes in their own countries. They arrive here, understandably enough, to create a new life for themselves, not to reform Australia's institutions.

Innovation. To innovate is to effect a change within something already established. The innovator is not the natural opponent of the conservative. Most conservatives will accept a measure of innovation providing it does not threaten the existence of the institutions within which the change is effected. The natural opponent of the innovator is not the conservative but the reactionary, who reacts against change, fearing that any change will produce chaos. The genuine innovator is an inventor, like a scientist, and usually picks up hints from something within his or her contemporary environment in order to make something, develop some idea useful to, or more in keeping with, contemporary ways of living. The innovator wants to make it new and to graft the new onto the present.

The radical, like the innovator, seeks change, but in this case change of a substantial nature that will alter society's existing forms and institutions. The radical perceives society's existing institutions as oppressive, or corrupt or decadent. Their power must be broken before society can be healed. The radical differs in method from the innovator. Instead of looking for hints in contemporary life for ideas about change, the radical invokes a compelling vision of an earlier time when society's institutions were not oppressive and corrupt. That is what the word means: to be radical is to go back to the roots. And the radical projects that vision of a better past into an image of a better future. At one end of the radical vision is a golden age of the past, at the other end a utopia of the future. It is a very powerful myth indeed and it has operated continuously in European society to effect major changes in institutional structures. It would therefore be misleading to dismiss it as an illusion.

Tradition. Tradition is a handing down of shared attitudes and beliefs. The traditionalist is like the conservative in that they both possess a strong sense of the importance of the past. But the conservative also supports the past as it reveals itself in the present, in its existing social institutions, legal codes, rituals, and so on. Tradition, however, is never wholly embodied in such institutional forms. It is as it were in the air, transcendent, fluid: you can never pin it down. So it's possible to have radical and reactionary and innovative traditions as well as conservative traditions.

Now a warning. The four words I've described are concepts, and it's not possible to describe the varied activities of any one individual adequately within the meanings of a single concept. Human beings, mercifully, are more varied than concepts. There are I suppose differing components of conservatism, traditionalism, radicalism, a touch of the reactionary and a desire to innovate, in most of us. Young radicals, notoriously, become old conservatives ready enough to accept an honour from her Majesty the Queen, on Australia Day, with a dismissive remark and an embarrassed giggle. Life has its little ironies.

One last point must be made before I turn to the subject itself. I want to make a distinction between art in Australia and Australian art. When I use a term such as Greek art I obtain a clear visual image. When I think of Australian art, the only clear visual image of a comparable kind, is evoked by Australian Aboriginal art. Nevertheless, even though the art in Australia that has derived from European tradition is still little more than a curious blend of

British, French and North American art, modified by the endur-
ing imperatives of place and distance, I still want to consider it in
the stronger sense of the term, Australian art, that is, an art
possessing specific characteristics rather than merely as art in
Australia, in the weaker sense. Because if we are only talking
about art in Australia, our discussion should not centre on
Australia at all but upon the great metropolitan sources in the
northern hemisphere from which most of it derives. Our unit of
study would be this metropolitan art in its colonial and post-
colonial manifestations in Canada, Brazil, Australia, etc.

This is crucial because I would argue that it is the radical
tradition that is steadily transforming art in Australia into Aus-
tralian art, that is to say an art with its own distinctive traditions
but traditions that interact continually with other traditions both
national and international.

To begin with there was only Aboriginal art and almost a
century after 1788 there was still only Aboriginal art, though it
had suffered severely as a result of the European invasion, be-
cause our colonial art is not Australian art but a kind of European
art in Australia. Martens, Glover, von Guerard did not think of
themselves as Australian artists; nor did native-born Australians
accept them as Australian artists until after the Second World
War. They only became 'Australian' artists when their work was
appropriated to constitute an Australian tradition. I can speak
with some knowledge about that appropriation because I played
a prominent part in it, and would be prepared to justify it, but
won't attempt that here as it's not central to our subject.

What is central is that our colonial art and artists were fun-
damentally conservative. This needn't surprise us, for no other
response, surely, to their situation was possible. You can't de-
velop a critique of institutions until you possess institutions. So
our colonial artists and their cultured friends set about estab-
lishing the basic art institutions, the art schools, museums, critical
and exhibiting procedures, travelling scholarships that con-
stituted the European art system as they understood it.

They rightly believed it was important that art students finish
their education in Europe; and by the 1880s a sizeable number of
them were travelling to Europe—the generation of Tom Roberts.
They found things had changed since the times of Glover and
von Guerard. Artists were now painting out of doors; impression-
ism had arrived. They brought back news of these European
innovations to Australia and modified their own art practice,
choosing those aspects of pleinairism and impressionism that

suited their needs, while rejecting others. In doing this they were seen in Australia, and indeed may have seen themselves, as innovators. But note that they were not themselves true, original innovators. It is better to think of them as messenger boys bringing news to Australia of the innovations of others, of Bastien-Lepage, Monet, Cézanne. There was also an important messenger girl, Norah Simpson, who brought the good news from London to Sydney that the battle for post-impressionism had been won. What in fact these messenger girls and messenger boys were doing, and their successors are still doing, was and is to ensure that innovations that had been accepted into the traditions of European art were and are acclimatized to Australian soil. That is the way it began in the 1880s and that is the way it largely is in the 1980s. Art in Australia is a lazy dialectic between a slow-moving colonial and post-colonial tradition and its continuous assimilation of northern hemisphere innovations introduced by successive generations of messenger boys and messenger girls. That is the history of art in Australia. But it is not the history of Australian art.

To understand the history of Australian art, in the strong sense, we must study closely the work of its radical artists. I do not mean artists who have been strongly influenced by radical politics, though there is an important link. I am not here talking about the impact of radical politics upon art in Australia, but the very process of the radicalization of the tradition itself.

The radical artist tends to perceive some aspects of the social, moral or artistic institutions of his or her country as corrupt or decadent and proceeds to target his or her art at that corruption and decadence; not only in their conservative but also in their innovatory aspects because, for the radical, innovations are more often than not the principal way in which conservative traditions maintain their oppressive power. In opposition to the corrupt present the radical invokes an image of a finer past that is being corrupted by more recent change. Now to some of you trained to accept innovatory change as the normal process of change, the invocation of past models of perfection may seem self-contradictory. But it has been argued by some very influential students of historical change, such as Hegel and Marx, that that in fact is the way that major change does occur. It is not a view of change, incidentally, that appeals to our present prime minister Bob Hawke. He sees change as essentially achieved by a process of conciliation and arbitration. He is, you might say, an innovator not a radical. The radical, he has recently described more

than once in a colourful image, as one who sits under a banyan tree and dreams.

Before we accept the banyan dreamer as one of Bob Hawke's more profound political insights let me mention quite briefly four major changes in European culture that were sustained and fortified by radical ideologies of a past perfection. First change: the artists of the Italian Renaissance invoked an image of Roman art as a model to challenge what they saw as the decadent art of their time. In so doing they changed the very nature of art as we understand it. Second change: during the Reformation, religious reformers invoked an image of primitive Christian communities that were self-governing and not controlled by the Bishop of Rome. They changed fundamentally the history of religion in Europe. Third change: the political radicals of revolutionary France were inspired in part by Rousseau's doctrine that civilization corrupts natural virtue and in part, by a vision of republican Rome as a civic ideal. They changed fundamentally the nature of European politics. Fourth change: the Bolsheviks responsible for the October Revolution in Russia believed in a period of primitive communism at the dawn' of history when there was no oppression of one class by another and also believed that that time would return. It is too early yet perhaps to pass judgement on that process of radical change; but President Ronald Reagan, for one, believes it to have been considerable.

Now there are two common features about all these radical ideologies that stimulated and supported such major changes in European culture. All of them invoked either a classical or a pre-classical past as a model. Some kind of classicism or primitivism invariably seems to be present in all radical ideology. Perhaps this is understandable when we recall that at the tender heart of European civilization lie the institutions and sacraments of the Christian religion, and to invoke the classical or the primitive is to invoke the non-Christian, the pagan, to conjure up before the eyes of the good Christian conservative an image of the devil. For many in our society who see themselves as progressive, inno-vative, radical even, the Christian sacraments associated with birth, marriage and death, still mean much. Even Norman Lindsay, of whom I shall have more to say in a moment, was buried according to the rites of the Methodist Church, the church of his missionary grandfather who first introduced him to the delights of art, in a piece of nineteenth-century classicism, Solomon J. Solomon's painting *Ajax and Cassandra*, in the Ballarat Art Gallery.

Classicism, mediaevalism and primitivism are the principal ideologies by means of which radicals have attacked the conservative art values of the present, including the innovating present. From the time of Charlemagne varieties of classicism have been invoked to purify contemporary art. More recently, many radicals, especially Christian radicals such as Pugin, Ruskin and Eric Gill, have invoked an image of the mediaeval past. Still more recently, modernism, from Gauguin onwards, has fashioned a potently radical weapon out of primitivism; that is to say from the art of those traditional societies being destroyed by the expansion of Europe.

With all this in mind it may be possible now to trace the emergence of a radical tradition in Australian art. It emerges first in the work of the painters of the Heidelberg school. In one sense they were messenger boys adapting *plein air* and impressionist techniques to the local scene, but their art took a radical turn when they began to turn back to colonial history for the themes of their paintings. It is apparent in the work both of Roberts and McCubbin. As a radical move its importance was that it responded to and identified with the possibility of a local tradition for art distinguishable from European tradition.

They were not of course true innovators. I doubt whether we have ever had a major innovator in Australian art; they all turn out, surely, on close examination to be messenger girls or messenger boys bringing the news of innovation. Max Meldrum is a possible exception; the only artist who developed both a theory and practice of art that can be clearly distinguished from European precedents. But, though he attempted to export it to America, it had little influence outside Australia, and it proved to be a powerful support for conservative art though Meldrum himself was, in many respects, a political radical.

The next important radical is Norman Lindsay. The source of his radicalism lies in the political radicalism championed by the left-wing journals of the 1880s and 1890s like the *Bulletin* and the *Tocsin*. Lindsay drew for both. But he did not develop into a political radical. The target of his radical art was the puritanical moral institutions of colonial culture, which he suffered as a boy, and their source in British culture. Against them he opposed a liberating sexuality and a sense of joy, based on Greek models. When he first saw post-impressionist art in Paris and London in 1910 he took it to be clear evidence of a decline in the aesthetic standards of Europe. Against it he opposed the Greeks and Rubens, and by the early 1920s his aggressive radicalism had

taken the form of a vision: a vision of an Australian renascence of Europe's declining culture. It was in a sense a development of that radical vision of hope that left-wing radicals had expressed in the 1890s, as in Bernard O'Dowd's vision of Australia in his poem *The Bush*:

> She is a temple that we are to build:
> For her the ages have been long preparing:
> She is a prophecy to be fulfilled.

The next important radical in Australian art was Margaret Preston. In her case, as with the Heidelberg artists, we have an interesting mix of messenger and radical. As an art student in Europe she accepted early modernism and as its messenger in Australia championed its 'futuristic' acceptance of industrial society. But later in her development she turned from the innovatory to the radical component in modernism, from futurism to primitivism, and began to champion the art forms of Aboriginal art as a model for Australian artists to follow. So there is a contradiction within Preston's work, in its futuristic aspects it supported a Eurocentric industrialism, in its primitivistic aspects it was subversive of those values. That is the radical aspect of her work.

There is a firm national component in all these early manifestations of radical art in Australia; but they are not due to an ignorance either of the European tradition or of the modernist art of the time. But all accepted the imperative of place; that art in Australia had to be, was bound to be, different from art in Europe.

Roberts and McCubbin, Norman Lindsay and Margaret Preston are the forerunners of a radical tradition in Australian art that asserted itself strongly around the year 1940. It was not surprising that the new generation of artists was radical. They had lived through, most of them, the deprivations of the great Depression, were witnessing fascism in the process of destroying the traditional cultures of Europe; saw the Catholic Church giving its support to General Franco in the Spanish Civil War, and during 1940 experienced the shock of Hitler's troops overrunning Europe.

The importance of the radicalism of 1940 is that it was a radicalism of modernists who had developed a radical critique of modernism itself. The critique of modernism did not begin in the 1970s when terms like post-modernism became fashionable, it began when modernism began; in Australia it begins with Lindsay. Anyone who wishes to understand the nature of modernism

should be prepared to re-examine the critique of modernism from its beginnings.

Melbourne developed as the more powerful radical centre, though there was a radical modernism in Sydney too. The so-called Angry Penguins group, centred on the patron, John Reed, was deeply influenced by the free, informal expressionism of Danila Vassilieff. I do not myself see Vassilieff as an Australian radical artist but rather like Ian Fairweather as a highly creative artist in Australia. Which is no criticism as to the quality of their work, but a way of describing it. Perhaps Vassilieff was Australia's most influential messenger boy. But Nolan, Boyd, Tucker and Perceval, at least in youth, were radical. They used the liberating techniques of expressionism and surrealism to explore their own personal psyches, and their moral and social place in Australian society. This is also true of the Melbourne social realists such as Counihan, Bergner and O'Connor, who were influenced by the work of the early Picasso and nineteenth-century masters such as Goya, Daumier and Courbet.

In the work of both the Reed group and the realists a basic re-orientation of imagery begins to occur. Art in Australia, in its colonial and post-colonial phases, had been to a very large extent a kind of pastoral false consciousness. Artists born and bred in cities took pleasant excursions into the countryside to produce landscapes which reinforced a legend that, whatever its social and historic significance, said little about their personal lives as city-dwellers. The new radical iconography was city-based and it was an image, predictably, of an oppressive and corrupt city. Images of life in the Depression, the condition of refugees flying from the fascist terror, the plight of urbanized Aborigines. The new iconography was rejected by conservatives and most modernists in Australia loyal to post-impressionism. Both groups said it was important to keep politics out of painting. By politics they meant the new urban iconography. Significantly, unlike Margaret Preston, neither the Angry Penguins artists nor the social realists dismissed the Heidelberg school out of hand. Instead they revalued it: Roberts began, for the first time, to become a more important figure than Streeton. Awareness of a significant local tradition was growing.

In 1941 a major radical move occurred in landscape painting itself, after which it was never the same again. This move was made by the young Russell Drysdale. There are two aspects to Drysdale's radicalism: one technical, the other cultural. Direct *alla prima* methods had long been favoured by landscape painters in

Australia. Drysdale experimented with the indirect methods, such as underpainting and glazing, of the old masters, Titian especially. It was a curiously anti-modernist move. He also turned away from the conventions of the pastoral landscape and began to evoke rural images of menace and threat, deprivation and loneliness, and began to put the Aborigine back into the landscape. Where he led, others, like Nolan, followed.

Radical art in Sydney around 1940 is less well known. Despite its liberalism (largely the work of Sydney Ure Smith), or because of it, Sydney remained a more conservative city in art than Melbourne, but disguised its conservatism by its readiness to accept innovation at face value. But there were radical artists active in Sydney, first in the Teachers' Federation Art Society and then after 1945 in the Studio of Realist Art, artists such as James Cant, Roy Dalgarno, Nan Hortin, Roderick Shaw. We still need a full account of that time in Sydney. I was very much in the centre of it, but did not choose to write about it in my own historical writings. The first thing a radical has to learn is to learn how to survive. Let me illustrate the radical scene in Sydney in 1940 with two of my own paintings. They are little known, so you will forgive me if a say a word or two about them.

They are not social realist paintings. Their inspiration lies in expressionism, surrealism and to some extent in the naive painting which was interesting us all at the time. The first I called *The Advance of Lot and his Brethren*. It is an allegory, a vision of hope for the future of human society based upon a Marxian interpretation of history. The masses are depicted passing through the blood and muck, what James Joyce called the 'nightmare of history', but the old, oppressive institutions of state and church are collapsing on all sides about them. They are led by a curious figure, who is part Karl Marx and part clown. The point of the painting, I suppose, because no artist ever quite knows what he or she is doing, is that though the masses may be led by a mythical hero they are, at least, moving. It is, that is to say, a vision of hope.

The only other painting from that time which I did not destroy, is a vision of despair. It was painted a few months after *Lot*, at a time when Hitler had overrun most of western Europe. It records among other things my rejection of surrealism at that time, stimulated in part by the way the surrealists were behaving in the face of the Nazi terror. It is designed in three registers, and I find that the painting now contains for me some strange premonitions. I called it *Pompeii*. At the top is a waste land of ruins and

bodies. The grass has grown again but there are no signs of life. I see it now as a premonition of the atomic bomb. And then at the centre of the lowest register I depicted the surrealist gazing like Narcissus into a pool at his own beauty and wandering around in the caverns of his own mind. On one side of his head is a group dancing around a fire. I had the Hitler 'Strength through Joy' youth movements in mind; but more generally the group signifies the retreat from reason, the decline into mysticism. On the other side is an image of the concentration camps. It is sometimes said that we knew nothing about the camps until 1945, but those of us on the left had a pretty good idea of what was going on. At any rate that is my premonition of Auschwitz, painted late in 1940.

In 1940 paintings like these were far too radical even for the political left to accept. They were unspeakable. I stopped painting at the end of 1940 and turned to writing about Australian art.

I must conclude, aware that I cannot refer to many artists who at that time made a major contribution to the emergence of a radical tradition in Australian art—Dobell, for example, in portraiture. By the early 1940s a radical tradition had established itself in Australian art. It was a discontinuous tradition, not a family affair. There was no love lost between Norman Lindsay and Margaret Preston. Nobody made the Angry Penguins more angry than the social realists, and they also did their best to dismiss the importance of Dobell and Drysdale. The realists, in their turn, underrated the importance of surrealism and expressionism in radicalizing the local scene. But in all these conflicting groupings there lay the emergence of an independent tradition in Australian art. At no point, however, did they attempt to ignore the European tradition, either in its historic or in its modernist manifestations. Indeed, what distinguishes them from the innovating modernists was their willingness to draw upon the whole body of European culture, rather than the most recent forms of it. Norman Lindsay, for example, was the first Australian artist who drew deeply upon the whole body of European art and literature for his own personal development as an artist; Preston was probably the most widely-travelled Australian artist of her time.

The national component in our radical art arose not out of ignorance or a desire for isolation, but in opposition to the conservatism of a colonial and post-colonial culture that was predisposed to accept anything from Europe and North America at its face value. This has meant that, for the radicals, modernism always presented two faces: a progressive face that might be put

to good purpose and a potentially reactionary face that in its development could strengthen colonial and post-colonial values.

Finally it must be said that the most influential opponents of an independent and radical art in Australia have never been isolationists and reactionaries, but those returning messengers who wear the masks of innovation, but are really conservatives in disguise. There is one very easy way to identify them, for their opinion about the nature of art never seems to change. They argue that all basic changes in art take place within the traditions and disciplines of art itself. But the true innovators, and I am talking about innovators now, not radicals, know that art is always a dialogue with life, and that life is where you are. If a radical tradition can be sustained in this country, it may one day produce genuine innovators in art, rather than messengers disguised as innovators. But that, you might say, is a prophecy to be fulfilled.

21

An Australian Impressionism?

—1985—

The tank trap undulated across the dried, yellow grass of innocent Australian paddocks: it was as if someone had cut a photograph of a tank trap from a foreign magazine and pasted it on to an 1890s Australian impressionist landscape.

Donald Horne, *Confessions of a New Boy* (Melbourne, 1985)

For Donald Horne, as for a great many Australian writers and artists, too numerous to mention here, the existence of an Australian impressionist style of landscape painting during the 1890s is not in doubt—and I see no reason for doubt either. Yet one of the most interesting facts to emerge from the splendid 'Golden Summers' exhibition is the manner in which so many curators and art historians are now seeking to qualify the existence of an Australian school of impressionist painting virtually out of existence. It is *plein air*, or *juste milieu*, or 'impressionist' painting, but never Australian impressionist painting.

Of course one possible but, as I want to suggest, highly questionable way of demonstrating that there is no such thing as Australian impressionist painting is to substitute a painting by Claude Monet for Donald Horne's tank trap and then point to the difference between Monet's technical methods and the pasted-upon Australian impressionist landscape.

But such an imposition simply won't do.

'Golden Summers' is probably the best exhibition of Australian art that has ever been mounted and this is because it combines a superb capacity for design and display on the part of those responsible with the diligent research of Jane Clark and Bridget Whitelaw, the gallery curators working on the exhibition.[1] The value of their work, however, has been enhanced immeasurably by the availability now of Helen Topliss's *Catalogue Raisonné* of the work of Tom Roberts, an exemplary achievement,[2] and Leigh

Astbury's wide-ranging study of the popular sources of the imagery of the Heidelberg school.[3] For the first time the work of these painters can be considered in the light of recent research which reveals both the diversity of their sources and the variety of their visual interests. Yet paradoxically this close analytical work on individual artists has left their relation to impressionism as an international style in a more confused state than ever.

Dr Ann Galbally takes note of the fact, in the catalogue introduction, that 'the overseas models for artistic revolution for Streeton, Roberts, McCubbin, Conder...were the *plein air* French artists of the 1860s and 1870s'.[4] The implication is that the changes that took place in their art between 1885 and 1890 are to be understood in terms of *plein air* but not impressionist painting. What I find questionable here is the account of a style in terms of its alleged sources or models. The trouble with such an approach is that the linkages are certainly demonstrable but the differences are not. It is not only the sources of the Heidelberg artists that reside in *plein air* painting but the sources of most of the leading French impressionists also, Monet in Boudin, for example.

Impressionism itself was a development out of *plein air* painting, but it was a revolutionary development, that created contemporary dismay and alarm. We cannot therefore reduce the explanation of the emergence of impressionism as a style either in France or Australia to an account of its *plein air* sources; the logical problem is one of defining an object in terms of its origins, e.g. the oak in terms of the acorn. If the '9 × 5 Impression' exhibition was nothing more than an assertion of *plein air* painting, why, for example, did James Smith choose to denounce it so vociferously? He was a keen supporter of *plein air* painting, as evidenced in his support of Buvelot. Dr Galbally takes the view that the Heidelberg School was much later invested with the mantle of 'French Impressions' to guarantee their role as revolutionaries.[5] But the important thing to remember in this context, surely, is that the '9 × 5 Impression' exhibition was mounted, challenged and defended in the name of impressionism. If we are to appreciate what occurred we have to come to terms with the contemporary discourse within which the work was discussed.

Bridget Whitelaw informs us that the term 'impressionist' was generally applied vaguely, in both Britain and Australia, to a work which the critic regarded as either unfinished or as departing too far from academic convention. The 'impressions' of the young Melbourne painters had little in common, in her view,

with 'Impressionist practice'.[6] The capital here apparently refers to French impressionist practice, however that might be described. Well, no doubt there were differences between the Melbourne and the French practices but the important thing that they did have in common was that they were both working within the impressionist style of painting. It was perhaps the one important thing they did hold in common. For Bridget Whitelaw the work of the Heidelberg school is best understood as a variety of the *juste milieu*, of artists who combined elements of impressionism with more academic concerns. The term was invented by Albert Boime,[7] as an art historian's tool to discuss the ways in which French academic painting accommodated itself to the innovatory impressionist style. But distinguishing between *juste milieu* painters and impressionists does not get us very far. Many of the leading impressionists such as Degas, Renoir and Cézanne also found in the course of their development that they had to accommodate their styles to the continuing demands of academic painting. The point at issue here is that in modern times at least, an artist can rarely, if ever, be defined within the ambience of one historical or period style. In this sense, all artists are eclectic; they make choices from styles in terms of what they need. Not even Monet was an impressionist all his life. He begins as a *plein air* painter and at the end it would seem to be the autonomy of the work itself rather than the desire to represent nature that, despite himself, takes over.

Jane Clark, in her essay on the '9 × 5 Impression' exhibition, brings us to the heart of the problem. The small paintings shown

were in no way comparable with large French Impressionist canvases such as Monet's *An Impression: Sunrise*, which gave the movement its name. Fresh colors, casual compositions and free brushstrokes are the only common factors. Nevertheless, the term 'impression' had long been used in Europe for exactly such small-scale, quickly worked studies of the transient moods of nature, intended as notations for future reference in painting full-scale compositions.[8]

Roberts and his colleagues, however, did not store such studies away for future paintings. They exhibited them for sale and in that act asserted their right to be seen and judged as impressionist painters. Who, then, are we to say that they were not?

One way to resolve the problem is to argue that they were impressionists in the weaker or more general sense but not in any strict or full sense of the term. I would, however, argue the reverse: that it is the so-called strict sense that is the unsatisfactory sense and the more general sense that is the valid one.

The problem with the so-called 'strict sense' is that it seeks to define a style in terms of technique. Thus Dr Galbally writes: 'The knowledge of French impressionist techniques was minimal in Australia in the 19th Century as it was practised by Monet and Renoir in the 1870s.'[9] But if we reduce the concept of style to the imitation of the techniques of archetypal exemplars we reduce it to a kind of imitative inertia. A style, if indeed it is a genuine style, and not some art historian's label, such as *juste milieu*, once it emerges develops its own dynamic, its own temporal and spatial history that is distinguishable from the individual work of those artists who contribute to it or draw upon it. One can no more reduce the impressionist style to Monet's 1870 techniques than one can reduce the picturesque style to Claude Lorraine's techniques, or romantic painting to Turner's techniques. Or must we say that Rubens and Rembrandt cannot possibly be described as baroque painters because their techniques differ so markedly from those of Caravaggio?

From the time the critic Louis Leroy first used the term impressionism to describe *An Impression: Sunrise*[10] it quickly developed an innovatory discourse in painting that was used to criticize, interpret and come to terms with an array of pictorial problems that confronted a wide group of painters first in France, and then throughout Europe and the world. Even within the varied interests and concerns of the fifty-odd painters who participated from time to time in the eight exhibitions held in Paris between 1874 and 1886, by which impressionism was publicly declared as a pictorial style, it would be hopeless to attempt to define the style in the terms of Monet's techniques. Consider for example how different were the techniques of Boudin, Cézanne, Degas, Redon, Seurat, Sisley.

What is at stake here really is the concept of style in art historical discourse. It has been under attack in recent years, but art history as a distinct intellectual discipline cannot be practised without a developed rationale of style. It is the syntax of the discourse. The attempt to write art history without any concept of style reduces it to biography or to a kind of visually illustrated social or political history.

A truly innovatory style arises initially in the painterly practices of a group of artists. It is rarely, if ever, the work of one artist. In this, it is unlike scientific invention. Initially the innovations exist as potentials, in a prelinguistic situation. It is, however, the process of naming the style, of providing it with a verbal discourse, by which it acquires a temporal and spatial history. Then it is

that word and image enter into a fructifying dialectic. It is within this dialectic that the pejorative contexts that attend the birth of new styles need to be given more attention than they have been. They are usually dismissed as the misunderstandings of the ill-informed. But the naming process, even when it emerges in the form of abuse, as it did not only in the case of the impressionist but also in the case of the gothic, baroque, rococo and fauves styles (to name some of the most prominent), is essential to the evolution and ramification of the style. In the process a new area of possibility is outlined, a new space becomes available, in the dialectic between word and image. The value of words for an artist in such situations, even the words of abuse, such as Leroy's, is that they evoke a landscape of the mind that is still to be realized visually. One has only to look at a painting by Roberts, such as *Bourke Street*, or Conder's *Departure of the SS Orient*, or Streeton's *Redfern Station* (and numerous other examples could be cited) to realize that they did not have to study the techniques of Monet to be impressionist painters. The impressionism is there in the paintings for those who are able to see it, and it is there also in the terms that defined impressionism as a major pictorial style. All that they needed was the vaguest hints of a programme and the sense of a genuine visual challenge in order to create their own kind of impressionism. It is summed up in J. P. Russell's words to Roberts: 'Go in forget style and tackle our stuff for love.'[11]

However, the current vogue of attempting to define Australian impressionism in terms of Monet's techniques results in the absurdity of defining the local impressionist as he who apes Monet the most closely. In these terms the arrival of impressionism is delayed until the arrival of Phillips Fox, a sensitive but very uneven painter, whose work even at its best, as in *The Art Students*, lacks the robust vitality of the earlier men. This reductivist approach to style as technique could end in the absurdity of describing Will Ashton, a comparatively dull painter at the best of times, as the one true Australian impressionist because he imitated Monet more closely than any of the others. Indeed he spent a great deal of his life working on the actual sites of French impressionist painting. The urge to return to the womb is a most understandable and forgivable desire, but it does not make for independence; and in artistic practice it does not make for quality.

One gains little by attempting to define impressionism precisely. A much better approach, and a more historical one, is to relate the contemporary 'impressionist' discourse that emerges around

1874, in its application to painting, to the great array of contemporary paintings at which that discourse is directed. We shall never find a one-to-one fit. Impressionism is after all a word not a painting. But in the process we shall gain a better idea of the way in which contemporaries perceived and responded to paintings they chose to describe as impressionist. Furthermore, if we approach impressionism as a programme or rhetoric of yet unfulfilled possibilities ('go in forget style') and not the aping of a master (appointed by art historians in retrospect) we shall gain a much better understanding of the dynamic within the impressionist style that eventually spread it throughout the world. In gaining some idea of the scope of that programme we cannot do better than to go back to Camille Pissarro's advice to the young painter Louis Le Bail in 1896–97. Pissarro, as is well known, was the artist who kept the impressionists together, the only one to exhibit in all their eight group exhibitions, the only one to cling loyally to impressionism as a mode—perhaps the ultimate mode—of naturalistic painting. Pissarro did not advise Le Bail to ape techniques; he outlined a programme that allowed for infinite possibilities.

Look for the kind of nature that suits your temperament. The motif should be observed more for shape and color than for drawing. There is no need to tighten the form which can be obtained without that. Precise drawing is dry and hampers the impression of the whole, it destroys all sensations. Do not define too closely the outline of things; it is the brushstroke of the right value and color which should produce the drawing. In a mass, the greatest difficulty is not to give the contour in detail, but to paint what is within. Paint the essential character of things, try to convey it by any means whatsoever, without bothering about technique. When painting, make a choice of subject, see what is lying at the right and what at the left, and work on everything simultaneously. Don't work bit by bit but paint everything at once by placing tones everywhere, with brushstrokes of the right color and value, while noticing what is alongside. Use small brush-strokes and try to put down your perceptions immediately. The eye should not be fixed on one point, but should take in everything, while observing the reflections which the colors produce on their surroundings. Work at the same time upon sky, water, branches, ground, keeping everything going on an equal basis and unceasingly re-work until you have got it. Cover the canvas at first go, then work at it until you can see nothing more to add. Observe the aerial perspective well, from the foreground to the horizon, the reflections of sky, of foliage. Don't be afraid of putting on color, refine the work little by little. Don't proceed according to rules and principles, but paint what you observe and feel. Paint generously and unhesitatingly, for it is best not to lose the first impression you feel. Don't be

timid in front of nature: one must be bold, at the risk of being deceived and making mistakes. One must have only one master—nature, she is the one always to be consulted.[12]

Pissarro here warns against thinking of impressionism in terms of technique. Instead he outlines a generous and inspiring programme that does not reduce the artist to imitating his teacher. One does not have to inquire as to whether Roberts or any of his associates had also taken advice from Pissarro, to realize when we look at so many of their paintings, that they too were following the programme, the impressionist programme, that Pissarro so generously and so eloquently outlined. They did not have to study paintings; being creative people all they needed was the slightest hint picked up in Spain or Paris, in order to get up and go and 'forget style'. Historians should remind themselves constantly that they are condemned to work with documents that have adventitiously survived; the whole network of contemporary communication is no longer available to them. It is a highly dangerous practice to accuse the past of ignorance, of implying that it would have done differently had it only known. In such cases it is usually our own ignorance as to what actually occurred that is in question: 'The owl of Minerva flies in the night.'

Art historians need to develop a generous concept of impressionism as a style and use it as they might use the picturesque or the romantic. Indeed I believe they have no alternative, for in the contemporary discourse (c. 1874−1914 and later) impressionism spreads out into all the arts, so that we have impressionist music, writing, etc. This is not of course to say that Roberts and his colleagues always worked in an impressionist style; they used it to the extent that they found it useful, for the subject, the occasion, the genre, etc.

One final question, it seems to me, is of particular interest. Why is it that so many of our curators and art historians in Australia now seek to dismiss the concept of an Australian impressionism on the grounds that it does not conform to Monet's pictorial strategies? Unfortunately, by choosing such techniques as the rainbow palette, pure, divided and broken colour, working with spots or dabs of colour, etc., they provide neither a necessary nor a sufficient definition of impressionism. For many of these techniques are common also to neo-impressionism, post-impressionism, and fauve painting. This, however, provides a clue to the problem.

There is, as is well known, a crucial paradox about the development of French impressionism as a pictorial style. It begins as a

naturalistic style of painting and is presented as such by Pissarro, as we have seen, as late as 1896, but impressionism contained within itself an internal dynamic (of which the practitioners of the style were themselves not wholly aware) that led it progressively away from naturalism towards painting as an autonomous activity. They clung desperately to a vision of nature even as their attempts to realize their sensations drove them towards another kind of painting. It is only with Gauguin that the move away from nature becomes a consciously admitted activity.

In seizing upon those components of French impressionist technique: rainbow palette, divided colour, etc., which were driving impressionism away from naturalism towards the antinaturalism of modernist paintings, our curators and historians reveal just how much they are themselves the children of modernism. This is, from an historical point of view, all too understandable. But it also provides a way for misunderstanding Australian impressionism.

For it was precisely those components of Monet's pictorial techniques and their further development in the hands of the neo-impressionists, that the artists of the Heidelberg School drew back from. They remained, they chose to remain, on the naturalistic side of impressionism; they distrusted the moves that were taking painting towards autonomy, a distrust that is continually revealed in their letters.

If we choose to take a view that is at once Europeanist, unilinear and modernist in its explanations then we might want to deplore the fact that Roberts and his little company did not embrace the problems that overwhelmed the naturalism within French impressionism. But were they in a position to do so without becoming little more than provincial imitators of techniques that were not really addressed to their problems?

The degree to which they were not imitators of Monet but creative artists deploying an impressionist style when they had need of it, for their own purposes, in their own ways and in another world with its own challenges and problems, is admirably revealed in the magnificent exhibition at the National Gallery of Victoria.

22
Apollo's Vanguard
—1985—

Norman Lindsay's water-colour painting *Apollo's Vanguard* was painted in 1933, at a time when the Great Depression was transmitting shivers of fear through Australian society and premonitions of worse to come. It is divided into two main sections. On our left we see images of those types of adventurers and explorers who were responsible for the European discovery and settlement of the Australian continent: Portuguese, Spanish, Dutch and English navigators; Governor Phillip and the NSW army corps, gold diggers and bushrangers, the capitalist entrepreneur, the heathen 'chinee,' the drunken Aborigine of the Native Corps, clinging to his bottle of plonk. If all these constitute Apollo's vanguard, they're a motley and muddled lot. Most appear to be gazing with mingled feelings of admiration, wonder and apprehension, some even with alarm, at the emergent figure of Apollo, who dominates the right. He points, you will note, to the good Australian earth with a highly creative finger, like the God of Michelangelo creating Adam. If they are indeed his vanguard, is he exhorting them to go forward to possess and subdue the land, or is the gesture a sign of dispossession? Is he informing the motley, whose misguided ambitions and native greed have reduced Australia to its present depressed condition that he has now arrived to appropriate their mismanaged society and give it over to a wholly pastoral kingdom, of young jackaroos and boundary riders, who will tend his flocks and herds and listen with enjoyment, perhaps even sing the songs of the god? If the mob at left are his vanguard then Lindsay, it would appear, has depicted them just at that dramatic moment when they begin to realize that they have fought in a battle in which they are now no longer required. Their place is about to be taken by those who will nourish the arts. For is it not a law of nature that the creative should and must exploit, and if need be expropriate, the uncreative?

Norman Lindsay *Apollo's Vanguard*. Water-colour, 66.2 × 100.2 cm, 1933.

Such a reading of the painting accords with the philosophy of art that Norman Lindsay expounded in his book *Creative Effort*, published in 1924. Apollo, his jackaroos and flocks, represent Life (with a capital L). And Life, Lindsay explains in *Creative Effort*, at some length, is drawn by the cart-horse Existence. The mob on the left is the visual embodiment of Existence. It was the Greeks who first revealed Life and discovered consciousness; discovered that Life was more than mere existence. Indeed they discovered Mind (with a capital M); and if Mind had been discovered once, could it not, Lindsay argues, be discovered again, and in Australia; for Mind had long been obliterated, in modern industrial society, by the cart-horse Existence. But for such a rediscovery to occur creative mind must breed with creative mind. And that meant that the mob on the left had to be passed by, mastered, or at least ignored, for, as Lindsay put it: 'the physical act of breeding mind with mind, must be a matter of first importance, for since the primitive expression of mentality, whether in life or art, is a retrograde one, a primitive mentality, mated with a developed mind, will always throw advance back many centuries'.[1] Lindsay had come to the conclusion that that is precisely what had happened to European culture in his own day. If it were not to occur

in Australia, excellence in art must be sustained by the exclusive intermarriage of creative mind with creative mind. Creative effort could only be sustained by a perpetual intercourse between the pure merinos of Apollo.

If my reading of *Apollo's Vanguard* is a valid one it provides a close visual analogy to the views concerning the future of Australian art that were being promoted, during the early years of the Great Depression, by Norman Lindsay's brother Lionel, and the critic and connoisseur James Stuart MacDonald. In an ecstatic article on the art of Arthur Streeton, which sought to establish Streeton as the key figure in a canon of Australian landscape painters, MacDonald claims that Streeton's paintings 'pointed to the way life should be lived in Australia, with the maximum of flocks and the minimum of factories'. Australia could be the last Arcadia. 'If we so choose we can yet be the elect of the world, the thoroughbred Aryans in all their nobility.'[2] It was a view to which both Norman and Lionel Lindsay subscribed. Primitive Aborigines, inscrutable Chinese, captains of industry, the members of the proletariat, whom Lionel loved to call *canaille*, might all be called upon to draw the cart-horse Existence but they could not expect to contribute to Life. There are no shearers, it may be noted, in Apollo's Austral Arcadia.

So far as I know the role that the idea of the classic has played in the development of Australian culture has not been investigated in any thoroughgoing way, though a good deal has been written that concerns specific aspects of the subject. Here I want to touch briefly on that large subject in so far as it may help us to understand the relationship between Norman Lindsay and Howard Hinton.

There are, it seems to me, three distinguishable, though often interrelated ways in which the memory of the classical world, of the life, art and literature of Greece and Rome, have operated within Australian culture. First, and most importantly, there is the classic as a mode of perception, as an inexhaustible fountain of metaphor, by means of which Australians of European origin have sought to maintain, and revivify, their links with their cultural origins. It would be pointless to cite examples. Classical metaphors have always been and I have no doubt will continue to be invoked and expressed in our architecture, our art and our literature. The classical as metaphor has become, you might say, an integral part of the prosody of the European imagination.

The free flight of the metaphorical imagination can however be weighted down when metaphor hardens into trope or cliché. Again, quotation is hardly called for. But I must note that the

hardening of metaphor into trope tended to take place already in colonial times around the geographical nature of the Australian continent. It possessed, it was said, a fine Mediterranean climate like that of Greece. It was by its character naturally a pastoral country. It possessed clear sunny skies. So the vision of hope for a new civilization in the south, imaged in terms of the classical pastoral, becomes a powerful trope from the beginning. It is expressed in Erasmus Darwin's 'Vision of Hope', published in Governor Phillip's *Voyage to New South Wales*; it is present in John Dunmore Lang's modest versifications invoking the free migrant to the new land. It is a vision of an Australian arcadia freely transacted between squatters on the one hand and their class enemies the shearers on the other throughout the later nineteenth century. It is present in the social and socialist aspirations of such writers as O'Dowd and Furphy. The Lindsay family inherited this arcadian vision of hope, but in a late and curiously suburbanized form, as an Arcadia played out by Ernest Moffit and his young friends in the gardens of Charterisville, in Heidelberg, Victoria, after the depression of the 1890s had dampened all hope of a socialist arcadia. In that deserted garden, as the land boom burst, they played at being Greeks and Romans with their girlfriends, read Nietszche and the Greek Anthology and began to conceive of themselves as the legitimate children of Apollo. The artist, with models from classical art and literature always in mind, might yet save Australia.

If such a vision was to be realized, however, Australia had to be protected from those forms of culture which the industrial life of the cities, in their mindlessness, bred and fostered. So there arose among the artists of the Lindsay circle a third, and highly authoritarian use of the classical; the classical, that is to say, as norm, as a yardstick for the excellent, around which a canon of master artists might be constructed. If a canon were firmly established, young artists might then breed authentically pure works from the works of their masters and teachers. A demand for a canon of the excellent was raised. It was then, as it still is today, the most effective way of saying no to the new and the experimental. So during the years between the wars this third use of the classical, the classical as *class*, as norm, as canon, that had been a common enough usage in Europe from at least the time of the Emperor Hadrian onwards, began to prevail in Australian culture.

The Australian flocks of Apollo were to be bred from a carefully selected stud. Norman Lindsay, of course, made effective use of

all three modes of the classic: as metaphor, as Arcadian trope, and as a defensive canon against the corruption of Australian art.

But what of Hinton? We know so much about Norman Lindsay, so little about Howard Hinton, and the little that is known prompts questions. But it is clear that Howard Hinton was Norman Lindsay's first patron of consequence and his most faithful one. In the same year (1933) that Norman painted *Apollo's Vanguard*, Howard wrote a letter to him. It is dated 8 September 1933. 'Ever since 1911', he writes,

when I first met you and spent an afternoon over the Petronius drawings you and your work have been a wonderful inspiration to me, and many a time after a worrying day in town, I have come home, got out your sketches and the worries have faded, in the keen interest your work always arouses in me. I shall ever be grateful to you for the delightful work of Art to which you introduced me.[3]

Just how close that friendship was is revealed by the wealth of letters (now gathered together in the Mitchell Library) that Howard wrote to Norman from 1914 on, after Lindsay settled in Springwood.[4] Howard not only regaled Norman with weekly letters; he also regularly sent books that he felt might be of use to Norman. On 4 March 1920 we find him sending Lindsay a book on the Greek method of Life drawing.[5] After thanking him in his reply, Norman added 'I find many valuable suggestions which I trust I shall be able to use in future work', and thanks Hinton also for a book on Boucher that Howard had sent a few days after sending the book on drawing.[6] By this continuous process of gifting and letter writing, over a long period of years which only ended with Hinton's death, he became Norman's closest friend and confidant. On one occasion Norman wrote 'you are my sole means of information in the world of affairs since I never read a newspaper'.[7] Lindsay and Rose, his wife, would sell Hinton a treasured drawing or etching when they would refuse it to all others.

The friendship between Norman and Howard deserves more attention and study than I can give it here. I can only suggest one or two lines of enquiry. To what extent, for example, was Lindsay responsible for the formation and the guidance of Howard Hinton's taste? In the letter cited above Howard tells Norman how grateful he is to him for introducing him to the world of art.[8] Yet we are informed in the biographical sketch published in the memorial volume to Hinton, that Howard's father permitted him and his brother (when Howard was only 12) to travel together, unaccompanied, to St Petersburg, because both boys wanted to

enjoy the masterpieces in the Hermitage. This insatiable love of art, we are informed, took the two boys to the continent on several occasions, before Howard emigrated to Sydney, and his brother to Johannesburg, in search of work. In Sydney, Howard first took a modest post as an office boy but rose later to be a partner in the shipping firm of W. & A. McArthur.[9]

Perhaps if we knew more about Hinton than we do we should have little difficulty in evaluating this story of the much travelled young man who visited the great art museums of Europe at an early age because of his passionate interest in art and took art classes in Paris before he emigrated to Sydney to become an office boy.

But at present that story cannot be reconciled easily with his own statements that it was Norman who introduced him to the delightful world of art, not the European galleries; and there is some evidence that Howard's taste was formed in Australia, that his passion for Australian art began in the camps around Mosman's bays where he lived for a time after arriving in Sydney.[10] Certainly, his letters give the impression of a young man who had found a mission in life; the mission of a young English migrant to make a fine collection of Australian paintings so as to make Australians more widely aware of the quality of Australian art. It was at heart a populist vision as distinct from Norman Lindsay's élitist one.[11] But the letters do not give the impression of a young man who possessed a developed taste in art before he arrived in Australia or indeed of one at all confident in his own taste and judgement. What is impressive is Hinton's almost compulsive generosity. Not only his persistent gifting of Lindsay that might have possessed, even if unconsciously, an ulterior motive (for he was ambitious to make a unique collection of Lindsay's work) but his generosity to impecunious artists. He bought their work it would seem (particularly during the years of the Depression) as much out of compassion for their needs, as with a ruthless eye for quality. But his letters do not reveal him as a man exercising his own confident, aesthetic judgement. Indeed he often defers to Norman in such matters.

Allow me to cite two examples. On 1 October 1920 Howard sent Norman a copy of the *Studio* which included an illustration of Jacob Epstein's *Christ*. There was something about it that appealed to Howard though he realized that it might not appeal to Norman. So he expressed himself cautiously. 'At first sight it looks weird', he wrote, 'it smacks down the orthodox idea of all artists from early centuries till now, save Munkasky's "The

Saviour of the World", but when you think of his (i.e. Christ's) simple mode of life, a nomadic wanderer according to history (he is quoted as saying "Birds of the air have nests, but the Son of Man hath not where to lay his head") despised and rejected of the men of his day, is Epstein so far out in his conception? You might give me your idea,' he concludes, 'when next we meet'.[12]

Norman did not wait until they met. So far as he was concerned Christ was a Jew and Epstein was a Jew and neither had any place in Apollo's kingdom. 'As regards the Epstein Christ', Norman wrote a few days later,

I must confess I have very little sympathy, or rather none, with the primitive movement in art. It is a movement towards ugliness, and I regard all that fails to record Beauty as a failure not only in art, but in the whole morality of Life. I have gone deeply into this problem in *Creative Effort*, as you will see. It is too large a subject to dismiss in a brief note, but roughly speaking, I believe primitivism as expressed in Cubism, Futurism, post Impressionism, Free Verse, and the Epstein brand of Sculpture, as the evidence of a decay of Mind, which has found the effort to respond to the vital problem of Beauty expressed by grand form and spirit too much for it, and has relapsed into childish simplicities of form and incoherence of speech, and a use of colour akin to a savage's instinct to decorate himself and his belongings. You have only to compare the Christ of Epstein with Rodin's *Burghers of Calais* to see how Epstein has done no more than affect a simplicity borrowed from primitive sculpture, whereas Rodin has stamped the simplicity of his forms with a terrible human drama, whose very lack of dramatic gesture lends his figures the tragic significance of men about to die. No I think that the only significance of Epstein is that he defines that element of mind which is not Art. I regard him as a passing phase, the little notoriety which arrests public attention by cutting undignified capers and is forgotten in a decade.[13]

A day or so later, Howard wrote back. 'So many thanks for your letter this morning re Epstein. I was having a talk only yesterday with a friend at lunch re this sculptor and told him that the simplicity of the figure might pass but not the ugliness. I am glad to have you confirm this.'[14] But as he penned these sentences there was much crossing out, an endeavour, doubtless, to find the right accommodating words that would not offend his mentor. In their correspondence and their conversations Norman kept a close rein on Howard's aesthetic judgement, not allowing it to stray into the ranks of the enemy. If you are going to defend an aesthetic canon there must be no waverings, no uncertainties. For there is room for a few only at the top, in each category of

art, and their aesthetic virtues must be known and proclaimed, if they are not to be trampled upon by the mob. Norman Lindsay, for example, had no doubts at all as to who was Australia's greatest landscape painter. It was Elioth Gruner. Gruner was not only Australia's greatest landscape painter, he was in Norman's opinion 'the greatest painter of pure light the world has ever seen'.[15] Gruner, who painted the flocks and herds of Apollo's kingdom in the frosty light of spring mornings with an unsurpassable beauty.

So imagine Norman's feelings when Howard told him that Gruner himself had informed him, Howard, that during a visit to Europe he had been 'considerably impressed with the paintings of Paul Gauguin'. So Howard sent Norman by the same post a little book of Gauguin reproductions. And was more cautious this time. 'I don't want the book back', he wrote, 'as his work does not appeal to me in the slightest.'[16]

Norman's reaction, as with the Epstein gambit, was immediate and forthright. 'You are right', he wrote,

to find Gruner's interest in the obscene Gauguin inexplicable. Among the various shocks that I have experienced during 47 odd years, I count the discovery that Gruner had experienced an appreciation of this frightful savage to be one of the severest. But to tell you the truth, I don't believe for one moment that Gruner really believes such rubbish is worth consideration. He has merely picked up the European trick of pretending to see virtues in it, and if you keep on pretending long enough, it is quite possible to believe that the virtues are there. One can only call this sort of thing self-hypnotism.

With Gruner, I think it only a passing phase that goes about as deep as an interest in the latest fashion in hats. But with a poor devil like Rupert Bunny, a man of amiable character but weak intellect, it is plain death. Gruner may talk Gauguin but doesn't paint him. For a while I was troubled over his apparent lean towards modernism (in its bad sense) but I found that it goes no further than talk. And Gruner does not make his real analysis of art in words, but in his inner vision of light and colour. I confess it makes me feel foolish to hear a man of his powers expressing an appreciation for stuff that he would have damned at the age of five, but the best thing is to say nothing, and leave the question of what he really thinks to his paint brush. As for Gauguin and van Gogh and Matisse and the whole mob of modern Hottentots, one can't discuss them seriously. They are not even ordinary bad art; but are simply the expression of a reversion to savagery... I don't hesitate to believe that in twenty year's time not a vestige of this set back will remain. The humour of it is that Gruner's art is going to do more to kill Gauguin than any attack on his rubbish could do.[17]

In such a fashion Norman defended, as did his brother Lionel, a classical canon of Australian artists (of whom Gruner was the greatest) against the barbarians who might trespass in Apollo's kingdom. The great Australian public, in their eyes, were barbarians.[18] They had no need of them and the worst thing one could attempt to do was to educate them in art. For Norman there were only two kinds of persons who were capable of entering into the kingdom of Life: the creative producers and the creative perceivers. Those who possessed the gift of inspiration and those who possessed the gift of perception. One needed the other, the artist must have his patron, the rest would be quite happy dragging the cart-horse Existence. Norman believed that he possessed inspiration but had grave doubts about his capacity to perceive the quality of his own work. 'It's a damnable thing', he wrote to Howard in June 1942, 'that I have no ability to see quality in one's own work. I have to rely on other eyes, of which yours are the most valuable asset.'[19] Hinton, that is to say, was one of those chosen souls who possessed perception. Writing to the man in Hinton's firm who returned Norman his letters to Howard, after Howard's death, to thank him for the gift, Lindsay added: 'I have always held that Perception is the other half of Creation.' It was this gift of perception that made Hinton, in Norman's view, 'the greatest patron of art in this country. And the only one who made it his objective to acquire works as a gift to the country itself'.[20]

For Hinton, though he deferred to Norman's judgements and assembled a collection of Australian art that did not trespass beyond the limitations of Norman's taste, was not himself an élitist. He was by nature a compassionate man, an educator, a popularizer, and made it his mission in life to popularize the Lindsay canon of the best that had been drawn and painted by Australian artists, by collecting their work and then giving it to appropriate institutions. I suppose one of the most interesting questions that might be asked of Hinton is the psychological source of his collecting and gifting mania.

What was it that prompted this bachelor who lived for the greater part of his life in a modest room in a boarding house in Cremorne to collect and then gift his collections throughout life? To what extent is the Hinton Collection a monumental protest against the masculine and philistine codes of behaviour that dominated Australian social life during Howard Hinton's lifetime; to what extent is it an expression of it? Michel Foucault

includes the solitary collector among that motley group of what he calls peripheral sexualities that were thrown up and began to proliferate, he argues, under the new conditions of modern industrial society, with its new ways of articulating and classifying the constantly interacting needs of social power and sexual pleasure.[21]

Hinton's collection does not conform to any conventional view of a homosexual taste. If anything it's the reverse. Repeatedly he told Norman how he would come home and take Norman's drawings out of their cupboard and how they would act as a tonic after a tiring day in the office.[22] It reminds us of Matisse's ambition to paint pictures that would serve as a kind of comforting armchair for the tired businessman; and of Kenneth Clark's timely warning, in his book on the nude, that disinterested aesthetic discrimination can never be satisfactorily distinguished, Kant notwithstanding, from sensuous desire. So we might well be tempted to ask to what extent Howard's passion for Norman's etchings might not have been prompted, at least in part, by the need for a little personal gallery of pin-ups to comfort his solitary existence. What does Howard Hinton's devotion to Lindsay's massively fleshed but not massively clad young women, or his interest in pictures of cheeky and rosy-cheeked girls, such as Emil Pap's *Red Apples* or of van Beers's, radiantly coquettish *Sister Rigoletta*, tell us about the nature of Hinton's sexuality? Perhaps one of the reasons why he became the first and most consistent of Lindsay's patrons was that he did not have the need to call in the advice of a wife in making his purchases. In this respect a comment that was made by Lionel Lindsay, in a letter to one of his closest friends, Sir James McGregor the woolbroker (who was reputed to possess at that time, the best cellar in Sydney) is of interest. The occasion for the comment occurred in 1947 when Norman offered the Art Gallery of New South Wales a full collection of his work, which he valued (or Rose his wife did, for she was the business manager) at £100 000. Lionel was speculating as to how the trustees would react and commented on the taste of the President of the Trust, the architect B. J. Waterhouse. 'The President', Lionel said—and he had a nice feeling for a bit of scandal—'has drawers full of the [Norman's] etchings, kept from home, the solace of long frustrations'.

Such comments may serve to remind us that however elevated Norman's conception might have been of Woman as the Eternal Feminine, and mother of all things, his work was also collected to serve more palpable pleasures.

Not that I would want to reduce Hinton's passion for collecting to a personal need for pin-ups. Indeed out of the thousands of works he purchased he kept only about a dozen hanging on the walls of his bedroom in Cremorne. The others he gave away. In his buying he had a public purpose in mind from the beginning. Shortly after he was appointed a trustee of the (National) Art Gallery of New South Wales in 1919 he wrote to the President recommending that Elioth Gruner be given a commission to paint a typical Australian painting, a commission that was agreed to, and resulted in Gruner's painting *Valley of the Tweed*. What Hinton had in mind was the presentation of a kind of canon of the best Australian art, by means of a series of panels in the Australian Court of the gallery. It depressed him to realize how little the trustees were doing to encourage the recognition and enjoyment of Australian painting. 'To me', he wrote to Norman shortly after he became a trustee,

the Australian School is the strong attraction; since the eighties it has been as brilliant as the sunshine of this beautiful land, and continues so today. By now the Gallery should have panels in the Australian Court of all the front rank men, thus perpetuating in the best way (both for the artist and the Gallery) a History of the home born art of New South Wales.

In this direction I still carry a hopeful heart, thinking in a large sense of the powerful stimulus it must bring to future ranks of Students, and I trust yet to see the day even if I am an old man then, when the Norman Lindsay panel will shine with a splendid fascination for the generations to come.[23]

During the years of his trusteeship he gave many pictures to the Art Gallery of New South Wales Gallery by Gruner, Hilder and Norman Lindsay, to constitute panels of Australian art masters for permanent showing in an Australian court. Hinton thus became the vehicle, under Norman Lindsay's tutelage, for the assembling and transmission of a canon of Australian art and artists grounded in Lindsay's 'classical' norm. The creation of the canon was begun in the Art Gallery of New South Wales and carried on into the Armidale Teachers' College after, it seems, the trustees refused, on one occasion, to co-operate with Howard in his policy of gifting. What was Sydney's loss, it has often been said, was Armidale's gain. And that, at least in a quantitative sense, must be conceded. But the pity of it was that Hinton, under Norman's tutelage, assembled a collection designed to define and defend a standard of excellence that was already old-fashioned from the time it began to form. In the thousand or more works that Hinton gave to Sydney and Armidale there will

be found nothing of that art which overturned the values that Lionel and Norman so bravely defended. No surrealist, no expressionist, no abstract or constructivist art, no social realism. All that, as Norman would have told Howard, was the art either of the savage or the *canaille*. When the work of comparatively advanced artists such as Dobell, Eric Wilson or Adrian Feint were purchased by Hinton they are works that reveal the conservative and craftsmanly rather than the experimental aspects of their art. Work, in other words, that could be accommodated within the Lindsay aesthetic.

Nor is it possible to say, as one would like to, for no one was more kind and gentle than Howard Hinton, that he created within that aesthetic a collection of unquestioned and sustained quality. The fact is, surely, that it is remarkably uneven in quality. There are, of course, as is well known, here and there, works of real quality, by Conder, Streeton, Roberts, Murch and others.

Nor does the Hinton collection give much support to any of the major cultural myths of this country, of any Australian legend, of country or city, or of a redeeming dead heart. It is rather a homely, suburban vision that we gain from the collection as a whole, dominated by the kind of paintings the subjects of which might warm the heart of a sociologist such as Hugh Stretton. To the extent that Hinton collected the work of the Heidelberg school and the work of its admirers and associates it is the 'Heidelberg' school of the camps around Sydney Harbour not of *Shearing the Rams* or *Bailed Up*. Hinton was not interested in an heroic vision of Australia; what we see repeatedly are Australians enjoying themselves on their beaches, or in their suburban gardens. He spent his life, we recall, with a shipping firm, and as we pass along his collection we are never far from the comfort of water and picturesque gardens. Hinton's Arcadia, one sometimes feels, could be encompassed within a spacious Cremorne backyard, a Charterisville from which the girls had faded into art. Hinton avoided all forms of art that disturb either by style or meaning.

So the Hinton Collection does not succeed, it would seem to me, in its original intention of serving as a canon of pictorial excellence for Australian art students, even of that *retardataire* excellence based on the Nietszchean classicism that Norman Lindsay championed. Hinton did not possess the ruthlessness of the collector who seeks for only the best. He was much too compassionate a man for that. And the programme itself was doomed from the beginning. Hinton began too late. If he had been born earlier, if he had begun his collection in 1890, when the best of

the pictures that he loved were being painted, instead of beginning thirty years later, at a time when the vision of the Heidelberg painters had long lost its freshness and zest and was then being reconstructed as a repressive ideology, it might have been possible to tell a different story.

And even when that is conceded one must still question the value of selecting a few artists and promoting their work among students and the public at large as a canon of excellence. True, it is a process that none of us who teach in this field can wholly escape from, whether in the writing of texts, the assembling of exhibitions, or the construction of courses. But to the extent that such procedures are supported by the power and influence of institutions, the solidified, hypostasized, codified judgements tend to function as repressive ideologies rather than as inspirations for a younger generation. A safer standard for our conduct might perhaps be found in Eliot's remark (I cite from memory), that every work of art that is genuinely original has the effect, however slight, of revaluing the whole corpus of existing art.

Hinton wanted his collection of paintings at the Armidale Teachers' College to encourage young teacher trainees to enjoy and treasure Australian art. They would function better in a college where they were readily available in the class rooms than they would if shown occasionally on the walls of a gallery. The classical canon however that Hinton espoused worked against his intentions. It was in that other place, the Sydney Teachers' College, with its sympathy for modernism, that the revolution in art education in New South Wales, during the 1930s and 1940s, was nurtured and promoted; in the teachings of May Marsden and her talented pupils, such as Rah Fizelle and James Gleeson. They were taught to be open-minded about the work of artists like Epstein and Gauguin and what followed. Indeed, in Armidale, one of Marsden's pupils, Walter Placing, undertook a similar task. It would be of interest to know to what extent he found the Hinton Collection of assistance to him and to what extent he found it to be a burden.

Now all this must sound rather dispiriting to those who may be charged with the responsibility of curating and conserving the Hinton Collection. No doubt there are positive aspects that I have underestimated. It would be surprising, for example, if during the fifty-odd years of its open exposure in classrooms to successive generations of student-teachers it exercised no effect in raising the standard of art appreciation in the schools, even if the taste it promoted was of a somewhat conservative kind. It

certainly exercised a major influence on the life of at least one student. Lyn Bloomfield, who now runs her own art gallery in Paddington, has described the impact of the daily presence of the Hinton Collection upon her when she was a student at the college; and with the death of Douglas Stewart, she is now, through her books and exhibitions, probably the most active champion of Norman Lindsay's art and aesthetic values. Not that, from a marketing point of view at least, Norman's graphic work has ever stood in need of champions. The prices his works fetch have stood firm throughout the fifty-odd years of the modernist ascendancy. Whether that is because there will always be buyers who respect craftsmanship more than sensibility, or whether Norman Lindsay's work still continues to cater, even in these so-called permissive days, for the masculine snigger, I must leave you to decide.

After fifty years the Hinton Collection has now entered into a kind of half-life where it will no longer be exposed daily to teacher-trainees. This is in part because the marketing of art creates its own subtle form of censorship. Many of the finest works in the collection, such as those by Roberts and Streeton, have become so valuable that no college principal, no departmental auditor, could possibly bear leaving them upon classroom walls, an easy prey to theft. And they have also become too valuable to be left to the extremes of heat and cold of the Armidale climate. Like treasured grandparents they must now be housed and coddled in a manner suited to their years. Their pricelessness and fragility impose an inevitable censorship and they cease to be daily and freely accessible aids to an aesthetic education. They will now appear only under special conditions when selected by curators to serve the needs of a special exhibition or the needs of a special occasion. In other words Hinton's original purpose will now be modified to suit other purposes and different needs.

It is difficult not to conclude that the collection's value is today more of an historical than an aesthetic character. But will the long-term evaluation of history be, as Norman and Howard would have hoped, that it provided evidence of that enduring respect for classical quality, that was for a generation or two in Australia and elsewhere, eclipsed by the madness of modernism, or will it be seen as a vain attempt to make the classical popular and resistant to the forces of change?

23
Two Art Systems
—1980—

If a perennial difference does exist between the visual art of Melbourne and Sydney we cannot begin to locate that difference by comparing allegedly typical Melbourne with allegedly typical Sydney artists. For artists, in the formation of their style and attitudes to life, are subject to a diversity of interests and influences which extend far beyond the cities in which they happen to live. Must we therefore conclude that the difference between Sydney and Melbourne art is a non-question? That the only question which matters is the one about individual aesthetic merit? We must not be intimidated by this antique conversation-stopper. There are quite subtle, complex and continuing differences between the art of Melbourne and Sydney, but they are not easily elucidated mainly because the continuing influence of a city is only one among many of those which affect the way an artist chooses to work.

Nor is it wise to begin by looking for the presence or absence of antithetical ideologies—comparing, say, the optimistic, organic humanism of Melbourne with the pluralistic pessimism of Sydney. This is one of the central theses of John Docker's important book *Australian Cultural Elites* (Sydney, 1974), which seems to me in many ways most illuminating, and much of what I shall have to say here will support his thesis. It is his method I find questionable, conducted as it is entirely at the level of ideas. Why, we must ask ourselves, does one city tend to settle for one constellation of ideas and another, another? Humanism, pluralism, optimism, pessimism are philosophical dispositions with a universal, if uneven, spread about the world. Why is it that one idea or set of ideas finds a congenial home in one city and not another? Is it the influence of great men, and of their admiring disciples echoing their opinions down the years? There is something in this surely, but not everything. An analysis which is

conducted entirely at the level of ideas or personalities cannot reveal to us why some ideas and attitudes, like returning mutton birds, settle year after year in the same urban rookeries, and not in others.

A more promising approach in an urban-centred enquiry of this kind is to seek out those specifically urban factors which continuously affect the production, marketing and preservation of works of art, the enduring institutional supports which a city creates in the course of its historical development and which operate as an interrelated system.[1]

I would suggest that in their development Melbourne and Sydney have devised support systems which are distinctive, and that it has been from the character of these support systems that subtle differences in the tone, presence and mood of the art of the two cities have issued. But first a warning. It is easy to over-emphasize the differences. All the world loves an antithesis. Indeed Lévi-Strauss and the more rigidly oriented structuralists would argue that our minds are constructed for creating them. What we are concerned with here, however, are not antitheses, not even a whole bagful of them, but rather a difference in the weight, influence and dynamic power of the varying components which constitute the art systems prevailing in the two cities.

First let me explain briefly what I mean by a support system for the visual, or fine arts. When in the late fifteenth century the generation of Alberti and Leonardo began to establish the crucial distinction between fine art and craft which has been maintained in Western societies down to the present time, they required a new institutional support system which would manufacture and maintain a new mode of aesthetic valuing based upon the distinction between art and craft. This new system was realized in the creation of a set of loosely related institutional components: fine art schools and academies, art museums, art exhibitions, and art dealing houses, and the new intellectual disciplines of archaeology and art history, and of art criticism, by means of which objects of our material culture could be endowed with a powerful mix of historic and aesthetic values. Beginning in Florence and Rome these urban-based fine art systems came to be regarded as one of the distinguishing hallmarks of civil society—for they testified to the presence in the city of a highly privileged mode of production. Most cities subject tò European influence, upon attaining a certain size, create such systems. And the differences in the nature of the art which arises from cities depends upon the ways in which the institutional components are related within

their systems. Fine art systems, I might add, are characteristic formations of early capitalism, in that they are pre-eminently pre-industrial in character, their concern being primarily with the making and producing, marketing and conservation of hand-crafted objects elevated to the status of works of art.

Let's consider Melbourne. Because of its rapid economic growth during the second half of last century up to 1889, together with the presence in the city at that time of a group of highly talented and public-spirited citizens, as well as professional artists (Sir Redmond Barry, James Smith, Augustus Tulk, von Guerard, to name but a few of the leading lights, and somewhat later the businessman Alfred Felton), the city was able quite early in its history to develop a fine arts system on the Renaissance model. Certainly it was that model as seen through the educational and moral aspirations of the late nineteenth century, but its Renaissance source is indisputable. It is worth remembering in this connection that the concept of the Renaissance itself is the product of nineteenth-century historians (Michelet, Burckhardt, John Addington Symonds) and that the creation of the concept heralded in several parts of the world the re-creation of many typical Renaissance social formations. The re-creation, not all unsuccessful, of mediaeval-type institutions in the first half of the century, stimulated by the Gothic Revival, affords an interesting parallel.

Though it may seem strange to evoke the Renaissance when talking about Melbourne public institutions of the nineteenth century, in considering religious, educational and cultural institutions it is often more rewarding to address our attention to the long-term continuities, as Fernand Braudel[2] has reminded us, rather than seek out the nodal points of innovation and change. Innovation is a feature of industrial production and probably not the best historical model for enquiring into the nature of pre-industrial-based activities.

What is particularly characteristic of the Melbourne fine arts system is the strength of its educational and conservational components. Melbourne's National Gallery set out from the beginning to establish a collection which ranged across a wide field of the fine and applied arts, beginning with a collection of casts of classical sculpture, coins and gems, in the manner of a Renaissance *Wunderkammer*. When the first consignment for the new collection was exhibited in the new public library in 1861 it attracted 62 000 visitors in the course of two months. A contemporary report informs us that an attendance of this order 'was clearly advantageous to the foundation of a correct taste'.[3] It was

also expected to improve moral values. This is all in the spirit of that role for the fine arts in the civic polity which the humanists of the Renaissance championed—and the source of their inspiration was classical antiquity. From the beginning the tone of Melbourne's art system has been classical, or more correctly neo-classical. Indeed in 1865 an attempt was made to purchase for the city the whole of the contents of the Villa Albani[4]—still the greatest collection of neo-classical art remaining in Rome today. I have always felt a little uneasy about formulations which have sought to argue that Melbourne art is romantic in character; its tone and aspirations, even when the personal style departs far from Renaissance models, are neo-classical in character. Romanticism, images of revolt, nationalism: these the city assimilates or rejects, as it tamed Peter Lalor and hanged Ned Kelly.

Melbourne developed impressive public institutions for the training of artists: in the city itself, the Gallery School and the Royal Melbourne Institute of Technology; in the inner suburbs, an impressive range of high-level suburban colleges such as Prahran, Caulfield, and Swinburne. Prominent provincial towns such as Ballarat and Bendigo sought to emulate Melbourne's model in the creation of similar institutions. By contrast, the marketing side of the fine arts system—the development of artists' societies, the private art galleries and the auction houses—though of the greatest functional importance for the system as a going concern, developed somewhat later and cannot be compared in strength to the weight of the educational components. This is understandable, for in the early life of any fine arts system it is necessary first to produce the artists and create the taste for art before the art goods begin to flow in any great quantity into the marketing components of the system, which in the earlier years are thus relatively weaker.

In contrast, Sydney's art system, though cast at first in a mould similar to that of Melbourne, emerges later, is weaker in its growth and is largely provincial to Melbourne. The Art Gallery of New South Wales was established more than a decade later than Melbourne but with similar aspirations; indeed Melbourne seems to have been the immediate, though unadmitted, model. The artist—businessman Montefiore, who had been active in the creation of Melbourne's art system, both in the development of an art society and its gallery, was a prime mover in the creation of the Sydney Gallery, and its first Director. But for some mysterious and unexplained reason—and I have no explanation to offer—in the sensuous, sub-tropical atmosphere of Sydney the

humanist aspirations of Melbourne did not gell. The Art Gallery of New South Wales, instead of setting out to collect a selection of the best that had been wrought and proclaimed in order to create a 'correct' public taste, came under the domination of the representatives of two rival art societies, the Royal Art Society and the Society of Artists. They vied with one another in acquiring the work of their members for the public collection. Similarly, though I cannot discuss the question in detail here, the history of tertiary training in the fine arts is intermittent and weak compared with that of Melbourne.

The strength of the Sydney system and the clue to its differentiation from that of Melbourne lies in its professionalism. Although the Melbourne system was, as I have argued, ultimately a professional system based upon Renaissance models, Sydney's developed in a more narrowly professional way. Its strength came to lie not in its educational but in its marketing components. The reasons for this are historical. Elements of a dynamic fine arts system do not begin to appear in Sydney until the last two decades of the nineteenth century. They develop provincially to Melbourne and gain from Melbourne's political and economic crises. It was the crisis in the public service of 1878 known as Black Wednesday that sent the young J. F. Archibald from Melbourne, via Queensland, to Sydney where he established the Sydney *Bulletin*. Shortly afterwards Julian Ashton, trained in England and France but attracted to Melbourne by the opportunities for pictorial art made possible through the rapid growth of the illustrated press there, moved up to Sydney where in 1886 he established an influential private school, the Sydney Art School. For over fifty years it continued to produce most of Sydney's first-rank professional artists. The big stimulus to Sydney's art world came, however, with the collapse of Melbourne's boom in 1889. Streeton moved up to Sydney in 1890, Roberts in the following year. Both men lent their weight to developing the local art societies on a more professional basis. The basic reasons for all these moves were in every case primarily economic, though I have no doubt that aesthetic factors contributed: the great beauty of Sydney Harbour and perhaps even the climate, though why anyone can possibly prefer the sweaty humidity of Sydney to the sunny Mediterranean climate of Melbourne and its stimulating seasonal variations is a question whose answer continues to elude me. Yet one must concede that for artists down on their luck a tent on Sirius Cove, Mosman, is a more attractive proposition than an unheated Melbourne garret. Norman Lindsay did

not get a chance to move up to Sydney, and the *Bulletin*, until 1901. In the same year, though he was no more than a boy at the time, came Sydney Ure Smith.

Archibald and Ashton, Streeton and Roberts, Norman Lindsay and Syd Smith, all from the southern capital, laid down the basic character of the Sydney system as it exists today. What they created was not an art system which was a function of the civic polity, for the promotion of morals, taste and manners, but one which sought to create an effective economic apparatus by means of which Australian artists could exist. Perhaps it was the collapse of the Melbourne boom in 1889 that called the humanist assumptions of its art system so seriously into question—at least in Sydney, to which the leading Melbourne professionals had emigrated.

At the outset, Sydney's art system developed a strong nationalistic flavour, not only in the pictorial art of the *Bulletin* but also in the greater national emphasis in the Sydney work of Tom Roberts and his colleagues. This phase of nationalism, as is well known, developed around a romantic rural mythos. But it would be misleading to draw a sharp distinction between Melbourne's neo-classical humanism and Sydney's romantic nationalism. Sydney's nationalism, like its short-lived humanism, did not gell into an enduring feature of the Sydney system. That continuing characteristic, as I said, lies in its professionalism. It was largely the work of Sydney Ure Smith and Norman Lindsay building on the work of the earlier men. Its economic base lay not among Archibald's lone bush hands, but in the growing wealth of Sydney's middle classes located in the eastern and northern suburbs.

Sydney Ure Smith was the son of the manager of the Hotel Australia. His first publishing venture, the *Australia Kat*, written, illustrated and published by himself, was sold on commission by the lift boys of the hotel at threepence a copy. Later he established *Art in Australia* in 1916 and *The Home*, Australia's first glossy magazine, in 1920. Smith studied at Julian Ashton's school and there made a life-long friendship with a fellow-pupil, Charles Lloyd Jones, the talented amateur landscape painter who later took his father's place as managing director of Sydney's largest retail house. This close link between the man who did more than anyone else to widen the circle of patronage for Australian art through the pages and illustrations of his *Art in Australia* and his closest friend is crucial for any understanding of the Sydney system. Sydney's great retail houses such as David Jones, Anthony Hordern, and Farmers Ltd, created art galleries of considerable

influence and standing in the Sydney art system. Even when the Blake Prize for religious art was established in 1951 it was the retail house of Mark Foy's, with its close Catholic associations, which gave the competition exhibition space for over ten years. Then it moved to a bank.

To this highly professional strategy for the promotion and marketing of Australian art Norman Lindsay contributed an appropriately professional ethic. It was formulated in his *Creative Effort*, first published in book form in 1924. Lindsay saw the creative artist as a natural aristocrat who alone maintains contact with the true sources of life; the rest of the world consists of 'feminine half-minds' who must drag 'this Cart-horse, Existence'.[5] A potent mixture of Nietzsche and spiritualism was behind this highly élitist ethic—and I have no doubt, also a large element of personal guilt. For Lindsay, in dragging the cart-horse of his own existence during the war years, must have shamed many young Australians to their death in the First World War with his poisonous war cartoons for the *Bulletin*. In Lindsay's view, the artist is an amoral alienate surviving in a philistine world. Social concerns, moral stances, are signs of weakness, of going over to the enemy. Although Sydney artists have long moved away from Lindsay's *artistic* style, few have ever questioned his *life*-style and the professional ethic which he enunciated. More importantly the media in Sydney continue, generation after generation, to tailor the personality of the fashionable artist of the day, in the cut of the Lindsay life-style.

Because the Melbourne system has developed strong educational involvements it tends to produce more artists than it can support and for this reason acts as a metropolitan centre for the production of artists; Sydney, by contrast, emphasizing the market component of its system, has a tendency to draw trained artists to it. It is quite surprising, when one looks at the record, how few artists of first rank have been born in Sydney; they tend to come from Melbourne, the hinterland of New South Wales, or from abroad.

Because Melbourne is inclined to stress the training of artists and Sydney the marketing of art there is a discernible difference by which changes of style occur in the two cities. In Melbourne change tends to be traumatic. Melbourne resists change, but when change does take place there is considerable disputation associated with it. In 1889 the debate between impressionism and accepted modes of nineteenth-century painting came to an issue in the 9 × 5 exhibition; the debate over the advent of

modernism became an issue in the creation of the Contemporary Art Society in Melbourne in 1939; in 1959 the debate about figurative and abstract art became an issue in the Antipodean exhibition. Sydney avoids controversies of this kind. They disturb the market. Disputation is suited to the education of artists; young artists argue more about art than old ones, for they are involved in finding a meaning for their art and their life-style as an artist. The older professional has before him the economic responsibility of marketing his work in order to live. Argument begins to appear increasingly irrelevant as his economic position becomes assured. In Sydney stylistic change approximates to fashion change: an accepted feature of the market mechanism. All change is assumed to be change for the better. Explanation, not debate, is called for.

I have been considering the early stages of growth of the two systems. A full consideration of their history, however, would require an examination of the manner in which significant new components are accommodated to the existing institutions. I have gained the impression, to take a significant example, that the three relevant university departments in Melbourne, those of Melbourne, Monash, and La Trobe universities, have been added to Melbourne's art system without any prolonged controversy. Hardly any friction impeded their acceptance by an art system which had provided a significant role for education from the beginning. By contrast the establishment of the Power Institute of Fine Arts in the University of Sydney (with which I was personally involved) as an academic teaching institution cut against the grain of the traditional Sydney art system. The bias of the Sydney system favoured the view that the institute should be established in a narrow contemporary way, concerned with the study (and hence the promotion) of recent contemporary art only. Though it was clear, from a close reading of his will and his other writings, that John Power favoured no divorce of the study of contemporary art from the study of the art of the past, seeing the present as an emergence of the best from the past, the Sydney preference was all towards separating the acquisition and exhibition of works acquired by the institute from the educational component which was also initiated by the operation of the bequest. Twenty-three years before the establishment of the Power Institute I encountered a similar resistance to the development of educational activities in the Art Gallery of New South Wales. When I was seconded from the Education Department to develop travelling art exhibitions in country centres, the majority

of the trustees tended to disfavour the development of educational activities in the gallery, but acquiesced in it as a scheme favoured by the state government of the day. I recall vividly a conversation with the late Sir Lionel Lindsay towards the end of 1944 in which he explained to me, with all the speed and eloquence of which a Lindsay is capable, the insidious dangers associated with an art gallery engaging in educational activities.

I do not want to leave the impression that the art marketing system in Melbourne was weaker than that in Sydney. So far as I know, the gross annual value of sales of works of art in the two cities is not computed, and figures are not available. Impressions vary. Melbourne is probably the stronger market for the re-sale of art works. Certainly some private galleries, such as the Australian Galleries, have played pioneering roles in encouraging the growth of a corporate and institutional patronage of the visual arts. But it is perhaps noteworthy that the most successful operation in private dealing in Melbourne, the Joseph Brown Gallery, pioneered a style of marketing which, it might be said, took on the mode of an educational exercise: each of the seasonal exhibitions constituting a cross-section, and usually a fascinating and illuminating cross-section, of the history of Australian art. By contrast it might be noted that it was the Art Gallery of New South Wales which in Australia pioneered the type which might be described as a 'status-asserting' exhibition, whereby living artists are given a personal exhibition of their work in the public gallery. This first occurred, unless I am mistaken, with the joint Margaret Preston and William Dobell Exhibition which was held in the Art Gallery of New South Wales in 1942. Prior to that, living artists' work only entered public galleries either through direct purchase or in large group exhibitions of the survey type; the use of the state apparatus was frowned upon at that time, even by private galleries, as an improper usage where the celebration and enhancement of living artists' reputations were concerned. Again it was Sydney which pioneered the scholarly, in-depth presentation of a living artist's work in the Dobell Retrospective of 1964. Whereas in Melbourne in the Joseph Brown exhibitions the marketing of art has taken on an educational mould, in such exhibitions as the Dobell Retrospective the state apparatus, originally devised as an educational apparatus, also becomes an agency for the promotion of the work and reputation of a living artist.

With the contrasting style of these two art systems in mind it would be of interest to contrast the personal styles and life-styles

272 Reflections on Australian Art

of Sydney and Melbourne artists who have spent most of their lives in one city or the other and achieved fame there. Frederick McCubbin might be compared with Sydney Long; Max Meldrum with George Lambert—the only artist to my knowledge who was born in St Petersburg and made his reputation in Tinsel Town; Thea Proctor with Napier Waller; Noel Counihan with Donald Friend; Fred Williams with Brett Whiteley. Many other contrasting pairs might be chosen. I am not certain what the results of a close empirical examination might be; but I suspect that Melbourne art seeks to assert a public function, aspiring to the conditions of classicism; that in Sydney art is regarded as a more private concern and continually reverts to a condition of décor, an embellishment of the artist's personality or the collector's residence.

Both systems have acted as metropolitan systems within Australia. But Melbourne's system, training more artists than it can employ, tends to thrust out; Sydney's system, strong in marketing but weak in the production of artists, tends to suck in.

24
Some Northern Critics of Southern Art
—1986—

During the past forty years some highly-distinguished writers on the theory and practice of art have visited Australia. Among the most notable who might be mentioned are Lord (then Sir Kenneth) Clark in 1947; Sir Herbert Read in 1963; Clement Greenberg in 1968 and Peter Fuller in 1982. Of these only Clark and Fuller have paid anything more than perfunctory attention to the nature of Australian art. Indeed for Read and Greenberg, then both facing the years of their declining influence, it must have seemed as if they had been invited, like ageing divas, to visit the end of the world.

Nor can it be said that Clark was much interested in Australian art as a cultural development with its own history. He viewed it essentially in environmental terms. It was the reaction of one or two talented individuals to 'the strange continent' that held his interest—that is to say, Nolan and Drysdale. His interest in Drysdale (who apparently wanted to live his life out in the place) soon waned, but to Nolan, who for Clark was a genius after the manner of Benjamin Britten, he continued to give warm support. That was Clark's way. He was, you might say, so far as living artists were concerned, a genius spotter. Civilization was the gift to humanity of the successive talents of the great. His most agreeable works are those that are concerned with genius, the work of such as Leonardo and Seurat. And so he kept a sharp lookout. There is much to be said for this patricianly, conservative view but for Clark, as for many of his countrymen, it was usually attended by an excessively Eurocentric vision. It was a vision in which he saw his culture threatened and tottering in his own lifetime. But he could not bring himself to believe that it was in any real danger. In any case his duty was, like Giotto's St Francis, to do what he could to prop it up. So his support for Nolan, for all its unquestioned clarity of perception, may also be

seen as an appropriation. Was there not in this quirky vitality, this naive genius à la Rousseau, a crude energy that might shore up the waning vitality of British art? For it was, we might recall, in 1947, the year that Clark began to champion Nolan seriously, that his former protegé Victor Pasmore experienced that dramatic and much publicized conversion to abstraction that came to so affect the teaching and reception of art in Britain. And the whole move to abstract art rested uneasily with the classical values of Kenneth Clark.

So Nolan became the first of those creative ones of that 1940s generation which revitalized Australian art whose task it was, at least in Clark's eyes, to assist in strengthening the waning vigour of British art. This is not the view of an uninvolved spectator. I knew them all. I lived through it. I saw it happening. It is also the way of the relationship between metropolis and province.

Herbert Read never revealed any deep interest in Australian art. This is to be regretted for he was a more sensitive man than Clark and his feelings were more finely attuned to the strengths and weaknesses of the modern movement. But by 1963 he was a tired and ageing man. The early modernism that he had championed in the 1930s in the masterly work of Henry Moore, Barbara Hepworth and Ben Nicholson had suffered a strange transformation and he knew that it was no longer liberating. It was now the art of a philistine establishment, it had also turned in upon itself to cultivate nihilism and despair. It had begun to deny the meaningfulness of life. Yet his vision was far too Eurocentric to allow him to imagine that anything in Australia might develop according to a different trajectory of values. That is to be regretted because it was to Read more than to any other writer that the young Australian artists of the early 1940s looked for intellectual and aesthetic support as they triumphantly broke from the local conventions that held them. His books provided them with a programme and a new sense of freedom. But by 1963 his central interests had turned away from adult art towards a psychological primitivism. His last hope for Western society was that it might be saved from the tyranny of technocratic 'reason' by his programme for 'Education through Art' in the schools of all the world. There was an enormous amount in favour of Read's advocacy of the importance of the creative imagination in the educational process, but there was also a deep anti-intellectualism at the heart of his Jungian dream and it has, in the event, led to an estrangement from the traditional skills upon which drawing, painting and sculpture (as in all other arts) depend. What

looked like a programme for liberation only served to promote, because of its excesses, the denial of life that Read perceived in the forms that late modernism took during his last years. Institutions, for all their imperfections, are not so readily mocked.

When Clement Greenberg arrived in Australia in 1968 it quickly became clear that he possessed neither the saving sense of tradition nor the range of sensibility that is characteristic of Clark and Read in their best writings. But it was also clear that he did possess an enormous confidence in his own judgements that was both intimidating and, in a sense, engaging. One felt at times that art began for him with Edouard Manet, that is to the extent that it foreshadowed the ultimate triumph of American painting. He had become, by that time, armed as he was with a rigid post-Kantian belief in aesthetic judgement as at once personal and universal and the conviction that painting unfolded the logic of its own history, the leading prophet of late modernism in its condition of decline. He saw modernist painting, as he called it, as a kind of platonic billiard table that was levitating itself through history as it moved towards its final condition of ineffable flatness. But in the USA it had already reached that state in the mid-1950s in the black canvases of Reinhardt; and the death of painting was soon being announced upon all sides. But it was not so much the death of painting as the rejection of those spiritual values that had once inhabited it that was occurring. What Peter Fuller had described as a *kenosis*, the 'emptying out' of later modernism.

It is surprising that Greenberg allowed his theories to propel American painting towards such a dead end. He possessed a good eye, but so far as American painting was concerned he was prepared to allow a determinist theory to rule his perceptions. He must have known that the paintings of Hopper are better than the paintings of Pollock. I was with him at that time when on visiting a commercial gallery in Sydney he pointed to a small Pro Hart and exclaimed 'now that's a fine passage of painting'—as indeed it was, though less could be said for the rest of the picture. But Greenberg was, I believe, also signalling that he preferred the figural expressionist painting of Australia (even in the late 1960s) to that of those unfortunate young Australian colour-field painters who had acquired their pictorial Americanisms at second-hand in the London art schools. That was the pathos of it; to see them crowding about the Master waiting for his blessing. But he preferred what had come to be known as Antipodean painting. As I said he possessed a good eye.

Like Clark and Read however Greenberg took no interest in Australian art as a tradition. What could possibly come from this part of the world? 'You remind me', he told me not unkindly one memorable evening in New York in August 1968, 'you Australians, of the good people of Saskatchewan. You are all so honest, so naive.' I felt almost grateful to him for so revealing to me this blind spot at the heart of his perception. Because for Greenberg, as for Bryan Robertson, who curated the Whitechapel exhibition of 1961 (the only exhibition of Australian painting abroad that has ever evoked anything more than a smothered yawn), we were redeemed by our innocence. But in this evil world innocence is usually in the eye of the beholder and distance can lend breadth to the view. At any rate I had already guessed in 1967 that Greenberg's commanding influence was almost finished. I doubt whether I would have invited him to give the first John Power Lecture in Contemporary Art had I thought otherwise.

Peter Fuller first visited Australia in 1982 to deliver, like Greenberg before him, the Power Lecture in Contemporary Art. Like Greenberg too he spoke with confidence but it was not the confidence of a critic speaking from the highly assured and heavily underwritten values of modernist formalism. Which is not surprising, for by 1982 Greenberg's aesthetic position looked like the ruins of a burnt-out hotel on skid row. Fuller's confidence was expressed in a somewhat grumpy, embattled way that perhaps might have been expected from a comparatively young man who had just arrived from a society experiencing a prolonged state of crisis. Indeed his own critical position was a product of that crisis. His professional career had begun in 1968, the year that Greenberg gave the first Power Lecture. 'The tumultuous political events of that spring and the subsequent summer', he has informed us, 'were undoubtedly a formative influence on my emergent political and critical perspectives'.[1] That is to say the political crisis of 1968 initiated the process of thinking out for himself a radical critique of late modernism, a process that is obviously still incomplete. So that in 1982 we were confronted in Fuller by a different kind of critical mind, one that did not speak to us from a secure (and secured) aesthetic but one still in formation. It seemed that between 1968 and 1982 the distance between metropolis and province had diminished remarkably.

This closure, this diminution of psychical distance, made it possible for a distinguished critic from abroad to speak to us without patronage. For Fuller had his problems too. This is what I have found attractive about his writings. His determination to

work out a fully-fledged aesthetic for himself, and one in which the concerns of society, of morality and of art all have their part to play. In explaining art he does not explain art away. So not surprisingly he has found himself embattled among those structuralists and Althusserian Marxists who do. He respects intellect but is aware of the danger of allowing it to override perception; so an engaging honesty often emerges in his writings as he seeks to revise earlier mistaken judgements and constantly define, and redefine his position. You may disagree with Fuller but you would have to be a nong not to know where he stood, whereas it would take more than the genius of Jean-François Champollion to decipher the meanings of most of those who write, say, for *Art and Text*.

Perhaps it is because Fuller takes such pains to make his position clear that so many feel that it must be reactionary. For many years now artists have become uneasy in the presence of those who set out to make their position clear. For they have become accustomed to changing step to every new tune they hear. But Fuller, far from being a reactionary, is in the process of fashioning one of the most radical critiques of late modernism that we have witnessed in a generation. This is emerging from his experiences of 1968, his prolonged study of the work of Karl Barth, of Marx and Freud, of the object-relations school of British psychoanalysis as expressed in the writings of Charles Rycroft and D. W. Winnicott, of his deep respect for the work of Ruskin and Morris, the more recent writing of Marcuse on art, and the work of the Italian Marxist, Sebastiano Timpanaro.

Despite the diverse, international character of such sources there is a strong regional character to Fuller's writings. This I find to be one of the most attractive features of his work. He is aware that since the death of Turner a spiritual grandeur has been lost to English painting and that since the death of Ruskin and Morris no British critic of the arts has done much to recover it. With Fry and Bell and their minor disciples the British visual culture began to look increasingly to Europe and then, with lights dimmed with such as Bryan Robertson, to look increasingly to America. The tradition became provincial, giving increasingly less support to its own artists on the pretence of supporting 'universal' values.

It was a situation that I became acutely aware of during my first visit to England in 1948–50 and on later visits: that after Victor Pasmore's conversion to abstraction British art seemed to lose its sense of purpose or tradition, that people like Sir Kenneth Clark and Alan Bowness who were in a position to exercise an

influence upon events felt helpless before the promotion of theories of art that were patently reductive and anti-human, products of what Fuller has since described as the 'megavisual', a failure of nerve that could only lead to the slow attrition if not the end of painting and sculpture as major areas of human achievement. Fuller's own writings are animated by the desire to reverse this trend and gain much of their energy from it.

It has led him to pay more attention to the nature of Australian art, in its most general aspects, than any of his predecessors. And I find it gratifying that he was the first person to grasp the trans-national implications of the Antipodean intervention of 1959 (that were its basic motivation) and led, despite the ideological manipulations to which it was subjected, to the Whitechapel exhibition of 'Recent Australian Painting' of 1961. Again, presumably it was a case of distance lending breadth and clarity to the view.

As I read Fuller I gain the impression frequently that I am traversing my own past, the same involvement with the work of Marx, Ruskin and Morris, a similar attraction to theological parallels in the search for aesthetic solutions, the same delight that I found in reading Marcuse's book on art, and the same sense of moral repugnance before the solipsism of structural theory and Althusserian Marxism. So that he either echoes my past or indicates positions I might well have adopted, or come to adopt, had I thought the issues through as thoroughly as he has done. Need I say that I also frequently find myself in disagreement. But here I can only give the barest hints of such disagreements without attempting to develop oppositional positions in depth.

Fuller is impressed (as I am) by the fact that we are aware, simply by looking at the way his face and body are rendered by his Hellenistic sculptors, that the *Laocoon* is 'in pain'. But I cannot agree that this is caused by a biological response on our part. For as biological organisms we possess no access to art. Such access requires a state of consciousness and consciousness is not adequately described as biological though it can only occur within biological systems (and of course not all biological systems at all times). The admiration of a work of art, aesthetic valuing, requires the operation of memory, and though I do not doubt that neurophysical descriptions of the activities and modifications of certain sections of my brain can be provided by biologists when I remember, they would not claim to provide me with any adequate account of what I remember or why I remember this rather than that.

Even if we should agree that the representation of a sensual

experience is more appealing 'biologically' than say the representation of the conclusion of a battle, does that mean that the former is in consequence more aesthetically compelling? Is the *Surrender of Breda* no less a convincing work of art than Manet's *Olympia*? To argue that the biological realm must be involved in our aesthetic appreciation is only to reduce the diversity and variety of art.

Fuller rightly criticizes Marx's somewhat tentative suggestion that the enduring appeal of Greek art may be due to the fact that humankind perennially enjoys the freshness and spontaneity of childhood and that the Greeks were 'normal children'. But he does not seem to note that Marx is here describing childhood in a biological sense as part of the ageing process. Here, as in Fuller's case, the argument from biology fails because it is reductive. Art is not a biological experience socially mediated; it is in itself a mode of social production. Baptism and Last Unction might be cited as socially-mediated rituals for birth and death but it is only in a very special sense that we might want to describe them as works of art rather than sacramental rituals.

We do not need biology to explain the enduring appeal of art. In one sense what we are confronted with here is little more than a tautology. The appeal of a work of art (or at least its potential to appeal) endures so long as the work, or its replications, endures. The Song the Sirens sang may still be a puzzling question to some, as it was to Sir Thomas Browne, but it can no longer exercise its appeal. In this regard it is important to note (though it seldom is noted) that aesthetic valuing by implication initiates a conservational programme. To say 'that's (aesthetically) good' is to suggest 'that's worth keeping'. Aesthetic valuing has worked to (among other things) preserve admired works of the past for our present valuing. Such works now inhabit our aesthetic environment and become available for contemporary judgement. So that we may admire the *Laocoon* expressing physical pain as we might admire Munch's *Scream* as an expression of psychological disturbance. In this regard it is insufficiently realized that not only works of art but all human productions, though emerging into history within a particular historic mode of production, continue to be 'consumed' until they pass physically out of existence. The enduring appeal of art is due primarily to the fact that art is conserved as an important aspect of the human heritage.

I found Peter Fuller's appraisal of the desert landscapes of Nolan and other contemporary Australian artists such as Williams most illuminating. He views their interpretation of the desert as an important original contribution to landscape as a

universal pictorial genre, and as such of trans-national signifi-
cance. That is an important insight. It may be that Nolan's
generation experienced that image of the desert powerfully both
as myth and as a recurrent and intimidating, contingent reality.
At any rate during the worst years of the Second World War the
imagery of Eliot's *The Waste Land* was constantly present in many
Australian minds.

> *What are the roots that clutch, what branches grow*
> *Out of this stony rubbish? Son of man,*
> *You cannot say, or guess, for you know only*
> *A heap of broken images, where the sun beats,*
> *And the dead tree gives no shelter, the cricket no relief,*
> *And the dry stone no sound of water. Only*
> *There is shadow under this red rock*
> *(Come in under the shadow of this red rock),*
> *And I will show you something different from either*
> *Your shadow at morning striding behind you*
> *Or your shadow at evening rising to meet you;*
> *I will show you fear in a handful of dust.*

Yet I also find myself in agreement with Jill Bradshaw when
she writes that the great emphasis upon landscape painting in
Australia 'represents a refusal to come to terms with the environ-
ment that European society has constructed'.[2] For there is un-
doubtedly a negative as well as a positive aspect to the long
dominance of landscape in the Australian tradition. At its most
sinister it might be seen as an appropriation at a spiritual level of
a process that began with the physical acquisition of the land
from its first inhabitants. Australian artists might do well to pay
more attention to the nature of their own, in most cases, pre-
dominantly urban existence.

Yet I cannot agree with either Bradshaw or Fuller in the belief
'that the pre-occupation with ancient Aboriginal art and sites
may yet again prove to be another escapist tendency'. Though
there are dangers and difficulties in Australian artists of Euro-
pean descent attempting to use the motifs and designs of Abor-
iginal art without any deep understanding or experience of
Aboriginal society that danger will be constantly faced. For this is
one way in which the visual arts have always operated. The
artists of one culture appropriate the motifs of another to widen
and deepen their own aesthetic understanding. Consider how
orientalizing motifs enriched Greek art in the 7th century BC,
how Irish Celtic art enriched Carolingian motifs or how, nearer
our own day, Paul Gauguin drew upon Indonesian motifs and

his experiences of Polynesian life and art to develop the first and some of the finest expressions of a self-conscious modernism. While such forms of culture-contact invariably reveal processes of appropriation they also reveal *empathic* processes by means of which one culture begins to understand, and sometimes to respect, another. Moreover there is a basic reason why such processes of contact and convergence are likely to develop increasingly in Australia. It will come primarily from those Aboriginal artists of mixed descent who owe a deep allegiance—Peter Fuller might describe it as a biological allegiance—to both the European and the Aboriginal traditions. It is already happening.

But these are but small points on large questions that demand further discussion. Peter Fuller's critical writings are both challenging and exciting in the way they stimulate us all to rethink the basic issues of visual aesthetics. In this regard his admirable essay 'In Defence of Art' published in *Beyond the Crisis in Art* should be highly recommended reading in all our art schools. Both for Australians who are Fuller enthusiasts and those who have not previously savoured his work this present book, which also contains the important essay by the late Jill Bradshaw to which I have already referred, will be found to be challenging reading.

25
Five Options for Australian Culture
—1982—

During the past two centuries the European nations, together with their two twentieth-century protégés, the United States and the Soviet Union, have steadily influenced, if not dominated, the varied cultures of the world. They have provided their advanced technology, and to a large extent their modes of government and administration. Where local cultural elements have survived it has mainly been in the fields of language and religion, and aspects of the social structure. Nevertheless, in a broad sense, the world has become Europe-dependent for all the major aspects of its cultural geography. And that is not all. Advanced technology, competing nationalisms, and those competitive models of the great society, capitalism and communism, have brought us to the brink of nuclear annihilation. Dynamic Europe, we might conclude, has succeeded in making the world one world, and its protégés are now in danger of making it a no-world, at least one not suited for human habitation.

I have sketched out this gloomy scenario, with which we are all only too familiar, because I feel I must make two preliminary points that are basic to any discussion such as this one; and having made them I shall proceed to ignore them. The first is this: on any long view which takes the perspective say from Peking, Moscow, Rome, Paris, London or New York, the Australian culture, to the extend that it is visible, is seen as a dependent culture, dependent largely upon Britain and the USA. Secondly, like other cultures, the Australian culture depends for its continuance upon the decisions, and not necessarily rational ones, of one or two powerful men who are in a position to launch a major nuclear war. If they were dragged to the point of making such a decision, I would expect that the continued existence or non-existence of the Australian culture would be one of the least of their considerations.

In the lurid light of such an apocalyptic possibility any discussion about the future of Australian culture must be an essay in optimism. It would be nice to think that we turned out to be culturally sophisticated enough, culturally independent enough, to dodge the draft for Armageddon. But though I am an optimist by nature, the historical tea-leaves in my cup just will not read that way. Still, the threat should encourage us to seek those potentials for independence the Australian culture does possess.

A culture is produced by people, individuals who make decisions within the cultural realm. One way into our problem, then, is to establish the kinds of cultural options that are available to people, by which I mean modes of evaluation and preference between which the producers and consumers of culture may choose. It seems to me that contemporary Australia possesses, and has possessed for some time now, five major cultural options, namely: the universal option, the national option, the ethnic option, the Aboriginal option and the convergent option. I will describe each of them in detail and then draw a few conclusions.

The universal option emphasizes the unity and interdependence of all human culture. It does not concern itself with regional, class or ethnic differences as specific and separate interests. Those who accept the universal option see themselves as competing with and/or collaborating with the great achievers of the past and the present. The stress is upon standards, upon excellence. It is above all a measuring option. It appeals strongly to the scientific culture, while in the arts its strengths lie in criticism and in some aspects of our poetry. Those who select this option usually possess exceptional intellectual ability, or are endowed with sensibility beyond the average, which they then seek to cultivate to perfection. They are usually extremely well-educated. They constitute, you might say, an Achievers Club; are candidates for, sometimes winners of, Nobel prizes. Predictably, the institutional strength of the option lies in the universities, indeed the word *universitas* announces it. In its supine forms the option tends to defer to the past simply because it is the past, or to the metropolitan simply because it is the metropolitan. The claims of the provincial, the national, are not raised in good company among universalists without a feeling of embarrassment. At its best the option sets up a creative and critical dialogue with the best of the past and the best of the contemporary. In this way it achieves a genuine sense of independence that transcends regional and specific limitations. Its weaknesses spring from its sense of security,

intellectual pride and insensitivity or impatience with alternative options. It is envied, because it can usually command the major assistance grants. But it is not to be mocked with impunity. The universal option is based upon the profound insight that our common humanity is the best court of appeal, when such matters as the good, the true and the beautiful are at issue. There are problems here of course, but who among us would want to dispense with that final court of appeal?

The national option directs its attention towards Australian problems and concerns, Australian achievement and experience. In the arts it seeks to reveal the nature of Australian experience; in science and technology it pays special attention to matters that are of special concern to Australians. In its historical modes it seeks to distinguish, to make visible the presence of national and local traditions, criticize them, and promote new traditions considered desirable. Whereas the metaphorical authority of the universal option is ultimately mathematical, stressing measurement, fine judgement, and excellence, the metaphorical authority of the national option is biological, stressing growth, vitality, and conversely, decline, decay, and degeneration. It assumes, I believe correctly, that cultures are specific to their geography, their society, their linguistic areas, and so forth. Whereas the universal option produces Nobel prize-winners, the national option produces prophets, and those who aspire to prophecy, namely the gurus.

It embraces a wide spectrum of attitudes. At one end of the spectrum it approaches the position of the universal option; in the proposal, for example, that teaching Australian literature in Australian universities is OK because that is the least that the international community of achievers, dead or alive, would expect of us. The ghosts of Shakespeare and Dante would be seriously affronted if Australian critics did not accept a special responsibility to achieve a sustained critique of the works say of Lawson, Furphy and White. At the other end of the spectrum, the anti-intellectual end, it has tended to shelter at times a good deal of chauvinism and racism. In its populist manifestations it also possesses a distinctly 'wet' side, for example in its misty-eyed adulation of some Australian manly sports, such as Australian Rules football. But, as in other countries in which culture has functioned increasingly to oppose colonial constraints and colonial servitude, the national option has inspired, in one way or another, much of the best in the Australian arts. I do not know whether this could be said of the scientific culture, but certainly Australian

scientists have achieved international fame where they have addressed problems of special interest, or in which Australia possesses natural advantages, such as virology and radio-physics.

The universal and national options are Australia's 'top dog' options, but, in recent years, many of us have become aware of three others, the ethnic, the Aboriginal and the convergent options, that are helping to bring a feeling of greater variety to our culture, and soften a little the dog-like devotion of the post-colonial Anglo-Saxon look.

The ethnic option is a product of the post-war migration policy. Here, the stress is placed neither upon excellence nor upon the morphology of culture, but upon the need for diversity. A vigorous, independent culture, it is argued, freed from the more pathological aspects of nationalism, stands in need of vigorous cultural minorities that are nourished from diverse historical roots. Ethnicity has given Australia more cosmopolitan values, better restaurants, and introduced more colour and pageantry into public life. Ethnic radio and television are giving us both a far better international news coverage than we have ever had, and better bookshops. They are also, in all probability, preparing an electorate which will one day help to transform this country into a republic; migrant minorities of one generation have a habit of producing the nationalists of the next. Consider, for example, the Irish contribution to Australia's republican movement of the late nineteenth century, and more importantly its contribution to the creation of a national art and literature.

I turn now to the question of an Aboriginal option, which I see as something quite distinct from the ethnic option. By an Aboriginal option I mean the continuing rights and opportunities to work within a traditional Aboriginal culture, in order to produce and to consume cultural forms that are addressed to, and received by, Aborigines as an integral, continuing part of their traditional culture. But the possibility of an Aboriginal option within the Australian culture raises sharply the question of Aboriginal nationality. Is Australia two nations: a white, intrusive majority and a black, original minority? That might be a fair summary, in a nutshell, of our history, but it would be absolutely disastrous to attempt to erect a cultural policy upon it, for if we take the notion of two nations seriously, that posits a division in law, in territory, in diplomatic representation, and much more. It sounds remarkably like apartheid to me. To say that a serious attempt to achieve it could present us with a future akin to that of Northern Ireland or Lebanon may sound like an exaggeration; but stranger

things have happened. The sane policy surely, is to accept that Aboriginal people are Australians, in every sense of the word, and then proceed to consider their special claims in the light of their past history and present situation. Black Australians have ample historical grounds, God knows, for hatred, but if they choose to cultivate hatred as a psychological and political weapon, then our own history could well become, as Joyce said of Ireland's, 'a nightmare from which I am trying to awake'. It is of profound importance that none of us, black or white, becomes the victim of our own histories.

If this is to be achieved, every effort will have to be made to ensure that the traditional Australian culture is not destroyed. That cannot be achieved except through the present political moves for land rights, self-management, reparation. As I have argued elsewhere, it seems to me that our bicentenary of 1988 can only be given some measure of human decency if it is made the occasion for an agreement, whether Treaty or Makaratta, which provides adequate reparation for the rehabilitation of the Aboriginal people.

That said, as it must be said, we can now ask what does the traditional Aboriginal culture bring to Australian culture as a whole? The first relevant question is this: although it is a culture of the greatest antiquity, it is only in quite recent years that white Australians have come to accept it as a contemporary cultural expression of Australians. What special values does it bring to the Australian culture? Well, if a degree of independence is important for a culture, here we possess a unique model of independence, because the essential forms and practices of the culture are its own. There is also a moral grandeur in the very fact of its survival, from which white Australians might learn respect and draw strength. It could be objected, of course, that the Aboriginal option is only fully available to people of Aboriginal descent. That I must concede. Yet Europeans and others have lived with Aboriginal tribes, some have been adopted by them and shared their mode of life. There is no reason to suppose that that will not continue. The artist Ian Fairweather befriended Aborigines and adopted some aspects of their life-style. He seems to have succeeded better than most in bridging an admittedly great cultural division. In the process he succeeded in producing art of unusual integrity.

Mention of Fairweather brings me to the convergent option. By this I refer to that process which is set in motion by those who, like Fairweather, seek to bridge the gap. It is based upon a

mutual respect which has been rare and fitful in Australian history. Like the acceptance by white Australians of traditional Aboriginal art, convergence, as yet, possesses a comparatively brief history. Perhaps it begins in the 1920s and 1930s when a few realist novelists, then the Jindyworobak poets, and later Margaret Preston, sought to draw upon Aboriginal sources as an inspiration for their own work; and then, a little later, when Albert Namatjira and the group associated with him began to work in the European mode of water-colour painting. Since that time, however, a cultural convergence has occurred in rich and varied forms in poetry, the novel, the arts and crafts, and is now active in the theatre. New forms of painting have been developed from their traditional art by the Western Desert peoples centred upon Papunya. The Aboriginal Theatre Company's production of Robert Merritt's *The Cake Man* has received widespread critical acclaim. The examples might be multiplied. Indeed we need a critical and historical account of convergence, for it is now fifty years old.

Convergence is not to be taken as a new name for assimilation. The convergent option depends for its existence upon the continued existence of the traditional Aboriginal option; indeed, it is inconceivable without it. People of Aboriginal descent will experiment increasingly with ways of relating their cultural productions to European, Asian, and other non-Aboriginal techniques, styles and audiences; but they will also, of course, draw upon traditional Aboriginal cultures, their techniques, styles, history and spirituality in the process. And if they do that, the traditional culture will have to be there.

A vigorous convergent art could help strengthen the traditional art by, for example, encouraging urbanized Aborigines to return to traditional cultural practices. It may, and probably will, affect the traditional art itself, because I do not think the traditional art should be defined wholly in terms of techniques and styles. To do this is to consign traditional Aboriginal culture to an anthropological museum. The art is best defined by the relationship between the traditional producers and the traditional audience. It is what the traditional communities perceive as their own culture, here and now, that is traditional, rather than some idea of purity that has been lost.

To conclude. I am aware that there are other ways of cutting up the Australian cultural cake—by religion, class, sex and so forth, but such options operate internationally, and it is only in their peculiar admixtures that they reveal national characteristics. The

five options I have discussed focus better, it seems to me, upon the issues and problems that are especially important for contemporary Australian culture, even if not peculiar to it. All five have an important part to play and three of them—the ethnic, Aboriginal and convergent—need our support and encouragement. In this I am an unrepentent pluralist. It is upon the free interplay between these options that, in large measure, the tone, texture, and quality of Australian culture will depend.

One final point. The five cultural options I have outlined are of course conceptual categories, not labels to pin upon individuals. Cultural producers may, and in fact usually do, choose not from one but from several of the available options, and so establish the internal relationships which will help to determine the character of their work—work which if it is worth anything at all, is usually complex. To put it another way, outstanding Australian cultural productions recognize the presence in our cultural environment of all or most of the options I have discussed. It is up to the audience and the critic to determine what has emerged from the individual choices and recognitions.

26
On Cultural Convergence
—1985—

Jenny Zimmer invited me to conclude this series of talks (held at the Glasshouse Theatre, Royal Melbourne Institute of Technology) with one on cultural convergence, a notion I borrowed from Les Murray[1] and used in the Boyer Lectures for 1980 to explore the future of our cultural relationships, as indigenous Australians of mostly European descent, with the culture of those who first settled this land.[2]

I agreed reluctantly because these talks have been constructed around the current 'Dot and Circle' exhibition of Western Desert art and I do not regard myself as a specialist in Aboriginal art, indeed I suspect that the Aboriginal people themselves are the best if not the only specialists in their art. Nor have I been an activist in the politics of land rights and confronted those burning political questions that any full consideration of the future of Aboriginal art in this country ultimately entails. But I did agree to speak because one does not have to be an Aboriginal art specialist to be deeply concerned about the relationships that have obtained between black and white in this country for the past two hundred years and what all that might possibly portend for the future of human culture in Australia.

Jenny suggested that I might be able to add, as she put it, an ethical dimension to the discussion, but I'm reluctant to adopt that line too. It's not that I'm worried about those hard-nosed, so-called practical men, such as Hugh Morgan, the Director of Western Mining Corporation, who imply that those who act out of a sense of guilt about what our forefathers have done towards the destruction of Aboriginal societies are little more than, how shall I put it, 'sentimental wets'.

But let me in fairness permit Morgan to speak for himself. In concluding an article entitled 'We Should be Proud of our History', published in the *Age* he writes in what can only be described as distinctly threatening terms:

The Australian people are not about to become infested with self-hatred or obsessed with fantasies of guilt. But if it becomes clear that those who are attempting to compromise our sovereignty are succeeding in undermining our international standing then popular retribution will surely follow.[3]

Mr Morgan is no doubt a specialist both in mining and undermining, but like so many of those who now live in fear of the new militancy that has arisen in recent years (and from the best of human reasons) among our Aboriginal population, he claims to speak for the Australian people as a whole. Such a stance might best be described as the Populism of Hate. When people such as Mr Morgan are not claiming to speak for the People they claim to speak for Nature itself. If we do not agree with their views the People, or perhaps Nature itself, will take its revenge. Pride, like a vigilante, rides on horseback.

There is nothing at all reprehensible about acting out of a sense of guilt. It's by guilt that we are roused to acts of social responsibility and by which we attain a sense of community. Most of the time in modern society we act, and train our children to act, out of self-interest. But motivation from guilt does possess an inbuilt weakness. All too often it permits us to take short cuts in order to relieve our feelings. We act out our guilt by making some symbolic gesture; one that may do little to change the reality of the situation. Such actions, despite our good intentions, acquire a patronizing air in the eyes of the patronized. I have no doubt that the real improvements that will be achieved in the future in the social and political conditions of the Aboriginal people will proceed from their own political ability to better their lot, in association with those who have become specialists in black/white relationships in the relevant areas of medicine, law, social service and education, that is to say, with those professionals who give years of their lives to these urgent concerns.

Nevertheless those of us who are amateurs in these matters, and that of course means the great majority of Australians, possess not only a human right but also a civic duty to make our opinions known. For only thereby can the confrontational anguish of the past two centuries be diminished, the moral tone of our society as a whole be improved, and the evil inherent in bad social programmes made visible.

For the amateur, and I suspect for the professional also, there is one way into these problems that can be of value. We might examine more closely those ruling ideas which we have chosen to

describe (and prescribe for) the presence of the two cultures in the one land. So it is that from time to time we have adopted a programme designed to *assimilate* the Aboriginal culture into one monolithic Australian culture, or we have thought of Aboriginal culture as one ethnic culture in an Australian *multi-cultural* society, or spoken about the *transitional* nature of much contemporary Aboriginal culture as it comes to terms with a dominant Euro- peanized and Americanized culture. Against all such formulations and in preference to them I want to consider the idea of a *convergence* of the Aboriginal and the white Australian cultures.

In the article in which Les Murray, so far as I know, first made use of the word convergence, he had this to say:

In art, in my writing, my abiding interest is in integrations, in convergences. I want my poems to be more than just National Parks of sentimental preservation, useful as the National Parks are as holding operations in the modern age. What I am after is a spiritual change that would make them unnecessary. And I discern the best hope for it in the convergence of the sort I've been talking about. In Australian civilisation, I would contend, convergence between black and white is a fact, a subtle process, hard to discern often, and hard to produce evidence for. Just now too, it lacks the force of fashion to drive it; the fashion is all for divisiveness now. Yet the Jindyworobak poets were on the right track, in a way; their concept of *environmental value*, of the slow moulding of all people within a continent or region towards the natural human form which that continent or region demands, that is a real process.[4]

Murray significantly presents convergence as 'a fact, a subtle process' not a proposed ethical programme.

From the beginnings of white contact with the Aboriginal peoples of Australia there has existed a minority view, one that revealed an admiration, often suppressed or highly qualified, for certain aspects of Aboriginal culture. They were, Cook said, 'far more happier than we Europeans'[5] and Sydney Parkinson, the young artist on the *Endeavour*, agreed that they were 'very merry and facetious'.[6] And if we had time we could trace, through the writings of explorers, anthropologists and others, an admiration for aspects of Aboriginal culture, for a kind of 'primeval happi- ness' that European societies, in their belief in the idea of prog- ress, had lost. But it has always been a minority view. Official policies fashioned by whites for the containment of the Abor- igines was long fashioned on the view, promoted by social Dar- winism, that they were destined to die out.[7] This was the philosophy behind the so-called assimilation policy. That there

were manifest evils in this policy, such as the forcible breaking-up of families and the destruction of tribal life, is now generally admitted, even in official circles. Yet it is important that out of the logic of the assimilation policy, if very tardily in practice, some positive features proceeded, such as the right of Aboriginal people to vote in Australian elections, to be numbered in the census, to obtain a standard of medical care comparable to that of whites. It could be said that these are offshoots of the assimilationist policy as it has worked itself out historically under political and moral pressure from both black and white communities. In opposing the evils of assimilation we would do well to keep in mind the even greater evils of those desegregation policies that lead to notions of black states in Australia's most arid regions, to apartheid.

But is the notion of convergence, we must ask ourselves, little more than a fashionable up-date of the assimilation concept? The two words seem at a glance not all that dissimilar in meaning. Converge, however, derives from the Latin *convergere*, meaning to meet together; whereas assimilate, *assimmilat*, means to make alike and hence to absorb and incorporate; on the one hand a meeting of equals, on the other an act of ethnic cannibalism. And here we might note that the concept of a *transitional* Aboriginal culture is not much better than the older concept of assimilation since it implies surely the gradual transformation of the indigenous Aboriginal culture into European modes and forms. Now it is undoubtedly true that during the two hundred years of white settlement Aboriginal contact with the white culture has produced kinds of art, such as the work of Albert Namatjira, that might be described as transitional. But the use of such a term brings with it the clear implication that the transitional process will ultimately transform traditional Aboriginal art into a kind of white art, since the latter is the dominant mode. The term convergence is better than either assimilation or transition since it grants and implies the presence of two highly durable and yet flexible traditions. That which may converge may also diverge: the act of convergence does not imply the destruction of either tradition.

Convergence implies that we respect the continuing presence in Australia of a traditional Aboriginal culture. But here too clarification is essential. There is a continuing danger for those Australians of European (or Asian) descent (and particularly so for artists) to idealize the traditional Aboriginal culture as an unchanging culture, and to deplore any observable changes as

evidence of corrupting influence. But in this we are fantasizing, dreaming of an *ideal* primitive culture that never was. We can only break ourselves of this habit if we keep reminding ourselves that in considering the Aboriginal people of Australia we are not talking about some mythical ideal race who live in the past of our imaginings but about individual human beings who live here and now with us in the same land, who occupy our time and our space. They face the same problems of ill health, unemployment, victimization, that we may have to—but in a far greater degree.

How then shall we describe traditional Aboriginal culture? For a culture to be genuinely traditional it must possess a high measure of internal independence; that is to say the individuals that constitute the culture must be in a position to make most of the decisions that affect their daily lives. Not all the decisions of course; because there are long-term factors, such as the increase or decrease of a population, the increasing aridity of a land, that are largely beyond the influence of individuals or even communities. Not all decisions of course; because human societies have never existed in total isolation unaffected by the destructive pressure and influences of more powerful societies. But it is, more often than not, precisely in reaction to such influences and pressures that traditional societies maintain a high measure of internal cohesion. Consider the history of the Irish and the Jews; consider the resistance of Aboriginal society to two centuries of white dominance. It is from such situations that traditional cultures acquire their flexibility and resilience.

A traditional culture can survive even though its members have to submit to laws that are alien to that culture. To the extent that Aborigines are also Australian they are subject to the same laws that apply to white Australians. We must make a distinction here between their rights and duties as Australian citizens and those rights and duties that they themselves perceive as their inalienable possessions as members of a traditional culture. Not all Aborigines will perceive these traditional rights in the same way. The presence of the two cultures in the one land will create complex problems for individual Aborigines, since the roles which individuals, families and tribal groupings play in the two cultures differ markedly. What would be our attitude to the problems of a young adult woman who wished to give up the tribal life of a traditional Aboriginal society and move to a city and live with urban Aborigines? We might be inclined to say good luck to her if she can manage it, that family and tribe have the right of dissuasion but that we should object to physical

detention against her will. In making such judgements we are of course imposing our own ethic, one that allows a greater degree of individual freedom than many traditional societies do. But I suspect that we have no other choice available to us if we are prepared to be bound by our own traditional ethics in such cases.

Such situations reveal that we are not so much considering the problems of contact between two monolithic cultures but rather a whole spectrum of positions from the most traditional rural societies to the most urbanized groups among Aboriginal people. And we may well have to find more or less empirical ethical and cultural justifications—an ethics of place, circumstance and situation—if we are concerned to direct our attention to the needs of individual human beings rather than the ostensible demands of an ideal, traditional and unchanging Aboriginal society.

Convergence, however, in its respect for the presence of the two cultures on the one soil, implies the active continuation of the traditional Aboriginal culture, and this means that Aboriginal people be given as much control as they seek over their own traditional concerns and the factors that affect their well-being. Professor Megaw, in his recent lecture here, indicated in some detail for us the ingenuity and adaptability of the Papunya people in their contacts with white society.[8] By similar processes traditional Aboriginal societies have had to adapt their ways to European ways since 1788 in order to exist. They have been faced with hard choices at the best of times, but those who have survived the duress have continued to make choices where choice was possible. Although they have been reduced to the least skilled and rewarding positions they have in many parts of Australia clung tenaciously to their traditional culture.

The idea of convergence implies that a traditional Aboriginal culture that is also adaptable, changing and comparatively independent will continue to exist in Australia. There would be nothing unusual about such a situation but it is not inevitable. Traditional cultures have survived, traditional cultures have been exterminated. If the traditional Aboriginal culture survives in Australia it will be the result of continuing choices and transactions between the black and white cultures. The Jewish people have been able to maintain a tenacious grip upon their traditional culture. But I suspect that even if the most traditional of contemporary Jews came face to face with some of their original Mosaic ancestors they would experience a culture shock. Yet a traditional Jewish culture exists today as it did in the time of

Moses, except that today it is at once more traditional and probably relatively stronger. The Irish likewise have maintained a remarkable tenacity to cling to some aspects of their traditional culture, though their culture has been transformed as a result of the exigencies and continuities of oppression perhaps far more radically than that of the Jews.[9]

It is often said that European settlement has a history of only two centuries in Australia whereas the Aboriginal people have been here for thirty thousand years or more. This is significant for the moral and legal problems that arise as a result of the dispossession of a people from their land and from their spiritual bonding to it. But it is largely irrelevant to this question of the convergence of culture. The European-based institutions and cultural forms transported to Australian soil possess an antiquity reaching back to Rome, Greece, the Hebrews and the ancient cultures of the Middle East. When we speak of a convergence of cultures in Australia we are referring to the interaction, on one soil, of two cultures of immense antiquity.

Consider the ways cultural convergence may express itself in the visual arts, the ways in which, for example, Aboriginal artists may use their abilities to survive in the modern world. Albert Namatjira and his fellow artists during the 1940s, the Papunya artists of today, have revealed a capacity to perceive that there is a European demand for a kind of art that they are able to supply. In so doing they revealed and still reveal a creative capacity to live with an alien culture. They did it, you might say, for the money. We all do what we do, professionally, for the money. That is what modern society requires even if we do succeed in convincing ourselves (or more cleverly others) that we do it for higher, more spiritual reasons also. The way that the art of Namatjira and the Papunya people is assessed aesthetically will depend upon the mode of taste and the level of taste to which their art is addressed in the white society. There is a paradoxical sense in which it can be said that all the art Aboriginal people have ever produced has been produced for a European market and for European taste. Before the conquest Aborigines possessed no conception of art that is in any way comparable to ours. The artefacts they produced (which we call art) were an inherent and unmarketable aspect of their culture. So as soon as we even begin to talk about Aboriginal art we begin to affect the character of Aboriginal society. I do not mean that we begin to corrupt it or destroy it. We begin to change it, and the Aboriginal people too,

in grasping what we mean by art, contribute to the change. Indeed in order for their traditional culture to survive they had to devise strategies that coped with the idea of a sacred and ritual artefact as an art work. It would not be difficult to construct a whole spectrum of aesthetic and technical strategies, from those which accepted European styles enthusiastically, as in Namatjira's water-colour paintings, to those of the Papunya people, who adopted modern materials in order to perpetuate a traditional symbolism.

Consider the case of urban Aboriginal people of mixed Aboriginal and European parentage. On a superficial view they might be considered the group most likely to exemplify the inevitability of a transitional art or even the inevitability of assimilation. Ulli Beier in the first lecture in this series introduced us to the work of a number of urban Aboriginal artists, such as Trevor Nicholls, of whose work it might be said that it had deeply absorbed European conventions and traditions.[10] Yet there were significant elements of mood and content in his paintings and a range of subject matter by which he expressed strongly the character of his Aboriginality. Now, paradoxically as it might seem, it is precisely from this aspect of Aboriginal art, the work of urbanized Aborigines working in European modes, that the most powerful moves towards a convergence of the two cultures may spring. Because for artists like Nicholls who have been radically Europeanized and have responded creatively to European forms, their Aboriginality is likely to consist in a large measure in their personal rediscovery of a lost Aboriginal past. By the re-creation of this past they help to discover themselves as contemporary individuals with a reason for existence. This, of course, is one of the most potent ways in which mythical elements work in any cultural situation.

Consider for a moment one's personal genetic origin. We may wish to think of ourselves as of Australian, English, Scottish, Irish, Turkish, Lebanese or Vietnamese descent. But our genetic ancestry links us to the past in the form of an increasing geometric progression. The further we go back in time the more widely are we related to an ever-decreasing total of the human stock. We may not all be related to Adam but we are all ultimately related to primeval humanity whether in Europe, Africa or Asia. But that is not the way we constitute our cultural origins. We constitute those out of myths that we find amenable and congenial; and if we do not do it for ourselves there are others who are ready and willing to do it for us. The traditional Scottish

Australian Aboriginal rock painting *A Crocodile Wandjina*. Oscar Ranges,
Kimberley, Western Australia.

Trevor Nicholls *Lovers* (original version). Oil on canvas, 167.5 × 111.5 cm, 1984.

highlanders' garb of kilt and tartan, accompanied by ear-splitting bagpipe, for example, which are commonly supposed to reach back to some vague mediaeval time, are largely the inventions of the romantic movement and nineteenth-century wool and bagpipe manufacturers.[11] We need not see anything unduly sinister about all this. We all seem to need some sense of a cultural identity with the past, and one way by which a traditional Aboriginal culture will persist and develop in Australia will certainly be through the efforts of urbanized Aborigines to re-create their own past in the process of self-identification within a modern, changing society.

But there is another side to this coin. To what extent is it legitimate for those of us of European descent to draw upon the Aboriginal culture for our own creative purposes? Here the situation is much more problematic. On the one hand it may be argued, as Margaret Preston argued, that since we inhabit the same country as the Aboriginal people and since they were here many thousands of years before we white Australians we cannot do better than follow their unique example.[12] There is a good deal of truth in this because art is in part fashioned by the nature of the physical environment in which it is produced. But there may be a danger also. Modern art is a personal matter that concerns itself with both personal and social identity. How then can we make use of Aboriginal motifs and Aboriginal art forms? For those who are personally related by descent to both cultures, as I said earlier, there should be less of a problem for we are genetically, culturally and emotionally tied to both. But for those who possess no such bondings the transformational processes of artistic creation may not work so readily. Apart from that we may be accused of appropriating Aboriginal culture for our own purposes. When we know that much of that art is both sacred and secret there may be considerable strength in such accusations; and the Aboriginal people whose art has been so utilized may regard it as a kind of sacrilege.

To argue, however, that Australians of non-Aboriginal descent have neither a moral nor an aesthetic right to make their own creative use of Aboriginal art would be to adopt a very dubious position from a historical point of view. At all times cultures in contact have borrowed styles and forms from one another; aesthetic form transcends cultural divisions. Furthermore, as we noted earlier, it could be said that Europeans themselves were responsible for injecting aesthetic value into the ritual artefacts of Aboriginal people. One of the major functions of aesthetic

valuing consists in appropriating the useful into the so-called 'useless' realm of aesthetics. So it was that Marcel Duchamp appropriated a gentleman's urinal from some anonymous lavatorial situation and exhibited it as a work of art under his own name in 1917. Duchamp was not prepared to admit (though he may have realized it) that the designer and fabricator of the urinal were as much artists as he was. When we paint we too often forget those anonymous artists who have already manufactured the canvas and the pigments, cut and shaped the stretchers.

There are two basic aspects of the artistic process involved here. On the one hand the powerful emotional sources of art, the artist's personal experience of life, particularly of childhood and family experience, are culture-bound both in time and place. On the other hand the forms by which those experiences are moulded into art more often than not transcend our own time and place. From a formal viewpoint the twentieth-century artist is in a position to make use of all the art of all the known cultures of the past and present. This is the paradox at the heart of the modern debate as to whether a work of art is regional or international. It depends upon whether we are speaking about its genesis and substance, its autobiographical reality or about the formal strategies that have been adopted in its construction.

One of the most interesting features of the modern movement was its open-endedness, its ability to draw upon all the arts of the world, not only those of European origin. On one view this may be seen as an aspect of the European imperial conquest and financial dominance of the world during the more creative moments of modernism. But it belittles the role of the artist to see him or her playing only a passive, sycophantic role in that conquest and dominance. A countervailing movement was also present, as Gauguin dying in the Marquesas with his one remaining 'witchdoctor' friend testifies, a new kind of empathy with the non-European, a genuine interchange and transaction of the spirit which opened up the hope for a creative rather than a destructive interchange between regional cultures around the world. In our part of the globe this creative interchange should continue to express itself in the form of a convergence between the traditional Aboriginal culture and the white culture which once imagined, in its misplaced pride, that it would displace it.

Does all this then mean that the traditional Aboriginal culture is to be regarded as but yet another ethnic culture within a modern Australian multi-cultural society? It is not as simple as that. A multi-cultural society is not something that exists in a

geographical sense only; it also possesses historical depth. For each ethnic culture, though spread in varying densities across the continent and dispersed among other communities, possesses not only a feeling for its historic past in another place but also an increasing awareness of its history within the Australian community. Who was the first Spaniard, Turk, Thai, Maori to arrive in Australia? These are historical questions that admit of an answer. They are being addressed by those who are writing the histories of ethnic communities within the Australian society, an increasing and valuable activity on the eve of the Australian bicentenary of white occupation. But who was the first Australian to arrive? That we shall never know. All that we may assume is that he or she was the first human being to step on shore and that afterwards other human beings have followed.

The fact that all this historical work is now being undertaken in the separate ethnic communities in Australia does not mean that we are losing a sense of our identity as a nation. It is rather an indication that increasingly we are coming to be prepared to face a closer scrutiny of the Anglo-Celtic myths that have dominated the ways we construct our history. A multi-cultural society, it needs to be constantly stressed, remains a single society to the extent that its members give allegiance, even reluctantly, to its legal institutions and forms. This is a contractual compliance so far as newcomers are concerned, an inheritance for those of us who were born here. But the unity of a multi-cultural society is not only expressed in its common allegiance to the society's laws, it is also expressed in its codes of behaviour, the courtesies and crudities of daily life, constantly generated and transacted by individuals and community groups in public; codes of behaviour by which we become known and identifiable by visitors.

These over-arching unities by means of which ethnic communities also become members of the one society proceed from the long-term constancies of our environment in its widest sense. It is that which remains here with us, to condition us, to make the one out of the many, or as Manning Clark has reiterated, 'the earth abideth forever'.[13] A multi-cultural society then is a many-layered historical community, consisting of ethnic communities each treasuring a memory of their own mythical past, but all of which are subject continually to the power of place. And those of course that possess the longest history of this place, this Australia, and have been most powerfully subject to it are the Aboriginal people. And because the creative ones in all communities borrow their forms, as often as not from beyond the conventions

of their communities, the mythical experience of a multi-cultural society becomes in itself more complex, mythically many-layered. But in the realm of myth it seems always to be the most ancient, that which has longest been acclimatized to the exigencies and constraints of the land itself that ultimately exerts the most enigmatic and ineffable influence, produces the most pervasive metaphors. It may not only be the Australian Aboriginal children of the future who will regard the Rainbow Snake with the same kind of guilty and bemused respect that the Irish (that many-layered people) give to their fairies.

Notes

1 Notes on Élitism and the Arts

1 From *The Stones of Venice*, ii, chapter 6, quoted by John Sheridan Moore in his unsigned article in *The Month* (of which he was then editor), vol. i, 1856.
2 Quoted by D. H. Souter, 'Tom Roberts, Painter', *Art and Architecture*, iii (1906), 37.

2 The Death of the Artist as Hero

1 On the routinization of charisma see Max Weber, *Theory of Social and Economic Organisation*, trans. A. R. Henderson and Talcott Parsons (London, 1947).
2 See E. H. Gombrich, 'The Renaissance Conception of Artistic Progress and its Consequences', *Norm and Form* (London, 1966).
3 *Lives of the Painters, Sculptors and Architects*, trans. W. Gaunt (London, 1963), I, 248.
4 Ibid., I, 290
5 L. B. Alberti, *Ten Books of Architecture*, trans. Leoni, 1755 edition (Tiranti, London, 1965), Book X, Ch. X, 205f.
6 Vasari, *Lives*, II, 204.
7 Ibid., IV, 108 f.
8 *A Study of History* (London, 1939), IV, 119 f.
9 Marx, *Capital*, trans. from the 3rd German edn by S. Moore and E. Aveling (London, 1912), 347.
10 R. and M. Wittkower, *Born Under Saturn* (London, 1963), 14.
11 Ibid., 188.
12 Ibid., 192.
13 Ibid., 228.
14 Salvator Rosa to Don Antonio Ruffo, 1666, quoted by M. Kitson in *Catalogue to Salvator Rosa Exhibition*, Hayward Gallery (London, 1973), 14.
15 Carolus Bovillus, *De Sapiente* (ch. 5), quoted by Ernst Cassirer in *The Individual and the Cosmos in Renaissance Philosophy*, trans. M. Domandi (Oxford, 1963), 89.

16 Marx, *Capital*, 422.
17 Adam Smith, *An Inquiry into the Nature and Causes of the Wealth of Nations*, ed. Campbell, Skinner and Todd (Oxford, 1976), I.i.f. 3, 15.
18 Ibid., V.i.f., 782.
19 *Jerusalem*, III, 65, II, 16–22.
20 Cf. Adam Ferguson's comment, 'We make a nation of Helots, and have no free citizens', *History of Civil Society* (London, 1767), 285.
21 Kant, *Critique of Teleological Judgement*, trans. J. C. Meredith (Oxford, 1952), 97.
22 In Zola's article on Manet, *Revue du XIX^e siècle, 1867*, quoted by G. H. Hamilton, *Manet and his Critics* (New York, 1969), 95.
23 Quoted by Linda Nochlin, *Realism* (Harmondsworth, 1971), 63.
24 Vincent to Theo van Gogh, 1888, *The Complete Letters of Vincent van Gogh* (New York 1959), iii, 16–17.
25 Quoted in H. B. Chipp, *Theories of Modern Art* (Berkeley, 1968), 489.
26 Tom Wolfe, 'The Painted Word', *Harper's Magazine* (New York), April 1976.
27 B. H. Friedman, *Jackson Pollock* (London, 1973).

5 The Writer and the Bomb

1 David Martin, *Armed Neutrality for Australia* (Blackburn, Victoria, 1984).
2 Ibid., 33–4.

6 History as Criticism

1 *Cahiers des Annales* (Paris, 1949). There is a translation by P. Putnam, see M. Bloch, *The Historian's Craft* (Manchester, 1954). See also E. H. Gombrich, 'Art and Scholarship', *Meditations on a Hobby Horse* (London, 1963), 106–19.
2 B. Smith, 'The Myth of Isolation', *Australian Painting Today: The John Murtagh Macrossan Memorial Lectures, 1961* (St Lucia, 1962), 6.
3 J. S. MacDonald, 'Arthur Streeton', *Art in Australia*, III, 40 (October 1931), 22.
4 Robert Menzies, Foreword to J. S. MacDonald, *Australian Painting Desiderata* (Melbourne, 1958), vii–viii.
5 Letter to the Editor, *Sydney Morning Herald*, 15 October 1940.
6 'The Fascist mentality in Australian Art', *Communist Review*, 58 (June 1946), 182–4; (July 1946), 47–54 (under the pseudonym Goya).
7 Gombrich, 'Art and Scholarship' (1963), 107.
8 Anne Bickford, 'The Patina of Nostalgia', *Australian Archaeology*, 13 (December 1981), 5.
9 John Barrell, *The Dark Side of the Landscape* (Cambridge, 1980).

7 Art Objects and Historical Usage

1 See page 38 ff.
2 L. von Ranke, Preface to *Histories of the Latin and Germanic Nations from 1494—1514*, 3rd edn, (1885), cited in F. Stern, *The Varieties of History: from Voltaire to the Present* (London, 1956), 57.
3 Sir Thomas Browne, *Religio Medici*, Everyman edn (London, 1906), 19.
4 Lord Macaulay, 'History', *Edinburgh Review* (May, 1828), cited in F. Stern, *The Varieties of History* (London, 1956), 76.
5 Karl Popper, *The Poverty of Historicism* (London, 1957), x.
6 K. Marx and F. Engels, *Collected Works* (London, 1975), 3, 296—7.

10 Jack Lindsay

1 H. M. Green, *History of Australian Literature* (Sydney, 1961), 973.
2 Ibid., 1147.
3 Jack Lindsay, *Life Rarely Tells* (Ringwood, Victoria 1982), 36.
4 Ibid., 102—3.
5 Ibid., 683.
6 Jack Lindsay, *The Anatomy of Spirit* (London, 1937), 90—1.
7 Ibid., 179.
8 Jack Lindsay, 'A Plea for Mass Declamations', *Left Review*, October 1937, 511—17.
9 Jack Lindsay and Edgell Rickwood (eds), *A Handbook of Freedom* (London, 1939), republished under the title *Spokesmen for Liberty* (London, 1941), from which the quotation is cited, 377.
10 Jack Lindsay, *A Short History of Culture* (London, 1939), 11—12.
11 Christopher Hill, 'Jack Lindsay the Historian', *Culture and History* (Sydney, 1984), 266.
12 Michael Wilding, 'Jack Lindsay', *Overland*, 83 (April 1981), 40.
13 Bernard Miles, 'Cleopatra: Her Latest Lover', *Culture and History* (Sydney, 1984), 223.

11 Jack Lindsay's Marxism

1 George Lukács, *History and Class Consciousness*, trans. R. Livingstone (London, 1971), 27.
2 Jack Lindsay, *A Short History of Culture* (London, 1939), 25—6.
3 W. Dilthey, *Selected Writings*, ed. and trans. H. P. Rickman (Cambridge, 1976), 89.
4 Jack Lindsay, *The Anatomy of Spirit* (London, 1937), 60, 62.
5 K. Marx and F. Engels, *Collected Works* (London, 1975), iii, 304.
6 *The Anatomy of Spirit*, 67.
7 Wolf Schäfer, 'Towards a Social Science of Nature', *Praxis International* (October 1983), 327, 332.
8 Jack Lindsay, *Blast-Power and Ballistics* (London, 1974), 430.

9 K. Marx, *Letter to Arnold Ruge*, 1843, quoted by Jack Lindsay, *The Crisis in Marxism* (Bradford on Avon, 1981), 50.
10 *The Crisis in Marxism*, 49.
11 *The Anatomy of Spirit*, 4.
12 *The Crisis in Marxism*, 123–4.
13 Quoted in *Marxism and Art*, ed. Maynard Solomon (London, 1979), 74–5.
14 K. Marx, *Capital* (London, 1912), 42–3.
15 Marx and Engels, iii, 277.
16 *The Crisis in Marxism*, 147.
17 Ibid., 78.
18 K. Marx, *The Critique of Political Economy*, trans. S. W. Ryazanskaya, ed. Maurice Dobb (Moscow, 1970), 21.
19 L. Kolakowski, *Main Currents of Marxism* (Oxford, 1978), iii, 486.
20 B. Smith (ed.), *Culture and History: Essays Presented to Jack Lindsay* (Sydney, 1984), 372–3.

12 Jack Lindsay's Biographies of Artists

1 K. Marx and F. Engels, *Collected Works* (London, 1975), iii, 142.
2 Jack Lindsay, *The Crisis in Marxism* (Bradford on Avon, 1981), 17.
3 Ibid., 147.
4 Jack Lindsay, *Thomas Gainsborough* (London, 1981), preface.
5 Jack Lindsay, *J. M. W. Turner. His Life and Work* (London, 1966), 121–2.
6 *Gainsborough*, 1.
7 Jack Lindsay, *William Blake* (London, 1978), 20.
8 Jack Lindsay, *William Hogarth* (London, 1977), 223.
9 Ibid., 225.
10 Ibid.
11 *Gainsborough*, 4.
12 'The Marriage of Heaven and Hell', *Poetry and Prose of William Blake*, ed. G. Keynes (London, 1961), 181.
13 Lindsay, *Blake*, xvi.
14 Jack Lindsay, *Gustave Courbet* (Bath, 1973), 324.
15 Jack Lindsay, *William Morris* (New York, 1979), 382–3.
16 Jack Lindsay, *Cézanne, His Life and Art* (New York, 1969), 305.

13 Marx and Aesthetic Value

1 Karl Marx, *Grundrisse*, trans. Martin Nicolaus (Harmondsworth, 1973), 81 f.
2 K. Marx and F. Engels, *Collected Works* (London, 1975), iii, 276. The section of the volume containing the *Economic and Philosophical Manuscripts of 1844* has been translated by Martin Milligan and Dirk J. Struik.

3 K. Marx, A Contribution to the Critique of Political Economy, trans. S. W. Ryazanskaya, ed. Maurice Dobb (Moscow, 1970), preface, 20–1.
4 K. Marx, Capital, A Critical Analysis of Capitalist Production, trans. from the 3rd German edn by Samuel Moore and Edward Aveling and ed. by Frederick Engels (London, 1912), 156–7.
5 Ibid., 2.
6 Ibid., 3.
7 Marx, Grundrisse, 81 ff.
8 J. C. F. Schiller, On the Aesthetic Education of Man, trans. Reginald Snell (London, 1954).
9 On Schiller's influence on Marx see Margaret A. Rose, Marx's Lost Aesthetic (Cambridge, 1984), 86–91 ff.
10 For example, in his The Stones of Venice, The Works of Ruskin (London, 1904), x, 214.
11 Kant, The Critique of Judgement, trans. J. C. Meredith (Oxford, 1952), 41 ff.
12 Marx, Capital, 42–3.
13 A good beginning has been made by John B. Thompson, Studies in the Theory of Ideology (Cambridge 1984).

15 The Art Museum and Public Accountability

1 For example, 'Where are our Gallery Catalogues?', Art and Australia, 21, 1 (Spring 1983), 26–8.
2 Anna Beatrix Chadour and Rüdiger Joppien, Kataloge des Kunstgewerbemuseums Köln, Band X, Schmuck I and II (Köln, 1985).

16 Notes on Abstract Art

1 Richard Haese, Rebels and Precursors (Ringwood, Victoria, 1981), 160.
2 Bernard Smith, 'Comments on Style-Change and Criticism in Sydney', Society of Artists' Book (Sydney, 1946–47), 54.
3 Lawrence Alloway, The Venice Biennale 1895–1968 (London, 1968), 138.
4 Sixten Ringbom, 'Occult Elements in the Early Theory of Abstract Painting', Journal of the Warburg and Courtauld Institutes, xxvi (1966), 386–418.
5 On Leadbeater see Gregory Tillett, The Elder Brother, A biography of Charles Webster Leadbeater (London, 1982), and Jill Roe, 'Theosophy and the Ascendancy', The Sydney–Melbourne book, ed. Jim Davidson (Sydney, 1986).
6 Michel Seuphor, Dictionary of Abstract Painting, trans. L. Izod, J. Montague and F. Scarfe (New York, 1958), 41.
7 An exhibition of Georgiana Houghton's work was held in the National Gallery of Victoria (May–June, 1978) in association with the work of Roy Opie. An earlier showing of her work took place in the same gallery in the early 1960s.

8 Fred Orton and Giselda Pollock, 'Jackson Pollock, Painting, and the Myth of Photography', *Art History* (March 1983), 114–27.
9 *XXV Biennale di Venezia. Catalogo* (Venice, 1950), 393 (author's translation).
10 See Richard Stringer's comments in the *College Art Journal*, USA (Spring 1982), 85.

18 The Truth about the Antipodeans

1 Barbara Blackman, 'The Antipodean Affair', *Art and Australia*, 5, 4 (March 1968), 608–16.
2 Franz Philipp, 'Antipodeans Aweigh', *Nation*, 29 August 1959, 18–19.
3 Ibid., 19.
4 Blackman, art. cit., 615.
5 See, for example, the article 'Antipodean School', Alan McCulloch, *Encyclopaedia of Australian Art*, vol. I A–K (1984), 32–5. McCulloch broadened the term to cover the art of Drysdale, Nolan, Tucker, Jacqueline Hick, James Wigley and Fred Williams under the general description 'Australiana'. But to describe it as Australiana is to profoundly misunderstand what the Antipodean exhibition of 1959 was about.

19 The Myth of Isolation

1 *Recent Australian Painting*, Whitechapel Gallery, London, June–July 1961, 13.
2 Ibid., 10.
3 *The Times*, 3 June 1961.
4 *The Guardian*, 5 June 1961.
5 *Recent Australian Painting*, 8.
6 William Moore, *Studio Sketches* (Melbourne, 1905), 13.
7 Roberts to Deakin, 2 December 1910, quoted in R. M. Crawford, 'Tom Roberts and Alfred Deakin', *In Honour of Daryl Lindsay*, ed. F. Philipp and J. Stewart (Melbourne, 1964), 175.
8 *Sydney Morning Herald*, 19 September 1911.
9 R. M. Crawford, *An Australian Perspective* (Melbourne, 1960), 61–2.
10 William Huntingdon Wright, *Modern Art, its Tendency and Meaning* (New York, 1916).
11 *Recent Australian Painting*, 13.
12 Ibid., 4.

21 An Australian Impressionism?

1 Jane Clark and Bridget Whitelaw, *Golden Summers, Heidelberg and Beyond* (Melbourne, 1985).

2 Helen Topliss, *Tom Roberts 1856–1931: A Catalogue Raisonné*, (2 vols., Melbourne, 1985).
3 Leigh Astbury, *City Bushmen. The Heidelberg School and the Rural Mythology* (Melbourne, 1985).
4 Ann Galbally in Clark and Whitelaw, introduction, 9–10.
5 Ibid.
6 Bridget Whitelaw, 'Plein air Painting: The Early Camps around Melbourne', Clark and Whitelaw, 54–7.
7 Albert Boime, *The Academy and French Painting in the Nineteenth Century* (London, 1971), 16–17.
8 Jane Clark, 'The Art Schools', Clark and Whitelaw, 31–4.
9 Galbally in Clark and Whitelaw, 9.
10 See John Rewald, *The History of Impressionism*, 2nd edn (New York, 1946), 256.
11 John Peter Russell—Letters to Tom Roberts, letter no. 4. Mitchell Library, State Library of News South Wales, Sydney, ML 82480, vol. 3, f.12. The sentence has been transcribed by Dr Ann Galbally, *The Art of John Peter Russell* (Melbourne, 1977), 89 as 'Go in prophet style and tackle our stuff for love', but the word seems quite clearly to be 'forget' not 'prophet'.
12 Quoted by Rewald, 356–8.

22 Apollo's Vanguard

1 Norman Lindsay, *Creative Effort* (London, 1924), 3.
2 J. S. MacDonald, 'Arthur Streeton', *Art in Australia*, ser. 3, no. 40 (October, 1931), 22.
3 Hinton Correspondence, Mitchell Library, Sydney, MSS.339.
4 Ibid.
5 *Hieroglyphic or the Greek Method of Life Drawing* (I have not been able to establish the author or the place and date of publication of the book).
6 N.L. to H.H., Hinton Correspondence, 16 March 1920.
7 Ibid.
8 Note also Howard's remark to Norman in a letter of 11 February 1935. 'Ever since I met you at Kalgoorlie St. Willoughby you have always been so wonderfully generous in gifts and advice to me with knowledge of what is best in art.'Hinton Corr., NL.339.
9 C. B. Newling, 'The Life', *A Memorial Volume to Howard Hinton*, (Sydney, 1951), 3.
10 Ibid.
11 Cf. 'what any collective body may think of it (i.e. his work), Trustees, public or what not, is a matter of indifference. My conviction is that no action of an artist's in his lifetime can ensure a value to his work. Time alone can do that, and for my part I prefer to leave the discussion there', N.L. to H.H. 4 June 1926, ML. MSS.339.

12 Hinton Correspondence, ML. MSS.339.
13 N.L. to H.H. October 1920.
14 H.H. to N.L. 7 October 1920.
15 *Elioth Gruner*, foreword by Norman Lindsay (Sydney [n.d.]).
16 H.H. to N.L. 26 October 1925, ML. MSS.339.
17 N.L. to H.H. 31 October 1925, ML. MSS.339.
18 Cf. 'At the back of my mind I always maintained a certain hope that
 the incessant hatred of the repressed classes for me and my work
 would be balanced by a certain backing from the intelligent minor-
 ity which would at least keep me from such a direct insult as this
 [i.e. the attempted police prosecution of his work published in *Art in
 Australia* in 1931]. I believed that we were building a culture here
 which would in future have a fine creative result. I did not expect it
 in my lifetime, but I expected that my life time would see some hint
 that it was being stabilised', N.L. to H.H. 22 July 1931, ML. MSS.339.
19 N.L. to H.H. 23 June 1942, ML.MSS.339.
20 N.L. to R. H. Goddard, Hinton Correspondence, 2 February 1948.
21 *The History of Sexuality*, trans. R. Hurley (Harmondsworth, 1981), 40.
22 H.H. to N.L. 8 September 1933, ML. MSS.339.
23 H.H. to N.L. 10 October 1919, ML. MSS.339.

23 Two Art Systems

1 See pp. 42–44.
2 For example, Fernand Braudel, *Capitalism and Material Life
 1400–1800*, trans. M. Kochan, original ed. 1967 (London, 1973).
3 Leonard B. Cox, *The National Gallery of Victoria 1861 to 1968* (Mel-
 bourne, n.d.), 10.
4 Ibid., 16 ff.
5 Norman Lindsay, *Creative Effort* (London, 1924), 3, 4.

24 Some Northern Critics of Southern Art

1 Peter Fuller, *Beyond the Crisis in Art* (London, 1980), 11.
2 Jill Bradshaw, 'Australia—the fringe discovery of 1983', Peter Fuller
 (ed.), *The Australian Scapegoat: towards an Antipodean Aesthetic* (Ned-
 lands, WA, 1986), 66.

26 On Cultural Convergence

1 Les Murray, 'The Human Hair Thread', *Meanjin*, 36, 4 (December
 1977), 550–71.
2 Bernard Smith, *The Spectre of Truganini, 1980 Boyer Lectures*, Austra-
 lian Broadcasting Commission (Sydney, 1981), 44 ff. I had however
 expressed similar views to those embraced by the concept of conver-
 gence much earlier in *Place, Taste and Tradition* (Sydney, 1945), 166:

It is undoubtedly true that the admixture of racial qualities where it has occurred in the growth of a nation has been extremely beneficial. The colonization of Mexico, in spite of the enslavement of the native Mexicans, during the beginnings of settlement, is an example of the development of a vigorous living art with its own distinctive qualities, from the blending of two ethnic types. But such a growth results only from a two-way development, the mutual contribution of two *living* traditions that eventually intermingle as they continue their adaptation to a common environment. The aboriginal culture will not affect Australian art unless the slow physical extermination of the aborigines by our own predatory culture is arrested. The problem is one for trained anthropologists, the Commonwealth and all those who are prepared to see the aboriginal, not as an idealised figure symbolic of the perfect cultural amity of man and environment, but as a contemporary of our own with very real problems who has never had even the semblance of a fair deal. If we can arrest its extermination, there will be sufficient time to talk about assimilating the Aboriginal culture with our own.

3 Hugh Morgan, 'We Should be Proud of our History', the *Age*, Melbourne, 5 September 1986.
4 Murray, 569.
5 *The Journals of Captain James Cook*, ed. J. C. Beaglehole, (Cambridge, 1955), 1, 399.
6 Sydney Parkinson, *Journal of a Voyage to the South Seas* (London, 1784), 146.
7 Smith, 20 ff.
8 Vincent Megaw, 'Painters of the Western Desert', loc. cit., 15 April 1985.
9 For a recent consideration of the condition of Irish culture see Vincent Buckley, *Memory Ireland* (Ringwood, Victoria), 1985.
10 Ulli Beier, 'Urban Aboriginal Art', loc. cit., 25 March 1985.
11 See Hugh Trevor Roper, 'The Invention of Tradition: The Highland Tradition in Scotland', *The Invention of Tradition*, ed. E. Hobsbawm and T. Ranger (Cambridge, 1983), 15–42.
12 Margaret Preston, 'The Indigenous Art of Australia', *Art in Australia* (March, 1925).
13 The sub-title of the fourth volume of Manning Clark, *History of Australia* (Melbourne, 1978).

Sources of Illustrations

Index

316 Index

Bernard, Emile, 139, 145
Bernini, Pietro, 17
Bernstein, Eduard, 119
Besant, Annie and Leadbeater, C. W., *Thought Forms*, 190
Beutler, Adolph, 107
Beyond the Crisis in Art (Peter Fuller), 181, 310
Bickford, Anne, 'The Patina of Nostalgia' (1981), 75–6, 304
Binyon, Laurence, 167
biological experience, art criticism and, 278–9
biological need, Jack Lindsay's theory of, 121
Black, Dorrit, 227
Blackman, Barbara, 208; 'The Antipodean Affair', 198–9, 308
Blackman, Charles, 197–9, 203, 206, 208
Blake, William, 26, 49, 82, 105–8, 115, 119, 127, 130–3, 138–40, 142–3, 144; 'Albion Arose', 23–4; *Poetry and Prose of William Blake*, 306
Blake Prize, 269
Blast-Power and Ballistics (Jack Lindsay), 110–11, 114, 121–3, 305
Blavatsky, Madame, 190
Bloch, Ernst, 115, 117, 123–4
Bloch, Marc, 70; *Apology for History*, 69; *The Historian's Craft*, 304
Bloomfield, Lyn, 262
Blue Poles (Jackson Pollock), 97, 182, 188, 212
Blunt, Anthony, 172; *Artistic Theory in Italy 1450–1600*, 173
Blunt, William Scawen, 112
Boccioni, Umberto, 186
Boime, Alfred, 243; *The Academy and French Painting in the Nineteenth Century*, 309
Bonnard, Pierre, 26
Bonython, Kim, 202, 212
Born Under Saturn (R. and M. Wittkower), 303
Bottomley, Gordon 108
Boucher, François, 253
Boudin, Eugene, 242, 244
Boulton, Matthew, 48
Bourke Street (Tom Roberts), 224, 245
Bovillus, Carolus, 18; *De Sapiente*, 303
Bowness, Alan, 277
Boyd, Arthur, 197–8, 200, 203–4, 207–8, 237
Boyd, David, 197–201, 203–4, 206–9; *Truganini, the Last of the Tasmanian Aborigines*, 207

Boyd, Hermia, 200
Boyd, Martin, 113, 209
Boyer Lectures (1980), 289
Boynes, Robert, 63; *Faith and Empire*, 63–4
Brack, John, 197–8, 200–1, 203–4, 206, 208, 210
Bradshaw, Jill, 280–1; 'Australia — the Fringe Discovery of 1983', 310
Braudel, Fernand, 265; *Capitalism and Material Life 1400–1800*, 310
Brisbane, art in, 212
Brisbane Grammar School Magazine, The, 103
Britain, art museums of, 161, 164; nineteenth-century, 98
British art, 232; Australian art and, 274
British Council, 210, 217
British Museum library, 74
British painting, Art Gallery of New South Wales catalogue of, 171
Britten, Benjamin, 273
Bronze Age archaeology, 95
Brown, Joseph, 271
Browne, Thomas, 79, 279; *Religio Medici*, 305
Brueghel, Pieter, *The Fall of Icarus*, 11–12
Brunelleschi, Filippo, 13
Bruno, Giordano, 109
Buber, Martin, 58
Buckley, Vincent, *Memory Ireland*, 311
Bulletin, 235, 267–9
Bunny, Rupert, 225, 256
Bunyan, John, 106, 114, 117, 127, 130
Burckhardt, Jacob, 16, 265
Burghers of Calais (Auguste Rodin), 255
Burlington, Third Earl of, 98
Burstall, Tim, 203, 209
Bush, The (Bernard O'Dowd), 236
businessmen, Australian art museums and, 174–5
Buvelot, Louis, 242
Byzantium, 113–14
Byzantium in Europe (Jack Lindsay), 113–14

Caesar Is Dead (Jack Lindsay), 109
Cahiers des Annales, 304
Cake Man, The (Robert Merritt), 287
Calvinism, 191
Camden Town School, 171
Campbell, Roy, 108
Canberra School of Art, 54
Cant, James, 238
Capital (Karl Marx), 121, 125–6, 146, 149, 151, 303–4, 307